THE ART BOOK

THE ART BOOK

DK | Penguin Random House

DK LONDON

SENIOR EDITORS
Georgina Palffy, Sam Atkinson

US EDITOR
Margaret Parrish

SENIOR ART EDITORS
Nicola Rodway, Gadi Farfour

PROJECT ART EDITOR
Saffron Stocker

MANAGING EDITOR
Gareth Jones

SENIOR MANAGING
ART EDITOR
Lee Griffiths

ASSOCIATE PUBLISHING
DIRECTOR
Liz Wheeler

ART DIRECTOR
Karen Self

PUBLISHING DIRECTOR
Jonathan Metcalf

CREATIVE DIRECTOR
Phil Ormerod

JACKET EDITOR
Claire Gell

JACKET DESIGN
DEVELOPMENT MANAGER
Sophia MTT

PRE-PRODUCTION PRODUCER
Gillian Reid

SENIOR PRODUCER
Mandy Inness

DK DELHI

JACKET DESIGNER
Suhita Dharamjit

SENIOR DTP DESIGNER
Harish Aggarwal

MANAGING JACKETS EDITOR
Saloni Singh

original styling by
STUDIO8 DESIGN

produced for DK by
COBALT ID

ART EDITORS
Darren Bland, Paul Reid

EDITORS
Richard Gilbert, Diana Loxley,
Kirsty Seymour-Ure,
Marek Walisiewicz

This American Edition, 2020
First American Edition, 2017
Published in the United States by
DK Publishing 1450 Broadway, Suite 801,
New York, NY 10018

Copyright © 2017, 2020
Dorling Kindersley Limited
DK, a Division of Penguin
Random House LLC

20 21 22 23 24 10 9 8 7 6 5 4 3 2 1
001—316698—Nov/2020

A catalog record for this book is available
from the Library of Congress.

ISBN: 978-1-4654-9141-1

DK books are available at special discounts
when purchased in bulk for sales
promotions, premiums, fund-raising, or
educational use. For details, contact: DK
Publishing Special Markets, 1450 Broadway,
Suite 801, New York, New York 10018
SpecialSales@dk.com

Printed in China

For the curious
www.dk.com

FSC
www.fsc.org

MIX
Paper from
responsible sources
FSC™ C018179

CONTRIBUTORS

CAROLINE BUGLER

Caroline Bugler has a degree in History of Art from Cambridge University and an MA from the Courtauld Institute in London. She has written several books, including *The Cat: 3,500 Years of the Cat in Art* and numerous articles. She has also worked as an editor at the National Gallery, London, and at the Art Fund.

ANN KRAMER

Ann Kramer has written well over 60 books for the general reader on various topics, including art and women's history. She has recently delivered a series of lectures and workshops on women artists linked to Sussex, where she lives.

MARCUS WEEKS

Marcus Weeks studied music and philosophy and worked as a teacher before embarking on a career as an author. He has contributed to many books on the arts and popular sciences, including several titles in DK's *Big Ideas* series.

MAUD WHATLEY

Maud Whatley is an art writer, researcher, and maker. She studied English Literature at Southampton University, and later received an MA in Art History at the Courtauld Institute in London. While there, she worked particularly on 19-century European depictions of the male nude. She now works in London on diverse projects for galleries and publishers.

IAIN ZACZEK

Iain Zaczek studied at Oxford University and at the Courtauld Institute in London. A specialist in Celtic and Pre-Raphaelite art, he has authored more than 30 books.

CONTENTS

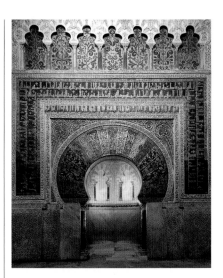

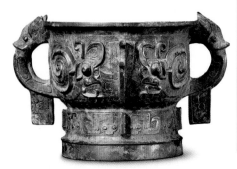

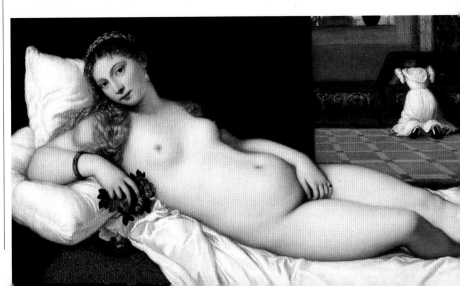

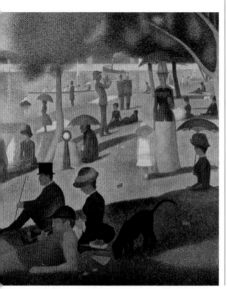

INTRODU

CTION

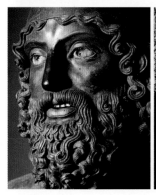
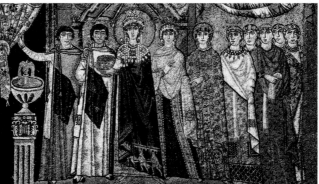

Art is one of the building blocks of civilization; no significant culture or society has ever flourished without it. Throughout history, artistic works have taken on many forms and served many purposes, and they have constantly evolved in the process. Sometimes these changes have been imperceptibly slow, while at other times—most notably in the early years of the 20th century—there has been an explosion of artistic diversity and innovation. This book looks beneath the surface of these changes, identifying the ideological, social, political, and technological forces that have shaped the development of art and generated such a kaleidoscopic variety of expression.

Art, belief, and ritual
The history of art stretches back more than 30,000 years, although art's earliest exponents would almost certainly not recognize any of the modern concepts denoted by the term, and contemporary theories about the purpose of prehistoric paintings and carvings are far removed from their creation. The earliest art may have been linked to beliefs about fertility, sun worship, reverence for the dead, or sympathetic magic (as an aid to

hunting) but, whatever their role, artworks were functional, ritual tools, designed to assist with the business of survival.

Beliefs about gods and the afterlife motivated much early art, and provided many of its subjects. The ancient Egyptians, for example, decorated tombs and papyrus texts with pictures of their gods in the hope that these images would protect them from evil and guide them on their journeys to the afterlife. The Chinese shared these concerns: the famous Terra-cotta Army, discovered in 1974 in Shaanxi province, was created in the late 3rd century BCE and buried with the first emperor, Qin Shi Huang, to keep him safe after death. The jade suits created for the rulers of the Han Dynasty who succeeded him are equally remarkable. Jade, it was believed, conferred immortality on the deceased, so the bodies of rulers were encased in special suits composed of thousands of jade plaques, stitched together with red silk or gold wire.

Religious expression varied enormously between different cultures and also changed over time within them. In the East, for example, early artists avoided representing the Buddha in human

form, but instead used symbols that indicated his presence, such as his footprints, stupas, and the dharma wheel. By the 1st century CE, however, anthropomorphic sculptures of the Buddha began to appear in northern India, inspired by interactions with Greek culture, which had spread eastward with the armies of Alexander the Great.

The Western tradition
Classical Greek art portrayed gods and heroes as idealized figures, placing perfect proportion at the heart of its aesthetic philosophy. Roman art built on this tradition to commemorate military victories and the triumphs of emperors, but preferred its own sharp realism, and, in turn, the art of the Christian

Painting is silent poetry, and poetry is painting that speaks.
Plutarch

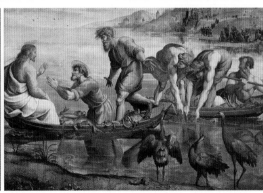

Church borrowed heavily from this classical tradition. Legitimized by the Roman Empire, the Church grew in wealth and power, and its many commissions helped to shape the face of art in Europe and also in the Byzantine Empire—the continuation of the Roman Empire in the east.

The purpose of Christian art through the Middle Ages was not to represent reality: instead, it served primarily to convey religious truths through symbolic conventions and so to educate the faithful, who were almost entirely illiterate. From the 6th century, the stylized, otherworldly works of early Byzantine art influenced painters across Europe. In the late medieval period, however, art gradually became more naturalistic, with painters such as the Florentine Giotto and his followers endowing biblical scenes with genuine emotion. After the mathematical principles of perspective had been developed in the early 15th century, other Western painters produced ever more realistic images of sacred events. The figures that they painted appeared solid and anatomically correct, and the settings of the figures—whether architectural or natural—seemed more convincing.

Art in the Islamic world—which at various times extended from Spain to western China—followed a different path, in which religious art largely avoided depiction of the human form, but adopted calligraphy to represent the divine word, and employed geometric and plantlike motifs as decoration.

The rise of the artist

The European Renaissance, or literally "rebirth," heralded an age of exploration, scientific enquiry, and artistic expression inspired by classical values of rationality and beauty. Before this time, artists had been viewed as craftsmen rather than intellectuals. They occupied a relatively low status in society and their names rarely survived into posterity. Originality and

A man paints with his brains and not with his hands.
Michelangelo

individual creativity were neither expected nor desired; indeed, documents of commissions show that patrons could be remarkably precise about their requirements, sometimes specifying the exact number of figures to be included in a work.

In medieval contracts it was not unusual for patrons to stipulate the exact amounts of costly materials to be used in a painting or sculpture. Ultramarine was a case in point. This brilliant blue color comes from lapis lazuli, a mineral that was mined in (present-day) Afghanistan. The rarity of ultramarine (its name translates as "beyond the seas") made it expensive, and so it was often reserved for the most important part of a picture—for example, the cloak of the Virgin Mary.

The role of the artist of the time was exemplified by the Netherlandish painter Jan van Eyck who, despite his appointment to the court of Philip the Good, Duke of Burgundy, in 1425, was expected to perform a variety of menial duties, including gilding statues and producing the decorations for a wedding feast.

Perhaps the first artist to be recognized as a creative genius in his lifetime was Michelangelo, »

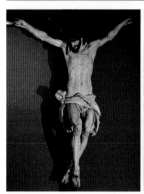
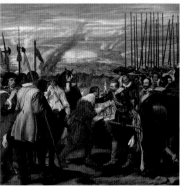
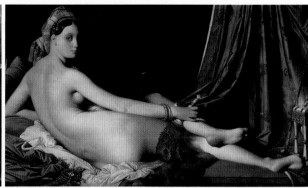

following his painting of the ceiling in the Vatican's Sistine Chapel in 1508–12. He and Leonardo da Vinci helped raise the profile of the artist to new levels, but, even so, most paintings still reflected the ideas and values of their patrons rather than their creators. This can be seen in the complex mythological allegories of Botticelli and his fellow painters, the driving force behind which was the desire of Italian princes to display their knowledge of classical texts and the latest Neoplatonic commentaries.

Similar impulses drove artistic endeavors for years to come: in the early years of the 19th century, for example, Napoleon promoted a new form of design—the Empire style—in a bid to liken his victories to those of the Roman emperors.

Personal expression
Societal changes are often reflected by changes in artistic style. Prior to the 17th century, for example, the most influential patrons of Western art came from the Church or from royal and aristocratic circles. However, when the Dutch maritime empire began to flourish, it gave rise to a wealthy new mercantile class. These middle-class citizens loved art, but had no interest in grandiose scenes of warfare or

classical mythology. Nor was there room in their modest townhouses for the huge canvases that had been commissioned for palaces and mansions. Instead, they looked for pictures that mirrored their own experiences: genre scenes (images of daily life), still lifes, landscapes, and—their particular passion—flowers. Artists rose to meet this demand, ushering in the golden age of Dutch art.

Toward the end of the 18th century, artists—some driven by revolutionary idealism—began to express their personal experiences and preoccupations in their work, further undermining the role of powerful patrons in art. Fueled by the writings of Sigmund Freud and his idea of the unconscious, some

> Fine art is that in which the hand, the head, and the heart of man go together.
> **John Ruskin**

later artists looked inward for inspiration, exploring their dreams, symbols, and personal iconography in their painting.

Ideas and movements
The canons of beauty and artistic worth are constantly changing, affected by the vagaries of time and fashion, shifts in attitudes, and the appearance of new technologies and materials. The ideas behind styles of art may spring from a plan or manifesto; sometimes they are deliberately fostered by members of an artistic "movement"; but often they coalesce around a group of artists in a certain time and place, and are only named and analyzed by later critics.

It has been impossible to foresee which artists or styles would find a place in history. Thomas Couture gained celebrity status for his historical paintings in 19th-century Paris but is all but forgotten today, while, conversely, 17th-century Dutch painter Johannes Vermeer sank into obscurity after his death and was only rediscovered in the 1860s. Value judgments usually stem from the cultural standpoint of the viewer. In the modern era, for instance, critics in the Soviet Union dismissed avant-garde experiments in the West as profit-driven and

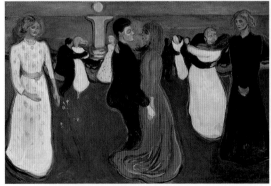

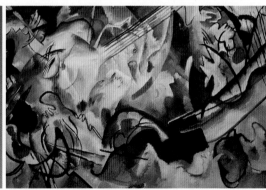

elitist, preferring their own Socialist Realism because it was more accessible to the general public and celebrated the achievements of ordinary citizens.

New technologies

Technological innovations are capable of stimulating or changing ideas in art, and the invention that has had the most profound impact on the history of art is printing. Woodblock prints had been made in China from the 3rd century CE, but it was Gutenberg's introduction of movable type in the 15th century that helped to spread Renaissance ideas; the technology to print text and images provided a wealth of inspiration for artists. Previously, artists seeking to view the work of others would have needed to travel to a private collection—there were no museums or art galleries—but printing greatly accelerated the transmission of new styles and techniques. For example, Raphael's paintings from the early 1500s were publicized throughout Europe by the engravings of Marcantonio Raimondi. The prints helped to make Raphael the most celebrated artist of his time and indirectly had a wider impact on the course of art history, because Raphael's work became the model for the teachings of the new academies and art schools. The print also enabled artists to produce multiple copies of their work and sell it at a lower price, so opening new markets and giving the artists greater independence from their patrons.

Discoveries and advances that at first seem insignificant can have huge impacts on artistic practice. The introduction of portable paint tubes in the 1840s, for example, initially appeared little more than a refinement of the old containers, but it enabled the Impressionists to develop one of the defining features of their working method: painting in the open air. Similarly, William Perkin's accidental discovery of a mauve pigment in 1856, while trying to make quinine, may have seemed nothing more than a happy accident. However, it prompted chemists to manufacture a flood of new synthetic pigments, which was a boon for painters, providing them with a wide range of new colors at affordable prices.

In the 19th century, the technological development with the greatest impact on the art world was photography. This invention caused panic among some artists, who predicted that it would bring about the end of painting. In fact, the reverse was true. Once the initial shock had worn off, groups including the Impressionists and the Pre-Raphaelites embraced the new technology, using it to find innovative ways of looking at the world around them.

The trend for experimentation gathered pace in the 20th century, as self-expression became the new watchword. Artists deliberately turned their backs on the styles of the past, in particular the realistic depiction of subjects, and began to work with shape and color in abstract forms. They sought nontraditional materials and techniques to help take their work in new directions and gain different perspectives. In the words of Paul Klee, "Art does not reproduce what we see; rather, it makes us see." ■

Every child is an artist. The problem is how to remain an artist once we grow up.
Pablo Picasso

PREHIST AND ANC ART

ORIC
IENT

A head of a woman is carved in mammoth ivory. Unearthed at a site at Dolní Vestonice, Czech Republic, it is dubbed "**the world's oldest portrait**."

A series of **colossal stone heads** carved from basalt boulders is a unique feature of the **Olmec civilization** of Mexico.

The **Ishtar Gate, Babylon**, is decorated with pictorial glazed tiles; it is later reconstructed in the Pergamon Museum, Berlin.

The celebrated *Discobolus* (*Discus Thrower*) is created by the **Greek sculptor Myron**; originally in bronze, it is known through marble copies.

c.24,000 BCE

c.1200–900 BCE

c.575 BCE

c.450

c.1500 BCE

c.900–600 BCE

c.530 BCE

c.350 BCE

A stone **rhyton**, or pouring vessel, in the shape of a bull's head is a masterpiece of the **Minoan civilization** of Crete.

Giant stone guardian spirits in the form of human-headed **winged bulls or lions** characteristically flank the entrances of **Assyrian** palaces.

In **Athens**, the **red-figure vase painting** technique is developed, in which red figures are shown on a black background.

Greek sculptor **Praxiteles** makes his **Aphrodite of Knidos**, the first known life-size female nude statue.

The idea of creating a work of art purely as an object of aesthetic delight is a fairly new development in human history. In the more distant past art was usually made with a purpose—sacred, ritual, or talismanic, for example—and in the case of some ancient and isolated cultures, these purposes remain unclear today. However, even when an intellectual understanding of the context of such art is elusive, the works can still carry a powerful emotional charge. The Woman (or Venus) of Willendorf, for example, is a potent rendering of the female form, in spite of its tiny size and exaggerated proportions; and the Paleolithic cave paintings at Altamira in Spain depict animals—bison, horses, and deer—with a sense of sheer life that has rarely been matched.

Relative values

The distinction that Western critics usually make today between the "major" visual arts—architecture, painting, and sculpture—and the "minor" decorative or applied arts does not, or did not, exist in many cultures. In Chinese art, for example, ceramics generally used to play a more significant role than sculpture, while some of the finest sculptural achievements of China are in bronze ritual vessels, rather than in works involving the human figure—the type that prevails in the Western tradition. In a similar vein, green jade stone has long been reverenced in China and used to create superb luxury objects (it was also greatly prized by the Aztecs and Maya of ancient America), but its use is almost unknown in European art. There

are other profound differences in outlook to consider. Chinese art, for example, typically expresses the philosophical attitude of its creator and attempts to capture the "spirit" of nature, where Western art is sometimes concerned more with representation or decoration.

Egyptian origins

Western art has a line of descent that can be traced to ancient Egypt; the Egyptians influenced the Greeks, the Greeks influenced the Romans, and Roman art lies behind much later achievement in the West, particularly since the Renaissance. Egyptian art is remote in spirit from the modern secular world, for its central idea is the service of divine rulers, and in particular sustaining them after earthly death. In spite of this gulf in

The paintings at the **Ajanta Cave Temples** show the sophistication of **Buddhist** art in India.

The **Altar of Augustan Peace** in Rome features the earliest known documentary sculpture (one showing identifiable people in an event of the time).

The **Arch of Septimius Severus** is dedicated in **Rome**; it is lavishly decorated in celebration of the emperor's victories.

A giant marble statue of **Constantine**, the first **Christian emperor**, is erected in Rome.

c.100 BCE **13–9 BCE** **203 CE** **c.315 CE**

c.80 BCE **100–200 CE** **c.200–300 CE** **c.320–550 CE**

Frescoes are painted at the **Villa of the Mysteries, Pompeii**; they are the best surviving examples of ancient Roman painting.

The Gansu **Flying Horse bronze** sculpture is made; excavated in 1969, it becomes an unofficial symbol of China.

The **Catacomb of Priscilla** in Rome is decorated with some of the earliest known Christian images.

The **Gupta dynasty** presides over a golden age of art, both **Buddhist** and **Hindu**, in northern India.

beliefs, the tomb figures of Prince Rahotep and his wife Nofret are so vividly characterized that they seem to animate the people who lived more than 4,000 years ago.

The ancient Greeks and Romans established many ideas and themes that had an enduring impact on the history of Western art. Through the conquests of Alexander the Great in the 4th century BCE, their influence spread as far as Gandhara in India, where Greek and Buddhist artistic traditions mingled, and new centers of hybridized Greek culture emerged in Alexandria in Egypt, and in Pergamon and Antioch, both in modern Turkey.

Classical depictions of the human figure were particularly influential, possessing a naturalism that celebrated the human body alongside a sense of ideal beauty.

The Riace Bronzes, for example, are exquisite in their detailing, but the figures also have a heroic magnificence that is distant from the real world. Similarly, the equestrian statue of Marcus Aurelius is a convincing portrait of a dignified middle-aged man riding a thoroughly lifelike horse, but it is also a distillation of the idea of the emperor's glory.

Christian art

Rome also played an important part in the establishment of Christian art. Christianity was suppressed in the Roman Empire until the reign of Constantine the Great, who promoted tolerance for the religion in the Edict of Milan of 313 CE. By the end of the 4th century, Christianity had been not only legalized, but made virtually compulsory. The sarcophagus of Junius Bassus, made in Rome in around 360 CE, is a major work marking this growing dominance.

In 330 CE Constantine established a new capital at Byzantium, which was renamed Constantinople in his honor, and on his death in 337 CE, the Roman Empire divided into a western part (with its capital at Rome) and an eastern part (with its capital at Constantinople). Ravenna became the western capital in 402 CE and, in the following century, the seat of the Byzantine governor of Italy. Characterized by its rich symbolism and a move away from naturalism, Byzantine art often fused religious and imperial themes; fine examples can be seen in Ravenna, particularly of mosaics, which in this period attained new heights of solemn splendor. ∎

THIS IS ACTUAL WOMAN

WOMAN OF WILLENDORF (c.25,000 BCE)

IN CONTEXT

FOCUS
Fertility figures

BEFORE
c.40,000 BCE The so-called "Lion Man" figure, from the Hohlenstein-Stadel Cave in Germany, is carved from mammoth ivory.

40,000–35,000 BCE The earliest known of the "Venus" figurines, the ivory Venus of Hohle Fels, is left in a cave in southern Germany.

29,000–25,000 BCE The Venus of Dolní Věstonice, in Moravia—the oldest known ceramic artifact—is made.

AFTER
c.23,000 BCE The ivory Venus of Brassempouy, in France, is among the first-known depictions of the human face.

6000 BCE The Seated Woman of Çatalhöyük in Anatolia (Turkey), a terra-cotta statuette, portrays what is believed to be a mother goddess.

It is impossible to know when or why the first art was created. Our distant ancestors began to make stone tools and weapons at least 2.5 million years ago, but artifacts without an obvious practical function emerged later in human history. Colored shells strung into necklaces have been dated to around 80,000 BCE, while the earliest cave paintings were made by people living some 40,000 years ago.

The first skillful representations of the human form appeared around 40,000–30,000 BCE, in the early Upper Paleolithic period (c.40,000–c.10,000 BCE), when more sophisticated tools and techniques enabled figurative sculptures to be carved from rock, clay, bone, and ivory. Hundreds of small statuettes, most of them dating from around 30,000 to 22,000 BCE and almost all of which depict the female form, have been found at wide-ranging sites across Europe in the shelters, caves, and burial grounds of early humans.

When the first few examples of the statuettes were discovered in the 19th century, they acquired the sobriquet "Venus"—an ironic reference to the idealized modesty of classical images of the Roman goddess of love, beauty, and fertility. The figures are anything but chaste; indeed they emphasize the sexual aspects of the female anatomy. Invariably nude or scantily clad, the figures feature heavily enlarged breasts, giant bellies and buttocks that taper to the head and legs, exaggerated genitalia, and no feet or hands. Many of them also lack a face.

Fertility symbol

Perhaps the most famous of all the figurines is the so-called "Venus" of Willendorf, a carved limestone statuette found in 1908 by the archaeologist Josef Szombathy at Willendorf in Austria. The Woman of Willendorf (as scholars of ancient art are increasingly calling her) is not only a blatantly immodest portrayal of woman, but she is also very probably not a goddess either; it is likely that the notion of a fertile mother goddess or Earth Mother evolved only with the advent of agriculture, and was not a feature of early nomadic societies. Despite the figure's exaggerated sexuality and her disproportionately small arms and legs, she is a real, albeit idealized, representation of woman, an embodiment of human fertility rather than a deity.

See also: Cave art at Altamira 22–25 ▪ Goddess Coatlicue 132–33 ▪ *Venus of Urbino* 146–51 ▪ *Diana after the Bath* 224 ▪ *Olympia* 279 ▪ *Maman* 334–35

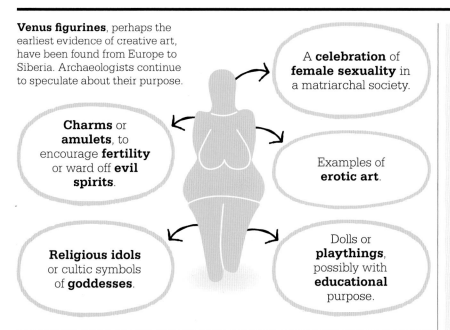

Venus figurines, perhaps the earliest evidence of creative art, have been found from Europe to Siberia. Archaeologists continue to speculate about their purpose.

A **celebration** of **female sexuality** in a matriarchal society.

Charms or **amulets**, to encourage **fertility** or ward off **evil spirits**.

Examples of **erotic art**.

Religious idols or cultic symbols of **goddesses**.

Dolls or **playthings**, possibly with **educational** purpose.

Male fertility figures

Compared to the large numbers of Venus figures, only a small number of male fertility statues have been found. The most noteworthy is a disembodied, life-size, polished stone phallus unearthed in the Hohle Fels, near Ulm in Germany, sculpted at much the same time as the early Venus figurines. Depictions of male fertility became widespread only in the civilizations of ancient Greece, with its representations of Priapus, the god of fertility; ancient Egypt, with its depictions of Min and Osiris; and ancient India, in the phallic representation of the god Shiva, known as a lingam. Fertility goddesses of classical antiquity were depicted with increasing modesty, possibly reflecting a more patriarchal society.

In the nomadic societies of Ice Age Europe, obesity would doubtless have been an uncommon trait. The corpulence of the Woman of Willendorf and other figurines, as well as perhaps symbolizing fertility, may represent the hope for survival, long life, and abundance. The Willendorf woman stands apart from other Venus figurines in the depiction of her hair, which has been elaborately braided or beaded. Hair has a long history as a source of sexual attraction, so it is most likely that the intent here was to portray erotic sexuality rather than purely reproductive fertility. Alternatively, some scholars see the seven carved concentric lines that encircle the figure's head not as hair but as some kind of ritual headgear.

Questions of purpose

The Venus statuettes are among the highest artistic feats of the Stone Age, and great speculation surrounds their function in Paleolithic society. Ranging from about 1½ to 10 in (4 to 25 cm) in length, they remained remarkably

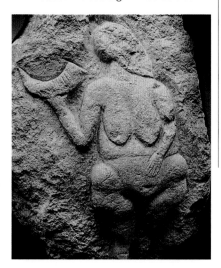

The Venus of Laussel, dating back to around 20,000 BCE, is a sexually explicit bas-relief, colored with red ocher. She was carved into a block of limestone in a rock shelter in southwestern France.

similar in form throughout the thousands of years over which they were made, suggesting some consistent and definite purpose. Some historians suggest that, fitting comfortably in the human hand, the sculptures may have been carried as charms or amulets, either to bring the bearer fertility or to protect against evil. Others have observed that the Willendorf woman was originally colored with red ocher, as used in burial rites, suggesting her significance in rituals. Still others have wondered whether the figurines were self-portraits, made by women without recourse to a mirror—thereby explaining the absence of a face. ▪

WE ARE A SPECIES STILL IN TRANSITION

CAVE ART AT ALTAMIRA
(c.15,000–12,000 BCE)

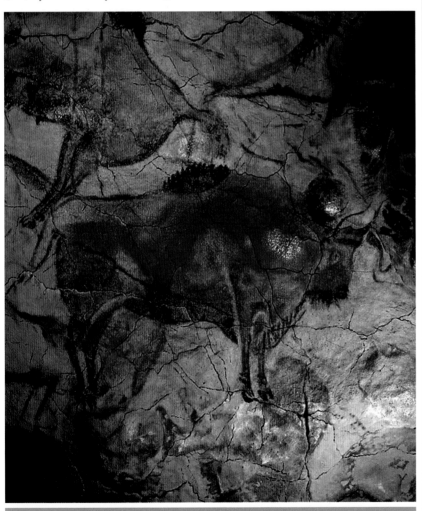

IN CONTEXT

FOCUS
Cave painting

BEFORE
70,000 BCE Abstract symbols are carved into the walls of the Blombos Cave, South Africa.

39,000 BCE Hand stencils and disks appear in the caves of El Castillo in Cantabria, Spain.

35,000 BCE Red ocher animals in Fumane Cave, Italy, are the earliest known figurative art.

17,000 BCE Up to 2,000 complex images are made in the Lascaux Cave, France.

AFTER
10,000 BCE Outdoor rock art in Tassili-n-Ajjer, Algeria, marks the move away from cave art and provides evidence of climate change and evolution.

7300 BCE The Cave of the Hands, South America, is full of hand stencils and handprints.

The vast majority of the cave art so far discovered dates from the period from 40,000 to 10,000 BCE, known as the Upper Paleolithic. This was the era in which *Homo sapiens* became the predominant human species across the world, replacing Neanderthal people in western Europe. This was during the Ice Age, when people led a nomadic existence as hunter-gatherers, finding shelter in shallow rock hollows, under overhangs, or in caves. The earliest artworks in these shelters and caves were simple rock engravings, but new forms and styles developed rapidly, including painting and the beginnings of figurative art.

See also: Woman of Willendorf 20–21 ▪ Assyrian lion hunt reliefs 34–35 ▪ *Hunters in the Snow* 154–59 ▪
A Lion Hunt 176–77 ▪ *Hambletonian, Rubbing Down* 225 ▪ *Lion Crushing a Serpent* 248

Hand stencils were made around 9,000 years ago in the Cave of the Hands in Patagonia. Other artworks in the cave include images of felines, humans, and hunting scenes.

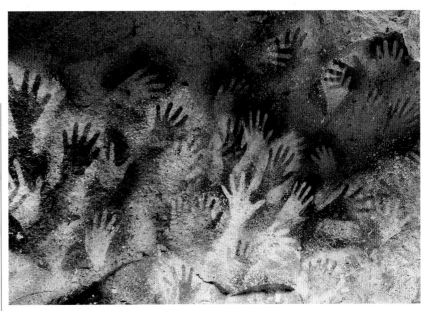

As early as 100,000 years ago, sub-Saharan humans had developed methods of mixing pigments, using ochers (earth pigments containing iron oxide), charcoal, and bones, mixed with saliva or animal fats. These appear to have been for face and body painting, as there is no evidence of cave painting this early, but the knowledge of these paints traveled with prehistoric people as they spread across the world. Painted images, such as hand stencils (which were created by blowing pigment through a hollow bone and were made by adults and children, males and females), handprints, dots, and disks, began to appear alongside petroglyphs, or stone carvings, in caves as far apart as Spain and Indonesia, between 39,000 and 35,000 BCE.

Representing the world
At around the same time, cave artists began to make recognizable representations of the world around them, in the first surviving works of figurative art. The earliest examples of animals painted or engraved onto the walls of caves are, to modern eyes, crudely stylized portrayals, barely distinguishable from the abstract symbols around them. However, notably in the caves located in what are now southern France and northern Spain, the artists soon mastered techniques to achieve more realistic representations. This can be seen in the meticulously depicted animal paintings and drawings in the Chauvet-Pont-d'Arc Cave in the Ardèche region of France, dating from c.30,000 BCE. The figurative cave paintings and drawings of this period were almost entirely representations of animals. With the notable exception of the so-called Bradshaw paintings (named after their discoverer) in the caves of Kimberley, Australia, human figures were extremely rare. At first, during the Aurignacian era (40,000–25,000 BCE), figurative paintings were mainly of predatory animals such as lions, wolves, and bears, but from about 25,000 BCE the majority of images depicted animals that were hunted for food and skins, including mammoths, horses, boar, deer, and cattle such as bison and aurochs.

Franco-Cantabrian art
The final period of the Ice Age saw the culmination of a gradual refinement of engraving and painting techniques, which was most evident in the cave art of the Franco-Cantabrian region of France and Spain. The population of this area was relatively dense, thanks to a moderately mild climate for the time, and so the region has a greater number of examples of cave art than elsewhere, and of a higher quality. In particular, the period from 15,000 to 10,000 BCE saw a flourishing of figurative cave painting here, marking the high point of cave art. Some of the »

No amounts of stone and bone could yield the kinds of information that the paintings gave so freely.
Mary Leakey
Disclosing the Past, **1984**

A timeline of cave art

Upper Paleolithic: Aurignacian (40,000–25,000 BCE)	Upper Paleolithic: Gravettian (25,000–20,000 BCE)	Upper Paleolithic: Solutrean (20,000–15,000 BCE)
The first cave paintings: hand stencils and abstract red dots, and, later, primitive stylized images of animals and humans.	More precise and realistic cave paintings and engravings, depicting predators as well as large herbivores.	Engraving and relief carving in caves more prevalent than painting, showing mainly large herbivorous animals.

Prehistoric abstract art

The stunning depictions of animals in the Altamira and Lascaux caves are a pinnacle of cave painting, but represent a fraction of the varied styles and techniques of prehistoric cave art. The earliest examples consisted of abstract signs and symbols, and even after the evolution of figurative styles, this more abstract art flourished. Initially, it was assumed that this was mere decoration, but the recurrence of abstract signs in sites around the world, and often found alongside figurative painting, suggests that they have symbolic significance. There are some 25 varieties of abstract symbols, from simple cupules (hemispherical holes) and painted dots or disks, through panels of engraved cross-hatching and "finger-fluting" (parallel lines made by fingers in a soft surface), to complex engraved and painted geometric figures, and stylized natural shapes. Handprints and hand stencils, often with varying numbers of fingers, are a further indication of meaning, albeit undeciphered, in these abstract symbols.

best-known examples of all cave painting come from this period of Franco-Cantabrian art, including the paintings found in the caves of Lascaux and Font-de-Gaume in France, and El Castillo and Altamira in Spain.

Polychrome paintings

The Altamira cave complex, in Cantabria, was discovered in 1868, but it was not explored properly until the early 20th century. The caves, stretching back about 890 ft (270 m), comprise three main galleries: the first of these, behind the entrance cavern, is known as the Chamber of Frescoes, or the Grand Hall of Polychromes; farther in is the Chamber of the Hole (or Basin); and at the extreme end is a narrow passage known as the Horse's Tail. A landslide several millennia ago sealed the caves' entrance, thereby allowing their spectacular paintings to be preserved intact. Originally, the large cavern inside this entrance was used for human habitation.

There are impressive examples of monochrome animal paintings and rock engravings in the Chamber of the Hole, and many abstract signs and symbols in the Horse's Tail passage, but it is the Chamber of Frescoes for which Altamira is justly famous. The chamber is around 59 ft (18 m) long

and 30 ft (9 m) wide. Its low ceiling is adorned with exquisitely realistic depictions of horses, deer, and bison in various poses, as well as handprints, hand stencils, and painted or engraved abstract signs.

While some of the symbols and handprints in the caves date back to 34,000 BCE, the magnificent paintings of bison and other animal species in the Chamber of Frescoes were executed after 15,000 BCE and before about 12,000 BCE, when the landslide blocked the entrance.

The bison, which greatly outnumber the other animals in this gallery, are depicted with unprecedented sophistication. Perhaps the most immediate impression is one of color:

Man is a creature who walks in two worlds and traces upon the walls of his cave the wonders and the nightmare experiences of his spiritual pilgrimage.
Morris West
The Clowns of God, 1981

**Upper Paleolithic: Magdalenian
(15,000–10,000 BCE)**

Greater range of colors, media, and techniques used; naturalistic depictions of hunter-gatherer life but focus still on animals.

**Mesolithic
(10,000–c.6,000 BCE)**

As Ice Age ends, rock art increasingly executed outside rather than in caves, with human figure gaining importance.

**Neolithic
(c.6,000–c.2,000 BCE)**

Cave art disappearing as humans adopt a more settled lifestyle based on cattle rearing and crop cultivation; ceramic art develops.

each animal is painted in up to three colors, in varying shades to give an effect of chiaroscuro (light and dark) and convey the texture of its hide. While the artists had a limited palette to work with (browns, reds, and yellows from various ochers, and black from manganese and charcoal), it matched the real colors of the animals, and by mixing pigments with fat and blood or saliva, artists could achieve different intensities. They would draw an outline in black and then apply color with pads of moss or hair—the results are astonishingly realistic.

But possibly the most striking aspect of these images can only be appreciated by visiting the caves. The bison—some of which are life-size—are painted onto the uneven rock surface in such a way that they appear three-dimensional; changing with the viewpoint and direction of light, they seem to have volume and movement.

Seeking meaning

Much cave art has been found in caverns that were not regularly inhabited, or are deep underground in barely accessible areas. The motives that impelled early humans to create their art deep in caves, where it would rarely, if ever, be seen, remain mysterious. Some scholars have suggested that game

animals were portrayed to summon them for the hunt—yet the animals in the paintings only rarely match bone debris found at the caves. At Altamira the principal meat source was deer, rather than bison, while the painters at Lascaux, famous for its paintings of horses, ate reindeer. It is now generally thought that the paintings, whether abstract or figurative, served a ceremonial or ritual purpose and may have been drawn by artist-shamans.

The end of the Ice Age in about 10,000 BCE marked the end of the Paleolithic era. During the

Mesolithic era that followed, the nomadic, cave-dwelling hunter-gatherers developed a more settled lifestyle and the instances of cave art dwindled, being replaced with outdoor rock art in the form of engravings and reliefs, as well as a greater interest in portable, or "mobiliary," art, such as carvings, figurines, and jewelry. ■

The red deer in the Altamira cave is life-size. Its belly is painted over a hump in the rock, using the contours of the cave to give a three-dimensional effect. The bison is drawn in charcoal.

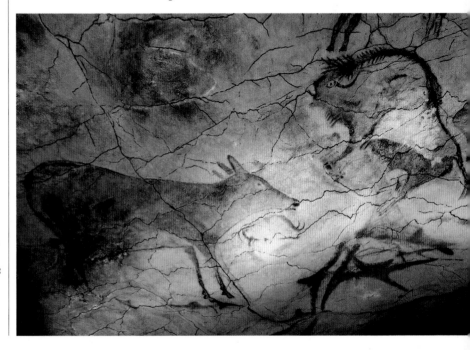

HISTORY IS A GRAVEYARD OF ARISTOCRACIES

OF ARISTOCRACIES

PRINCE RAHOTEP AND HIS WIFE NOFRET (c.2570 BCE)

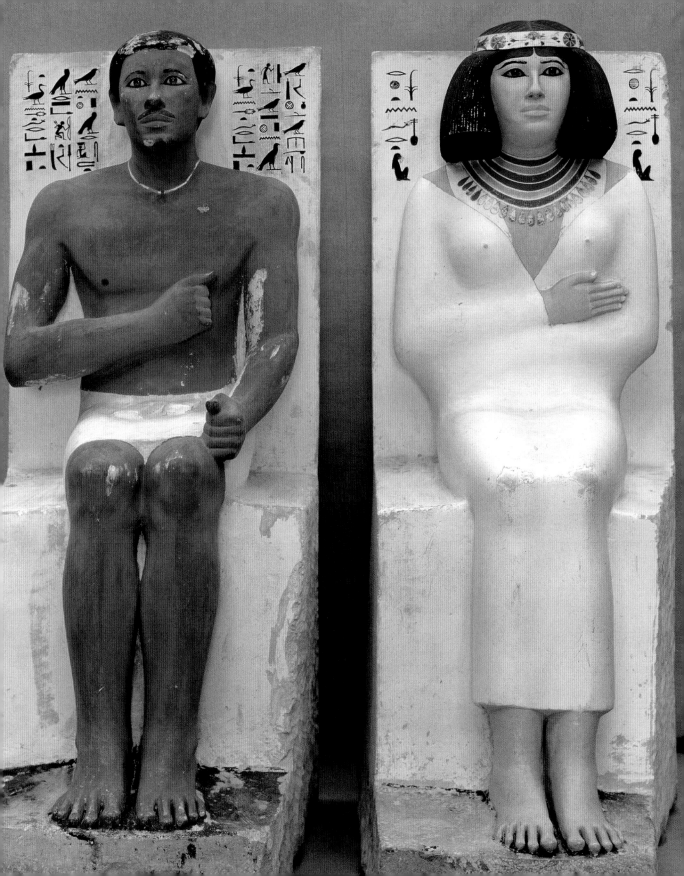

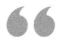

The Assyrians, the Egyptians had a powerful plastic sense, and so did the Archaic Greeks.
Emil Nolde
"The Artistic Expressions of Primitive Peoples," 1912

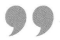

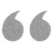

The style of ancient Egyptian art is transcendently clear … Its consistency and codification is one of the most epic journeys in all art.
Jerry Saltz
New York **magazine, 2012**

For at least 100,000 years—dating back to the Middle Paleolithic era—humans have buried their dead in special places reserved for the purpose. Archaeologists have found human remains in designated areas of caves and in simple burial sites, often with items such as tools, food, and personal belongings. These items, or "grave goods," are potential evidence that our earliest ancestors held some kind of funeral. One

The Great Sphinx of Giza (c.2530 BCE) is a colossal sculpture that is believed to protect the pyramid of King Khafre (seen in the background). The Sphinx has the body of a lion and the head of Khafre.

interpretation of grave goods is that they were provided to accompany the dead on their journey to the next world, suggesting that early humans believed in some form of afterlife.

Luxuries for the afterlife
During the Neolithic era (around 10,000 years ago), burial sites became more sophisticated, and many were marked with large stones (megaliths), or even structures in stone. While early Neolithic graves contained objects that may have belonged to the deceased in their lifetime, by the start of the Bronze Age (about 5,000 years ago), human remains began to be accompanied by specially made artifacts—a theme found in sites across the ancient world—such as jewelry, ornamental

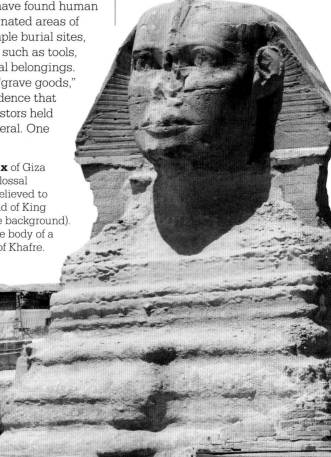
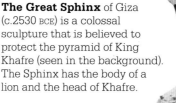

tools and weapons, and other objects that were presumed useful in the next world.

During this period, the grandeur of the tombs, and their artifacts, started to reflect the status of the deceased occupants. Previously, there had been no obvious hierarchy of burial sites, but as rulers, nobles, and military leaders emerged in the civilizations that followed, they were afforded more lavish graves, surrounded by magnificent funerary art in the form of tomb decoration and sculpture. These tombs of royalty and aristocracy provided the same luxuries for the afterlife that their occupants had enjoyed before death; they also served as monuments to their greatness. Impressive buildings, such as the pyramids of ancient Egypt, were built to house and memorialize the tombs of great leaders.

It was in the kingdoms of ancient Egypt that funerary art really flourished for the first time. From the start of the Early Dynastic Period in around 3000 BCE, a tradition of burying the pharaohs

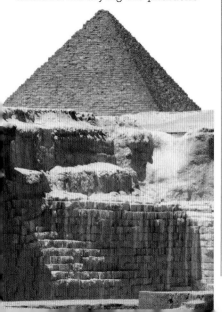

Funerary art and artifacts

In many cultures, **belief in the afterlife** led to people burying **artifacts** alongside their **dead**.

These artifacts took the form of **grave goods** to give the deceased **comfort in the afterlife**.

In addition to grave goods, there were often **effigies** to act as **vessels for their souls**, or as commemorative statues.

Royalty and the ruling classes commissioned **artworks**, including hieroglyphs or wall decoration, **for their tombs**.

and their families in elaborate tombs began, and the conventions of Egyptian art—which always had a ritual purpose, often relating to the dead—were established. A key aspect of the burial tradition was the creation of a statue of the deceased, usually seated, to be placed with the body in its tomb. Although a great deal was done to preserve the mortal remains, the Egyptians believed that the *ka* (the soul or life force) left the body after death. The tomb statue was made as a permanent resting place for it. Since everything in the tomb was associated with the rituals and ceremonies designed to ensure a successful passage to the afterlife,

these statues are more than just commemorative representations of the dead: they fulfill a specific function on behalf of the deceased.

Rahotep and Nofret
Unlike the nonrealistic royal statues placed in the outer rooms of tomb complexes for public view, the statues placed inside the tombs were often strikingly lifelike. When the statues of Prince Rahotep and his wife Nofret were unearthed by the French archaeologist Auguste Mariette at Meidum, south of modern Cairo, in 1871, workmen were so startled by their bright eyes sparkling in the candlelight that they fled in terror. Rahotep »

> I was struck dumb with amazement, and when Lord Carnarvon … inquired anxiously, 'Can you see anything?,' it was all I could do to get out the words, 'Yes, wonderful things.'
> **Howard Carter**

was an Egyptian noble, an official in the court of the pharaoh, and as such merited burial with his wife in a mastaba—a flat-roofed, sloping-sided building containing a temple and tomb chamber. As a result of the dry Egyptian climate, their tomb statues have remained virtually undamaged.

Carved in limestone and painted, the two life-size statues show Rahotep and Nofret seated on high-backed chairs, facing outward in a rather formal pose, with one arm placed across the chest. Egyptian art was highly symbolic, and performed a ritual function to benefit the deceased in the afterlife. For example, the body was by preference placed vertically, facing forward toward eternity; clenched hands held to the breast, as in the image of Rahotep, may signify veneration.

The paint on both statues is almost perfectly preserved and the colors remain vibrant. Rahotep has short black hair and sports the thin moustache that was popular during Egypt's Old Kingdom (c.2625–c.2130 BCE). He is wearing a short, white kilt, and a simple necklace with a heart amulet hangs around his neck. Nofret wears a full-length white gown, and an elaborate, brightly colored, jeweled necklace; a circlet, painted with a flower motif, holds a shoulder-length wig in place on her head. As was conventional in Egyptian art, the male is given a dark-red skin color, while the female is very pale. Both have piercing blue eyes, achieved by inlaying pieces of polished quartz into the stone.

Despite the realism of the statues, they were not intended to be accurate portrayals so much as representations made in the canonical, or traditional, style; the two figures' identities are made clear by hieroglyphic inscriptions on the seat backs. Tomb statuary served as the eternal repository for the *ka*, or spirit, of the deceased, so these inscriptions enabled the *ka* to find the right body. The hieroglyphs date to the Old Kingdom, and the statues already show sophisticated craftsmanship and display many of the artistic conventions that continued almost unchanged in Egyptian art for 2,500 years.

Grandeur and magnificence

Several of Egypt's royal tombs and sculptures were vast, grand creations, and some took decades to complete. The magnificent pyramid complex at Giza—which was built from around 2550 BCE—includes the pyramids of the pharaohs Khufu, Khafre, and Menkaure, as well as one of the world's oldest and largest statues, the Great Sphinx (from c.2530 BCE), dedicated to Khafre. Also outstanding are the colossal rock-cut temples of Ramesses II (reigned c.1279–1213 BCE) at Abu Simbel, on the west bank of the Nile, which took some 20 years to construct. The complex includes two pairs of giant statues depicting Ramesses II on his throne.

In addition to statues, royal tombs sometimes contained a wealth of grave goods, such as in the spectacular tomb of Tutankhamun (c.1323 BCE), in the Valley of the Kings at Thebes, which was

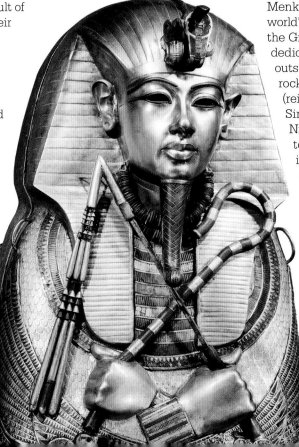

Tutankhamun's solid gold coffin (c.1323 BCE), inlaid with enamel and semiprecious stones, contained the pharaoh's mummified body.

unearthed by the English Egyptologist Howard Carter in 1922. Peering through a small hole cut into the antechamber to the tomb, Carter could make out initially only "… strange animals, statues, and gold—everywhere the glint of gold." When it was opened up, the room was overflowing with treasures—from life-size statues of the pharaoh to jewelry, models of animals, chariots, chests, and boxes of linen.

Grave goods such as those discovered in Tutankhamun's tomb reflected the lifestyle of the deceased. In Tutankhamun's case, in addition to the usual rich trappings of royalty there were several walking sticks: it is believed that the young pharaoh had a deformed foot. More typically, grave goods consisted of depictions of the dead person, such as masks and busts. The body was usually contained in a coffin, which was sometimes placed in an outer sarcophagus, both of which may have been decorated with paintings and carvings.

Lesser mortals

Such accomplished artistry was not restricted to depictions of the aristocracy. Regular citizens may not have merited burial in splendid tombs, but sculptures of servants accompanied the nobility to their final resting places, to serve them in the afterworld. These included statues of scribes sitting cross-legged with papyrus and pen, as well as depictions of household servants, and women preparing

The Anavysos Kouros (c. 530 BCE) was unearthed at a cemetery in Anavysos, Greece. It served as a grave marker to a young man who died in battle.

food or grinding corn for bread. These funerary figurines tended to be smaller than the statues of the deceased nobles, following the Egyptian artistic convention of hierarchical proportion, in which the size of a figure corresponded to the status and importance of the subject.

New traditions

The extraordinary richness of Egyptian tomb art came to an end after 3,000 years as the influence of the Greek and Roman empires spread across the Mediterranean, bringing their own belief systems with them. The Greeks developed a strong tradition of sculpture and, while their graves were very simple, from the 7th to the 5th centuries BCE, *kouros* (male youth) statues—often representations of the ideal male body—are thought to have served as grave markers.

For the Etruscans and early Romans, provision for the afterlife was important. Typical grave goods consisted mainly of foodstuffs and eating vessels buried with the dead. In the 2nd century BCE, Roman sarcophagi carved with reliefs in the classical Greek style housed the bodies of the rich and powerful, accompanied by life-size sculptures of the deceased. These images, however, no longer played the part of providing for the deceased's life in the next world—instead, they commemorated their lives. ∎

Ancient Egyptian tomb painting

Images frequently adorned the walls of tombs in ancient Egypt, from carved stone reliefs that were either left undecorated or colored with paint, to scenes painted onto the bare wall. They often depicted the body of the deceased being prepared for the afterlife by gods such as Anubis, the jackal-headed deity of mummification, and were intended to ensure a smooth passage to the next world. It was in these tomb paintings that the pose typically associated with Egyptian art—with head and legs in profile but torso facing front—was established.

In the latter part of the Dynastic period, the "Book of the Dead," a guide to the afterlife in the form of spells and instructions, would also be buried in the tomb. One of the spells illustrated in the book is the "weighing of the heart": the deceased's heart is weighed against the feather of Ma'at, goddess of truth. If the two balance, the soul will live forever; if they do not balance, the deceased is condemned to nonexistence and devoured by the "swallowing monster."

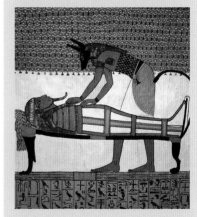

BRONZEWARE IN CHINA RECORDS THE SPIRITUAL CORE OF CHINESE CIVILIZATION

CHINESE BRONZE RITUAL VESSEL (c.1046–771 BCE)

IN CONTEXT

FOCUS
Bronze casting

BEFORE
c.3500 BCE Bronze artifacts are produced in the North Caucasus region using an alloy of copper and arsenic.

c.3200 BCE The Indus Valley civilization develops the "lost wax" method of casting bronze, using a wax model.

c.1200–1000 BCE Large-scale bronze masks and sculptures appear in Sichuan, made possible by the addition of lead to copper-and-tin bronze, which makes the metal stronger and easier to cut and cast.

AFTER
c.650–480 BCE Ancient Greek artists develop bronze-casting techniques, enabling them to produce life-size sculptures.

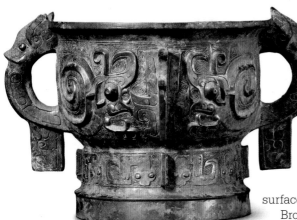

T he Chinese Bronze Age (c.1700–221 BCE) coincided with the establishment in China of a civilization ruled by a series of dynasties. The process of blending copper and tin to make bronze was developed during the first of these, the Xia Dynasty (c.2070–c.1600 BCE). Chinese bronze evolved independently of European and Indian cultures, which had created the metal alloy more than 1,000 years earlier. It was especially distinctive for the way in which it was cast. With the so-called "piece-

mold" method, use of a ceramic mold made in several pieces allowed the maker to carve or imprint patterns on the inside of the mold before casting, to produce well-defined and often intricate decorations on the surface of the finished item.

Bronze casting assumed a new significance in the Shang Dynasty (c.1600–1046 BCE). By this time, a sophisticated social order had been established, reinforced by rituals and ceremonies. Bronze, used for tools and weapons, was now also used to make the vessels associated with these rituals, such as the *ding* (a cauldron with legs), the *zun* (a cylindrical wine vessel), and the *gui* (a bowl with handles).

Decorative patterns

Ritual bronzes were sometimes fashioned in the shape of animals; more often, they were decorated

with dragons, birds, and the masklike face known as the *taotie*. The "face" became increasingly abstracted, hinted at rather than explicit, as on the *gui* from the Western Zhou Dynasty (c.1046–771 BCE) shown here. Typically, the eyes were prominent, depicted in high relief, either side of a stylized nose. Other facial features, such as eyebrows and ears, were suggested by various geometric patterns.

By the time of the Han Dynasty (206 BCE–220 CE), jade and iron were used instead of bronze for ritual objects; bronze vessels lost their ceremonial significance, becoming symbols of wealth and status. ∎

FINE, COMPACT, AND STRONG—LIKE INTELLIGENCE

CHINESE JADE ORNAMENT (599–400 BCE)

IN CONTEXT

FOCUS
Jade carving

BEFORE
c.4000–3300 BCE The Majiabang culture of the Yangtze River Delta carves jade ornaments and implements.

c.3500–2500 BCE The Hongshan culture of north China carves distinctive birds, turtles, cicadas, and C-shaped dragons in jade.

AFTER
c.960–1279 Jade carving is considered an art form in the Song Dynasty; a fashion develops for creating pieces in the archaic styles of the Shang and Zhou periods.

c.1800 Vessels made from a vivid green Burmese jadeite ("kingfisher feathers" jade) are popular in the Qing Dynasty.

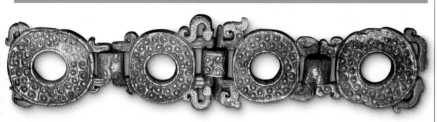

The highly skilled art of jade carving can be traced back almost seven millennia to the Yangtze River Delta in China, where milky-white nephrite—the favored color and variety of the gemstone jade—occurs naturally. Some of the earliest ritual objects carved in jade (c.3400–2200 BCE)

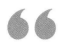

Gold has a value;
jade is invaluable.
Chinese proverb

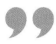

took the form of *bi*, circular disks with a hole in the middle (thought to represent Heaven), and *cong*, hollow, tube-like objects (thought to represent the Earth).

Chinese jade—which ranged in color from shades of green to white—was prized for its purity, strength, durability, and luster. As the stone is so hard and brittle, it was typically shaped with abrasive sand, rather than carved using metal tools. But during the Eastern Zhou Dynasty (770–256 BCE), new jade-working techniques and tools were developed, thanks to the discovery of iron and carborundum.

Status, power, and wealth
Imperial Chinese society, particularly in the Zhou Dynasty (c.1046–256 BCE), was rigidly hierarchical. Intricately decorated jade jewelry, and artifacts—such as the pictured belt, which is made from four linked disks of jade—were used to signify not wealth but rank or social status, being associated with the values of a "gentleman." Carved out of a single piece of jade, the belt is considered an exquisite example of jade craftmanship. Its abstract designs are typical of Zhou Dynasty decoration.

In the unified state of China created during the Qin Dynasty (221–207 BCE), and under the absolute rule of the Han Dynasty (206 BCE–220 CE), jade became less a sign of status, more a symbol of power, authority, and wealth. ∎

See also: Woman of Willendorf 20–21 ▪ Chinese bronze ritual vessel 32 ▪ Teotihuacán mask 50 ▪ Terra-cotta Army 56–57 ▪ Reliquary of Theuderic 62–63 ▪ Salt Cellar 152

A CHANNEL FOR THE UNIVERSAL SOUL

ASSYRIAN LION HUNT RELIEFS (c.645 BCE)

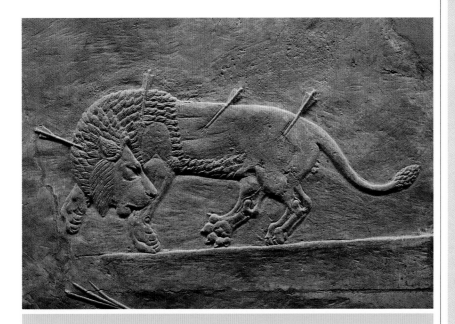

IN CONTEXT

FOCUS
Narrative sculpture

BEFORE
c.31st century BCE An Egyptian ceremonial siltstone palette, carved with relief images of King Narmer, is thought to depict either historical or mythical events.

AFTER
Early 1st century CE Depicting a scene from the Greek epics, the statue *Laocoön and his Sons* is carved in marble in the Hellenistic style.

c.106–113 CE A marble column commemorating the Roman emperor Trajan is decorated with a spiral bas-relief that narrates the story of Trajan's victories in the Dacian Wars.

950–1050 Hindu temples and monuments at Khajuraho, India, are adorned with a profusion of narrative scenes in high relief that express key ideas and values of Hinduism.

Ancient civilizations were largely oral cultures, even for some time after the invention of writing. Literacy was rare, so written records often held meaning only for the educated classes. But many early societies recognized the need for a graphic record of their culture's important events and the stories relating to their religion. Some painting—on the walls of palaces and tombs, for example—served this purpose, but sculpture in stone offered a more permanent and monumental medium for preserving a culture's history, legends, and mythology.

Rulers and military leaders were especially eager to be remembered for posterity and to have their likenesses carved in stone in grand, imposing statues. However, a more pictorial form of sculpture—relief—introduced the opportunity for presenting complex scenes and extended narratives in a series of panels or a frieze.

Visual narratives

The earliest narrative reliefs appeared on tomb walls in ancient Egypt. They showed scenes of the afterlife and images of gods and the deceased. However, it was in another of the great civilizations of the ancient Middle East—the Assyrian Empire—that narrative sculpture became an art form celebrating the living rather than the dead.

From around 1500 BCE, the empire developed a distinctive artistic style that was evident in the sculptures used to decorate the royal palaces. This style reached a creative peak during the reigns of emperors Ashurnasirpal II (ruled 883–859 BCE) and Ashurbanipal (ruled 668–627 BCE). As the empire became more powerful, they had huge statues of animals placed

See also: Prince Rahotep and his wife Nofret 26–31 ▪ *Laocoön and his Sons* 42–43 ▪ Marcus Aurelius 48–49 ▪ Parthenon frieze 56 ▪ Trajan's Column 57 ▪ Pisa Baptistery pulpit 84–85 ▪ *A Lion Hunt* 176–77

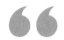

We wanderers were seeking what they left behind, as children gather up the colored shells on the deserted sands.
Austen Henry Layard
Discoveries among the Ruins of Nineveh and Babylon, **1849**

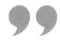

at the entrances of their palaces in the imperial city of Nineveh, while inside, bas-relief panels depicted the heroism of these rulers.

A new tradition

In addition to reliefs recording military triumphs and the emperors' victories in battle, a striking series of carved alabaster panels shows scenes of a staged spectacle in an arena. These scenes tell the story of lions being released from cages in the arena, the ensuing chase, and the gruesome death of the lions at the hands of King Ashurbanipal and his court officials.

The visual narratives were designed to remind courtiers and visiting dignitaries of the emperor's great bravery and power in action. As a symbol of his supreme control over his empire and the forces of

The king and his officials are shown in astonishing detail in the lion hunt reliefs. It is not known how the ancient sculptors achieved such delicacy without the use of hardened steel tools.

nature, the narratives were straightforward propaganda, but, executed with magnificent craftsmanship and sophisticated artistry, they vividly convey the drama of the event.

The lions themselves are carved in sympathetic detail as magnificent animals, in fluid poses showing their agility, might, and beauty, but also contorted and with expressions that capture the terror and terrible pain of being hunted. The humans are portrayed more formally, in rigid poses, but with no less attention to detail, emphasizing the contrast between the king's cool courage and nobility, and the more sensual nature of the animals.

The Assyrian reliefs marked the beginning of a tradition of narrative sculpture that, as well as glorifying the deeds of rulers, became a medium for illustrating the stories of myth and religion. This tradition continued in ancient Greece and Rome, and later in the telling of some of the prominent tales of early Christianity. ▪

Relief styles

Evolving from images that were scratched onto rock surfaces about 40,000 years ago, reliefs in the ancient world developed distinctive styles, tending to become more three-dimensional over time, with the forms or figures standing out higher from their background. The Assyrians favored a low relief, or bas-relief, with the forms projecting just slightly from the background. The ancient Egyptians used a sunk relief, in which the carving was sunk below the background that surrounded it. But in the high reliefs of classical Greece, forms stood out significantly from the background. High relief remained popular in Roman and early Christian times, and was also a feature of sculptures adorning Hindu and Buddhist temples in southern Asia.

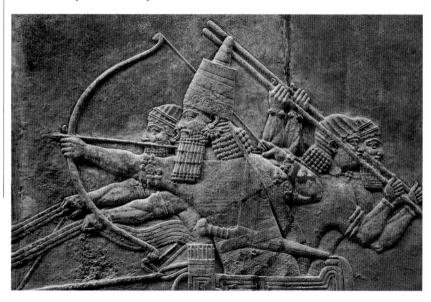

CERTAIN IDEAL BEAUTIES OF NATURE EXIST ONLY IN THE INTELLECT

RIACE BRONZES (c.450 BCE)

Detail of the face of Statue A

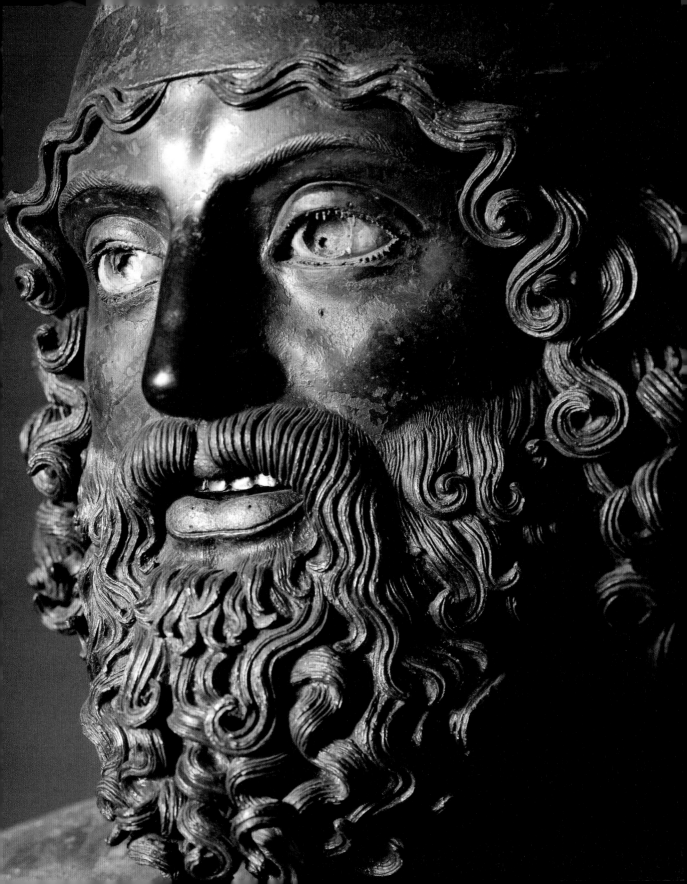

IN CONTEXT

FOCUS
The ideal human figure

BEFORE
c.2570 BCE In his funerary statue, the Egyptian pharaoh Khafre is shown in a typically Egyptian seated pose.

6th–5th century BCE Greek statues of standing youths and draped young women, the *kouroi* and *korai*, are made.

c.480 BCE The *contrapposto* pose of the *Kritios Boy*, a nude figure found in Athens, Greece, marks the beginning of a more realistic style in sculpture.

AFTER
c.435 BCE Greek sculptor Phidias completes a colossal statue of Zeus on his throne for the temple at Olympia.

2nd century BCE Artists in the Greek city of Pergamon (Bergama, in present-day Turkey) develop the expressive Hellenistic style of sculpture.

In the relatively brief period between 510 and 323 BCE, Greek civilization established conventions in all the arts that set the standard for what has since been considered "classical." Drama, music, and philosophy flourished in this period, but it was in the visual arts—architecture and sculpture in particular—that classical ideals were most strikingly exemplified.

A tradition of sculpture had already been established in Greece during the Archaic period from 700 to 500 BCE. Inspired by Egyptian and Mesopotamian stonework, Greek sculptors had begun to make free-standing human figures, which were used as funerary monuments, or dedicated to the gods. The three forms are the *kouros* (plural *kouroi*), a standing male nude; the *kore* (plural *korai*), a standing female clothed in drapery; and a less common seated female. Each type represented the noblest attributes of the aristocratic culture of the time. The powerful male figures were unashamedly nude, modeled on the athletes who competed naked in the games at religious festivals. By contrast, the young women in the statues, unlike the voluptuous and fertile figures of

The chief forms of beauty are order and symmetry and definiteness, which the mathematical sciences demonstrate in a special degree.
Aristotle
Metaphysics, c.350 BCE

other cultures, were portrayed with modesty; emphasis was less on the female form than on facial features and the delicacy of the drapery.

Archaic conventions

The *kouroi*, with their strong, lean bodies, were not only portrayals of the idealized male physique, but also embodiments of the values and virtues of ancient Greek society, such as glory, honour, and rectitude. Stylistic conventions guided artists on how to convey these values: for

Materials and techniques

Early Greek figures were mainly carved in stone or cast in bronze using the lost-wax technique. Lost-wax casting is a complex, multistep process in which a model is made in wax, then a clay mold constructed around it. When heated, the wax melts, and molten metal—usually bronze—is poured into the mold. The surface of Greek casts was polished, and the eyes were inlaid with glass, crystal, bone, or even onyx—as in the pictured bronze, *Charioteer of Delphi* (c.470 BCE)—while extras

such as copper or silver nipples, lips, and teeth were often added. Very few early bronze sculptures have survived, as most were later melted down for reuse, so many of the works are known today only from copies. Stone, the most prized variety of which was marble from Naxos, was worked with iron chisels and drills. The parts of a large figure were often made separately and then assembled. Many stone sculptures were colorfully painted and accessorized with jewelry or weapons. As with bronze, eyes were often inlaid.

See also: Woman of Willendorf 20–21 ▪ *Laocoön and his Sons* 42–43 ▪ Marcus Aurelius 48–49 ▪ Parthenon frieze 56 ▪
Young Slave 144–45 ▪ *Baptism of Christ* 162–63 ▪ *Grande Odalisque* 236–37 ▪ *Greek Slave* 249

Periods of Greek sculpture

Archaic (c.600–480 BCE)	Early Classical (480–450 BCE)	High Classical (450–400 BCE)	Late Classical (400–323 BCE)
• Standing nude male (*kouros*) or draped female (*kore*) figures • Stiff, near-symmetrical poses • An enigmatic "Archaic smile"	• More natural poses, with head turned slightly • Absence of decorative features • A severe, serious expression	• More relaxed poses • Increased anatomical accuracy and detailed drapery • Growing interest in the nude female form	• Greater realism in facial expression and pose • Smoother, softer, and more sensuous lines • More emphasis on elegance

most *kouroi*, they adopted a formal, front-facing pose that emphasized the symmetry of the body, while the relative proportions of the head, rather triangular torso, and limbs were determined by mathematical ratios. Offsetting this formality—in what was after all a celebration of the ideal human form—many of the later *kouroi* (and *korai*) were made more human by the addition of the "Archaic smile." Although appearing slightly false to the modern eye, this was intended to convey the well-being and happiness of the subject.

Toward the Classical
The start of the Classical period is usually dated to the emergence of a form of democracy in the city-state of Athens, under the direction of the magistrate Cleisthenes (c.570–507 BCE). The practice of democracy matured under the great statesman

Pericles (c.495–429 BCE), dubbed "the first citizen of Athens" by contemporary historian Thucydides. Around this time, Greek armies won decisive victories against their Persian enemies, who had long-held territorial ambitions in the area. As a result of these events, Athens prospered and became the cultural center of the Greek world.

In the dynamic environment of Athens, the arts flourished as never before, and some sculptors moved beyond Archaic traditions and started to portray real people, as well as characters from mythology. Through closer observations of the human body they strove to make sculptures that seemed to be "carved from within"—imbued with a life force. These departed from the static and symmetrical poses of the Archaic style and often adopted a *contrapposto* pose—having their

weight on one leg, the other leg slightly bent, and the hips, torso, and head turned slightly to one side. This innovation allowed for greater expression in the body, implying either movement or a sense of relaxation, but also invited the viewer to look at the figure from different angles, not just the front.

Elegant simplicity
Such changes represented a modification of the Archaic ideals of beauty rather than their complete abandonment. Classical sculptors still drew attention to the well-proportioned, muscular male form, but they made it more elegant and expressive. The decorative details of the Archaic style gave way to a greater simplicity, and the Archaic smile was replaced by features—often a frown—capable of supporting the narrative of the piece. »

The Riace Bronzes

The transition from the Early to the High Classical period—considered by many scholars to be the golden age of Greek art—can be seen in two bronze statues recovered from the sea near Riace, in southern Italy, in 1972. The exact date of the statues is not known, but they are believed to have been made between around 450 and 420 BCE, probably separately. Their creators remain unknown.

The poses and gestures of the Riace Bronzes are immediately striking. They both adopt an exaggerated *contrapposto* stance, arms held asymmetrically away from the body and heads turned to one side. They were likely to have carried spears and shields, which have since been lost. Showing these warriors ready for action gave the sculptor an opportunity to delineate the men's muscles in tension, animating both figures.

Slightly larger than life-size, the naked warriors are at once examples of an ideal physique, and yet very human characters, full of life and vitality. The figures appear

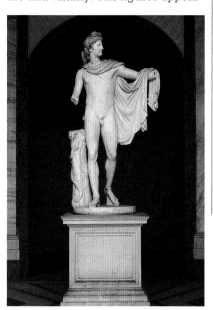

And if … man's life is ever worth living, it is when he has attained this vision of the very soul of beauty.
Plato
Symposium, c.380–360 BCE

to be real individuals—one is noticeably older than the other, his age discernible in both his physique and his facial features. Both faces conform to earlier Greek notions of the ideal, displaying the conventional "Greek profile," where the nose makes a continuous straight line with the forehead. However, the severity of the Early Classical face is replaced by an expression of serenity, and the figures are humanized by their finely executed hair and beards.

Realism and vitality

Sculptors of the High Classical period continued the search for realism and the expression of vitality in the human form. The Greek masters Phidias and Polykleitos preferred to carve in marble or ivory rather than to cast in bronze, as they were able to use softer lines and so produce more realistic depictions of skin and muscles. Less formal poses helped to enhance a feeling of movement,

Drapery was often used to enhance the beauty of the male nude in both High and Late Classical sculpture, as seen in the 4th-century BCE *Apollo Belvedere* (Roman copy of lost original).

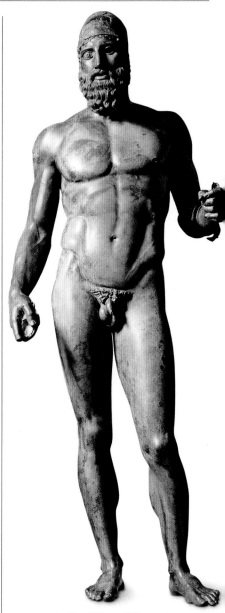

as seen in the Nike of Paeonius, which was discovered at Olympia. Here Nike, the winged goddess of Victory, appears on her toes, as if she has just alighted on her plinth.

Drapery became an increasingly expressive feature. Folds of cloth, carved with soft, flowing lines, added to the illusion of warmth in skin, aided the overall feeling of natural movement, and, in female figures, allowed artists to imply the

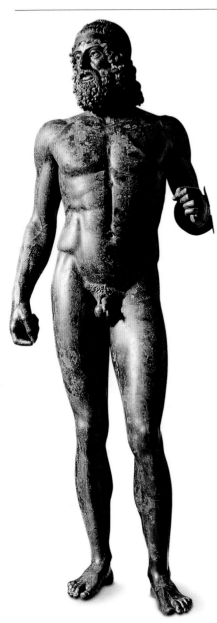

Phidias, for example, created a giant statue of Zeus (c.430 BCE) for the Temple of Zeus at Olympia. Polykleitos designed his *Doryphoros* (*Spear Bearer*, c.440 BCE) to embody the ideals of harmony and proportion in the human body.

The female nude became a worthy subject for artists much later in the Classical period. The earliest extant example (known from marble Roman copies of the lost bronze original) is *Aphrodite of Knidos* by Praxiteles, who worked around 350 BCE. Female statues, like their male predecessors, were intended to embody the ideals associated with their sex. Sculpted with the soft, rounded lines that became a feature of the Late Classical period, these voluptuous figures were portrayed in poses emphasizing their modesty.

Sculptors also made busts, relief panels, funerary monuments, and domestic objects, as well as architectural decorations—prevalent from the late 6th century BCE—which appeared on pediments, friezes, and temple walls. Some Greek figure statues became extremely famous in their time. They were much copied, especially in the Roman period; very often, only the copies survive, while the Greek originals have been lost. The copies can present problems to scholars, since they lack the original master's touch, may be in a different medium (marble rather than bronze), and may even mix body parts from different sculptures.

Hellenism

After the death of Alexander the Great in 323 BCE, the importance of the old city-states declined, and Greek influence spread over new territories in western Asia and northern Africa. This diffusion of Greek culture, known as Hellenism, was accompanied by changes in artistic expression as sculptors abandoned the ideals of Classicism in favor of new, more naturalistic, expressionistic portrayals of real people and extreme emotions. Nevertheless, Classical Greek sculpture continued to exert its influence, at first in Rome, and later in Renaissance Italy, when artists were inspired by the rediscovery of Classical art and its ideals of beauty, and the artistic virtues of balance, proportion, and harmony established by the ancients. ∎

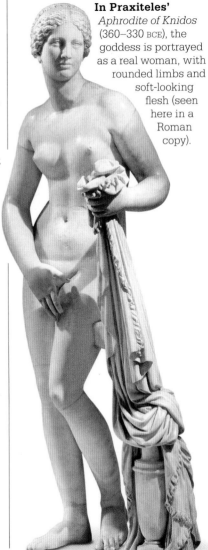

In Praxiteles' *Aphrodite of Knidos* (360–330 BCE), the goddess is portrayed as a real woman, with rounded limbs and soft-looking flesh (seen here in a Roman copy).

The two bronze warriors recovered at Riace are known as Statue B (left), an older man who would have worn a helmet that has since been lost, and Statue A (right), a younger man.

shape of the female form beneath. However, for the most ambitious Greek sculptors, many of whom are known because they signed their works, the freestanding male nude was the preeminent subject.

THIS WORK SHOULD BE CONSIDERED SUPERIOR TO ANY OTHER

LAOCOÖN AND HIS SONS (42 BCE–70 CE), AGESANDER, ATHENODORUS, AND POLYDORUS

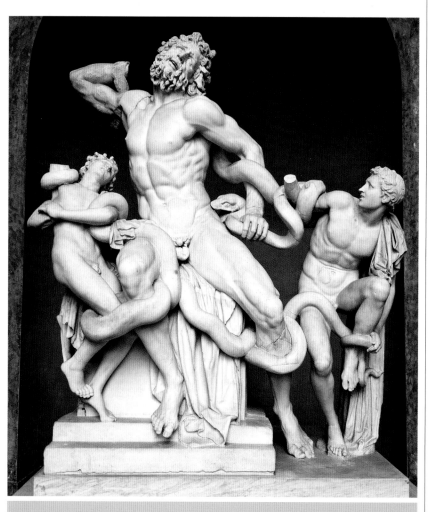

IN CONTEXT

FOCUS
Hellenistic naturalism

BEFORE
c.600 BCE The first of the standing statues of young men, known as *kouroi*, appear in Greek tombs and temples.

c.350 BCE Praxiteles of Athens sculpts a number of life-size statues emphasizing a realistic depiction of the human figure, including the famous *Aphrodite of Knidos*, one of the first life-size female nudes.

2nd century BCE Numerous sculptures created in the Greek city of Pergamon (Bergama, in present-day Turkey) establish the more naturalistic Hellenistic style.

AFTER
193 CE A triumphal column commemorating Marcus Aurelius develops a Roman tradition of monumental statues, which gradually replaces sculpture in the Greek style.

The aesthetic ideals of what is now called classicism were established during the Classical period of ancient Greece, from about 500 BCE to the death of Alexander the Great in 323 BCE. Following this "golden age" centered on the city-state of Athens, Greek cultural influence continued to spread into Europe, Africa, and Asia until the Roman Empire began to gain supremacy after 31 BCE. Known as the Hellenistic period, this time span saw the bounds of artistic expression expanded, particularly in sculpture.

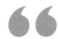

One antique sculpture furnishes us with the prototypical icon of human agony.
Nigel Spivey
Enduring Creation, 2001

While artists in the Classical style emphasized the elements of harmony, symmetry, proportion, and beauty, sculptors in the Hellenistic period adopted a more naturalistic, fluid style. Rather than aiming for formal elegance and poise, they sought movement, drama, and expression of thought and feeling. In place of idealized beauty, they chose sensuality—the first Greek female nude statues appeared during this period—and even the humorous or the grotesque. And where Classical art had concerned itself with the universal, Hellenistic sculpture often sought to capture a single, particular moment.

Agony and ecstasy

The larger-than-life-size sculpture *Laocoön and his Sons* epitomizes this Hellenistic style. It depicts an episode in Greek myth related by Virgil in his epic poem, the *Aeneid*, when the Trojan priest Laocoön and his sons are tangled in the coils of sea serpents sent by the goddess Athena. The extremes of fear and suffering are shown in their agonized expressions, and their desperate struggles are evident in their contorted poses. The central figure of Laocoön is shown with muscles straining, head thrown back, and eyes raised to heaven—a pose that was used to express both agony and ecstasy in subsequent art through the ages. His younger son, on the left, seems to be succumbing to the serpent's grip, while the elder boy, who gazes across at his father and brother, may have a chance to break free.

The statue was praised by the Roman writer and natural philosopher Pliny the Elder in his *Natural History* in 77 CE: "This work should be considered superior to any other, both for its painting and for its worth as a statue."

Expressive qualities

Lost for centuries, *Laocoön and his Sons* was hailed as a masterpiece after its rediscovery in a vineyard near Rome in 1506. The statue inspired the young Michelangelo to explore the balance between the High Renaissance style—influenced by Classical ideals—and the naturalism of Hellenism. The artist's sculptures *Dying Slave* and *Rebellious Slave* (both c.1513), and the four "*non-finito*" figures known as the *Slaves* (c.1520–34), show the direct influence of *Laocoön* in their use of the human body to express emotional content in a masterly and evocative way.

The expressive qualities of Hellenistic sculpture continued to be an inspiration for later artists of the High Renaissance and the subsequent Mannerist movement. Its emotionalism was especially appealing to the Baroque sculptors of the 17th century. ▪

Venus de Milo, or *Aphrodite of Milos* (c.100 BCE), is a Hellenistic take on a popular classical subject. The goddess is posed in a spiral composition, as if frozen in time.

Agesander, Athenodorus, and Polydorus

Laocoön and his Sons was displayed at the palace of the Roman emperor Titus, but, like most of the sculpture owned by the Roman nobility of the time, it was the work of Greek sculptors. It is credited to Agesander, Athenodorus, and Polydorus of Rhodes, although it is possible that the trio were copyists and reproduced an earlier work, perhaps a bronze statue of the Pergamon school. The statue may have been among the last of the Hellenistic works to be commissioned, as around this time a more stolid, unsentimental "Hellenistic–Roman" sculptural style began to emerge, a hybrid incorporating Etruscan, Greek, and Roman elements, which was better suited to the historical subjects favored by the Romans.

STYLIZED FORM AND SPIRITUAL BEAUTY HAVE BECOME RECOGNIZED FEATURES OF THE BUDDHA-IMAGE

STANDING BUDDHA FROM GANDHARA (1ST–2ND CENTURY CE)

IN CONTEXT

FOCUS
Early Buddhist art

BEFORE
3rd century BCE The stupas (domed relic shrines) at Sanchi, Bharhut, and elsewhere in India use symbols to represent the Buddha.

2nd century BCE Paintings in the Ajanta Caves in western India include some of the first portrayals of the Buddha.

1st century CE Depictions of the Buddha in Southeast Asia incorporate elements of the Indo-Greek style.

AFTER
5th century The Northern Dynasties of China develop more stylized depictions of the Buddha, with recognizably Chinese features.

507 The first of the two giant Buddhas of Bamiyan, in present-day Afghanistan, is carved into a rock face in the classic Gandharan style.

Buddhism, the religion and philosophy inspired by the teachings of Siddhartha Gautama in the 5th century BCE, spread rapidly across eastern Asia from its beginnings in northern India. However, for several centuries, Buddhist art avoided explicit representations of the Buddha, even in friezes depicting scenes from his life that decorated temples and stupas (domes housing a relic of the Buddha). Instead, the Buddha was alluded to by images of, for example, an empty throne, a riderless horse, a footprint, or the Bodhi tree under which he attained enlightenment. He was also represented by more abstract signs and symbols, including the spoked wheel that symbolized his teachings (dharma).

The reasons for not portraying the Buddha are unclear, especially as Indian figurative art—and sculpture in particular—was highly developed, and Hinduism provided a rich tradition of iconography. It was only in the 1st century CE that images of the Buddha began to appear, ending the long "pre-iconic" period. However, these depictions were not the product of a purely indigenous artistic tradition.

Roughly coincident with the growth of Buddhism, Greek influence in the Indian subcontinent increased, following the expeditions led by Alexander the Great in the 4th century BCE. The establishment of an Indo-Greek kingdom in 180 BCE in present-day Pakistan,

See also: Riace Bronzes 36–41 ▪ *Laocoön and his Sons* 42–43 ▪ Marcus Aurelius 48–49 ▪ Shiva Nataraja 76–77 ▪ Nio temple guardians 79 ▪ *Six Persimmons* 101

The Caves of the Thousand Buddhas

The Mogao Caves located near Dunhuang in China were first constructed in the 4th century CE as Buddhist shrines, and evolved into a complex of nearly 500 cave temples. They contain a wealth of Buddhist paintings and sculptures spanning a period of around 1,000 years. The emergence of a distinctive Dunhuang style can be seen in the thousands of sculptures of the Buddha, ranging from stone carvings to molded clay statues painted in bright colors.

While the earliest were in the Indo-Greek style, the figures soon became more recognizably Chinese, not only in their facial features but also in their more naturalistic and elegant poses. The Buddha is often depicted sitting on a throne rather than in the lotus position, sometimes lavishly clothed and attended by followers. Of note is the Nirvana Cave, which contains a huge reclining Buddha from the mid-Tang Dynasty (741–848); the walls are painted with mourning scenes.

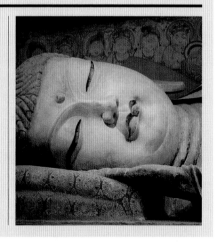

Afghanistan, and northwestern India brought many elements of Hellenistic culture, in particular contemporary Greek sculptural styles. In addition, a cultural influence was exerted by traders from the Roman Empire. A hybrid culture synthesizing Greco-Roman and Buddhist artistic traditions later emerged in the Gandhara region, an important crossroads on the Silk Road, where some of the first depictions of the Buddha were made after the fall of the Indo-Greek kingdom, during the Kushan Empire (1st–3rd centuries CE).

The Gandhara style

Typically, these early portrayals took the form of a statue of a standing Buddha carved in schist, a hard local stone. Each of the Gandharan Buddhas, such as the standing Buddha illustrated here, were recognizably Indian in their sensuousness, but owed more to Greco-Roman sculptural conventions than to any Indian cultural heritage. Most immediately apparent in this figure is the fact that the Buddha is clothed in a garment resembling a Roman toga, and the heavy folds of its drapery are depicted in the sort of detail that might be seen in a Roman statue of the same period.

The pose, too, is more European than Asian: the figure stands rather formally on a small plinth rather than being seated or in an active pose that is more typical of native Indian art. There is a hint of the *contrapposto* pose typical of Classical Greek statues, with the weight on the right foot and the other leg slightly bent, although this is far less pronounced than in Greco-Roman sculpture. The Buddha is depicted here flat-footed, as he is described in Buddhist scriptures. He is also shown facing squarely forward, giving an overall impression of balance and calm authority rather than expression and movement.

But it is the head that truly distinguishes this Gandharan Buddha as a product of a »

Carvings of the Buddha's footprints, or *buddhapada*, were often used to represent the Buddha, especially before the development of a figurative tradition. The footmarks to the left are from a 1st- to 5th-century CE Gandharan frieze. The central wheel symbolizes the Buddhist doctrine; auspicious symbols are carved above.

Two giant 6th-century Gandhara Buddhas in Bamiyan, Afghanistan, were destroyed by the Taliban in 2001. The larger statue, 180 ft (55 m) tall, is shown here before its obliteration.

syncretic (fused) Greco-Indian art. It is framed by a halo, which was used in Greek art to denote the holiness of a figure. The facial features, although they have the characteristic roundness and smoothness of Indian art, display both the idealized form seen in Greek sculpture, and a classically detached, serene expression. Certain features are Europeanized, such as the profile, which aligns nose and forehead in typical Greek fashion, while the eyes are recognizably

An all-pervasive moral and spiritual environment began to take shape in Gandhara.
Rafi U. Samad
The Grandeur of Gandhara, 2011

Asiatic. The elongated ear lobes are a reminder that the Buddha was once a wealthy prince who wore earrings and signify renunciation. The topknot of curly hair became a feature of Buddhist iconography known as the *ushnisha*, denoting enlightenment. It is thought to represent the turban of a prince, and may reflect Greek portrayals of the god Apollo in which his wavy hair was similarly styled.

Further, specifically Buddhist, symbolism is seen in the positions of the arms and hands. The standing Buddha is typically shown with his right hand raised in a gesture of fearlessness that also symbolizes reassurance, protection, and blessing. Although the right hand is missing in this figure, the gesture is common to a majority of Gandharan standing Buddhas, and forms the

The hands of this seated Gandharan Buddha form the *dharmachakra* mudra, indicating that he is teaching the dharma—the Buddhist way or doctrine.

first of a number of such gestures, known as mudras, that grew into a large, complex system of Buddhist iconography; this one is the *abhaya* mudra. His left hand, making the *varada* mudra, is lowered with palm facing forward, representing charity, compassion, and grace.

Iconographic poses
While these Gandharan standing figures were the first explicit representations of the Buddha, others soon appeared, in several different poses, known as asanas. Buddhist art also flourished in Mathura, in central northern India—another part of the Kushan Empire that ruled the Gandhara

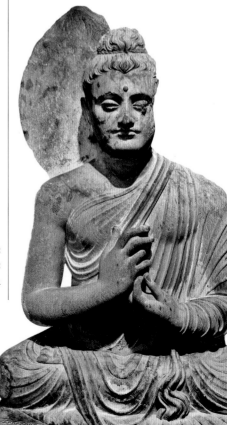

> Ultimately the image is only a means to understanding and experience, a symbol pointing beyond itself.
> **Albert C. Moore**
> *Iconography of Religions, 1977*

region. There, the influence of indigenous art was stronger, and the Buddha was often depicted as a seated figure wearing little more than a simple loincloth or a light cloth draped over a shoulder, yet still retaining the Hellenistic traits of realism and serenity.

The seated Buddhas brought a further layer of iconography. Roughly contemporaneous to the Gandhara Buddhas, the early Mathuran sitting figures established a new tradition of depicting the Buddha during meditation, his legs crossed in the lotus position, which has since become the pose most associated with statues of the Buddha. As with the standing Buddhas, the arms and hands are shown in conventional mudras. Typically, the left hand rests palm up in his lap, while the right hand touches or points to the ground, a gesture associated with the Buddha's enlightenment and his victory over the demon Mara.

Later, the seated Buddha was also depicted in a teaching pose. A common mudra associated with this was the "turning of the Wheel of Law," with the right thumb and index finger touching, and the left-hand fingers lightly touching the right palm. Less commonly, the Buddha was shown in a reclining pose, lying on his right-hand side, representing him at the end of his earthly life, about to enter Nirvana.

Buddhist evolution

The elements of iconography established in the Kushan Empire provided a defining foundation for subsequent representations of the Buddha across the Buddhist world. As Buddhism spread farther from its Indian roots, the Indo-Greek stylistic influence weakened over time. Until about the 7th century, for example, the Buddha was usually portrayed in the modest garb of a monk, but in some traditions he later came to be depicted in the robes and jewels of a prince.

Buddhist art elsewhere, from Southeast Asia to China, Korea, and Japan, followed the Indian precedent in its depictions of the Buddha, but adapted it. Some changes and additions to Buddhist iconography have persisted into modern times. In East and Southeast Asia, a slender, elegant Buddha figure is often depicted either on a throne, his legs crossed and his head tilted to rest on one hand, or seated in meditation with his hands in a "diamond fist" gesture, the right hand grasping the left thumb. In Korea and Japan, a teaching gesture associated with sitting Buddhas evolved, in which the raised forefinger of a clenched left hand is gripped in the right fist. ■

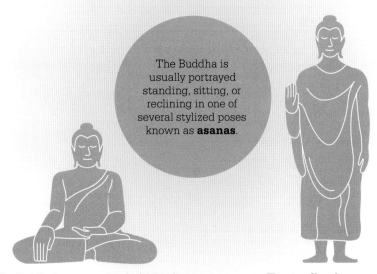

Reclining figures show the Buddha serene and composed at the end of his life, preparing to enter *parinirvana*— release from the cycle of life, death, and rebirth.

The Buddha is usually portrayed standing, sitting, or reclining in one of several stylized poses known as **asanas**.

The Buddha is most commonly depicted **seated**, typically in the lotus position and either meditating or teaching. Here the fingers of his right hand point downward in the gesture of calling the earth to witness.

The **standing** figures most often represent the Buddha posed with his right hand raised in the gesture of fearlessness and protection.

THE MOST MONUMENTAL AND AWE-INSPIRING VISIBLE EXPRESSION OF HIS AUTHORITY

MARCUS AURELIUS (c.176 CE)

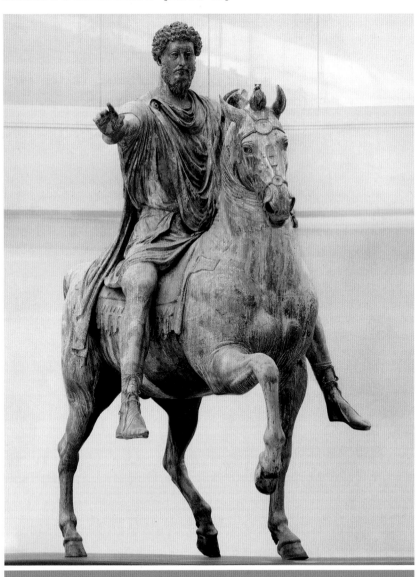

IN CONTEXT

FOCUS
The equestrian statue

BEFORE
c.550 BCE The "Rampin Rider," showing a *kouros* (male youth) figure on horseback, is carved in Athens, Greece.

210–209 BCE The cavalrymen of the Terra-cotta Army buried with Emperor Qin Shi Huang of China are depicted standing at the side of their horses.

AFTER
c.3rd century CE A bronze equestrian statue known as the *Regisole* or "Sun King" is cast in Ravenna, Italy.

1598 An equestrian statue by Giambologna of Cosimo I de' Medici is erected in Florence.

E questrian statues have a long tradition in Western art. The earliest examples date back to the Archaic period of ancient Greece (c.600–480 BCE). These first sculptures appear to portray an ideal horse and rider, rather than a real character.

The equestrian statue as a commemorative sculpture honoring a military hero or civic leader was very much a Roman idea. At least 22 major statues of Roman generals and emperors are known to have been made for public display in Rome from about the 6th century BCE onward. These tended to be cast in bronze, and were often gilded. Unfortunately, the majority of them were later destroyed and melted down for the bronze. The only one to survive to this day is the magnificent statue of Emperor Marcus Aurelius.

Originally cast in bronze in several pieces and then soldered together and gilded, the statue follows the Classical Greek tradition of portraying an idealized vision of the subject, emphasizing the most admirable qualities in a realistic style. The statue is thought to have been erected in c.176 CE, after Marcus Aurelius' triumph over the Germanic tribes, and the emperor is depicted as victorious but not at war, powerful but dignified. It is larger than life-size and when it is mounted on a plinth, the viewer is obliged to look up to the emperor both literally and metaphorically.

A wise and virtuous leader

The magnificent horse is shown with its muscles tensed and firm. Its ears are pricked, ready for action; the raised right foreleg adds to the impression of potential might. But it is the rider that is the main focus of the statue, and the restrained energy of his horse only serves to underline the fact that he is in control. The horse's head and neck, for example, show that the

Giambologna's bronze statue of Grand Duke Cosimo I was the first equestrian statue created in Florence. Erected in the city in 1598, its design was imitated throughout Europe.

animal is being held back, but the lines of the reins (now missing) draw attention to the emperor's left hand—he holds the reins lightly, suggesting the gentle but effective rule he had over his empire.

Every aspect of the statue is designed to represent the emperor as a wise, virtuous leader. His beard and curly hair identify him as the philosopher-emperor; his relaxed gaze is downward, suggesting a benign attitude to those under him. The military-style clothing makes it clear he is a soldier, and the fact that he is on a horse marks him as a commander. Portraying Marcus Aurelius as a military leader in a time of peace identifies him as the emperor famous for his reluctance to use military might, except to achieve peaceful ends. His right arm is outstretched, in a gesture associated with imperial power;

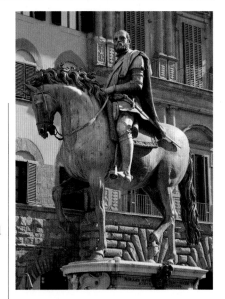

here it may suggest clemency toward a defeated enemy. The symbolism of the gesture as a signifier of power over the people is softened by the subtly spread and curved fingers, which imply a more paternalistic salutation.

Regeneration and renewal

The equestrian statue reappeared as a genre in the Renaissance, when it again became popular as a form of commemorative art, reflecting the revival of interest in classical ideals. The Greco-Roman style, combined with an increasingly realistic portrayal of character, reflected the growing humanist ethos of the time.

The statue of Marcus Aurelius was moved to the Capitoline Hill in the heart of the city of Rome in 1538, at the request of Pope Paul III. Michelangelo was invited to restore it—he designed an extensive new architectural complex, the Piazza del Campidoglio, around it, giving both the statue and the equestrian genre a new lease of life. ▪

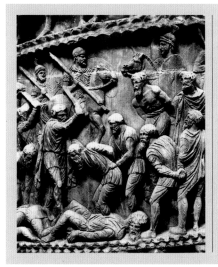

The triumphal column

Roman rulers were recognized in various forms of sculpture, including busts, statues, and triumphal columns. A marble column (c.180–196 CE) honoring Marcus Aurelius's victories over the Marcomanni and the Sarmatians features a spiral frieze depicting the emperor's triumphs (this detail depicts a group of Germanic nobles being beheaded). The reliefs reveal a shift from the Hellenistic style toward a darker, far more expressionistic portrayal of war.

THE FACE OF TEOTIHUACÁN
TEOTIHUACÁN MASK (c.50–600 CE)

I n the classic period of Mesoamerican culture, two great civilizations evolved from the culture of the Olmec of the coastal area of the Gulf of Mexico. One, the Maya, established a series of city-states in present-day southern Mexico and Guatemala, which flourished from around 300 to 600 CE. The other civilization was centered on the city of Teotihuacán in central Mexico, which at its height in about 450 CE had a population of more than 150,000 and ruled over a large part of central America.

Artistic traditions
A feature of both these cultures was the building of magnificent pyramid-shaped temples, which showed their creators to be skilled stonemasons on a monumental scale. The temples were decorated with sculptures and reliefs carved into the stone, as well as with colorful, and sometimes breathtakingly vivid, wall paintings. Many of these were stylized depictions of the people's deities, and the rituals that were associated with their religion, including human sacrifice and bloodletting.

The Pyramid of the Sun and the lesser Pyramid of the Moon in Teotihuacán also contained many smaller artifacts, which are believed to have had a religious significance. Among them are a number of masks—often with standardized faces—modeled in clay or carved in stone such as jade or basalt, then polished and sometimes inlaid with shell or obsidian. The life-size Teotihuacán mask shown here is made from stone, obsidian, coral, turquoise, and shell. The staring face, with its large, almond-shaped eyes, gives no indication of age or gender. Such masks—which often had no holes for eyes and were not made to be worn—are thought to be burial masks that would have been placed on mummified bodies.

Teotihuacán art came to be admired throughout Mesoamerica, and its influence lasted long after the sudden fall of the civilization, which occurred in around 550 CE. The ruined city was rediscovered by the Aztecs in the 14th century, who identified it by the quality of its art as the origin of their own culture, first giving it the Nahuatl name Teotihuacán, meaning "birthplace of the gods." ∎

IN CONTEXT

FOCUS
Mesoamerican art

BEFORE
Pre-900 BCE The Olmec people of Mexico's Gulf coast carve small figurines and "colossal heads" from basalt boulders.

AFTER
8th century The Maya people produce spectacular murals at Bonampak (now Chiapas), Mexico, using a vibrant palette to document political and ritual life and war practices.

11th century The Toltec people carve magnificent stone columns—depicting warriors dressed for battle—at Tollán, central Mexico; the columns support the roof of a pyramid-topped temple.

15th century Mexico is dominated by the Aztec Empire, whose people are skilled in stonemasonry and carving, especially of religious figures and symbols.

See also: Easter Island statues 78 ▪ Bonampak murals 100 ▪ Goddess Coatlicue 132–33 ▪ Benin Bronzes 153

A NEW TYPE OF FIGURAL COMPOSITION

SARCOPHAGUS OF JUNIUS BASSUS (c.359 CE)

IN CONTEXT

FOCUS
Early Christian iconography

BEFORE
Late 2nd century CE The catacombs of Rome are decorated with frescoes and sculpture in the Roman style, with references to Christianity.

c.330–340 CE The "Dogmatic" sarcophagus, carved with high-relief illustrations of the dogmas of the Christian Council of Nicaea in 325 CE, is placed in the Basilica di San Paolo Fuori le Mura, Rome.

AFTER
Late 4th century CE Ivory panels carved with images of the scriptures adorn a wooden box, probably made in Milan, known as the "Brescia Casket."

5th century CE The Basilica di Santa Maria Maggiore is built in Rome, and decorated with wall paintings of Old Testament scenes.

The beginnings of a clearly identifiable and explicitly Christian art can be traced to Emperor Constantine's Edict of Milan in 313 CE, which ended Christian persecution in the Roman Empire. Among the citizens who embraced the Christian faith around this time was the prefect Junius Bassus, who converted just before his death in 359 CE. Like many noblemen, he opted for burial, not cremation, and a sarcophagus was made for his remains.

The sarcophagus of Junius Bassus is carved from marble, and is decorated on the lid and three of its side panels with high reliefs in the contemporary Roman style. These panels depict overtly Christian imagery, including a representation of Christ himself and scenes from the Old and New Testaments: for example, in the top row (first niche), the sacrifice of Isaac, and in the bottom row (second niche), Adam and Eve beside the Tree of Knowledge. Christ is depicted, at the center of the top row, in a naturalistic pose, young, beardless, and with short hair— a representation that differs significantly from the older figure with long hair and a full beard that has become so familiar from later Christian art. He is holding a scroll and is flanked by saints Peter and Paul, in a scene the Romans would have recognized as the *Traditio Legis*, or "Giving of the Law." In a striking adaptation of pagan iconography, Christ is shown with Caelus—the Roman god of the heavens—beneath his feet as he hands over authority in the Church to the two saints. ∎

See also: Wall paintings from Dura Europos 57 ▪ Vienna Genesis 57 ▪ Reliquary of Theuderic 62–63 ▪ Pisa Baptistery pulpit 84–85

DRESSED TO ESTABLISH THEIR ETERNAL PRESENCE AMONG THE DIVINE

MOSAICS OF EMPEROR JUSTINIAN AND EMPRESS THEODORA (c.547)

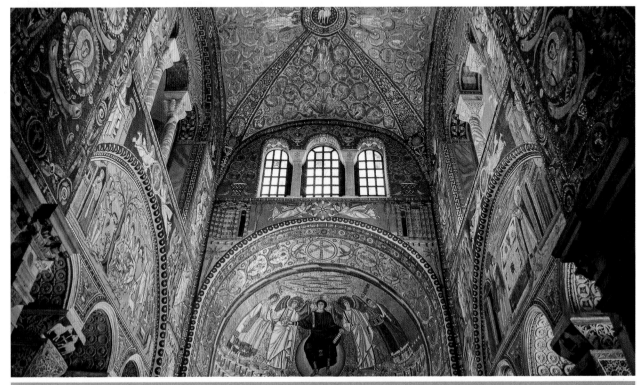

See also: Marcus Aurelius 48–49 ▪ Alexander Mosaic 57 ▪ Stained-glass windows, Chartres Cathedral 80–83 ▪ *The Arnolfini Portrait* 112–117

IN CONTEXT

FOCUS
Byzantine aesthetics

BEFORE
c.430 CE The interior of the Roman-style mausoleum of Galla Placidia in Ravenna is decorated with a Byzantine mosaic depicting the stars in the sky around a golden cross.

532 On the orders of Emperor Justinian, work begins on the rebuilding of Hagia Sophia, Constantinople; the new church is richly decorated with mosaics.

AFTER
11th century The tradition of ivory sculpture is revived under the Macedonian dynasty of the Byzantine Empire.

13th century After the restoration of Constantinople to Byzantine rule, frescoes begin to replace mosaics as narrative church decoration.

During the initial three centuries after the death of Christ, the early Christian Church became established around the Mediterranean basin and farther afield. The religion spread despite opposition from the Roman Empire and its regional governors, who at this time saw Christianity as an undesirable cult, blaming it for outbreaks of civic unrest, and often forcing it—quite literally—underground by persecution. Given this atmosphere of repression, it is not surprising that the Christian art that developed—of catacomb frescoes and sculptures—alluded allegorically rather than directly to central tenets of the faith.

The official attitude to Christianity changed when Constantine (c.280–337 CE) became the undisputed Western Roman Emperor in 312 CE. Constantine attributed his success to his conversion to Christianity after he had a vision of a flaming cross in the sky, although there were sound political reasons to win the support of the Christian world. The following year, Constantine and Licinus—the Eastern Roman Emperor—issued the Edict of Milan, which granted freedom of worship, setting the scene for the gradual displacement of paganism.

A new capital

Constantine unified the Western and Eastern empires in 324 CE, and established his capital in Byzantium (present-day Istanbul)—renamed Constantinople in his honor—in 330 CE. As the western part of the Roman Empire declined, the headquarters of the Christian Church relocated to Constantinople. This marked the start of a Christian cultural and artistic tradition that would develop separately from that of Rome and eventually lead to a schism in the Church.

Roman and Greek artists and craftsmen were drawn to the new center of Empire and Church at Constantinople. Positioned at the crossroads between East and West, the city exposed them to novel influences from Arabia and Persia. The sensual richness of this Oriental art gave artists a new language with which to express

The mosaic of Christ Pantocrator from Hagia Sophia in Constantinople depicts Christ as an all-powerful judge of humanity, making the blessing sign with his right hand.

Christian mysticism—a language that had been lacking in the more refined Greco-Roman tradition.

Byzantine art

Unlike early Christian art, which was necessarily understated, the new Byzantine art was deliberately conspicuous, extrovert, and imperial. In place of the muted tones of stucco that Roman Christians used to decorate the walls of their catacombs, the interiors of Byzantine churches were covered with variegated marble and dazzling gold or richly colored mosaics that imparted all the opulence of a royal palace.

Mosaic had long been used in Rome and Greece as floor decoration, or in water features where painted motifs would have been impractical. In Byzantine churches, however, it became elevated to the status of art, and given pride of place on the walls and ceilings of churches. Some of the finest Byzantine mosaics can be seen in the church of San Vitale in Ravenna, Italy. »

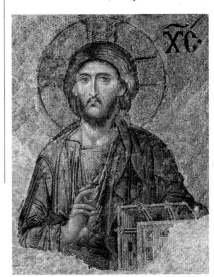

The San Vitale mosaics

Dedicated in 547 by the Byzantine bishop Maximian, the Basilica of San Vitale is one of few surviving churches from the long reign of the Byzantine emperor Justinian (c.482–565). Justinian oversaw the construction and restoration of a host of buildings in Constantinople, including the Hagia Sophia cathedral. Ravenna became the Western seat of Justinian's Byzantine government in 554, and the wealth of mosaic decoration created in San Vitale was fitting for its new role.

San Vitale is a small, octagonal, domed church with an airy marble interior. It is made spectacular by its apse and choir, whose walls and

The emperor Justinian stands at the center of a group of clerics and soldiers, one of whom holds a shield bearing the "Chi-Rho" symbol, standing for Christ, reinforcing the Church–State link.

ceiling are completely covered in shimmering mosaics, formed from small, colored glass and gold tiles that reflect the light. The execution and subject matter of San Vitale's mosaics exemplify the Byzantine style, in which symbolic imagery was used to represent the divine and transmit theological teaching. Figures are portrayed with a rigid formality and clothed in stylized drapery, and show little emotional expression. They lack solidity, and appear to float in front of an indistinct background, suggesting a transcendence of time and space. The blue skies of the classical world are replaced with solid gold space, evoking a paradisiacal state that is nowhere and everywhere.

Every surface in San Vitale's presbytery and apse is covered with mosaics, depicting saints, prophets, and scenes from the Old Testament against a colorful

decorative background of floral motifs, foliage, abstract patterns, animals, birds, and even fish.

In the semicircular ceiling of the apse is a representation of a purple-robed Christ as ruler and judge, seated on the orb of the Earth and flanked by angels, St. Vitalus, and Bishop Ecclesius, the founder of the church. These otherworldly figures appear high above the viewer, their faces impassive, giving an impression of mystical perfection.

Justinian and Theodora

Two mosaics on the side walls of the choir, in front of the apse—one showing the emperor Justinian, the other his wife, Theodora—convey to the congregation the intimate connection between Church and Empire. Tall, angular, and imposing, Justinian is pictured as both a political and a spiritual leader, with a retinue of soldiers to one

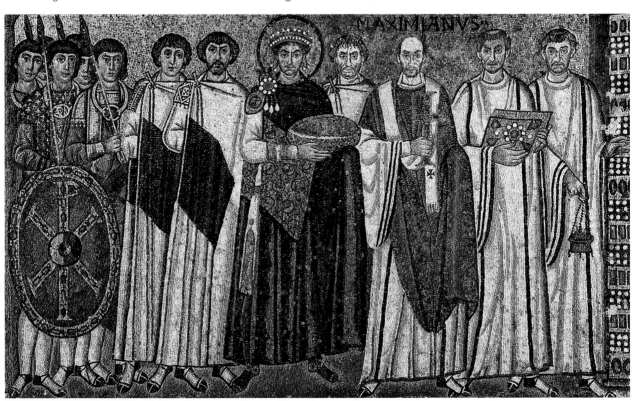

The empress Theodora bears a chalice containing the communion wine, her heavenly halo and opulent robes and jewelery carrying both religious and political overtones.

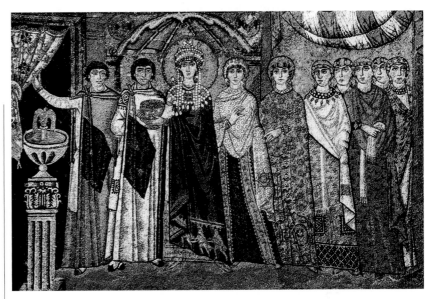

side, and priests, led by Archbishop Maximian holding a jeweled cross, on the other. Dressed in a robe of imperial purple, Justinian wears a crown, and his head is surrounded by a halo. In the panel opposite, the empress is similarly depicted among the ladies of her court, lavishly dressed, bejeweled, and crowned, and also with a halo.

The figures in these two panels are formally posed. The haloes of Justinian and Thoedora echo the image of Christ and are a reminder of the divine origin of imperial authority. The faces of the more important figures bear a hint of expression and character, making them recognizable as individuals, but there is no sense of depth or weight; the flat, stylized, frontal presentation typical of Byzantine art gives the figures an abstract quality while the prevalence of gold detailing, rich and ornate fabrics, and ostentatious jewels emphasizes their imperial magnificence. The art weaves together Roman figures with religious iconography in a way that is simultaneously imperial and Christian, and works overall as an emblem of Justinian's control after his reconquest of Italy.

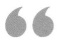

> God is beheld not with the eyes of the flesh, but only with the eye of the mind.
> **Theodulf of Orleans**
> *Libri Carolini*, c.790

Iconic imagery

The symbolism that appeared in early Byzantine mosaics later became a feature of other genres, including relief sculpture, murals, and ceramic art, but above all of the icon painting that dominated in the later Byzantine style.

By the late 11th century, the Christian Church was irreconcilably divided between its centers in Constantinople and Rome. While there was some artistic cross-fertilization, such as the decoration of the interior of St. Mark's Basilica in Venice and to some extent the International Gothic movement of the 14th–15th centuries, the schism between the Roman Catholic and the Eastern Orthodox churches led to quite separate developments in their art.

The stylized abstraction typical of Byzantine art is seen in *The Virgin of Vladimir* (1131)—in the angular features, the sweep of the outline of the figures, and the drapery's golden brilliance.

The Byzantine Empire continued until the Ottoman Turks took Constantinople in 1453, by which time its artistic and cultural identity (typified by luxury, beauty, and learning) had become established across the Middle East, eastern Europe, and Russia. The sensuous and symbolic Byzantine style continued to influence the arts of the region for several centuries. ■

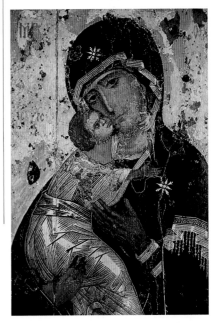

PORTFOLIO

PAINTED LIMESTONE BUST OF QUEEN NEFERTITI
(c.1350 BCE)

In 1912, German archaeologists excavating at Amarna, capital of the Egyptian pharaoh Akhenaten, unearthed a bust of his wife, Queen Nefertiti. With its combination of regal authority and exquisite beauty, this unforgettable portrait has since become one of the most renowned symbols of the ancient world. Remarkable for its excellent state of preservation, the bust consists of a limestone core covered with layers of gypsum stucco, and was created by court sculptor Thutmose. Found in the sculptor's studio along with a number of other busts, it would have been used as a model by artists creating portraits of the queen.

ACHILLES AND AJAX GAMING
(c.530 BCE), EXEKIAS

Almost all large-scale ancient Greek painting has been lost, so knowledge of ancient pictorial art depends heavily on vase decoration. One such example, executed in the "black figure" technique—in which images were painted in a clay slip that turned black after firing—shows the two mightiest Greek warriors of the Trojan War playing a board game to while away the tedium of the siege of Troy. The scene's creator, Exekias (active in Athens in the late 6th century BCE), was both a potter and a painter, and is regarded as one of the greatest

exponents of his art, renowned for the dignity of his compositions and his skill at characterization.

PARTHENON FRIEZE
(447–432 BCE), PHIDIAS

The temple of Athena Parthenos (Athena the Virgin) is one of the masterpieces of world architecture. Characterized by harmony and lucidity, it marks the peak of the Classical phase of Greek art. Its crowning glory is the magnificent sculptural relief known as the Parthenon frieze, which, prior to its partial removal in the early 19th century, was 524 ft (160 m) long, with 378 figures and 245 animals. Carved from marble and originally finished with colored paint and metal detailing such as weapons, the frieze is known for its expressive depiction of the human figure, which contrasts with the stiffer style of earlier Classical sculpture.

SCULPTURES, MAUSOLEUM OF HALICARNASSUS
(4TH CENTURY BCE), SCOPAS

The mausoleum was made for King Mausolus of Caria (in modern-day Turkey), who died in 353 BCE. It was built on a hill above Halicarnassus, now the present-day port city of Bodrum. Surviving marbles include a freestanding figure that may be Mausolus himself, parts of a chariot, and bas-relief panels of battle scenes, some attributed to Scopas, a famous sculptor of the time. Their forceful style points to the emotionalism characteristic of Hellenistic sculpture.

TERRA-COTTA ARMY
(c.240–210 BCE)

In 1974, a farmer digging a well in Shaanxi province, China, uncovered the first fragments of what turned

Phidias

The Greek sculptor Phidias was the most famous artist of antiquity and his reputation has endured to the present day, even though no works from his own hand have survived. A highly renowned architect, sculptor, and painter, he lived from about 490 to 430 BCE and worked mainly in Athens. There, he was responsible for the sculptural decoration of the Parthenon, which reflects the grandeur and dignity of his style—seen most notably in his colossal cult

statue of the goddess Athena, which is known from the several Roman copies that survive. In his own lifetime, his most celebrated statue was the huge seated figure of Zeus (one of the Seven Wonders of the Ancient World) in the god's temple at Olympia. The building and statue were destroyed in the 5th century CE.

Other key works

c.450 BCE Lemnian Athena
446–438 BCE Athena Parthenos
c.435–430 BCE Olympian Zeus

out to be one of the most spectacular archaeological discoveries ever made—an army of about 8,000 life-size terra-cotta (baked clay) figures accompanying the tomb of Qin Shi Huang (260–210 BCE), the first emperor of a united China. The soldiers, court officials, entertainers, and horses comprised a huge retinue to guard the emperor in the afterlife. Made from molds on a production-line system, each one was individualized by hand. The project was begun soon after Qin became king in 246 BCE (at age 13) and involved thousands of workers.

ALEXANDER MOSAIC
(c.100 BCE)

One of the most impressive mosaics to survive from the ancient world, this was discovered in 1831 in the House of the Faun, Pompeii, where it served as a floor decoration. It depicts Alexander the Great in battle against the Persian king Darius III; fortunately the heads of these two main figures are well preserved—Alexander heroically ardent, Darius with fear in his eyes. The mosaic is probably based on a lost Greek painting and shows the naturalistic details for which Classical Greek art was renowned.

FAIYUM PORTRAITS
(c.1–300 CE)

The Faiyum region, south of Cairo, Egypt, became the center of a distinctive tradition of portraiture in the first three centuries CE. Faiyum portraits were life-size and painted in encaustic (pigment mixed with wax) or tempera on canvas or wood, then attached to mummy wrappings. Around a thousand portraits are

held in collections globally, and include men, women, and children. The hallmark of the portraits is their lifelike realism due to the Classical Greek style of painting that was used, in which flowing brushwork creates depth and vivid intensity.

TRAJAN'S COLUMN
(DEDICATED 113 CE)

Although the Romans had long used columns as bases for statues, Trajan's Column in Rome was original both in its great size—it is about 125 ft (38 m) tall—and in its decoration. A continuous spiral of narrative sculpture rises up the marble column in celebration of the emperor Trajan's military successes in Dacia (now in Romania). The relief depicts the Roman military machine at its most efficient and well organized; battle scenes are kept to a minimum, perhaps to enhance the empire's self-image of peaceful expansion. Trajan's Column has inspired various successors in later times, for example the Bernward Column at Hildesheim (c.1000) and the Vendôme Column in Paris (1806–10).

WALL PAINTINGS FROM DURA EUROPOS
(c.240 CE)

In the ancient world, the city of Dura Europos (in present-day Syria) was one of the easternmost outposts of the Roman Empire until it was destroyed by the Sassanians in 257 CE. Rediscovered in the 19th century, it was excavated from the 1920s on. The buildings uncovered included one of the earliest known synagogues, which was extensively decorated with wall paintings in a

provincial Greco-Roman style. Though only of modest artistic quality, these paintings are significant in being the earliest surviving cycle of biblical images.

ARCH OF CONSTANTINE
(DEDICATED 315 CE)

The earliest triumphal arches were temporary structures in the Roman Republic for celebratory parades. Permanent materials were used from the 1st century BCE, and there are around 50 examples surviving today. The largest and most richly adorned is the Arch of Constantine in Rome, built to mark the first decade of Constantine's reign and his victory over his rival Maxentius. Much of the sculptural decoration was taken from existing monuments. The new sculptures have somewhat stocky proportions in comparison to the more Classical form of the reused elements. As such, the arch is sometimes seen as marking the end of the classical world.

VIENNA GENESIS
(c.500–600)

The Vienna Genesis is the earliest surviving substantial illustrated biblical text, although only 48 out of around 190 pages in the original work survive. It is a luxurious product, the text—in Greek—is written in silver on purple-dyed parchment. Generally occupying the bottom half of every page, the illustrations are detailed and richly colored, with expressive figures. The manuscript was probably made in Syria or Palestine, although nothing is known for certain about its origins. It is first recorded in the 14th century, in Venice.

THE MED WORLD

The **Votive Crown of King Recceswinth**, made in Visigothic Spain, is one of the most impressive of all pieces of medieval metalwork.

The **Oseberg ship burial**, Norway, includes a superbly carved Viking ship and a large number of luxurious grave goods.

Sculptors in the **kingdom of Ife** (in present-day Nigeria) produce naturalistic heads in bronze, terra-cotta, and stone.

"Prophet" windows at Augsburg Cathedral, Germany, are the earliest **stained-glass windows** surviving in their original positions.

c.650–70 **834** **c.1000–1500** **c.1100–50**

c.700–720 **c.977–93** **c.1086–1106** **c.1123**

The *Lindisfarne Gospels*, made on Lindisfarne (Holy Island) in Northumberland, England, is one of the greatest **illuminated books** of the time.

The lavishly illustrated *Codex Egberti* (made for Egbert, Archbishop of Trier, Germany) is one of the masterpieces of **Ottonian art**.

Ru ware, one of the rarest and most exquisitely refined of all Chinese ceramics, is produced in northern China.

The powerfully expressive mural of Christ in Majesty from the church of San Clemente, Tahull, Spain, is a high point of **Romanesque** painting.

The period known as the Middle Ages is so called because it occurred between the fall of the Roman Empire in the 5th century and the birth of the Renaissance in 14th-century Florence, when various Roman ideals were revived. Spanning almost a thousand years, it was once regarded as a bleak era of ignorance and cultural debasement, when the flame of civilization flickered feebly and was in danger of being extinguished. Certainly, disruption and instability accompanied the collapse of Rome, but order was gradually restored, and—far from being debased—much medieval art is inventive, sophisticated, and rich in feeling.

However, medieval art is usually very different in character from classical or Renaissance art, not least in its attitude toward the human body. Rather than being celebrated in a naturalistic way, the human form was used primarily as a means of expressing spiritual values, for religion was by far the most important subject in medieval art. Another key difference lies in the love of bright, expensive materials typical of much medieval art. This is seen, for example, in reliquaries and similar richly ornamented liturgical objects, and in illuminated manuscripts, which were an important form of artistic expression in the Middle Ages.

Medieval styles

Highly diverse, medieval art can be divided into more specific phases or styles, notably Carolingian, Ottonian, Romanesque, and Gothic. Carolingian art is named after Charlemagne, who in 800 became the first Holy Roman Emperor. He oversaw a cultural as well as a political revival in his empire, which extended over parts of what are now France, Germany, and neighboring countries. Ottonian art is named after Otto the Great (Holy Roman Emperor, 962–73) and covers the art of the empire from the mid-10th to the mid-11th century. This period saw the revival of large-scale sculpture, notably the Gero Crucifix, a powerful work that is independent of classical influence or that of the highly stylized art of the Eastern Roman (Byzantine) Empire.

Romanesque art emerged in the 11th century and by the early 12th flourished throughout most of Europe—the first style to achieve such international dominance.

The *Virgin of Vladimir*, one of the most **venerated of all icons**, is painted in Constantinople and soon taken to Russia.

Bonaventura Berlinghieri paints an altarpiece depicting St. Francis of Assisi—one of the first images inspired by this saint's life.

Giotto paints the majestic *Ognissanti Madonna*, named after the church of All Saints, Florence, where it originally surmounted an altar.

The German architect and sculptor **Peter Parler's** work at Prague Cathedral includes a series of vigorous royal portrait busts.

↑ **c.1130** ↑ **1235** ↑ **c.1310** ↑ **c.1360–80**

───────────────────────────────

c.1200–1300 ↓ **c.1260–70** ↓ **1338–39** ↓ **1394–99** ↓

The "Luck of Edenhall" is made, probably in Egypt or Syria. It is an outstanding piece of **Islamic glassware** decorated with enameling and gilding.

The sumptuous *Psalter of St. Louis* (Louis IX of France) is an archetypal work of **French Gothic** illumination.

Ambrogio Lorenzetti's fresco cycle *Good and Bad Government* at the Palazzo Pubblico, Siena, includes an innovative treatment of townscape.

Melchior Broederlam paints an altarpiece for Philip the Bold. It is a masterpiece of International Gothic.

The name Romanesque was initially applied to the architecture of the period, which had a solidity that reflected the comparatively stable conditions of the time. Sculpture too became more ambitious and often formed impressive decorative patterns at cathedrals. The Gothic style—lighter and more elegant than the Romanesque—was born in the mid-12th century and perhaps reached its greatest heights in a number of French cathedrals of the 13th century, among them Chartres, which is famous for its sculpture and stained glass as much as for its architecture.

In much of northern Europe, the Gothic style lasted into the 16th century, becoming increasingly elaborate and fanciful. It was less visible in Italy, where the classical tradition was more accessible, inspiring Nicola Pisano's sculpture, for example. The Mediterranean climate of Italy discouraged the huge windows typical of northern European Gothic; in contrast, Italian church interiors of the period tended to have broad areas of unbroken wall space suitable for fresco decoration, such as the work of Giotto. Large painted altarpieces, notably Duccio's *Maestà*, were also characteristic of Italian churches of the time.

Wider views

Outside Europe, the period covered in this chapter saw the emergence of Islamic art, the growth of Hindu art, and the spread of Buddhist art. Islam was founded in the early 7th century in Arabia and spread rapidly through the Middle East and beyond, covering a vast area by the 9th century. Islamic art embraces many different peoples and types of work. Primarily an art of ornament, it is not always specifically religious. Unifying factors in both spiritual and decorative art include the use of Arabic script and a love of geometric pattern.

Hinduism has roots stretching back to prehistoric times and many of its earliest surviving artworks are sculptural temple decorations. By the 7th century, Hinduism was replacing Buddhism as the dominant religion in India. Buddhism virtually died out in India after the Muslim invasions of the 13th century, but by this time it had spread widely throughout the Far East. In Japan, for example, the illustrious sculptor Unkei was a devout Buddhist. ∎

IT IS NOT AN IMPURE IDOL, IT IS A PIOUS MEMORIAL
RELIQUARY OF THEUDERIC (c.600–700)

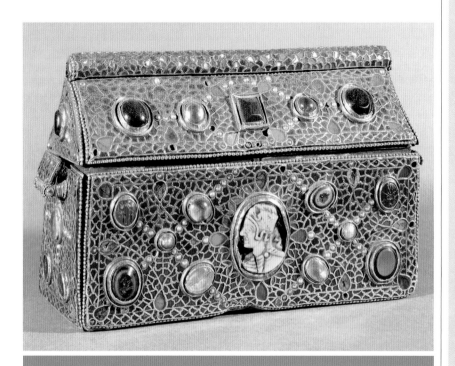

IN CONTEXT

FOCUS
Christian reliquaries

BEFORE
c.382 CE Pope Damasus reputedly sends St. Ambrose an early Christian reliquary, decorated with four reliefs, that contains relics of the apostles.

AFTER
1150 A gilded copper and enamel *chasse* honours first bishop of Limoges St. Martial.

1173–80 A silver, enameled reliquary casket is thought to contain a relic of murdered Archbishop of Canterbury Thomas Becket, and shows scenes from his martyrdom.

1205 Nicholas of Verdun produces a reliquary to saints Piatus and Nicasius for the Cathedral of Tournai, Belgium.

c.1280–1300 Queen Jeanne of Navarre commissions a silver-gilt reliquary of the Holy Corporal (mass cloth) in the shape of a miniature chapel.

The use of reliquaries to contain the holy relics of saints, or even of Jesus Christ himself, was a significant feature of Christian practice and art from at least the 4th century CE. For Christians, the relics—whether nails and bones of saints or pieces of holy fabric—were powerful objects that were believed to have healing qualities and to provide a spiritual link between humans and God. Miraculous powers were often attributed to relics, which were placed on altars and carried during processions, providing a focus for devotion and pilgrimage.

Medieval Christian worshipers believed that the objects of such veneration deserved precious containers to protect and display them. The production of reliquaries became a major art form, spreading through Europe and Byzantium during the Middle Ages. Skilled craftsmen produced the exquisite reliquaries, as well as other ornate liturgical objects such as shrines and crosses.

Many medieval reliquaries took the form of a casket, or *chasse*. These were often crafted in gold, silver, or ivory, and lavishly adorned with enamel and gems. Others were decorated with religious scenes. From the 9th century, relics of the True Cross—believed to be fragments of the cross that Christ died on—were popular, and were housed in lavish gold and silver cross-shaped reliquaries.

The casket of Theuderic
The reliquary of Theuderic was produced in southern Germany in the 7th century and holds the relics of St. Maurice, a 3rd-century soldier-saint who commanded the Roman Theban Legion, made up of Christian soldiers. According to legend, the legion, including

See also: Sarcophagus of Junius Bassus 51 ▪ Sutton Hoo helmet 100 ▪
Klosterneuburg Altar 101 ▪ Salt Cellar 152

> The remains of certain dead are surrounded with special care and veneration.
Dom Bernardo Cignitti
Church Teaching on Relics, 2003

Maurice, was massacred on the orders of Emperor Maximian after refusing to attack fellow Christians. Maurice later became a patron saint of the Holy Roman Emperors. The Abbey of St-Maurice is built on the site of the legion's supposed martyrdom, in Agaune, Switzerland, and dates back to 380 CE. Its treasury includes masterpieces from the Merovingian (476–750) and Carolingian (750–887) periods, one of which is this exquisite silver and gold reliquary casket, which was commissioned by the priest Theuderic.

Made of gilded silver and adorned with pearls, cloisonné enamel, and gemstones, it measures 5 in (12.7 cm) in height. In the center of the front is a 7th-century replica of an antique cameo. The back is plainer, being covered with a Latin inscription recording the fact that Theuderic commissioned the box in honor of St. Maurice. It also

names two donors, Nordolaus and Rihlindis, and the two goldsmiths who made it, Undiho and Ello. It is somewhat unusual for the craftsmen to be named in this way; it was not until later that individuals, such as the goldsmith Nicholas of Verdun (1130–1205), first began to gain a reputation for their religious art.

Containers of complexity
As reliquaries became increasingly ornate and lavish, they were also created in other forms. Some were made in the shape of churches, others as images of the saints they represented. Some were shaped in the form of body parts, echoing the relic they contained. The Abbey of St-Maurice, for example, has a magnificent reliquary head (c.1165) of St. Candide, another martyred soldier of the Theban Legion. The saint's remains are contained in the hollow cranium, while a relief on the base depicts his gory death by decapitation and his ascent to Heaven.

By the 16th century, the proliferation of relics meant that many were fakes. Church reformers, including Martin Luther, opposed the cults that surrounded them, and many reliquaries were destroyed. Those that remain, however, bear witness to a rich and sophisticated period of religious art. ▪

The reliquary head
of St. Candide, c.1165, is an opulent, beautifully crafted work, made from gold leaf, silver, gemstones, and wood.

Saintly attributes

Since the 3rd century CE, Christian iconography has included the use of symbols to define and identify important individuals, from the Madonna and Christ to the saints. While recognizable facial features emerged for such important figures as Jesus, St. John the Evangelist, and the Virgin Mary, artists frequently used symbols or motifs, known as attributes, to identify saints and enable their images to be recognized easily. Attributes included animals, objects, and plants, and acted as reminders of the significance of the saint in question. Mary Magdalene, for example, was shown with a jar, symbolizing the jar of ointment she used to anoint Christ's feet; St. Peter was often depicted holding a key or keys, symbolizing his role as the gatekeeper of Heaven; and St. Jerome was signified by a lion, recalling how he removed a thorn from a lion's paw in the desert. St. Denis, who was beheaded in around 258 CE, is often shown, as at Notre Dame Cathedral (above), with the attribute of his martyrdom—a severed head.

THE WORK OF ANGELIC RATHER THAN HUMAN SKILL

BOOK OF KELLS (c.800)

IN CONTEXT

FOCUS
Celtic art

BEFORE
c.800–50 BCE Celtic artists of the Hallstatt and La Tène cultures produce jewelry and weapons decorated with distinctive patterns.

c.650–680 The *Book of Durrow* is the earliest fully decorated Christian Gospel text in the Insular tradition—the style of art created in post-Roman Britain and Ireland.

AFTER
980 Monks in Germany create the *Egbert Psalter*, an illuminated manuscript that features lavish illustration.

1880s–90s The Arts and Crafts Movement incorporates traditional Celtic designs and symbols into metal panels, furniture, and stained glass.

The Celts were fascinated by pattern. Complex spiral, interlacing, and animal and plant designs adorn many of their creations—from statues, cauldrons, and crosses to weaponry and jewelry—in a vast range of media, including stone, enamel, pottery, bronze, silver, and gold. There is evidence that Celtic peoples in Europe first created metalwork with distinctive geometric and knotwork patterns more than 2,500 years ago, and archaeologists have discovered evidence of their artistry at sites in Austria, Ireland, and Switzerland.

As the Roman Empire expanded from the 1st century BCE, much Celtic culture died out. However, it continued to exist in the British

See also: *Vienna Genesis* 57 ▪ Gero Crucifix 66–67 ▪ Ruthwell Cross 100 ▪ Utrecht Psalter 100 ▪ *Holy Trinity* 107 ▪ *Très Riches Heures du Duc de Berry* 162

The Virgin and Child, on this page from the *Book of Kells,* appear crudely represented when set against the exquisite, intricate interlace patterning that adorns the borders of the image.

Isles, particularly Ireland, which remained untouched by the Romans. In the 5th century, with the arrival of Christianity in Ireland, there was a revival of Celtic art. This reached its greatest expression with the creation, between the 6th and 9th centuries, of superbly illustrated Gospel manuscripts. Early examples include the *Book of Durrow* and the *Cathach of St. Columba.* The finest example of Irish religious manuscript illumination, however, is the spectacular *Book of Kells.*

Illuminating God's word
One of the greatest treasures of early Christian and Irish art, the *Book of Kells* is a manuscript that contains the four Gospels of the New Testament. It is written on glazed calf vellum and measures 13 in (33 cm) by 9½ in (24 cm); the pages were originally larger, but were cropped during rebinding in the 19th century. The exquisite penmanship—in black, red, purple, and yellow ink—is in a beautiful, round half uncial script (curved capital and lowercase letters), which was often used by medieval scribes.

The book's lavish patterning and ornamentation are particularly striking. Three pages of full-length decoration, known as chapter pages, precede each of the Gospels. One of these displays an image of the Virgin and Child, which is believed to be among the first representations of the mother of Christ in Western art; others,

such as the Chi-Rho (opposite)—the first two letters of "Christ" in Greek—are a mass of swirling circles, geometrical patterns, and ornamentation. The book's text pages are decorated with animal forms and rhombus and lozenge shapes. There is also a variety of ingenious eternal knot designs, interlaced patterns that are thought to reflect the idea of eternity and Celtic belief in the interconnectedness of life.

Pulsating with energy
The large capital letters at the beginning of each paragraph in the *Book of Kells* provided an opportunity for the illustrators to showcase their skills: one scholar has described them as having a "pulsating [and] kinetic energy." Sometimes there are three or four capitals on a page; they are vividly colored and form interlinked patterns, often metamorphosing into stunning entwined birds, snakes, plant life, or even human figures, some performing sinuous

athletic feats. There are more than 2,000 of these capitals in the book and each one of them is unique.

The knot patterns, rhombus shapes, and concentric circles that adorn the early pages of the Gospel of Matthew reflect the distinctive design of pagan Celtic artwork. However, the *Book of Kells* fuses Celtic design with Anglo-Saxon technology and the imagery of Eastern Christianity. The image of the Virgin and Child is a common feature of 9th-century Coptic art produced by early Christians in Egypt, although making its first appearance in the West here.

By the mid-9th century, the great age of Celtic-inspired illuminated Gospels was in decline. However, the immense skill of the Irish artist monks spread to other religious centers in Britain and Continental Europe, influencing Gothic, Ottonian, and Romanesque illuminated manuscripts, psalters, and Bibles. From the mid-19th century, there was a revival of interest in Celtic art, which found expression in the Arts and Crafts Movement and in Art Nouveau decoration, both of which flourished in Western Europe and the US. ▪

Here you can look on the face of divine majesty drawn in a miraculous way.
Gerald of Wales
Topographia Hibernica, c.1188

A CLEAR SYMBOL OF CHRIST TRULY HUMAN AND TRULY DEAD ON THE CROSS

GERO CRUCIFIX (c.970)

IN CONTEXT

FOCUS
Christ humanized

BEFORE
1st–3rd century CE The Roman "Alexamenos graffito," the earliest known depiction of the crucified Christ, mocks Alexamenos, a Christian.

586 The earliest surviving crucifixion in an illuminated manuscript, from the Syriac Rabbula Gospels, shows Christ alive on the cross.

AFTER
1000 The processional Cross of Lothair, an Ottonian *crux gemmata* (jeweled cross), has a suffering Christ engraved on its reverse side.

1310–15 Giotto's painted wooden *Crucifix* in Ognissanti Church, Florence, realistically depicts the pain and humility of Christ on the cross.

For the first four hundred years of Christianity artists were reluctant to depict Christ on the cross, in part because crucifixion was associated with criminality. Early Christians were mocked for worshiping a man who had been crucified, as shown in the Alexamenos graffito found in Rome, which depicts a man worshiping a crucified ass-headed figure. However, from the 5th century CE, images of the crucified Christ began to appear. Early depictions of the crucifixion avoided or minimized suggestions of suffering, instead focusing on Christ as a divine being. An image from the Rabbula Gospels, a 6th-century Syriac

Ottonian art

Art historians do not know who carved the Gero Crucifix, which has been in Cologne Cathedral since it was made. It was ordered by Gero, Archbishop of Cologne (c.900–76), during the Ottonian period, which takes its name from the dynasty that ruled much of northern Europe and Italy from 963 to 1002. Art flourished in this era thanks to the artistic legacy of Charlemagne's empire and a renewed interest in both Italian and Byzantine art. One of the characteristics of art of this time was the importance given to the human figure and its expressive potential. Powerful clerics, such as Gero, were important patrons, encouraging a renewed interest in Christian ecclesiastical art. Other great artworks included illuminated manuscripts, ivory carvings of the apostles, and fine metalwork, including gold altar crosses and the 11th-century box binding pictured here. Especially notable is a three-quarter-life-size wooden sculpture of the Virgin and Child that is entirely covered in gold leaf, now housed in Essen Cathedral, Germany.

illuminated Gospel book, shows Christ on the cross, flanked by two thieves on crosses. They are surrounded by soldiers, while the Virgin Mary and St. John the Evangelist look on in horror. The crucified Christ is alive yet shows no pain; his body is straight with his arms out, his head erect, and his eyes open. He wears a purple and gold robe, colors associated with kingship. The image suggests the dual nature of Christ: while his crucified body represents his mortal humanity, his royal garb and serene expression signify his divinity. Artistic representations of Christ on the cross followed this style for the next few centuries.

A mortal Christ

The 10th-century Gero Crucifix marks a definitive shift toward a more lifelike and mortal Christ. Standing 74 in (187 cm) high and with an arm span of 65 in (165 cm), it is the earliest surviving life-size, freestanding sculpture of Christ on the cross. An immensely powerful piece, it shows Christ humanized

by his suffering, his twisted body hanging from the cross, his arms forming a V shape as his weight pulls downward. This Christ is dead: his eyes are closed, and his head has fallen onto his chest. Blood trickles from the spear wound in his side. With a bulging stomach and muscles stretched across the shoulders, his sagging body is humble and utterly human.

Sculpted in wood, painted, and partially gilded, the Gero Crucifix stands in its own chapel in Cologne Cathedral, Germany. The body, halo, and cross are original, while the Baroque-style sun and the altar it decorates were added in 1683.

The Gero Crucifix's innovative depiction of Christ humanized had a profound influence on much of the Christian art that followed. The Lothair Cross, a crucifix carried in religious processions, made in Germany in about 1000, portrays a crucified Christ in a similar manner, with drooping head, twisted body, and blood flowing from his wounds. Later artists produced increasingly realistic

imagery, among them the crucifix (c.1288–89) by Giotto in the church of Santa Maria Novella in Florence, and Duccio's crucifixion scene from the *Maestà* altarpiece (1308). The iconography of the suffering and mortal Christ became increasingly commonplace over time, as can be seen in such differing but equally powerful renderings as Matthias Grünewald's Isenheim Altarpiece (1512–16), Diego Velázquez's oil painting *Christ Crucified* (1632), and Rembrandt's etching *The Three Crosses* (1653). ▪

Crucified Christ as a slain man rather than a triumphant God.
Annika Elisabeth Fisher
Decorating the Lord's Table, 2006

YOUR EDIFICE UNRAVELS THE MYSTERY OF THE FAITHFUL

MIHRAB, GREAT MOSQUE OF CÓRDOBA (c.961)

IN CONTEXT

FOCUS
Islamic art

BEFORE
692 Early Islamic vegetal (based on plant forms) and geometric patterns in the Byzantine style decorate the Dome of the Rock in Jerusalem.

706–15 Byzantine artisans decorate the Umayyad Mosque in Damascus with mosaics featuring landscapes, but no animal or human figures.

AFTER
1354 The Madrasa Imami in Isfahan, Persia, is founded. Its mihrab is decorated with mosaic tilework in arabesque and calligraphic designs.

14th century The Alhambra Palace in Granada, Spain, is richly decorated with fine floral and geometric motifs and calligraphic inscriptions, as well as *muqarnas*, a form of honeycomb-style vaulting.

Islamic art is a term coined in the West in the 19th century to define the visual arts created in lands under Muslim leadership, encompassing both religious and secular art. Works described by the term span a period of nearly a thousand years, from soon after the foundation of Islam by the Prophet Muhammad in the 7th century to the peak of the last great Islamic empires in the 17th century. They can be found across a geographical area extending from Islam's origins in Arabia as far as Spain in the west and India in the east. While Islamic art displays strong historical and regional variations, there are recognizable stylistic elements in its many expressions across time and space.

Early influences

In its first days, Islamic practice did not stipulate any specific kind of architectural form or the use of any type of image. The earliest styles of Islamic art reflected the influences and artistic traditions of the lands that the Muslims conquered under the first Umayyad dynasty. Dating from the 7th century and probably created by artists who had worked

To Córdoba belong all the beauty and ornaments that delight the eye or dazzle the sight.
Stanley Lane-Poole
The Moors in Spain, 1888

for Byzantine patrons, the mosaics at Jerusalem's Dome of the Rock— one of the oldest surviving examples of Islamic architecture—feature rich blue and green vegetal, or plantlike, forms and geometric patterns that foreshadow later Islamic work. Such elements, evolving from local traditions, remain common to much Islamic art and make it identifiable.

The golden age of Islamic art began in 750, under the Abbasid dynasty, which moved the capital of Islam from Damascus to Baghdad. The vast Islamic empire later gradually fragmented into regionally

Figurative art

Figurative art has been discouraged in Islam on the grounds that only God can create living beings, but it is not prohibited by the Qur'an. In fact, there is a strong tradition of figurative art in secular Islamic art, some of which was influenced by the existing artistic traditions of conquered lands. From the late 7th and 8th centuries, notably in Persia, Islamic artists created illustrated manuscripts that featured miniature paintings of humans and animals, portrayed either realistically or in stylized

form, on subjects ranging from medicine to astronomy. Artists also illustrated works of poetry, such as the 10th-century Persian epic *Shahnameh* (Book of Kings). During the Mogul Empire in India, portrait painting was popular as artists made realistic portraits of rulers.

Objects and ornaments were also decorated with figures, including fantastical images of griffins and female-headed birds, as well as more realistic images of horses and other animals.

See also: Mosaics of Emperor Justinian and Empress Theodora 52–55 ▪ Book of Kells 64–65 ▪ *Akbar's Adventures with the Elephant Hawa'i in 1561* 161 ▪ *Composition VI* 300–07

powerful dynasties, including the Fatimids in Egypt, the Umayyads in Spain, and, later, the Safavids, the Ottomans, and the Moguls, but the visual arts continued to flourish. The medieval period saw a rich artistic flowering as Islamic artists decorated buildings with brilliant ceramic and glass mosaics.

Decorative art

The art of Islam is predominantly decorative and nonfigurative, making great use of pattern and geometry. Depictions of people and animals, although not forbidden by the Qur'an, are discouraged. Interpretations of the Hadith, or traditions of the Prophet, suggest that the creation of living forms is unique to God and that painters should not attempt to "breathe life." Neither Allah nor the Prophet Muhammad may ever be depicted. However, stylized figural motifs are sometimes integrated into surface decoration of objects, along with fantastical creatures; and figures appear in manuscripts—as a visual aid to the text—and in secular art.

Since its beginnings, Islam has been a political and cultural entity as well as a spiritual and moral one. However, the art of mosques and madrasas (theological schools) served to express Islam's essential religious beliefs and to encourage spiritual focus. To achieve this, and as a result of the avoidance of figurative art, Muslim artists turned their creativity toward developing a distinctive decorative art that featured abstract geometric patterns, vegetal and floral designs (or arabesques), and calligraphy, written in various types of Arabic script. These elements formed an integral part of Islamic »

Islamic geometric patterns are built on a set of simple shapes that are interlaced and repeated. The most common are the circle, square, star, and polygon, which can be combined, reflected, and rotated to form infinitely complex designs, as in the example here.

1 The center point of the pattern is defined, around which five circles are drawn to equal diameters.

2 Three squares are drawn within the central circle, using points where the circles intersect.

3 The central circle is split into 24 segments using the intersecting points of the three squares.

4 A smaller circle is drawn within the central circle.

5 Twelve points along the circumference of the smaller circle are linked with straight lines to form a 12-pointed star.

6 A continuous line is drawn between points on the underlying structure to form a 12-pointed rosette.

7 The 12-pointed rosette, itself formed from circles, squares, and star shapes, becomes part of a greater, complex, repeating design in which polygons and other geometric forms can also be discerned.

The octagonal dome above the *maqsura* (space before the mihrab) at Córdoba dazzles with its gold mosaics, radiating floral patterns, elegant Kufic script, and eight-pointed central star.

architecture and can all be seen in the mihrab (prayer niche) of the Great Mosque of Córdoba in Spain.

Geometry and pattern

Beginning with four basic shapes—the circle, the square, the star, and the multisided polygon—Islamic artists developed geometric patterns that interlaced and repeated in complex designs. Geometric images such as these were not random. Building on the classical traditions of ancient Greece and Rome, science and mathematics flourished during the golden age of Islam, reaching an unequaled level of sophistication and knowledge. The designs developed by Islamic artists were founded on strict rules for aesthetic geometry that symbolized the unity and order of the universe, as created by Allah.

Often interleaved with this intricate geometric imagery are floral and vegetal designs, derived from stalks, leaves, and flowers.

As well as having a decorative function, luscious foliage is often associated with paradise in the semi-arid climates of the Middle East. Inspired by earlier Byzantine traditions, these motifs were originally naturalistic, but they became more abstract as the Islamic aesthetic developed. In the 18th century, after Napoleon's expeditions to Egypt, which brought "Oriental" art to the West, they became known as arabesques, meaning simply "in the Arab style."

Calligraphy, or the use of artistic lettering, also played a major role in Islamic art—frequently combined with geometric or floral patterns. Often considered to be the highest form of art by Muslims, beautifully inscribed Arabic script also has a

Floral and vegetal patterns, such as the elaborate decoration adorning this intricate tilework at the Topkapi Palace in Istanbul, Turkey, are a constant motif in Islamic art.

profoundly spiritual purpose reflecting the importance of the Qur'an, which Muslims believe is the word of Allah transcribed. Calligraphy is therefore far more than decoration; it also serves to convey the message of the Qur'an as transmitted to the Prophet. All Islamic calligraphy is written in Arabic, which reflects the importance of this language as the language of prayers, and the importance of literature and writing in Islamic culture. Two main scripts are used: the angular Kufic script and the more rounded Naskhi.

Art and architecture

Used architecturally, geometric and floral patterns and the abstract forms of calligraphy adorn buildings in the form of decorative carving or painted tiles. When applied to mosques and madrasas, elaborate interwoven patterns provide a focus for spiritual contemplation. According to one commentator, they enable the devotee to "bemuse himself in the maze of regular patterning…." They are used to decorate not just the walls of

The Mosque is the dwelling place of the pious.
Prophet Muhammad

mosques but also the mihrabs, or prayer niches, within all mosques. Shaped like an arched doorway, the mihrab is the most important element in mosque architecture. It is an alcove that indicates the direction of Mecca (*qibla*), toward which all Muslims face when praying. The imam (prayer leader) may stand before the mihrab to lead the congregation in worship, and its concave shape has the effect of amplifying his voice. Given their religious importance, mihrabs are usually lavishly ornamented, enhancing the impression of a door leading to Mecca.

Córdoba's Great Mosque
One of the finest examples of Islamic art in architecture is the 10th-century mihrab in the Great Mosque of Córdoba in southern Spain (the region had been ruled by the Umayyad dynasty since the early 8th century). The mosque, now a Christian cathedral, is characterized by its vast hall of 856 elegant columns topped by double arches of alternating white stone and red brick. A three-aisle axis leads to the mihrab, which was built by the caliph Al-Hakam II as part of his expansion of the mosque in 961. In front of the mihrab is an enclosed space called the *maqsura*, reserved for the ruler and his retinue,

signaled by interlocking arches and topped by an exquisite dome. The mihrab itself takes the form of a horseshoe arch set in an *alfiz*, or rectangular surround, dazzling with its gold and multicolored mosaics in flowing floral and vegetal patterns. Calligraphic inscriptions snake around the edges of the *alfiz*, made of tiny gold or black tesserae (mosaic tiles). Written in Kufic script, they include both Qur'anic verses and historical and political statements. Behind the arch is a recessed chamber with a roof shaped like a scallop shell (a symbol of the Qur'an), carved from a single piece of marble.

Other arts and crafts
Forms of Islamic art found in the decoration of mosques are also used in secular art. Geometrically patterned mosaics, for example, are used to tile everything from walls and ceilings to courtyards and fountains. Muslim artists and craftsmen from the Abbasid dynasty worked in a range of art forms, including glass, ceramics, ivory, metal, and textiles. Between the 7th and 13th centuries they developed a number of innovative techniques, including a tin-glazing process applied to pottery that produced a porcelain effect. Under the Abbasids, Muslim artists made "lusterware," a form of ceramic or glassware that was decorated by applying metallic pigments over glazes. Artists in Persia (now Iran) adopted the technique during the 10th century, and by the

medieval period Islamic glassware had become the most sophisticated in Europe and Asia, with Egypt, Syria, and Persia being major centers of production. Carpets and other textiles were also world-famous, many of them bearing the typical geometrical patterning.

By the late 15th century, the golden age of Islamic art was in decline, but the influence of the Islamic style on European art and architecture was apparent. From the Renaissance on, the arabesque motif in particular was widely used in illuminated manuscripts, and on walls, furniture, metalwork, and pottery. The cross-fertilization of decorative techniques between Europe and the Islamic Middle East became such that it is not always clear where objects originated. ∎

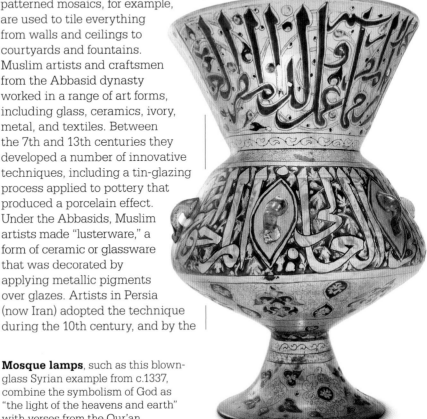

Mosque lamps, such as this blown-glass Syrian example from c.1337, combine the symbolism of God as "the light of the heavens and earth" with verses from the Qur'an.

IT IS A STORY SHAPED BY PURPOSE

THE BAYEUX TAPESTRY (c.1070)

A remarkable achievement of medieval art, the Bayeux Tapestry relays a narrative of events that took place in England and northern France between 1064 and 1066, resulting in the Norman invasion and conquest of England. Regarded to this day as one of the key historical accounts of the victory of William, Duke of Normandy, over the Anglo-Saxon Harold, Earl of Wessex, the tapestry's version of events is nonetheless regarded with scepticism by historians.

A key scene in the tapestry shows Harold, with both his hands placed on religious relics, swearing his oath to William, who is seated in a throne. Latin text explains the oath.

Elements of the tale can be seen as political propaganda that seeks to justify William the Conqueror's claim to the English throne.

Versions of history
Created for the Normans soon after the conquest, the tapestry resembles a giant comic strip, 230 ft (70 m) in length and 20 in (50 cm) in height. Technically it is not a tapestry at all, but embroidery, since the images are not woven but stitched carefully onto a linen backing cloth. The first part shows Harold being captured by Count Guy, a Norman noble, after a shipwreck off the French coast. Ransomed by William, Harold swears an oath to marry William's daughter—an act

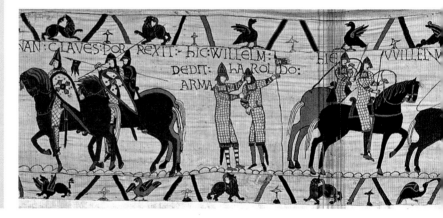

See also: Trajan's Column 57 ▪ Arch of Constantine 57 ▪ *The Surrender of Breda* 178–81 ▪ *Apollo and the Continents* 206–09 ▪ *Death of Marat* 212–13 ▪ *Napoleon on the Battlefield of Eylau* 278

that strengthens William's claim to England's crown. Crucially, the contentious oath is recorded only in this tapestry and in one other, much later, Norman document, suggesting the tapestry may be a key piece of Norman propaganda.

When Harold returns to England and is crowned king, the Normans consider his oath broken. They launch an invasion that culminates in the Battle of Hastings and the death of Harold (see opposite, top left). The tapestry's last panel is missing, but some scholars believe that it might have shown William's coronation: if this is the case, its message seems clear—William is the rightful king of England, and Harold is a liar.

Experts may be divided as to the interpretation of the events that are depicted in the Bayeux Tapestry, but its status as a priceless historical document is undoubted: it is the sole visual record of the Battle of Hastings and provides images of important aspects of medieval life, such as clothing, farming, weapons, humans, animals, and buildings. And whatever its propagandistic intentions, it remains the zenith of Anglo-Saxon needlework.

Who made the Bayeux Tapestry?

Most historians believe that the Bayeux Tapestry was commissioned in about 1070 by Odo, Bishop of Bayeux, the half-brother of William the Conqueror. Odo himself appears in the textile in several places, notably during the Battle of Hastings, where he is seen urging on the Norman soldiers. The tapestry may have been intended for his new cathedral, which was dedicated in 1077, or for hanging in a castle. The designs for the tapestry were probably first drawn onto linen before being embroidered—work that was carried out in England, not France, by Anglo-Saxon needlewomen, whose skilled work was highly regarded throughout Europe. The designer is thought to have been Scolland, the abbot of St. Augustine's monastery in Canterbury, Kent. In 1064, he was a senior monk at Mont Saint-Michel in Normandy, so would have had knowledge of the places and events pictured.

The value of art as a tool of propaganda has been recognized since the Roman Empire, when great works were commissioned to celebrate heroic campaigns. In the modern age, state-sponsored art has been used to boost morale in times of war and to reshape perceptions of nations: just as Socialist Realism glorified the values of Soviet Russia, so the CIA showcased the "superiority" of US culture through touring exhibitions. Individual artists have used their work to oppose the brutality of war and state oppression. ▪

Here Harold has sailed the sea and with sails filled by the wind has come into the land of Count Guy.
The Bayeux Tapestry

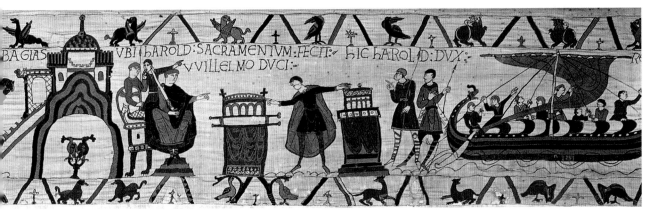

THE RHYTHM IS THE HEARTBEAT SOUND OF THE COSMOS

SHIVA NATARAJA (12TH CENTURY)

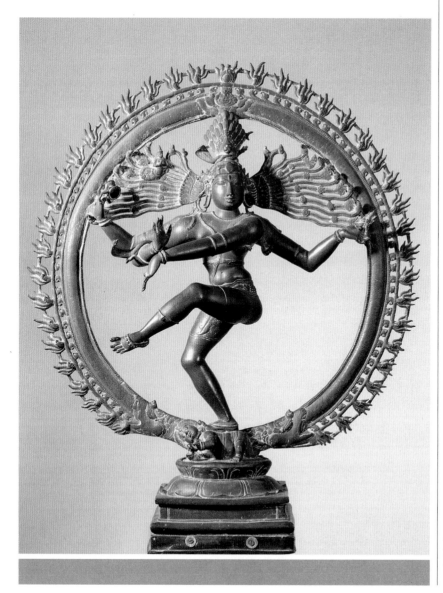

IN CONTEXT

FOCUS
Hindu sculpture

BEFORE
c.2300 BCE A cylinder seal from Mohenjo-daro, modern-day Pakistan, shows a three-faced, cross-legged figure, possibly a forerunner of the Hindu god Shiva.

c.550–720 Statues of Hindu gods include a colossal, 20 ft (6 m) high, three-headed statue of Shiva in rock-carved caves on Elephanta Island, Mumbai.

AFTER
17th century Some of Hinduism's finest examples of temple sculpture appear in the magnificent temple complexes of southern India.

Throughout their rich and extensive history, Indian art and faith have been inextricably entwined. Sculpture is a favored form of religious art in the Indian subcontinent, giving rise to spectacular images of the divine, whether Hindu, Buddhist, or Jain. From terra-cotta and relief-cut sculptures through to intricate bronze statues, these creations are complex, symbolic, and mystical.

Hinduism, which emerged from the Indus Valley civilization as long as 2,500 years ago, had been adopted as an official religion by the time of the Gupta dynasty (c.320–550 CE). Often described as a golden age, the Gupta period saw a cultural flowering in northern India. During this time, numerous relief or stand-alone carvings of the three main Hindu deities—Brahma, Shiva, and Vishnu—were created

See also: Riace Bronzes 36–41 ▪ Standing Buddha from Gandhara 44–47 ▪ Nio temple guardians 79 ▪ Benin Bronzes 153

(some in rock-cut caves), along with their incarnations and consorts, such as Devi, the earth goddess, and Ganesha, Shiva's elephant-headed son. Many of the carvings showed the gods with multiple heads, faces, or limbs, symbolizing their multifaceted aspects; these features of Hindu sculpture were continued over the centuries.

The cosmic dance
In the Chola dynasty (c.860–1279), some of the finest works of Hindu art were created, particularly in the form of bronze temple sculptures. This type of sculpture was already well established by the time of the Chola, but examples from this period are notable for their beauty and elegance. The most famous of these is a statue of Shiva in his personification of Nataraja, lord of the dance. Shiva is both creator and destroyer of the universe, and in this representation he is the divine dancer whose joyous movements symbolize life itself. The rhythm of the dance is a metaphor for the balance between good and evil in the universe.

Shiva is depicted as a four-armed god encircled by a ring of fire, representing the continuous creation and destruction of the universe that reflects Hindu belief in cyclical time. As he dances, his upper right hand holds a small *damaru*, or drum, on which he

Vishnu appears in this elegant 12th-century stone sculpture with his attributes: a wheel, symbol of the cycle of existence, and a conch shell, the source of all things.

beats out the rhythm of creation. In his upper left hand he holds the *agni*, the flame of destruction. His lower left hand crosses his chest and points to his upraised left foot in a gesture that signals protection; his right foot tramples on ignorance, represented by a dwarflike figure, the demon Apasmara. Shiva's gestures signify that belief in him offers release from ignorance and illusion as well as the opportunity for salvation.

The statue of Shiva Nataraja is a masterpiece of Hindu sculpture—conveying not only movement but also the mysticism and power of the god—and it epitomizes the richness and complexity of the Hindu art form.

Temple sculpture
From the end of the 12th century, Muslim invaders gradually took control of India, first of the north and then of the rest of the country. Under the Mughals, miniature painting flourished, and the art of the subcontinent reflected both Islamic and Hindu influences. From the 15th century onwards, however, Hindu temple art and sculpture enjoyed a rennaissance, most notably in the Tamil Nadu region of southern India. ▪

The rules of creation
In producing an image or a statue of a deity, Indian artists set out to create not simply a work of art, but rather a sacred object, for use in rituals and ceremonies, that would serve as a focus for worship. Hindus consider such images to be an incarnation of the divine being.

The creation of a Hindu image or sculpture is subject to strict regulations, as laid out in the ancient texts the *Shilpa Shastras* (the Rules of Manual Arts). The *Shastras* give precise instructions on proportions, gestures, attributes, facial expressions and features, coloring, and costume—which accounts for the uniformity of appearance of much Indian sculpture from different periods.

After an image has been created, a *prana pratishtha*, or "establishment of life" ceremony is held by a temple priest—accompanied by the chanting of mantras and the burning of incense—in order to transform the *murti* (image of god) from a mere object into an incarnation of the divinity.

This is his dance in the last night of the world.
Benjamin Rowland
The Art and Architecture of India, 1967

THE FINISHED STATUES SIMPLY WALKED TO THEIR STATED DESTINATIONS

EASTER ISLAND STATUES (c.1200)

Standing with their backs to the sea, the monolithic humanlike forms, or *moai*, of Easter Island are monumental representations of the spirits of the chiefs who once ruled over Rapa Nui, the name given to the island by its indigenous Polynesian people.

The earliest *moai* are thought to date back to around 700–850, but most were produced between 1050 and 1500. Nearly 900 survive today. Most vary in height between 10 ft (3 m) and 20 ft (6 m), although the tallest is nearly 33 ft (10 m) tall. The vast heads have flattened features, heavy brows, deep eye sockets, and jutting chins, giving them a proud appearance. The heads stand on long torsos, which feature bas-relief arms that rest against the body. It is thought that the statues were venerated as general representations of past chiefs and their power to mediate between people and gods.

Using basalt picks, skilled craftsmen sculpted the *moai* out of hardened, yellow-gray volcanic ash from the crater walls of the Rano Rafaku volcano. The *moai* were then transported to the coast and embedded on ceremonial bases, or *ahu*. Some speculate that the heavy statues were moved by the islanders "walking" the *moai*, by rocking them sideways and forward. The islanders themselves believed that the sacred *moai* walked by themselves to their *ahu*. ∎

See also: Woman of Willendorf 20–21 ▪ Prince Rahotep and his wife Nofret 26–31 ▪ Goddess Coatlicue 132–133 ▪ *Day of the God* 281 ▪ *Single Form* 340

LIFE AND DEATH, THE BEGINNING AND THE END

NIO TEMPLE GUARDIANS (1203), UNKEI

IN CONTEXT

FOCUS
Guardian spirits

BEFORE
711 The earliest surviving Nio guardian statues are created at the Horyu-ji temple, near Nara.

733 A life-size painted clay sculpture of Shukongojin, a thunderbolt-wielding guardian deity, is made for the Todai-ji temple, Nara.

1064 Japanese sculptor Chosei makes life-size statures of the Twelve Heavenly Generals, guardians of the Buddha of healing, to protect the Koryu-ji temple in Kyoto.

AFTER
Early 14th century In Sakai, Japan, a fearsome wooden Nio statue is carved to guard the gate of the Ebaradera temple.

The arrival of Buddhism in Japan in the mid-6th century gave rise, over the centuries, to the creation of great artworks. Sculptors known as Busshi ("Buddhist Masters") made extraordinary statues, not only of the Buddha, but also of deities, guardians, and other figures in the Buddhist tradition. Among these were the Nio, benevolent Hindu guardian gods that, according to some accounts, accompanied the Buddha during his wanderings in northeast India during the last years of his life. The Nio were among the Hindu deities that were adopted by the Japanese, and paired Nio figures were placed at the entrance to Buddhist temples, where they stood as powerful deterrents to evil.

Best known of the Nio figures are those created by Unkei (who died in 1223). The leader of the Kei school of Buddhist sculpture in Nara, a former capital of Japan, he was the most influential artist of his time. He lived during the Kamakura period (1185–1333), when Japan was ruled by shoguns (military dictators) and which saw the rise of the samurai warrior. In keeping with the spirit of the times, Unkei's sculptures showed a new, heroic, dynamic realism, which had a powerful influence on Japanese Buddhist statuary in the 13th and 14th centuries.

Carved in wood, Unkei's two guardian figures outside the South Main Gate of the Todai-ji temple, Nara, stand more than 28 ft (8 m) high, and weigh nearly 8 tons each.

They are fearsome and warriorlike, with muscular bodies, prominent veins, and plump, fleshy faces.

Working with another great Kei sculptor, Kaikei, and assistants, it took Unkei just over two months to complete the statues. They were made using a technique known as *yosegi*, in which pieces of wood are sculpted separately before being assembled, allowing dynamic poses to be created. Following tradition, the figure on the right of the gateway is open-mouthed, symbolizing the beginning of all things, while the guardian on the left (pictured) has his mouth closed, representing the end of things. ■

See also: Standing Buddha from Gandhara 44–47 ▪ Shiva Nataraja 76–77 ▪ *Six Persimmons* 101 ▪ *Sudden Shower over Shin-Ohashi Bridge* 254–55

LET THERE BE LIGHT
STAINED-GLASS WINDOWS (c.1220), CHARTRES CATHEDRAL

IN CONTEXT

FOCUS
Light in Gothic art

BEFORE
c.800–20 Colored window glass is used in the Abbey of San Vicenzo, Volturno, Italy.

c.1065 Stained-glass windows at Augsburg Cathedral in Germany, depicting the prophet Daniel, are the oldest known examples still in place.

AFTER
1405–45 Renaissance artists design stained-glass windows depicting biblical scenes for Florence Cathedral.

1860s British Pre-Raphaelite artist William Morris revives interest in medieval art with designs for stained glass.

1974 Russian-born French artist Marc Chagall designs three new stained-glass windows for Reims Cathedral.

D esigned by artists to exploit the properties of light, stained-glass windows are a unique form of religious art that reached its most spectacular expression in the 12th and early 13th centuries during the period of Gothic architecture and art. Despite later developments in the manufacture of glass, medieval creations such as the stained-glass windows of Chartres Cathedral are masterpieces that have rarely been equaled.

Window glass had been used since around the 1st century CE, and fragments of ecclesiastical colored window glass have been found in Italy that date back to the early 9th century. However,

See also: Mihrab, Great Mosque of Córdoba 68–73 ▪ *Maestà* 90–95 ▪ The Wilton Diptych 98–99 ▪ *Last Judgment* tympanum 100

developments in architecture made it possible to incorporate huge stained-glass windows into churches and other buildings.

The Gothic revolution

The new type of architecture that began in the north of France in the 12th century and spread across northern Europe was originally known as "French work" (*opus francigenum*). Centuries later, it was scornfully dubbed "Gothic" by Renaissance architects, after the barbarian invaders of the Roman Empire, the Goths. Yet the style was far from barbarous, being a soaring, elegant, supremely skilled evolution of the Romanesque.

The semicircular vaults and round arches that are typical of Romanesque churches required extremely thick walls to carry their weight. Punching openings in the walls weakened them, so windows in these buildings were few and small, and interiors were dim. As the Gothic style developed, architects experimented with new

The transept crossing of Chartres Cathedral shows soaring ribbed vaults on slim columns, and two stories of stained-glass windows. The exterior walls are vast expanses of glass.

ideas and techniques that opened up the interiors of cathedrals and churches, creating light and space.

Pointed arches were adopted, which had less lateral thrust than round arches and could therefore be adapted for different-sized openings. Stone ribs were used to distribute the weight of vaults onto columns and piers, so that thick load-bearing walls were no longer required. One of the great architectural innovations in the Gothic era was the flying buttress—an external support—which transformed architecture's potential. It consisted of a massive, freestanding block (the buttress) with an arch (the flyer) between the buttress and the wall it supported. The lateral forces from the weight of the roof were transferred via the arch from the wall to the buttress, thereby allowing the creation of cathedrals with high roofs and soaring interior spaces.

Walls of light

Because walls no longer needed to be load-bearing, they could almost disappear. Gothic architects and artists found themselves free to use the spaces between the pillars for windows, bringing light and color into the gloom of the interior, a particularly important factor in northern European countries.

The ribbed vault, the pointed arch, the flying buttress: with these three key innovations in place, architects and artists competed to create high-vaulted cathedrals expressing verticality and light. »

Working with glass

Skilled medieval artisans and artists used a rich palette of colors for their windows, including yellows, greens, reds, violets, and dramatic blues. Colors were obtained by adding metallic oxide chemicals to the molten glass mix. Adding cobalt produced a vivid blue; copper resulted in blue and green; manganese or nickel produced violet; and adding lead produced a pale yellow. Red was harder to achieve but involved adding gold. Varying the basic mix and adding different stains could enhance tones.

For the Gothic artists of Chartres and other cathedrals, stained glass was a difficult medium to work with. The process involved not just producing, coloring, and cutting out the glass but also organizing pattern and color to create images and narratives. Small pieces of glass were held together by strips of lead. Religious iconography was incorporated, but this type of art could not produce the same figurative realism that could be created with other forms of art such as sculpture and painting. Nevertheless the imagery was bold, dramatic, and often extraordinarily detailed.

In Notre Dame de la Belle Verrière (12th century), Mary's robes are an intense, luminous blue, a color so characteristic of Chartres windows that it is known as "Chartres blue."

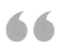

The lofty Gothic ceiling arched far above my head … through the stained windows the light came but dimly—it was all still, solemn, and religious.
Bayard Taylor
Views A-foot, 1846

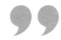

Vertical height represented an aspiration toward Heaven, while, following the writings of a 6th-century Christian philosopher and theologian now known as Pseudo-Dionysius, all light was believed to embody the divine. In the Bible, light is associated with God, with Christ, and with such concepts as life, goodness, and truth. Thus the very fabric of Gothic cathedrals gave physical shape to Christian beliefs. Stained-glass windows, allowing colored light to enter, became an integral symbolic and decorative feature of the new architecture.

Painting with light
One of the most spectacular of the Gothic cathedrals is Chartres, in northern France. Built largely between 1194 and 1250, it is some 430 ft (130 m) in length and 105 ft (32 m) wide, and is one of the finest examples of French Gothic architecture. Its spacious nave boasts an unbroken view from the western end to the apse in the east. The interior of the cathedral is remarkable: it has two tall stories of stained glass. No light enters unmediated; it is all filtered through magnificent stained-glass windows. The effect is not to flood the interior space with light, but rather to evoke spiritual intensity with a host of rich, translucent colors.

Medieval stained-glass windows were decorative, instructive, and symbolic. As well as being beautiful, they could be "read" as illustrations of biblical stories that were aimed at educating a congregation who could not read. Their purpose was also to create an atmosphere.

At Chartres, there were originally 176 stained-glass windows, most of which were created and installed between 1205 and 1240; of these, approximately 150 still survive. The most famous of all the windows is the 12th-century Notre Dame de la Belle Verrière (Our Lady of the Beautiful Window), one of only four windows to survive a fire in 1195 that largely destroyed the cathedral.

Positioned in the center of the window is an image of the Virgin Mary, dressed in a vivid cobalt-blue robe, her throne upheld by angels and the Holy Spirit hovering above her head in the form of a dove. Around the edges are segments (added later) depicting scenes from the life of Christ.

Lancets and roses

Each bay of the aisles and the ambulatory (walkway) around the choir contains one large lancet (pointed) window, most of which are about 26 ft (8 m) high. With extraordinary sophistication, these portray stories from the Old and New Testaments, episodes from the lives of saints, and symbolic images such as signs of the zodiac. Some include pictures of local tradesmen and laborers, including stonecutters and carpenters.

Scenes of artisans—some of which represent individuals or guilds who were donors of that particular window—are depicted in the lower panels of some of the windows at Chartres.

Thanks to flying buttresses, the nave ceiling is higher than those of the side aisles, and the walls of the upper level, or clerestory, are entirely taken up with windows. Each clerestory window in fact comprises two lancets surmounted by a small rose window. Because they are so high and distant from the viewer, these are less complex than the lower windows, and depict images of individual saints, prophets, kings, and members of the nobility.

Chartres Cathedral is also renowned for its three large circular rose windows. One of these, in the north transept (shown on p80), portrays Mary and the baby Jesus at the center encircled by figures from the Old Testament; another, in the south transept, has a New Testament theme and includes a vision of the Apocalypse. The rose in the west transept depicts the Last Judgment. Below it are the three remaining lancet windows that were created during the 12th century and survived the fire: they show Christ's Passion, the Infancy of Christ, and a Tree of Jesse (a popular medieval theme).

Visions in glass and stone

During the 13th century, beautiful stained-glass windows were created in numerous other churches and cathedrals across Europe, including Reims, France; Bruges, Belgium; and Canterbury, England. Stained glass formed an integral part of the decorative and instructive themes, but was just one element in the overall visual effect of these great buildings. In particular, sculptural features seemed to grow out of the

Marc Chagall designed three new stained-glass windows for Reims Cathedral in 1974. With splashes of color on a background of cobalt-blue, he achieved a fusion of old and modern.

architecture in an almost organic way. Entrance portals were major sites for carved depictions of great complexity, both in execution and theological theme. Figures emerged from columns, and scenes were carved across lintels and in spaces over and around doorways. With its sculpture and stained glass, its soaring verticality and light, the Gothic cathedral was a work of art expressing a single coherent vision.

Stained-glass art continued during the Renaissance, with artists such as Lorenzo Ghiberti and Donatello designing spectacular windows for the cathedral in Florence. In 19th-century Britain, the Gothic revival saw stained glass being produced by such artists as William Morris and Edward Burne-Jones. ∎

A STRONG CLASSICAL SPIRIT MOTIVATES ITS FORMS

PISA BAPTISTERY PULPIT (1259), NICOLA PISANO

IN CONTEXT

FOCUS
Revival of the antique

BEFORE
c.1130 Eve, by French sculptor Gislebertus, is the first large nude sculpture to appear in Europe since antiquity. It is later hailed as one of the masterpieces of medieval art.

1178 Parma Cathedral is decorated by Italian sculptor Benedetto Antelami with a bas-relief of Christ's Deposition from the Cross. Antelami incorporates local traditions dating back to antiquity.

AFTER
1301 Giovanni Pisano, son of Nicola Pisano, continues his father's style, but brings a more energetic approach to the pulpit of Sant'Andrea, Pistoia.

1403–24 Lorenzo Ghiberti's bronze doors to the baptistery in Florence are Gothic in style but demonstrate an awareness of the antique.

The mid-13th century saw the emergence in Italy of what is often described as a dynamic new style in Western art—the revival and reinstatement of antique artistic traditions. The innovator was Nicola Pisano, who is credited by some as the founder of Italian sculpture. His first major work, the pulpit in the baptistery of Pisa, called on a broad range of motifs and styles, demonstrating a brilliant assimilation of, in particular, the classical traditions of ancient Greece and Rome, and French Gothic art and architecture.

See also: Assyrian lion hunt reliefs 34–35 ▪ Marcus Aurelius 48–49 ▪ Sarcophagus of Junius Bassus 51 ▪ Santa Trinita *Maestà* 101 ▪ *Sacrifice of Isaac* 106 ▪ Tomb of Maria Christina of Austria 216–21

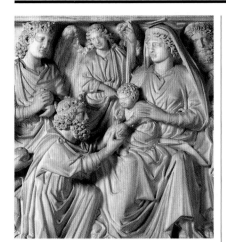

In the Adoration of the Magi, one of the pulpit's five panels depicting the life of Christ, Pisano draws on classical style: his figures are naturalistic and sensuous, and convey human feeling.

The pulpit is freestanding and hexagonal in shape—in itself a radical departure, as most pulpits at the time were rectangular. Its six-sided form harmonizes with the octagonal baptismal font and the baptistery's round shape. Five of the pulpit's panels depict scenes from the life of Christ; the sixth is open to allow for the stairwell. Although Christian in content, the panels' sculpted narratives are reminiscent of scenes shown on ancient Roman sarcophagi (stone coffins), of which there were many around the cathedral site. In some cases, Pisano borrows directly: his Madonna is derived from the figure of Phaedra on a sarcophagus; Dionysus, Greek god of wine and fertility, becomes the Christian priest Simeon; and the classical hero Hercules is transformed into a personification of Christian fortitude.

Pisano's figures wear Roman-style tunics, and headdresses and facial features are sculpted in a classical style. The figures are both beautiful and realistic, their bodies suggesting movement and elegance.

Carved in marble, the pulpit is supported by a central column on a base sculpted with figures and animals, surrounded by six columns, three of which stand on carved lions and their prey, symbolic of Christianity's victory over paganism. Quasi-Corinthian capitals, which support Gothic arches, crown the columns and are carved in classically Roman style and adorned with acanthus leaves, motifs that were used extensively in ancient Greek architecture.

Pisano's baptistery pulpit was groundbreaking: rather than simply imitating classical traditions, he incorporated and reinterpreted classical themes and motifs in Christian religious art to produce innovative work that became highly influential. The pulpit in Pisa—widely acknowledged as a masterly reworking of antique forms in a wholly altered context—is hailed as a significant precursor of the Italian Renaissance.

Both the nude and the draped figures were skillfully executed and perfectly designed.
Giorgio Vasari
Lives of the Artists, 1550

Pisano's legacy

After Nicola Pisano's death, his son, Giovanni, continued his father's new sculptural style, but in a more expressive way. Giovanni's Massacre of the Innocents, a panel in a pulpit in Pistoia, depicts grieving mothers in a realistic style. Other sculptors also followed in Pisano's footsteps, including Lorenzo Ghiberti, whose bronze carvings in Florence gesture to classical antiquity. ▪

Nicola Pisano

Nicola Pisano is thought to have been born in southern Italy, some time between 1220 and 1225. He trained in the workshops of Frederick II, the Holy Roman Emperor, and was encouraged to absorb classical art styles. Around 1245, Pisano moved to Tuscany, at some point settling in Pisa, where he accepted a commission for the baptistery pulpit. Over the next 20 years he had commissions in Bologna, Siena, and Perugia. His son, Giovanni, collaborated with him, and became a great sculptor in his own right. Nicola Pisano died in about 1284.

Other key works

1260 Relief sculpture of the Deposition from the Cross, San Martino Cathedral, Lucca
1265–68 Pulpit, Siena Cathedral
1275–78 Fontana Maggiore, Piazza Grande, Perugia

EVERY PAINTING IS A VOYAGE INTO A SACRED HARBOR

RENUNCIATION OF WORLDLY GOODS, BARDI CHAPEL (1325), GIOTTO

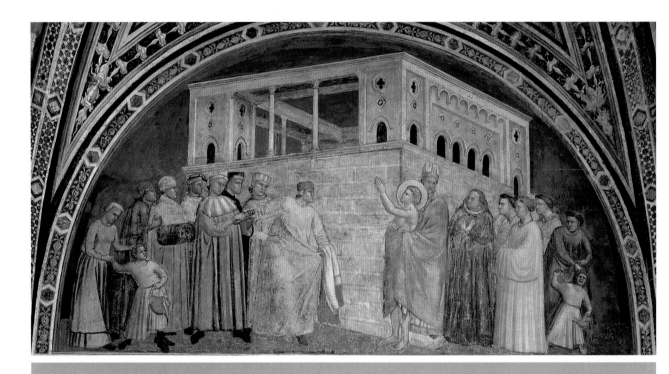

By the late 13th century, established Christian iconographies of the Old and New Testaments were being supplemented by narratives of lives of the saints, known as hagiographies. These stories were collected in chronicles, the most famous of which was the *Golden Legend*, compiled around 1260 by Jacobus de Voragine, a Dominican friar and the archbishop of Genoa. The *Golden Legend* served as a medieval sourcebook for artists depicting saints' lives and the symbols associated with them.

Since most people were illiterate during the Middle Ages, visual representations also tended to be the principal means of disseminating these tales of martyrdom.

The life of St. Francis of Assisi was included in the book and instantly captured the medieval imagination with its simplicity. Francis had been canonized in 1228, two years after his death. Known for his love of animals and ordinary people, the saint became hugely popular, and his story and "image" were soon being spread by the best artists of the day.

Francis was born into a wealthy family in Assisi, Italy, in 1181 and lived the frivolous life of a rich young man of his time. After experiencing a mystical vision of Christ, however, he gave away all his worldly goods, renounced his family, and embarked on a life of piety and poverty. In 1210, he founded what was to become the Franciscan Order, seeking a return to the simplicity of Christ's earliest disciples. In 1224, two years before Francis died, the stigmata— corresponding to the five wounds inflicted on Christ on the cross—

See also: *Maestà* 90–95 ▪ Santa Trinita *Maestà* 101 ▪ *Holy Trinity* 108–11 ▪ *St. George* 162 ▪ *Ecstasy of St. Teresa* 182–83

IN CONTEXT

FOCUS
Painting the lives of the saints

BEFORE
1246 Painted in the Byzantine style, frescoes in the Basilica dei Santi Quattro Coronati, Rome, depict the legend of Emperor Constantine's cure from leprosy by St. Sylvester.

c.1289–1305 The St. Francis cycle of frescoes at the Basilica di San Francesco, Assisi, features a new realism. The cycle is attributed to various artists, including Cimabue and possibly Giotto.

AFTER
1424–28 Masaccio's frescoes for the Brancacci Chapel in Florence feature stories from the saints' lives, including one of St. Peter healing the sick.

1485–90 Painter Domenico Ghirlandaio depicts scenes from the life of St. John the Baptist in the Tornabuoni Chapel in Santa Maria Novella, Florence.

Giotto di Bondone

Probably born near Florence around 1267, Giotto di Bondone, known as Giotto, is regarded as the first great Italian master. Details of his early life are scant; he may have been a pupil of Cimabue, who was a pioneer of naturalism. Giotto's fresco cycle of the life of the Virgin Mary for Padua's Arena Chapel in 1305 established him as a significant artist, and commissions began to pour in. By 1311, his workshop was the leading studio in Italy, and he owned large estates in Florence. Giotto was highly revered in his lifetime: in 1334 the city of Florence honored him with the title of Magnus Magister (great master), and appointed him chief architect to Florence Cathedral, for which he designed the bell tower. He died in 1337, before its completion.

Other key works

1305 Arena (Scrovegni) Chapel frescoes, Padua
c.1315 Ognissanti *Madonna*
1320 Peruzzi Chapel frescoes, Florence

appeared on his body, symbolic of Francis having lived according to the principles of Christ.

Painting St. Francis
From the late 13th century, various great Italian artists painted fresco cycles of the life of St. Francis. The fresco technique was well suited to narrative painting and was used to decorate the walls and ceilings of churches and public buildings. The damp wall was coated with a layer of lime plaster, onto which a design was drawn. The work was painted in sections, each one made up of a smooth plaster layer, to which the artist applied pigment. As the plaster dried, the pigment stayed in place, bound by a chemical reaction.

Early frescoes of St. Francis from around 1296—made some 30 years before Giotto's versions in the Bardi Chapel—are found in the nave of the Upper Church of the Basilica of St. Francis at Assisi. Twenty-eight panels depict the life of the saint as recounted by St. Bonaventure, a follower of Francis, in his *Life of St. Francis of Assisi* (1260–63). These outstanding frescoes have been attributed to various artists, including the Florentine Cimabue and the great Italian master Giotto. It is now disputed that Giotto worked on the Assisi frescoes, but the realistic style with which they depict the life of St. Francis prefigures the naturalism of the new visual language that Giotto developed.

Giotto, more than any artist before him, made a definitive break away from earlier traditions. Typical painting of this period was still heavily influenced by Byzantine art, which was characterized by a stylized, formalistic approach. Members of the Holy Family were generally painted larger than others to indicate their importance, and the stiff, flat figures were usually depicted in rigid, conventional poses. Giotto ushered in a new era of extraordinary realism as well as an intuitive use of perspective »

[Giotto] may rightly be called one of the shining lights of Florentine glory.
Giovanni Boccaccio
Decameron, c.1349–51

Key characteristics of St. Francis

Wandering preacher
Francis casts off shoes and staff, dons a rough tunic, and sets out to preach, with his Friars Minor (street preachers).

Carer for the sick
Francis lives among the lepers and cares for the sick. He overcomes his own repugnance to kiss a leper.

Lover of nature
Francis sees nature as a mirror of God. He calls animals brothers and sisters, preaches to birds, and tames a wolf.

Imitator of Christ
Francis sets out to imitate the life of Christ, walking in his footsteps to venerate the Eucharist.

Evangelist of poverty
Francis renounces worldly goods to embrace poverty, inspiring others with his humility.

that was to influence artists for many years, and which is generally seen as a forerunner to the art of the Renaissance.

The Bardi Chapel
In the Bardi Chapel in Santa Croce, Florence, Giotto painted a stunning cycle of frescoes between 1323 and 1328, commissioned by Ridolfo de' Bardi, a banker and member of one of the most prosperous Florentine families. Like many wealthy people of the period, Bardi was eager to maintain good relations with the Church, and engaged Giotto to paint frescoes telling stories from St. Francis's life. The seven frescoes show a number of key episodes, including the saint's renunciation of worldly goods, his visit to the Sultan in Egypt, and his death and ascension. The stigmatization of Francis, perhaps the most significant event in the saint's life, is given a dominant position over the entrance.

The Bardi frescoes are not only outstandingly beautiful, but also masterpieces of early perspective and realism. In each of them, Giotto

The *Death of St. Francis* is remarkable for the way the artist conveys the emotions of each individual mourner through their gestures, postures, and facial expressions.

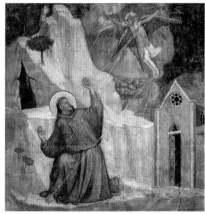

In the *Stigmatization of St. Francis* Giotto offers a less realistic illusion of space, focusing instead on the mystical experience of the saint receiving the wounds from Christ, who hovers above.

creates images of individuals who appear truly human both physically and emotionally. He achieves a sympathetic realism by means of gesture and expression.

All the Bardi frescoes feature this new naturalistic style. The *Renunciation of Worldly Goods*, for example, is a dramatic portrayal of the occasion when Francis publicly renounced his wealth and his inheritance. Measuring 110 in x 177 in (280 cm x 450 cm), it shows a seminude, praying Francis being covered by the cloak of the bishop. His followers stand behind him, while on the other side his angry

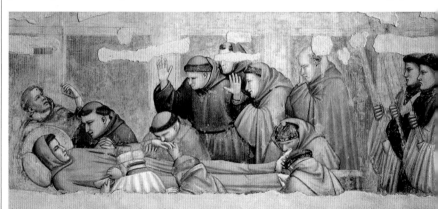

In the *Apparition at Arles*, Giotto uses the architecture as a framing device. The symmetrical structure serves both to unify the scene and to highlight Francis as the central focus.

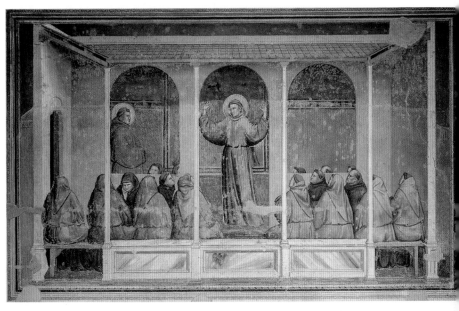

father confronts him, lunging forward but held back by onlookers. Two boys at the back of the two groups throw stones at Francis, restrained by their mothers.

Giotto uses light and shade to create modeling, so that the figures appear three-dimensional: their postures are lifelike and their expressions varied. Experimenting with depth and spacing, the artist arranges his figures in a realistic way. They are placed carefully and with a convincing sense of physical space. The impression of perspective is further enhanced by a classical-style building in the background, its foreshortened walls serving to separate the two groups of figures both literally and symbolically. Giotto uses color to enhance the mood of the scene, painting a dark sky to emphasize the father's sense of fury.

Composition
The emphasis on composition and naturalistic depiction occurs throughout the cycle. Colors are somber and muted and the scenes are simple. Giotto accentuates his focus on the three-dimensional human figure by the use of wide, heavy draperies that add volume. As in the *Renunciation of Worldly Goods*, he consistently uses the positioning of his figures to achieve spatial depth.

In the *Death of St. Francis*, which portrays the dead saint and his mourners, the artist has rejected the Byzantine tradition of stacking flat figures vertically one above the other to indicate depth, in favor of creating a realistic setting in which

mourners gather naturally around the sides. The pain and despair of loss is conveyed in the expressions and gestures of the brothers who cluster around the deathbed. The banner held by the friars at the foot of the bed acts to draw the viewer's eye up to the top of the painting, where Francis's soul is carried up to Heaven by a group of angels.

Giotto also uses architecture as a compositional device, extending the architectural space to the edges of the picture plane, so that it acts as a frame and also directs attention toward the focal figures in a given image. By making the human figures small in relation to the architecture—they generally take up only around half the picture plane—Giotto makes the scenes seem monumental.

Artistic turning point
Chapel frescoes depicting the tales and legends of the saints were commonplace during the medieval period. St. Francis was one of the most popular subjects, but artists also portrayed the stories of other saints, as well as key events from

the life of Christ. Simone Martini produced a cycle of frescoes of scenes from the life of St. Martin for the Lower Church at Assisi. Following Giotto, other artists who took inspiration from the stories of the saints include Masaccio and Filippino Lippi. However, Giotto's Bardi frescoes mark a turning point in the artistic retelling of Christian stories and in the history of Western art. With their unprecedented realism and use of pictorial space, they laid the basis for the Renaissance art that followed. ■

Giotto truly eclipsed Cimabue's fame just as a great light eclipses a much smaller one.
Giorgio Vasari
Lives of the Artists, 1550

O HOLY MOTHER OF GOD, GRANT PEACE TO SIENA AND LIFE TO DUCCIO WHO HAS PAINTED YOU THUS

MAESTÀ (1311), DUCCIO DI BUONINSEGNA

Detail from *Maestà*

IN CONTEXT

FOCUS
The altarpiece

BEFORE
1105 The gold and silver *Pala d'Oro*, created by craftsmen in Constantinople and housed in St. Mark's Basilica, Venice, is a stunning example of an early rectangular altarpiece.

1291 Vigoroso da Siena's gabled altarpiece, *Virgin and Child with Saints*, paves the way for the development of the polyptych altarpiece.

AFTER
1432 Jan van Eyck completes the Ghent Altarpiece, a highly complex polyptych comprising 12 panels, eight of which open and close on hinges.

1512–16 The Isenheim Altarpiece, by Nikolaus Hagenauer and Matthias Grünewald, shows images of saints Sebastian and Anthony, as well as Christ's crucifixion.

The late Middle Ages can be seen as a high point of Christian art that sought both to express the power of the Church and to inspire congregations to prayer and faith. Altarpieces— paintings, sculptures, and reliefs situated in the area behind a church altar and used as a focus for devotion—were perhaps the most elaborate expression of this art. They appeared from around 1000 CE, when they began to supplant decorated reliquaries as devotional aids, and evolved in style and complexity through the Renaissance to the period of the Counter-Reformation in the mid-16th century.

Evolving forms

Early altarpieces were usually simple in shape, consisting of a rectangular panel on which was painted a large central figure— usually Christ or the Virgin Mary — flanked by a series of smaller figures, including saints and

The Archangel Michael is depicted in a panel from the exquisite *Pala d'Oro*, a 12th-century Byzantine altarpiece made with enamelwork, gold, and precious gemstones.

characters from the Bible. Influenced by the Byzantine art of icon painting, which reached Europe in the 13th century, artists in Italy and elsewhere created ever more ornate panels, which were not only a focus for worship but also a reflection of the growing wealth of cathedrals and monasteries. While icons were considered "true copies" of their holy models, altarpieces also took on a narrative function of instructing the faithful. The shape of altarpieces became more elaborate, too, the simple rectangular panel giving way to gabled outer structures that framed hinged panels.

Popular in both Eastern Orthodox and Western churches, the most usual forms were the triptych, consisting of a central panel with a hinged "wing" at each

In keeping with Byzantine stylistic tradition, the figures of the Madonna and Child at the center of Duccio's *Maestà* are larger than the other individuals, emphasizing their importance. A step toward realism is seen in the effect of three-dimensionality in the figures, although they still lack the sense of real weight that would be developed in the Renaissance.

See also: The Wilton Diptych 98–99 ▪ Klosterneuberg Altar 101 ▪ Santa Trinita *Maestà* 101 ▪ Portinari Altarpiece 163 ▪ St. Mary Altarpiece 163 ▪ Isenheim Altarpiece 164

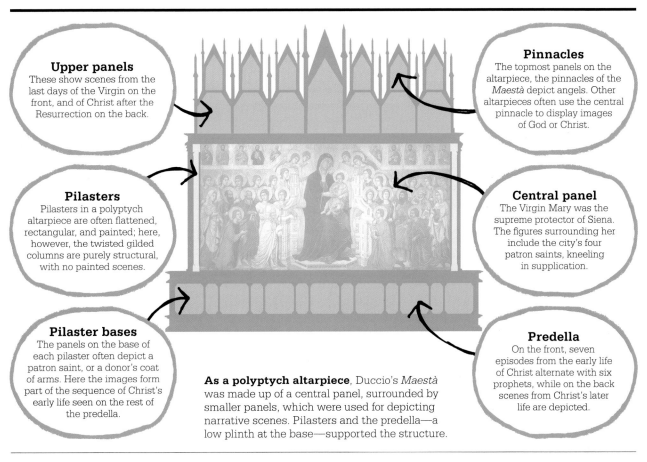

Upper panels
These show scenes from the last days of the Virgin on the front, and of Christ after the Resurrection on the back.

Pinnacles
The topmost panels on the altarpiece, the pinnacles of the *Maestà* depict angels. Other altarpieces often use the central pinnacle to display images of God or Christ.

Pilasters
Pilasters in a polyptych altarpiece are often flattened, rectangular, and painted; here, however, the twisted gilded columns are purely structural, with no painted scenes.

Central panel
The Virgin Mary was the supreme protector of Siena. The figures surrounding her include the city's four patron saints, kneeling in supplication.

Pilaster bases
The panels on the base of each pilaster often depict a patron saint, or a donor's coat of arms. Here the images form part of the sequence of Christ's early life seen on the rest of the predella.

Predella
On the front, seven episodes from the early life of Christ alternate with six prophets, while on the back scenes from Christ's later life are depicted.

As a polyptych altarpiece, Duccio's *Maestà* was made up of a central panel, surrounded by smaller panels, which were used for depicting narrative scenes. Pilasters and the predella—a low plinth at the base—supported the structure.

side, and the polyptych, a hinged altarpiece with multiple panels. Hinged altarpieces, with wings or panels that could open and close, were often painted on both sides. A steplike block, the predella, was often added to support these large and heavy structures and became a canvas on which to tell stories of the lives of the saints.

Crowning glory

Duccio's *Maestà* (the Italian for "majesty") is a stunning altarpiece from the 14th century, and is widely regarded as the pinnacle of the form. Duccio di Buoninsegna (c.1255–1319), known as Duccio, was the greatest painter of the

Sienese school (see box on p95) and one of the most influential figures in pre-Renaissance painting. Little is known of his personal life, but historians know he was active in Siena by 1278, producing mainly religious art, including the Crevole Madonna (c.1280) in Siena and the Rucellai Madonna (c.1285).

The *Maestà* was a colossal work of art, originally consisting of 84 panels. It was commissioned for the high altar of Siena Cathedral in 1308 by the city of Siena, and took Duccio about three years to paint. Originally measuring 190 in (480 cm) in width, it remained at the high altar for nearly two hundred years before being moved to a side chapel

in 1505. In August 1771 it was taken apart, and some of the panels were subsequently misplaced.

The huge, free-standing altarpiece was painted on both sides in tempera (pigment mixed with egg) and gold on wood. The front of the central panel, which on its own measures 83 in (210 cm) in height, shows the Madonna and Child, surrounded by 20 angels and 19 saints. The exact content of the surrounding panels is a matter of speculation. The predella is likely to have shown scenes from the lives of Jesus and Mary, while the upper panels and pinnacles are thought to have carried scenes from their deaths and ascent to Heaven. »

Eight of the panels are now housed in museums in Europe and the US, while the main front panel—along with several others—remains in its home city of Siena.

Education and protection

Duccio's magnificent altarpiece was designed as a focus for devout contemplation, but it served other functions, too—most notably, the education of Siena's population in biblical history. The lavish piece was also commissioned for the

The reverse of the main panel portrays scenes from the Passion of Christ. The central scene—the Crucifixion—is much larger, befitting its importance in the Christian faith.

glorification of the city, advertising Siena as a place of wealth and importance. The altarpiece was dedicated to the Virgin Mary, the city's patron saint, and is inscribed with a plea to her to protect Siena and grant it peace. The work was installed in the cathedral in 1311 amid great pomp; according to a witness, a solemn procession of clergy filed past the altar, followed by civic officials and ordinary citizens. Prayers were offered to the Virgin Mary asking her to intercede on behalf of the city.

The didactic function of the altarpiece is evident on its reverse side, which is designed as a commentary on the Gospels, and shows 26 scenes from the life of

Christ, including the Annunciation, the Nativity, the Flight into Egypt, and the Resurrection.

Byzantine influences

In common with other artists in Siena at the time, Duccio was heavily influenced by the works of Byzantine painters, which typically featured beautiful, stylized figures, often on a gold background, with an emphasis on symmetrical composition. This style of art had predominated since the Crusaders' conquest of Constantinople in 1204, when greater cultural exchange between the Byzantine Empire and Italy began to take place. In his paintings—among them the *Maestà*—Duccio adopted many

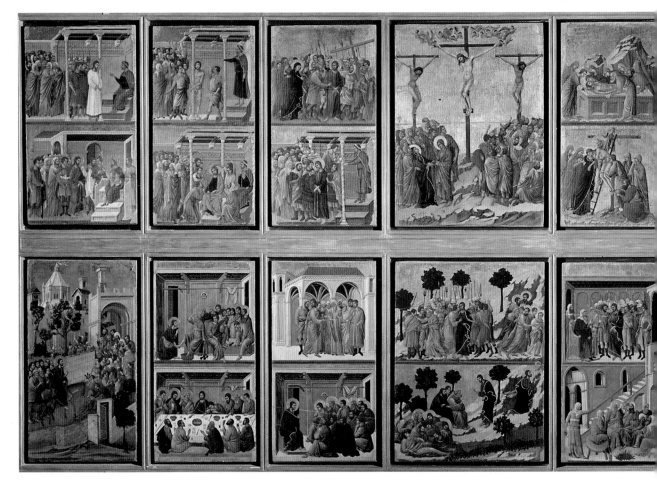

features of Byzantine art, but he also introduced new stylistic elements to create a human warmth.

Duccio's figures are expressive and realistic; they demonstrate liveliness, character, and movement rather than being flatly positioned against the background as in the Byzantine style. The soft body outlines, fluid drapery, and use of light and dark to model shapes help to give a three-dimensional effect. Such figurative realism was also being adopted, to a greater degree, by Giotto in Florence at much the same time.

Duccio's depictions of the biblical stories on the altarpiece's reverse are dramatically vivid, making up a lively narrative with

figures inhabiting detailed pictorial landscapes. The artist used gold and other rich colors as decorative elements, producing an overall effect that was elegant and bold, an approach that foreshadowed the International Gothic style that spread across Europe from the late 14th century. Duccio's style was extremely influential, and was notably expanded by one of his pupils, Simone Martini, who in 1315 painted a *Maestà* as a fresco for the Palazzo Pubblico in Siena.

Diverse styles

Altarpieces continued to be made well into the Baroque period. Their usage was never formalized by the Catholic Church, so styles varied considerably. They were often commissioned by wealthy families and guilds. In the Low Countries, altarpieces were painted in oil on wood, a notable example being the Van Eycks' Ghent Altarpiece (c.1432). In Germany, artists sculpted them from wood, while in England, alabaster was favored. In Italy, polyptych altarpieces gradually gave way to simpler painted works on canvas. During the period of the Baroque in the 17th century, altarpieces became flamboyantly theatrical, merging sculpture, painting, and ornament. ■

It was the most beautiful picture ever seen and made.
Agnolo di Tura del Grasso
Sienese Chronicle, 1311

The Sienese school of painting

From the 13th to the 15th century, the city-state of Siena was one of the great artistic centers of Europe, rivaled in Italy only by Florence. Its school of painting, the first two masters of which are considered to be Coppo di Marcovaldo and Guido da Siena, had a significant impact on the development of pre-Renaissance art.

Rooted in the Byzantine tradition but enlivened by Gothic elements, the Sienese style was refined, elegant, and aristocratic, with an exquisite use of color. It flourished throughout Italy and also in the courts of France. Its greatest exponent, Duccio, was succeeded by his brilliant pupil Simone Martini, whose depiction of an unidentified saint (c.1320) is shown above.

As the Renaissance developed in the 15th century, artists began to look to Florence for inspiration, but the Sienese tradition was maintained by such artists as Stefano di Giovanni (Sassetta) and Giovanni di Paolo, and later by Domenico Beccafumi, who incorporated Renaissance ideas into the Sienese style.

WHY SHOULD I WORRY IF IT SHOWS LIKENESS OR NOT

WIND AMONG THE TREES ON THE RIVERBANK (1363), NI ZAN

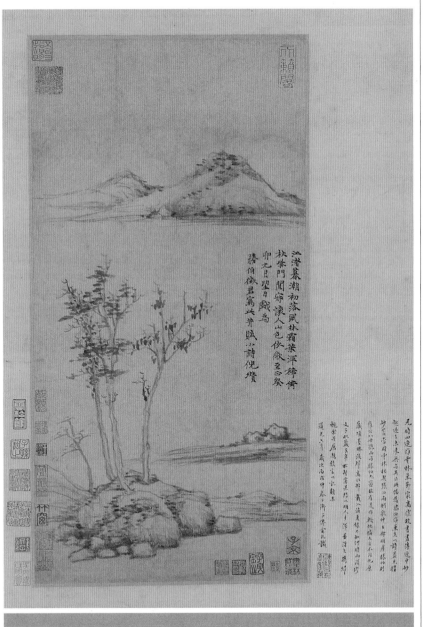

L andscape painting is often regarded as the highest form of Chinese art but, unlike Western landscape painting, Chinese landscape art is less concerned with capturing the reality of a scene than with grasping its inner atmosphere. It emerged as an art form at the end of the Tang Dynasty (618–907), with artists such as Li Sixun, Li Zhaodao, and Wang Mo creating landscapes in a sparse, monochromatic style. Landscape painting embodied the longing of educated men or scholar artists (known as "literati") to flee

See also: *Hunters in the Snow* 154–59 ▪ *Tintern Abbey* 214–15 ▪ *Bentheim Castle* 223 ▪ *The Avenue at Middelharnis* 224 ▪ *The Wanderer above the Sea of Fog* 238–39 ▪ *Women in the Garden* 256–63

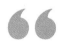

On the riverbank the evening tide begins to fall; The frost-covered leaves of the windblown grove are sparse.
Ni Zan
Inscription on *Wind among the Trees on the Riverbank*

the commonplace routines of daily life in favor of communing with nature. This aim of withdrawing into the natural world became a major inspiration for artists.

The Great Age
Encouraged by imperial patronage, landscape painting flourished in the Song Dynasty (907–1127), which was known as the "age of Chinese landscape"—a time when classic techniques were established. Artists in the north, such as Fan Kuan and Guo Xi, worked on silk using ink wash, strong black lines, and dotted brushstrokes to produce images of towering mountains and rough stone. In the south, Dong Yuan and others used softer strokes and paler colors to capture the essence of rolling hills and rivers.

Art of the Song period came to an end with the Mongol invasions and the establishment of the Yuan Dynasty (1271–1368). The Mongol Yuan Dynasty did not encourage traditional Chinese art and many artists, particularly the literati, withdrew from public life. Chinese

Early Spring (c.1072), a hanging-scroll painting by Guo Xi, is one of the most famous works of Chinese landscape art from the Song Dynasty.

painters such as Zhao Mengfu and the so-called Four Great Masters promoted "literati painting," which valued scholarship and spirituality above materialism and overtly decorative art.

One of the Four Great Masters was Ni Zan, whose pictured *Wind among the Trees on the Riverbank* epitomizes a new style of abstract landscape, sometimes described as "mind landscapes." Working with ink monochrome on a paper scroll, Ni Zan depicts a grove of trees on a rocky foreground shore; in the background are mountains. It is a desolate scene painted in a sparse and almost abstract style, reflecting the artist's state of mind at the time—his wife had died and he was experiencing intense isolation. Typical of his style, some areas of the paper are untouched and Ni

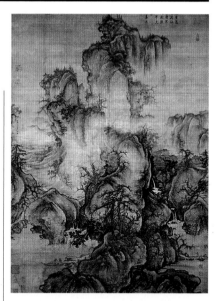

Zan—an acknowledged poet—inscribed his work with a poem describing loss and isolation.

Ni Zan was still painting when the Ming Dynasty was established and his work had a considerable influence on later artists, among them Ming Dynasty literati such as Shen Zhou and Wen Zhengming. ▪

Ni Zan

Born into a wealthy family in Wuxi, Yiangsu province, southern China, in 1301, Ni Zan received a traditional Confucian training. A quiet, generous, and fastidious man, he was one of the Four Great Masters who rejected realistic representations of nature in favor of work that reflected their inner feelings. He preferred a very sparse approach, and repeatedly painted the same landscapes. Forced to flee his hometown in the 1340s, possibly because of aggressive tax collectors, he gave away all his goods to follow Daoism

(the Way), a philosophy that prescribes harmony with nature, relying on patronage or income from his paintings. During this time, he produced his finest work, which established him as a master during his lifetime. In 1371 he returned to Wuxi, where he died in 1374.

Other key works

1339 *Enjoying the Wilderness in an Autumn Grove*
1355 *Fishing Village after Autumn Rain*
1372 *The Rongxi Studio*

AN ELEGANT AND ENIGMATIC MASTERPIECE

THE WILTON DIPTYCH (c.1395–1397)

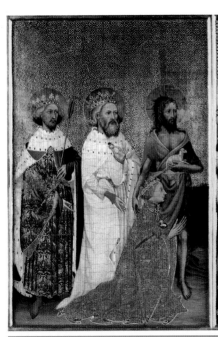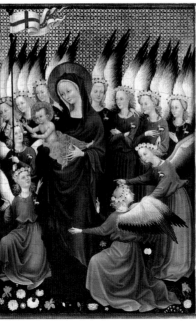

IN CONTEXT

FOCUS
International Gothic

BEFORE
1300 Sienese artist Duccio di Buoninsegna develops the tradition of panel painting, using egg tempera to paint soft, gentle figures in his *Madonna and Child*, which resembles an icon.

1315 Simone Martini creates his huge *Maestà fresco*—one of the formative pieces in the development of International Gothic—in the Palazzo Pubblico, Siena.

AFTER
1411–16 The *Très Riches Heures du Duc de Berry,* a book of hours illustrated by the Dutch Limbourg brothers, uses bright, lavishly colored illustrations typical of the International Gothic style.

1420–22 One of the late International Gothic artists, Siena-born Lorenzo Monaco, paints *Adoration of the Magi.*

1423 Gentile da Fabriano's *Adoration of the Magi*, often seen as the high-water mark of International Gothic, is unveiled in Florence.

Between about 1375 and 1425, a new artistic style flourished in royal courts across western Europe, finding expression in painting, sculpture, and the decorative arts, including tapestries and manuscripts. Called "International Gothic"—due to its Gothic elements and international nature—by art historians in the 19th century, the style was marked by elegance, delicacy, flowing lines, a luxurious use of color, and greater realism, particularly in its depiction of the natural world. The style spread as many artists of the time traveled between the major European courts, whose royal families were often linked by marriage.

Some of its earliest examples can be seen in the paintings of Italian artist Simone Martini. His *Annunciation*, painted in 1333 for an altar in Siena Cathedral, departs markedly from the sober Florentine painting of the time, featuring instead the gentle forms and elegant, elongated likenesses that became typical of the style.

International Gothic reached maturity toward the end of the 14th century, when one of its most outstanding examples—the Wilton

See also: Apocalypse Tapestries 101 ▪ *Young Man among Roses* 160 ▪ *Très Riches Heures du Duc de Berry* 162 ▪ *Adoration of the Magi* 162

> The old Byzantine manner suddenly seemed stiff and outmoded.
> **E. H. Gombrich**
> *The Story of Art*, 1950

Diptych—was created by an unknown artist (or artists), perhaps working in England, France, Italy, or Bohemia. The piece is named after Wilton House, England, where it was kept from 1705 until 1929. It was probably commissioned by the English King Richard II (who reigned from 1377 to 1399) as a portable altarpiece for use in his private religious devotion. At just over 19 in (50 cm) high, it consists of two hinged, gilded oak panels, which enable the diptych to be opened like a book.

The inner left wing shows Richard II kneeling in devotion on rough ground. Three pious men stand with him: John the Baptist, Richard's patron saint, who carries the lamb of God, and two canonized Saxon kings: St. Edward the Confessor, holding a ring, and St. Edmund, holding the arrow that killed him. Facing them on the opposite panel, the Virgin Mary, object of Richard's devotion, holds the infant Jesus, who appears to be reaching out to the king. Eleven angels, their dark-tipped, elongated wings raised, surround the Virgin and Child; they stand on a meadow of exquisite, bright flowers. One angel is holding a pennant bearing the St. George's cross, symbol of England. Both Richard and the angels wear brooches with his emblem—a white hart with golden antlers—and collars made from the pods of the broom plant, an emblem of Charles VI of France, whose daughter Richard married in 1396.

The flowing lines, realistic but slightly elongated figures, and dainty motifs typify International Gothic, with the realism of the flowers and other details indicating that the artist had closely observed the natural world.

Precious materials

The diptych is painted in egg tempera (pigments mixed with egg as a binder). In common with other International Gothic artworks, it is vividly colored and decorated with costly materials. Gold leaf is used for much of the background and details of both panels, while the Virgin Mary and the angels are clothed in garments painted using a pigment made from the semiprecious stone lapis lazuli.

While the Wilton Diptych, with its decorative colors, was perhaps the purest example of International Gothic, the style flourished in western Europe into the early 15th century. The *Adoration of the Magi*, an altarpiece for the Strozzi chapel in Florence by Gentile da Fabriano, is seen as the final flowering of International Gothic, although with its more natural depictions of movement, proportion, and depth it is often regarded as marking the transition between that style and the early Renaissance. ▪

The outside of the diptych bears heraldic devices that refer to Richard II. On the left is his coat of arms and the arms of Edward the Confessor; on the right, his emblem, the white hart.

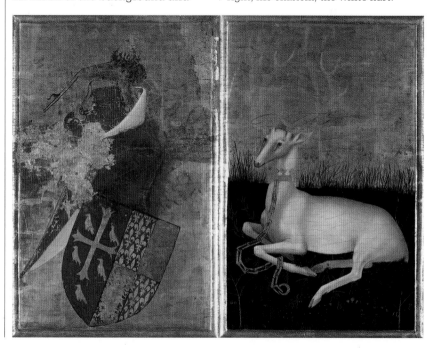

PORTFOLIO

SUTTON HOO HELMET
(c.625)

Of all the superbly crafted objects found in the Anglo-Saxon ship burial site at Sutton Hoo in Suffolk, England, perhaps the most imposing is a warrior chief's helmet made of iron and copper alloy. It is stamped with battle scenes and animal motifs, and finely decorated with silver and garnets. The eyebrows, nose, and mouth form a bird of prey, whose red-garnet eyes—along with those of a dragon on the helmet's crest—may have been intended to watch over the wearer.

RUTHWELL CROSS
(c.750)

The freestanding stone cross at Ruthwell in Scotland dates to the 8th century and is 18 ft (5.5 m) tall. It is finely carved all over, featuring sculpted reliefs of scenes from the New Testament and related Latin inscriptions on its north and south sides. Carvings of birds and animals entwined with vines, framed by lines from the Old English poem *The Dream of the Rood* written in Anglo-Saxon runes (an early alphabet), decorate the other sides.

BONAMPAK MURALS
(c.790–800)

These murals, showing historical events, give a vivid picture of Maya society near its peak. Undermining the once-popular idea that the Maya were a peace-loving people, some of the most striking scenes depict warfare, torture, and sacrifice. Even in such bloodthirsty subjects, the paintings' style is exquisite and colorful. The finest surviving group of fresco paintings from the ancient Americas, they occupy three rooms of a small temple in Chiapas, Mexico, covering its walls and ceilings.

UTRECHT PSALTER
(c.830)

Probably made in or near Reims, France, the copiously illustrated Utrecht Psalter (book of Psalms) was one of the most influential works of its time. Each of the 150 psalms and 16 biblical hymns is accompanied by a pen drawing illustrating the text in an innovative and detailed way. A variety of human figures is depicted, along with animals, demons, and elements such as buildings and landscapes. Probably created by eight artists, its energetic, expressive style of figure drawing was widely imitated.

BERNWARD DOORS, HILDESHEIM
(1015)

Commissioned by Bishop Bernward, the huge bronze doors at Hildesheim Cathedral, Germany, are one of the high points of Ottonian art. Each of the 15 ft (4.7 m) high doors was cast in one piece, requiring immense technical skill. The eight panels on each door depict biblical scenes in simply composed but vividly

rendered low-relief images, in which figures project dramatically from the backgrounds. The Old Testament scenes on the left depict man's fall from grace, mirroring the New Testament scenes on the right, showing man's salvation by Christ.

LAST JUDGMENT TYMPANUM
(c.1130), GISLEBERTUS

One of the great masterpieces of medieval sculpture, the *Last Judgment* is remarkable for its tremendous expressive power, using exaggeration and distortion for emotional effect in a way typical of Romanesque art. The sculpture decorates the tympanum (the area over a doorway) at Autun Cathedral in Burgundy, France. A dramatically elongated Christ is placed at its center, with figures including Mary and the apostles to his right. Under his throne are the Saved and the Damned. The work is signed, unusually for the time, *Gislebertus hoc fecit*—"Gilbert made this."

THE CLOISTERS CROSS
(c.1150)

This mysterious Romanesque cross is also sometimes known as the Bury St. Edmunds Cross after the place where it is thought to have been made. Carved from walrus ivory and 23 in (58 cm) high, it is remarkable for the superb quality of its workmanship and its complex iconography. With 92 tiny carved figures, it depicts Old and New

Testament scenes, including Jesus's death and resurrection, in incredible detail. Prophets and saints hold scrolls with intricately carved Latin citations. Some of the inscriptions are anti-Semitic, perhaps reflecting anti-Jewish feeling in England at the time.

KLOSTERNEUBURG ALTAR
(1181), NICHOLAS OF VERDUN

The altarpiece triptych in the abbey church at Klosterneuburg, Austria, is made up of 51 gilded copper and enamel plaques, in three rows, depicting scenes from the Bible. The middle row shows events from the life of Christ; these are flanked in the upper and lower rows by prophetic Old Testament events that prefigure them, in a Christian convention known as typology. The brilliance of the enamel recalls Byzantine art, but the drapery style and the increasing realism of the figures show a shift from the stylized Romanesque toward the Gothic. The French artist, Nicholas of Verdun (active 1181–1205), was a brilliant enamelist and goldsmith.

SIX PERSIMMONS
(c.1250), MUQI

Six Persimmons is a Chinese brush-and-ink drawing of six persimmons against a plain background. The fruits vary subtly in size, shape, position, and tonality, ranging from dark to light. With an extraordinary economy and true spontaneity of brushwork, the artist infuses the monochromatic fruits with a sense of the infinity of time and space. Muqi (c.1210–80) was a Buddhist monk, and his work exemplifies a meditative approach to painting typical of Chan (Zen) Buddhism.

SANTA TRINITA *MAESTÀ*
(c.1280–1290), CIMABUE

Painted by Cimabue (c.1240–1302) for the high altar of the church of Santa Trinita in Florence, this was the most ambitious panel painting by any Italian artist up to this date. With its flat, gold background, its elongated Mary holding an adult-seeming Christ child, and its stacked angels, the painting appears Byzantine in style. Yet attempts to render an intuitive form of perspective, and the beginings of chiaroscuro in the facial modeling, show the first moves to a more naturalistic style prefiguring the Renaissance. This would be developed by Giotto in a painting of the same subject 20 years later.

APOCALYPSE TAPESTRY
(1373–1382), JEAN BONDOL

This set of tapestries, made for Louis I, Duke of Anjou, over seven years, depicts in vividly imagined and realistic detail the story of the Apocalypse from the Book of Revelation. Comprising 71 scenes (of an original 90) in six sections, each 20 ft (6 m) high, it is one of the finest surviving pieces of medieval art, with a total length of more than 330 ft (100 m). The designer, Jean Bondol (active 1368–81), was a Flemish artist working in France. His style has a courtly sophistication that heralds International Gothic.

WELL OF MOSES
(1395–1403), CLAUS SLUTER

This monumental sculpture formed the base of a fountain made for the Chartreuse de Champmol, a grand Carthusian monastery in Burgundy, France. Six full-size figures of prophets, including Moses, David, and Isaiah, are posed around the hexagonal base, with six angels above them on columns. The figures have a majestic weightiness and a powerful sense of character. They were originally painted and gilded, and Jeremiah wore a pair of copper eyeglasses. The sculpture was once topped by a Crucifixion group, destroyed in the French Revolution.

Claus Sluter

The outstanding sculptor of his period in northern Europe, Claus Sluter (c.1340–1406) was born in the Netherlands, possibly in Haarlem, but spent virtually all his known career in Dijon. This is now in France, but at the time it was capital of the Duchy of Burgundy, a powerful state. In 1389 Sluter became chief sculptor to Philip the Bold, Duke of Burgundy, who was a lavish and discriminating patron. Sluter's style was robust and dynamic, making expressive use of deep folds of drapery and creating highly individualized figures. It marks a step away from the graceful International Gothic style toward the more naturalistic idiom that was characteristic of Netherlandish art in the 15th century.

Other key works

1391–97 Portal sculptures for the Chartreuse de Champmol
c.1397 Head and torso of Christ (fragment from Well of Moses)
1404–10 Tomb of Philip the Bold (completed posthumously)

RENAISS
AND MAN

ANCE
NERISM

The Tomb of Ilaria del Carretto in Lucca Cathedral is made by Sienese sculptor **Jacopo della Quercia**.

Jan van Eyck completes the famous multipaneled *Adoration of the Lamb* altarpiece for Ghent Cathedral.

Benozzo Gozzoli paints *The Journey of the Magi*, a glittering fresco in the chapel of the Medici Palace, Florence.

The German sculptor **Bernt Notke** completes a magnificent group, *St. George and the Dragon*, for Stockholm's main church.

c.1406 **1432** **1459–61** **1489**

1425 **c.1450** **1475–76** **c.1495–97**

Lorenzo Ghiberti begins his second set of bronze doors (completed in 1452) for the **Baptistery of Florence Cathedral**.

Jean Fouquet, the leading French painter of the 15th century, creates one of the first formal self-portraits.

In Venice, the Sicilian **Antonello da Messina**, a pioneer of oils in Italy, paints the San Cassiano Altarpiece.

Leonardo da Vinci paints his celebrated *Last Supper* mural in the monastery of Santa Maria delle Grazie, Milan.

The word "Renaissance" means "rebirth," and in the context of the visual arts it refers to the rediscovery of the art of ancient Rome and Greece, and the imitation of their naturalistic ideals. Classical art had not been entirely forgotten during the Middle Ages—the Roman sculptural style was, for example, referenced by Nicola Pisano in the 13th century— but its influence was sporadic, and it was not until the 15th century that it became widely accepted as a model to inspire artists. This new interest paralleled the enthusiasm of Renaissance writers and scholars for the works of great Latin authors such as Cicero, Ovid, and Virgil.

However, it was not in Rome itself that the Renaissance initially flourished, but in Florence. After the fall of the Roman Empire in the 5th century, Rome had degenerated into to a squalid shadow of its former self. The papacy abandoned the city from 1309 to 1377, moving to Avignon in southern France, and it was not until the reign of Pope Martin V (1417–31) that Rome began to recover from its decline.

Florentine wealth

Florence had become extremely prosperous by the mid-13th century. It was a major center of banking and the wool industry, and its wealth helped foster a stimulating cultural atmosphere in which the trade guilds as well as rich individuals regularly commissioned works of art as a matter of prestige. It was the cloth merchants' guild, for example, that in 1401 sponsored the competition—won by Lorenzo Ghiberti—to make a set of bronze doors for the city's baptistery. Ghiberti was part of a generation of Florentine artists active in the early 15th century who are considered to be the fathers of Renaissance art. They also included Masaccio (whose paintings marked the first great advance in naturalism since Giotto), the sculptor Donatello, and the architect Brunelleschi.

In addition to a growing realism in art, Renaissance interest in antiquity was expressed in, for example, Pisanello's development of the portrait medal (inspired by Roman coins) and Botticelli's revival of classical subject matter based on mythology and allegory.

Florence continued as a major center of art in the 16th century, becoming a stronghold of the elegant Mannerist style, but it was no longer the undisputed artistic

Giovanni Bellini, the greatest Venetian painter of his time, produces the majestic San Zaccaria Altarpiece.

In Parma, **Parmigianino** paints *The Madonna of the Long Neck*, one of the archetypal works of Mannerism.

Tintoretto paints an enormous *Crucifixion* as part of his extensive decoration of the Scuola di San Rocco, Venice.

In Toledo, **El Greco** paints *The Burial of the Count of Orgaz*, one of his greatest altarpieces.

1505

1534–40

1565

1586–88

c.1514–21

1541

1576

1587–95

Hans Brüggemann's huge Bordesholm Altar (now in Schleswig Cathedral) is the last great carved German altarpiece in the medieval tradition.

In Rome, **Michelangelo's** overpowering *Last Judgment* fresco is unveiled in the Vatican's Sistine Chapel.

Titian dies in Venice, leaving unfinished a sublime painting of the *Pietà* intended for his own tomb.

Giambologna produces the first equestrian statue in Florence—a monument to Duke Cosimo I de' Medici.

leader, because Rome had once again assumed a key role. Pope Julius II (1503–13) employed Michelangelo and Raphael, among other artists, and began the rebuilding of St. Peter's Basilica under Donato Bramante, the greatest architect of the age. Leonardo da Vinci also worked briefly in Rome, but he had a much more important association with Milan. This became one of the chief art centers in northern Italy, but it was outshone by Venice, where the long-lived Titian had a glorious career that spanned two-thirds of the 16th century.

Northern Renaissance

Much European art of the 15th and 16th centuries outside Italy has been described as belonging to the "Northern Renaissance." This is a broad label of convenience rather than an indication that a revival of the antique played the same kind of role that it did in Italy. However, the artistic revolution in the north was of almost equal magnitude, and was based on a new capacity for detailed, incisive realism made possible by the use of oil paint. The first great master of the medium was the Netherlandish painter Jan van Eyck, who was closely followed by his compatriot Rogier van der Weyden.

Their artistic successors in the Netherlands included Hieronymus Bosch and Pieter Bruegel, who likewise used the oil medium with finesse but applied it to different subjects—most memorably fantasy scenes (Bosch) and landscape and peasant life (Bruegel). The most famous artist of the Northern Renaissance, the German Albrecht Dürer, was an outstanding painter and theorist, but his fame was based mainly on his prints, which, in the words of the 16th-century Italian biographer Giorgio Vasari, "astonished the world."

Dürer was aware of the new worlds that were being discovered beyond Europe in his lifetime—records show that, in 1520, he enthusiastically described seeing Aztec treasures that had been sent by Hernan Cortés to the emperor Charles V. In about 1485 Portuguese explorers first reached Benin City (now in Nigeria), where metalwork and carving flourished at a highly sophisticated level. Initially, the products of such societies were regarded in Europe as curiosities but they soon became regarded as serious works of art. ∎

TO ME WAS CONCEDED THE PALM OF VICTORY

SACRIFICE OF ISAAC (1401–1402), LORENZO GHIBERTI

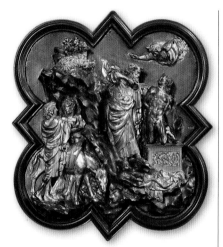

IN CONTEXT

FOCUS
Competitions in art

BEFORE
Late 5th century BCE Greek painter Zeuxis depicts grapes so naturalistic that birds peck them. In response, his rival Parrhasius produces a painting of a curtain so deceptive that Zeuxis tries to pull it aside.

AFTER
1503–04 Leonardo da Vinci and Michelangelo are hired to paint battle scenes on opposite walls of the Council Hall of the Palazzo Vecchio in Florence in direct and fierce competition with one another.

1832 J. M. W. Turner adds a bright red buoy to his seascape to outshine a competing work by John Constable at London's Royal Academy.

The son of a goldsmith, sculptor Lorenzo Ghiberti (c.1380–1455) found fame in the early 15th century when he won a competition to produce a pair of bronze doors for the Baptistery of San Giovanni in Florence.

The competition was set up by the Arte di Calimala, or cloth merchants' guild, one of the seven elite trade guilds that controlled commerce in Florence from the 12th to the 16th century. The guilds were also important sponsors of the arts, and the Calimala was responsible for maintaining the octagonal Romanesque baptistery.

Each entrant in the competition was given four sheets of bronze from which to produce a relief depicting a particular biblical episode: that of Abraham, on the brink of sacrificing his son Isaac, being interrupted by an angel.

Economy and style
Ghiberti used both Gothic and classical traditions to inform his entry. The figure of Abraham adopts a *contrapposto* pose: a stance in which a figure thrusts out a hip, transferring all weight onto one leg, introducing a twist in the body and a certain sense of movement or emotion. This device, first used in ancient Greece, was also popular in Gothic sculpture, with its typically more flowing, curvilinear style. The boy, Isaac, is rendered as a classical, muscular nude. The composition also pays attention to perspective, as demonstrated by the foreshortened angel and receding landscape that creates a convincing illusion of depth. Ghiberti's poised and graceful vision, cast in just two pieces, beat six other artists, including Filippo Brunelleschi, whose panel also survives. In contrast to Ghiberti's, his depicts the scene as a moment of urgent, anguished drama.

The young sculptor won not only for his artistry but also for producing a more lightweight and economical piece than his rivals. Ghiberti's work was key in the development of the Renaissance style, and his workshop went on to be a training ground for such artists as Donatello and Paolo Uccello. ∎

ICONS ARE IN COLORS WHAT THE SCRIPTURES ARE IN WORDS

HOLY TRINITY (1411), ANDREI RUBLEV

IN CONTEXT

FOCUS
Icons

BEFORE
c.400 CE *The Doctrine of Addai*, a Syriac Christian text, tells of a portrait of Jesus sent to Abgar, ruler of Edessa (now Urfa in Turkey). It is considered by some to be the first icon.

6th century An icon of Christ Pantocrator ("the Almighty") is painted and preserved in St. Catherine's Monastery in the Sinai desert. It is the oldest known surviving icon.

AFTER
1495–96 Russian icon artist Dionisy paints monumental iconographic frescoes at Ferapontov Monastery in the Vologda region of Russia.

1988 The Russian Orthodox Church canonizes Rublev.

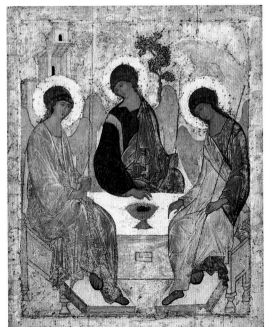

Derived from the Greek word for likeness or image, in the Eastern Orthodox Church an icon is a religious painting, often on a flat panel, that typically shows scenes with Jesus, Mary, or the saints. Icons were considered to be far more than works of art—they were sacred artifacts that offered their viewers direct contact with the figures portrayed.

Divinity and angels

The most famous Russian icon painter of the Byzantine period (c.330 CE–1453) was Andrei Rublev (c.1360–1430), whose *Holy Trinity* is a masterpiece of the genre. In the picture, God appears to Abraham in the form of three angels representing the Father, the Son, and the Holy Spirit. The figures are assembled around an altar, which bears a filled chalice, representing the Eucharist. Behind them is a mansion denoting God's house, a mountain that demonstrates spiritual assent, and an oak to signify the Tree of Life and Christ's crucifixion. Blue robes signify divinity and green new life, while gold denotes kingship.

Rublev conveys the dynamic between the visitors in his gentle circular composition. The viewer's eye moves from one figure to the next around the central chalice, keeping the energy concentrated within the image and so hinting at the unity of the Father, Son, and Holy Spirit. The image is contained by the shapes of the two outer angels, which make the form of a chalice. Subtle hand gestures elaborate on the intimate, intuitive relationship between the figures. The harmony of the picture makes it an ideal focus for meditation and prayer—a conduit to mystical experience of the Holy Trinity. ■

See also: Mosaics of Emperor Justinian and Empress Theodora 52–55 ▪ Reliquary of Theuderic 62–63 ▪ *Barge Haulers on the Volga* 279 ▪ *Composition VI* 300–07 ▪ *The Defense of Petrograd* 338–39

PERSPECTIVE IS THE BRIDLE AND RUDDER OF PAINTING

HOLY TRINITY (1428), MASACCIO

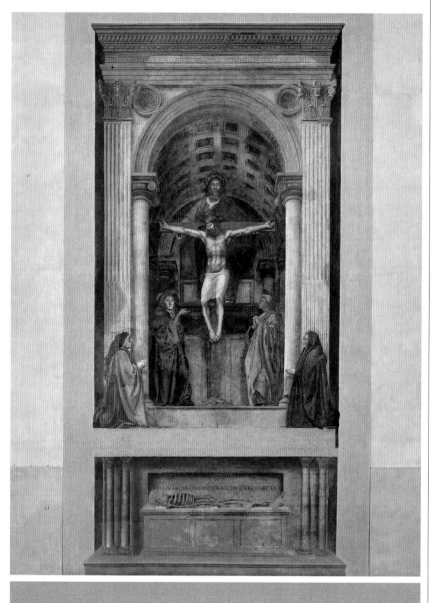

IN CONTEXT

FOCUS
Linear perspective

BEFORE
c.1st century CE Hellenistic painters experiment with depth in landscape painting.

Early 14th century Giotto di Bondone creates the illusion of three dimensions on a flat surface through foreshortening and chiaroscuro.

1413 Filippo Brunelleschi demonstrates the function of single-point perspective.

AFTER
1508–12 Michelangelo paints the ceiling of the Sistine Chapel in Rome, influenced by techniques he had seen displayed in Masaccio's work.

1907 With Cubism, Pablo Picasso and Georges Braque make a radical break with three-dimensional perspective.

The physical impossibility of condensing a three-dimensional scene onto a flat surface means that painters must rely on perceptual tricks to convey a sense of depth. Ancient paintings and most pre-Renaissance European art make no attempt at such veracity. For example, in ancient Egyptian drawings, people are shown with their feet in profile while their bodies face forward; and in other early paintings, the relative sizes of people are set by factors other than their physical position—such as status or age.

Artists in ancient Greece and Rome had experimented with techniques to represent spatial

A mastery of perspective allows artists to show the true scale of objects at a distance, and—through foreshortening—gives three-dimensional objects a real sense of depth. The artist is able to create and organize a complex yet highly realistic space.

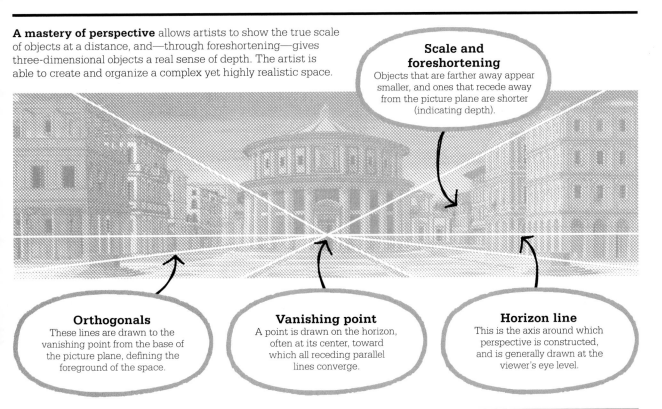

Scale and foreshortening
Objects that are farther away appear smaller, and ones that recede away from the picture plane are shorter (indicating depth).

Orthogonals
These lines are drawn to the vanishing point from the base of the picture plane, defining the foreground of the space.

Vanishing point
A point is drawn on the horizon, often at its center, toward which all receding parallel lines converge.

Horizon line
This is the axis around which perspective is constructed, and is generally drawn at the viewer's eye level.

relationships accurately. Most of their work was lost after the end of the classical era, but by the 14th century, Italian masters Giotto and Duccio were again addressing the problems of representing three-dimensional space on a flat surface.

The first truly successful representations of depth were arguably created by the young Florentine painter Masaccio, who was convincingly able to lead the viewer's gaze into a scene. While his contemporaries painted flat, stylized figures in a continuation of the International Gothic style, Masaccio took the radical step of applying revolutionary new principles of perspective to his art in such works as the *Holy Trinity*—his fresco in the church of Santa Maria Novella, Florence.

The science of perspective

Mathematical guidelines for representing depth in a painting were developed by Masaccio's friend, Florentine architect Filippo Brunelleschi, around 1413–20, and written down by another architect, Leon Battista Alberti, in his *On Painting* (1436). Known as linear perspective, this technique allowed an artist to map space and depth onto a two-dimensional surface.

Alberti described how the picture plane should be thought of as an open window through which the painted world is seen. The artist first draws a horizon line, then identifies a vanishing point on the horizon. Using lines converging on the vanishing point as a guide, the artist can achieve two effects to create a coherent impression of a three-dimensional space. The first is to make distant objects appear proportionately smaller than closer objects; the second is foreshortening, or making an object that recedes away from the viewer appear to be shorter than if it were parallel to »

Among the first to clear away the hardness and imperfections of the past.
Giorgio Vasari
Lives of the Artists, 1550

Masaccio

Tommaso di Ser Giovanni di Simone was born near Florence in 1401. He was affectionately known by the name Masaccio, "hulking Tom," because, according to the biographer Giorgio Vasari, he possessed an absent-minded disregard for anything other than art, including the way he dressed.

Little is known about Masaccio's life until he joined the Florentine painters' guild in 1422. Among his greatest friends and mentors were the architect Brunelleschi and the sculptor Donatello. Masaccio received many commissions in Florence, and worked on what is considered to be his masterpiece—the fresco cycle in the Brancacci Chapel—from around 1425. Leaving the work unfinished, he moved to Rome in 1428 and died shortly afterward, possibly of plague, although the suddenness of his death raised suspicions that he had been poisoned.

Other key works

1422 San Giovenale Triptych
c.1425–28 Fresco cycle on the life of St. Peter, Brancacci Chapel, Santa Maria del Carmine
1426 Pisa Altarpiece

the viewer. The latter is particularly important for true representations of the human body.

The concept can be illuminated by thinking of the plane of the ground as a chessboard. From the point of view of a chess player, the squares on the board appear to decrease in size the farther away they are, although we know their dimensions to be identical; they also appear less deep than wide as a result of foreshortening. It is this phenomenon that is the basis of the illusion of depth in painting.

From theory to practice

Masaccio's *Holy Trinity* depicts a barrel-vaulted chapel within which a crucified Jesus is supported by God the Father, with the Virgin Mary and St. John flanking the cross. At the lower level is a painted sarcophagus containing a skeleton, a reminder of death, that contrasts with the promise of everlasting life depicted above. In a further painted illusion, the patrons of the work kneel just "outside" the chapel, forming part of the framing classical architecture and seeming to exist somewhere between the real space of the viewer and the painted space of the Holy Trinity.

Masaccio places the vanishing point below the cross, at the eye level of the viewer, so that the viewer must look up at the Trinity, but down at the sarcophagus. The coffers on the ceiling follow the orthogonal lines of perspective, and help create a convincing illusion of volume that brings the holy figures into almost physical space—an effect that would have astonished viewers of the time.

The technique of foreshortening serves to bring parts of painted objects closer to the viewer than others. This is evident in the *Holy Trinity* in the angled haloes of the

Virgin and Child (1426) was painted by Masaccio as part of a triptych. It includes a deliberate contrast between the correct perspective of Christ's halo and the flat haloes of the angels.

figures, and especially in Mary's extended arm, which appears to beckon the viewer into the image.

Light and shadow

Masaccio's approach to rendering light in his paintings—known as chiaroscuro (light and dark)—also contributed to his success in representing space. The technique of chiaroscuro had been pioneered by Giotto in the previous century. It involved illuminating a scene with contrasting light and dark areas so as to produce realistic shadows, which seem to sculpt surfaces in three dimensions. The figures in the *Holy Trinity* are thrown into relief according to how the light would have struck them, enhancing their three-dimensional appearance.

In Christian art, darkness and light have deep symbolic resonances: in the Bible, Jesus says, "I am come a light into the world that whosoever believeth in me may not remain in darkness" (John 12:46). Masaccio's mastery of light and of chiaroscuro was therefore more than just a technical achievement: it gave him access to a more nuanced emotional and symbolic language in religious painting and made him capable of far more sophisticated expression than that which had been achieved previously with a more stylized approach.

By combining Brunelleschi's perspective with Giotto's tricks of the light, Masaccio made viewers of the *Holy Trinity* feel as if they were looking through the painting into a fully realized, physical space beyond—an architectural cavity that must have seemed as real as the church its viewers stood in. Masaccio was able to extend the walls of God's house and breathe life into the holy figures that occupied the extra space—a feat that art historian E. H. Gombrich famously described as knocking a "hole in the wall."

Everything done before Masaccio can be described as artificial.
Giorgio Vasari
Lives of the Artists, 1550

Big Tom and little Tom
While Masaccio is considered to be the pioneer of perspective in painting, the older Florentine artist Masolino da Panicale also played a key part in the development of the technique. For a time, the two painters were close associates, collaborating on the fresco cycle in the Brancacci Chapel of Santa Maria del Carmine in Florence. Even their nicknames seem to have set them up as a painterly double act, translating roughly as "big Tom" or "hulking Tom" (Masaccio) and "little Tom" (Masolino).

Masolino adhered closely to the principles of linear perspective, as seen in his fresco *The Healing of the Cripple and Raising of Tabitha* (1425–28). However, he never quite achieved the same skill of narrative expression as Masaccio, which may account for the latter's greater fame.

Masaccio's command of three-dimensional space and the way it could be molded with light brought a wave of new emotive and narrative possibilities. His paintings were so believable and his figures so well characterized that his technique was emulated widely. It can be seen in the paintings of Andrea Mantegna, Piero della Francesca, and Leonardo da Vinci, reaching its High Renaissance peak with Raphael. The use of linear perspective became a standard feature of Western art until the late 19th century, when Paul Cézanne's flat designs sought to represent depth "only through color." ∎

Masolino's fresco *The Healing of the Cripple and Raising of Tabitha* exemplifies one-point perspective. Even the cobblestones diminish in size with distance to complete the effect.

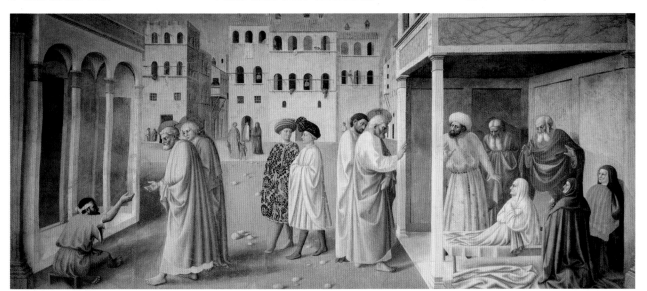

THE MAN WHO TRANSFORMED THE MERE BINDING OF PIGMENTS WITH OIL INTO OIL PAINTING

THE ARNOLFINI PORTRAIT (1434), JAN VAN EYCK

IN CONTEXT

FOCUS
Oil painting

BEFORE
c.650 The oldest known oil paintings are created on the walls of caves in the Bamiyan Valley, Afghanistan.

c.1110–25 *De diversis artibus* is written by Benedictine monk and artist Roger of Helmarshausen. The monastic manuscript describes how to bind pigments with oil.

AFTER
1565 Pieter Bruegel the Elder paints *The Harvesters*, demonstrating a rapid and economical use of oil paint. The artist uses very thin layers that do not conceal his drawings beneath.

17th century Rembrandt develops a loose technique with the medium, moving oil paint around the canvas even when it is very thick.

J an van Eyck was among the founders of the Early Netherlandish (or Flemish) School of painters. This group moved away from the extravagantly decorative International Gothic style that prevailed in Europe at the time and adopted a more naturalistic way of painting, which blended realism and detail with spiritual symbolism.

Van Eyck's *Arnolfini Portrait* is populated with symbolic objects rendered in a high-definition style that was made possible only by the artist's mastery of oil paint. Through this and other paintings, van Eyck gained a reputation for conjuring perfection with oils that is demonstrated by his microscopic control of the brush. Writers such as Italian Giorgio Vasari (1511–74) later claimed that van Eyck had invented, or reinvented, oil painting. Although the Flemish painter was far from the first to use oil paint— it was employed in both China and Afghanistan in the 7th century— both van Eyck's development of the medium and his skill with it influenced the trajectory of painting in Western art. The luminous detail and clarity that van Eyck was able

His eye operates as a microscope and as a telescope at the same time.
Erwin Panofsky
Early Netherlandish Painting, 1953

to bring to his paintings helped to promote the benefits of oils to the wider artistic community.

A flexible medium

The prevailing medium for artists in 15th-century Europe was egg tempera paint, in which pigment was bound together with egg yolk and water. However, tempera has limitations: the paint dries rapidly, so it cannot be stored, and only small areas can be painted at one time; also, tempera does not lend itself to blending, so color mixing relies on overlaying opaque layers of color or crosshatching. Oil carries

Jan van Eyck

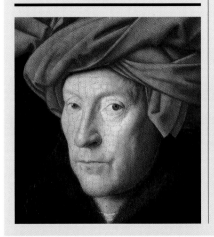

Jan van Eyck's life is shrouded in mystery. He may have been born in the 1380s in the town of Maaseik (now in Belgium), but the earliest records of him place van Eyck in The Hague at the court of John of Bavaria, Count of Holland, in 1422. Van Eyck entered the service of Philip the Good, Duke of Burgundy, in 1425. Alongside painting, he undertook diplomatic assignments for his employer. He is known to have bought a house in Bruges in 1432, and married at around the same time. His dated oils, which include *Man in a Red Turban*, considered to be a self-portrait,

were made during the following decade. The artist's masterpiece, the *Adoration of the Lamb* altarpiece, was probably a collaboration with his brother, Hubert. Van Eyck was held in high regard by the court and earned a generous salary. He died in 1441 in Bruges.

Other key works

1432 *Adoration of the Lamb* altarpiece in Ghent Cathedral
1433 *Man in a Red Turban*
c.1435 *The Madonna of Chancellor Rolin*

color more effectively than tempera and dries more slowly, allowing for blending and reworking over time. It is slow-drying because the particles of pigment are suspended in drying, or siccative, oils. Instead of evaporating like water, drying oils gradually become semi-solid through a chemical process known as polymerization.

Van Eyck used linseed mixed with nut oils in his paint. The linseed oil was gently heated, or exposed to sunlight in a shallow dish, before use. This started the polymerization process before the paint was applied. Paint prepared in this way could be used for soft impasto (to build up a thick layer) when mixed with lead white, or for shiny glazes when made with translucent colors like red or green.

A picture of affluence

By painstakingly building up layers of paint and working exceptional detail into them with the use of fine brushwork, van Eyck was able to create a sense of tactile, three-dimensional objects. He paid considerable attention to luxurious textures and polished surfaces, aiming to render them as accurately as possible.

The Arnolfini Portrait is thought to depict an Italian merchant named Giovanni di Nicolao Arnolfini and his second wife, so far unidentified. Like van Eyck, Arnolfini was a courtier of Philip the Good, Duke of Burgundy. He lived with his wife in Bruges in some comfort: affluence

permeates every shining surface and carefully maintained fabric on display in the room behind the couple, and van Eyck's palette is as rich as his subjects. From the frothy white of the woman's linen headdress to the plush green of her costume, and from the warm red of the bed and cushion to the lustrous

darkness of Arnolfini's fur-trimmed robe, the colors and textures are at once lavish and true to life.

Van Eyck exploits all of the properties of oil paint to conjure up dense, chalky, porcelain tones for the figures' faces, gleaming bright highlights for the brass chandelier, and delicate transparent glazes »

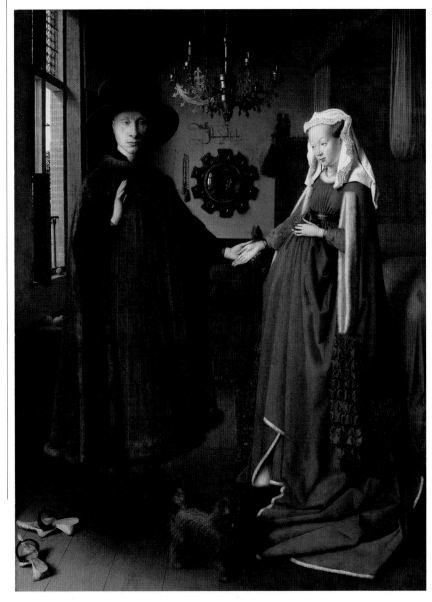

The Arnolfini Portrait is full of details that have literal and symbolic meaning. For example, oranges were a costly fruit that indicate wealth, but may also be a symbol of purity.

for the shadows that are cast by the window frame. Refined, impressive, and expensive to commission, the work reinforces—through its slick perfection—the desired projection of wealth, taste, moral principles, and power of its subjects.

Questions of intent

Many critics have speculated about the context of the painting. In 1934, German art historian Erwin Panofsky argued that it might have been commissioned as a legal document—irrefutable proof of a marriage taking place—and he made much of the hidden symbolism behind the objects within the room. Others have seen it as a record of a betrothal, a pledge, or a memorial to a deceased wife. Questions also surround whether or not the woman in the picture is pregnant, as her rounded

The mirror is the focal point of the composition. In the miniature scene, van Eyck reveals the presence of two men, looking in from the same position as the viewer of the painting.

abdomen would suggest; some art historians have argued that the dog in the foreground represents the couple's lust and that the painting therefore deals with their desire to conceive a child.

However, the likely explanation is far less mysterious: a rounded stomach was widely considered beautiful in 15th-century Flanders, and many women were similarly pictured in contemporary portraits. It is possible that van Eyck painted the woman in this way to draw attention to the volume of her dress and—by extension—to the couple's sumptuous possessions. Certainly, the woman's dress is barely

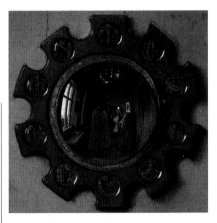

contained within the picture, and her silhouette is significantly widened as a result of the excess gathered fabric. It is as though the physical presence of these people is inflated by their belongings.

Van Eyck uses the material wealth of the couple to exhibit his skill. The extravagant, heavy folds of drapery in the woman's dress

Symbolism in *The Arnolfini Portrait*

A **single lit candle** symbolizes the **light of God** and his all-seeing presence. Lit candles also express the triumph of the Church, and a worshiper's **devotion** to God.

Beads hang by the mirror as evidence of **devotional prayer**. The beads are known as a paternoster and symbolize **piety**; they were a common gift from a man to his wife.

The couple's **discarded shoes** recall a passage from the Bible: "put off thy shoes from off thy feet, for the place whereon thou standest is **holy ground**" (Exodus, 3.5).

The figure of **St. Margaret**, patron saint of **childbirth**, is carved into the top of the bedpost. Other **fertility** symbols within the painting include the **red bed** and the **rug** on the floor.

A **hanging brush** represents St. Martha, patron saint of **housewives**. Its appearance may also be self-referential: the brush is an attribute of St. Luke, patron saint of **painters**.

Ten **miniature paintings** around the mirror detail the events leading up to the **crucifixion** of Christ. The **mirror** itself is a Christian symbol of the everlasting **purity** of the Virgin Mary.

The *Madonna of Chancellor Rolin* was commissioned from van Eyck by Nicolas Rolin, chancellor of the Duchy of Burgundy. It shows Mary presenting the baby Jesus to Rolin himself.

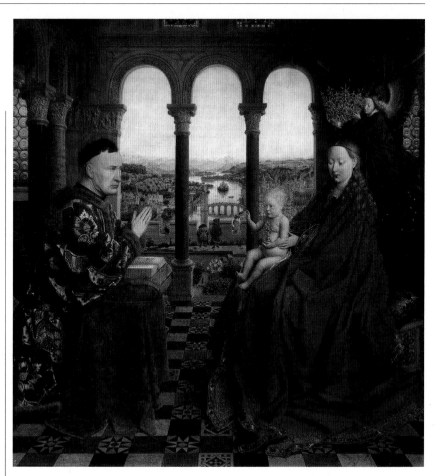

allow the artist to demonstrate his masterly control of the vibrant hues possible with oil paint. He subtly blends different tones of green to achieve the deep, dark ripples of fabric with a realistic sense of weight.

Surface and reflections

Van Eyck's delight in surface properties extends to every detail in the room. Tiny rectangular panes of blue and red sit side-by-side in the window with small circles of dimpled, transparent glass. The grain running through the wooden floorboards, and through Arnolfini's discarded shoes, is carefully delineated. A sliver of intricately woven rug can be seen. The fur trim of the couple's garments looks as if it could be stroked. In all this detail, van Eyck's brushwork is almost entirely imperceptible. The slow-drying nature of the oil paint allowed him time to blend and shape the different colors to achieve a polished result.

Van Eyck capitalized on oil paint's glossy quality, sending shafts of naturalistic illumination glancing off reflective objects, and warm embers of sunlight to lick the matte surfaces in his pictures. This is illustrated in *The Arnolfini Portrait* by the glinting brass chandelier and the remarkable convex mirror on the back wall. The chandelier is impressively ornate, its six arms presenting a multitude of reflective surfaces at different angles to the light from the open window. A solitary candle burns in one of the holders. In a painting rich with Christian symbolism, this candle represents the omniscient

gaze of God, but van Eyck cleverly reverses the literal purpose of this object: instead of illuminating the room, the chandelier itself is lit up by the gleaming light effects on its complex reflective surface.

Seeing and being seen

The mirror is uncannily pre-emptive of the camera lens, its convex surface capturing a warped reflection of almost the whole room. It spies on the scene like a giant, unblinking eye. The mirror again demonstrates the acute detail that van Eyck could achieve with paint. Its frame is decorated with 10 tiny biblical scenes. The indented rim of each is highlighted with a deft slick of white pigment where light hits the varnished wood. The looking glass itself achieves a miraculous optical illusion, reflecting back a bulging view of the room as well as reducing it many times in size. The chandelier is rendered with minute precision in this reflection, as a delicate but legible web of spidery highlights. Two figures are seen reflected on the threshold of the room, one of them probably the painter himself.

Van Eyck signed the picture in a space just above the mirror, so that it looks as if the words are really painted on the wall. The Latin inscription translates as "Jan van Eyck was here." In a painting about seeing, being seen, and the desire for social visibility, the artist has deliberately not erased himself and his brush from the composition. ∎

BY TWO WINGS IS MAN LIFTED ABOVE EARTHLY THINGS, EVEN BY SIMPLICITY AND PURITY

DESCENT FROM THE CROSS (1435–1440), ROGIER VAN DER WEYDEN

See also: *The Garden of Earthly Delights* 134–39 ▪ *Avignon Pietà* 163 ▪ *Portinari Altarpiece* 163 ▪ *Christ of Clemency* 172–75

IN CONTEXT

FOCUS
Devotio Moderna

BEFORE
c.1425 *The Entombment*
by Robert Campin sets
the sculptural, expressive
figures of Christ's passion
in a landscape against a
medieval gold background.

1427 *The Imitation of Christ*
by Dutch priest Thomas à
Kempis is printed. Inspired
by *Devotio Moderna*, it is
the most popular book of the
15th century.

AFTER
1457–75 Devotional panels
by Netherlandish painter
Dieric Bouts prove popular
for personal *Devotio Moderna*
worship. Their small size helps
focus the act of prayer.

c.1570 *Devotio Moderna*
comes to an end in the wake
of the Protestant Reformation.

Rogier van der Weyden

Born in 1399
in present-day
Belgium, Rogier
van der Weyden
is thought to
have studied
under the great Flemish painter
Robert Campin, although details
of his early life are hazy. In 1436,
he was appointed painter to the
city of Brussels. His work there
included panels for the judicial
court, which were his most
famous paintings, until they
were destroyed in 1695.

Rogier's works were exported
to France, Germany, Spain, and
Italy—bringing him fame—and
he was emulated widely. Most
of his art was religious in
content, although he painted
some secular pieces and several
portraits. He died in 1464.

Other key works

c.1445–50 *Last Judgment*
c.1460 *Crucifixion with the
Virgin and St. John*
c.1460 *Portrait of a Lady*

A religious movement that
began in the Netherlands
and spread through parts
of Europe between the 14th and
16th centuries, *Devotio Moderna*
(or Modern Devotion) promoted a
focus on the inner, spiritual self and
called for a return to piety through
conscientious imitation of the
actions and attitudes of Christ. This
was seen by its devotees as the
essential basis for practising faith.

The empathy and spirituality
advocated by *Devotio Moderna*
finds visual expression in the works
of Rogier van der Weyden, and
particularly in his *Descent from the
Cross*, which takes as its subject
the grief of the Virgin Mary and
other attendant figures following
the death of Christ. It portrays
Joseph of Arimathea (in a red hat),
Nicodemus (in a gold cloth), and a
servant (on the ladder) supporting
Christ's corpse; Mary is assisted
by St. John (in red, left) and a holy
woman as she faints from grief.

Parallel poses

Mary's pose echoes her dead son's
in a poignant representation of her
crippling emotional experience of
his physical agony. This sensitive
portrayal of intense suffering aims
to bring the pain of the Crucifixion
narrative to life for the viewer, with
the intention of promoting a closer
relationship with Christ and the
magnitude of his sacrifice.

The parallel pose encourages
contemplation of *compassio*, the
doctrine that Mary shares Christ's
suffering. The painting portrays
acute individual anguish but also
highlights the dignity with which
each figure carries their literal and
psychological burdens; it distills
the enormity of Christ's sacrifice
into a moving portrayal of the
debilitating torment that his death
wreaked upon his loving, devoted,
and bewildered followers.

Spiritual compassion

Rogier crams his composition
into a small frame and flattens
the background with gold paint,
pushing his figures into the
foreground as though they are
performing on a stage. The shallow
space and sense of intimacy
heighten both the dramatic and
emotional impact of the work. The
gold background acts as a striking
foil for Christ's pallid body and
Mary's ashen face. Like a play
with no set, extraneous detail is
removed so that nothing detracts
from the intense feeling on display.
The focus falls instead on the
moment of collective grief, in which
kindness and concern are spiritual
acts in themselves. In Rogier's
hands, in accordance with the
ideals of *Devotio Moderna*,
compassion for fellow humans
becomes not only a way to imitate
Christ, but also a way to spiritually
communicate with him. ▪

AN ELEGANTLY COMPACT IMAGE OF THE SUBJECT'S PROCLAIMED VIRTUES

CECILIA GONZAGA MEDAL (1447), PISANELLO

Medals have been used since antiquity for commemorative purposes—to honor a ruler or statesman, to remember a military victory, or to celebrate a betrothal. The earliest known examples are Roman, but the late Middle Ages saw a revival of the medal tradition. Renaissance humanism—the renewed interest in classical arts and philosophy—led to the growing popularity of medals. Rulers and nobles used these portable portraits for propaganda and gave them as gifts to political allies.

Made from gold, silver, or bronze, these medals were cast from a mold or die-struck (stamped to create an impression), and were produced in series of a few to several hundred. Complementary scenes were inscribed on either side. A low-relief profile portrait appeared on the obverse (front), usually with an inscription around the edge. On the reverse there might be a crest, an emblematic motif, or an allegorical allusion.

Credited with reshaping the trajectory of commemorative art in the 15th century, Pisanello elevated the portrait medal to the grand league of portraiture. His works were cast rather than struck, and feature designs of great clarity and nuance. Pisanello's first medal (c.1438), a portrait of the Byzantine emperor John VIII Palaeologus on

IN CONTEXT

FOCUS
The medal

BEFORE
509 BCE—476 CE During
the Roman Republic and the
Roman Empire, gold and silver
coins feature portraits of
consuls and emperors.

c.578–89 An Anglo-Saxon gold
medalet found in the British
city of Canterbury depicts the
Frankish bishop Liudhard.

c.1400 French prince and
patron of the arts Jean, duc de
Berry, commissions portrait
medals in the classical style.

AFTER
1666–67 Belgian-born English
engraver John Roettiers creates
a new Great Seal for restored
King Charles II of England.

16th century Italian sculptor
Leone Leoni produces struck
medals of subjects including
Michelangelo and Holy Roman
Emperor Charles V.

1896 Jules-Clément Chaplain,
medallist to the French state,
produces a gold medal to
commemorate the visit of Czar
Nicholas II of Russia to France.

See also: *Pallas and the Centaur* 122–23 ▪ *Young Man among Roses* 160 ▪
Très Riches Heures de Duc de Berry 162 ▪ *Adoration of the Magi* 162

Ludovico, perhaps as the pair to
a medal, also by Pisanello, that
depicts him. The daughter of the
Marquis of Mantua, Cecilia was
educated by Italian humanist
Vittorino da Feltre, himself the
subject of a Pisanello medal. Cecilia
famously refused an arranged
marriage and instead entered a
convent in 1445. She lived the rest
of her life as a nun. However, her
elegant profile on the obverse of
Pisanello's medal is depicted in
secular, courtly clothing.

On the reverse of the medal,
Pisanello presents an allegory of
Cecilia's intellectual brilliance and
virtue, using classical and medieval
symbols that reflect her humanist
education. He portrays a beautiful,
seminude woman in classical
drapery, who is seated in a rocky
landscape. One hand touches the
head of a unicorn that has the body
of a goat. The goat symbolizes
knowledge, while the depiction
of a maiden taming a unicorn was
a common symbol of chastity. A
crescent moon above the scene
represents the goddess Diana of
Roman myth.

This medal aided the spread of
Cecilia's reputation for purity and
intelligence, and her likeness, in
promotion of the Gonzaga dynasty.
It both commemorates Cecilia's
admirable qualities and showcases
Pisanello's masterly talent.

Medals of honor
Between 1438 and 1449 Pisanello
created medals for many of the
powerful ruling families of Italy.
Combining sensitive portraits with
symbolic yet realistically rendered
scenes, these represent the peak
of both the artist's work and the
Renaissance cult of the medal. ∎

Pisanello

Antonio di Puccio Pisano,
known as Pisanello, or "the
little Pisan," is thought to have
been born in Pisa around 1394.
He spent time in many Italian
cities, but was predominantly
associated with Verona. He
was notably employed at the
Este court in Ferrara and the
Gonzaga court in Mantua,
where he was noted for his
large frescoes. His few
surviving paintings have
secured him a reputation as
one of the figureheads of the
International Gothic in Italy.
His decorative painting style
was inspired by earlier 15th-
century artists such as Gentile
da Fabriano. In the field of
portrait medals, Pisanello
was the most important artist
of the 15th century. He made
more than 20 medals before
he died in Naples around 1455.

Other key works

c.1426 *Annunciation*
c.1438 Portrait medal of
Emperor John VIII Palaeologus
1449 Portrait medal of King
Alfonso V of Aragon

the occasion of his visit to Italy,
already displays the unprecedented
degree of fluid detail and expression
that the artist was able to achieve.
The piece is signed "the work of
Pisano the painter," as are all his
medals, indicating that he regarded
them as the equal of his paintings.

Cecilia Gonzaga
The medal of Cecilia Gonzaga
(1426–51) by Pisanello was probably
commissioned by her brother

THE NOBLEST PLEASURE IS THE JOY OF UNDERSTANDING

PALLAS AND THE CENTAUR (c.1482–1484), SANDRO BOTTICELLI

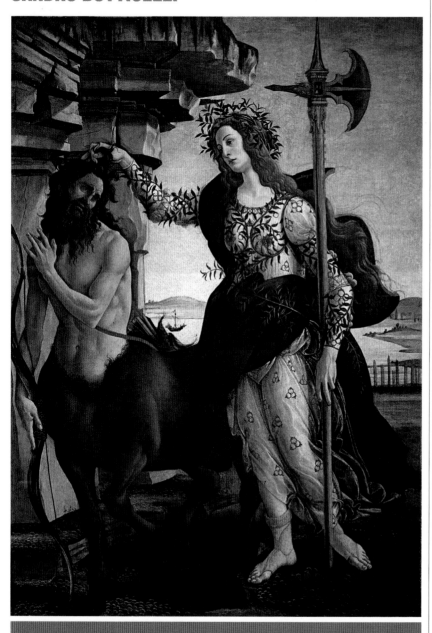

IN CONTEXT

FOCUS
Allegory

BEFORE
c.3000 BCE Ancient Egyptian artists employ allegorical groups of pictorial elements intended to be read together.

1338–39 Ambrogio Lorenzetti decorates the Palazzo Pubblico in Siena with a series of large allegorical frescoes.

c.1482–85 Botticelli paints the *Birth of Venus*, an allegory based on myth and containing Neoplatonic allusions.

AFTER
Early 1530s Hans Holbein the Younger paints *An Allegory of the Old and New Testaments*, combining images and words.

c.1670–72 Catholic convert Johannes Vermeer uses Christian iconography in his *Allegory of the Catholic Faith*.

The Renaissance—literally "rebirth"—was a period spanning the 14th to the 16th centuries during which scholars and artists looked back to antique sources for inspiration, aiming to revive the wisdom, grace, and nobility of the ancient world. The ideals of Christianity were reconciled with the paganism of classical antiquity in a school of thought called Neoplatonism. In art, mythology attained the same dignity accorded to Christian subjects, and mythical subjects proliferated in the 15th century. The use of myth in art often served an allegorical function: that is, it conveyed a veiled meaning, such

See also: *Renunciation of Worldly Goods* 86–89 ▪ *Maestà* 90–95 ▪ *The Tempest* 164 ▪ *Allegory with Venus and Cupid* 164–65 ▪ *Apollo and the Continents* 206–09

Sandro Botticelli

Alessandro di Mariano Filipepi, known as Sandro Botticelli, was born in Florence in 1445. He was apprenticed to the painter Fra Filippo Lippi and, by 1470, had his own workshop. He enjoyed the patronage of the powerful Medici family in Florence, for whom he executed numerous commissions. Between 1478 and 1490 he created his famous mythological works, such as the *Birth of Venus*. In 1481, he was called to Rome by Pope Sixtus IV to produce frescoes for the Sistine Chapel, the only significant work he did outside Florence. In the 1490s, Botticelli began to follow the apocalyptic preacher Savonarola, adopting a more simplistic style of painting with deeper moral overtones. His work fell out of favor and the once-prolific artist descended into poverty before his death in 1510. His name was almost erased from history until the late 19th century, when he was rediscovered, in particular by the Pre-Raphaelites.

Other key works

c.1477–82 *Primavera*
1500 *Mystic Nativity*

as a political stance, a didactic message, or a spiritual reference. The decoding of paintings that featured mythological subject matter therefore depended on a certain amount of sophistication in the viewer. Moreover, allegory could work on multiple levels.

In his allegorical paintings, such as *Primavera* (c.1477–82), *Pallas and the Centaur*, and the *Birth of Venus* (c.1482–85), Botticelli juxtaposes apparently incongruent figures and symbols to create a visual narrative for an informed body of spectators. Such works also served to flatter Boticelli's patrons, the Medicis, who moved in the circle of Neoplatonists in which the artist was also active.

Decoding the allegory

Pallas and the Centaur is an enigmatic painting, depicting a young woman with the fingers of her right hand entangled in the hair of an anguished centaur—a mythological creature that was part man, part horse. While there is no known myth in which this scene occurs, the woman is thought to be Pallas Athena, the Greek goddess of wisdom. Clues to Botticelli's allegorical intentions can be found in various tropes that are associated with each character.

The female figure is identified as Pallas Athena by the olive branches winding around her body: Botticelli's audience would have known that, in mythology, the goddess became the patron of Athens after offering its citizens an olive tree. However, his Pallas carries a halberd instead of the lance with which she is traditionally associated. A weapon that was often carried by sentries, the halberd here marks the goddess out as a guardian.

Renaissance Italians would have recognized the centaur as a personification of unbridled lust. In classical myth, these creatures were often depicted in pursuit of virginal nymphs. Pallas, by grabbing the centaur's hair, which is a symbol of his untamed instinct, holds him back, and he yields to her. The theme of the work can thus be read as the triumph of virtue and reason over passion and vice.

A further layer of allegory lies in the motif of the three interlinked rings—an emblem of the Medici family—repeated across Pallas's white dress. Lorenzo de' Medici, known as "the Magnificent," had recently formed an alliance with Naples that avoided war between Florence and the anti-Florentine forces led by the Pope. A political reading of the work equates Pallas with Lorenzo, representing peace, who is subduing the warlike instincts embodied by the centaur. ▪

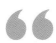

Botticelli's goddess—the Pallas Medicea—is ripe with irreducible meaning and identities.
Adrian W. B. Randolph
Engaging Symbols, 2003

THE EYE MAKES FEWER MISTAKES THAN THE MIND

STUDIES FOR *THE VIRGIN AND CHILD WITH ST. ANNE* (1490–1500), LEONARDO DA VINCI

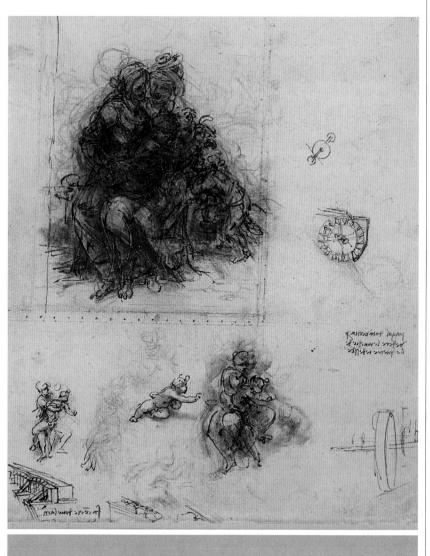

IN CONTEXT

FOCUS
Preparatory drawings

BEFORE
1400–25 An unknown artist compiles the *Vienna Album*, a model book of drawings of faces for artists' reference.

c.1475 Verrocchio makes a detailed preparatory drawing of a female head. It epitomizes the type of draftsmanship adopted by his pupil Leonardo.

AFTER
c.1507 Raphael produces preparatory drawings for his *St. Catherine of Alexandria* (c.1507), which offer insight into his creative processes.

1974 Joseph Beuys creates a group of drawings in response to the rediscovery of two lost notebooks by Leonardo: *Drawings after the Codices Madrid of Leonardo da Vinci*.

Medieval and early Renaissance artists relied on model books for much of their source material. These bound volumes of sketches and cartoons showed figures and faces, and other formulaic elements, which artists would copy and adapt into their own compositions. By the 15th century, however, practices were changing, with artists making far more use of drawings to record and develop their ideas, to refine forms and compositions, and to experiment with perspective.

Leonardo da Vinci trained as an artist in Florence under Andrea del Verrocchio, himself a talented and expressive draftsman. Although he

See also: *Maestà* 90–95 ▪ Santa Trinità *Madonna* 101 ▪ *Pallas and the Centaur* 122–23 ▪ *The Four Horsemen of the Apocalypse* 128–31 ▪ *The Miraculous Draft of Fishes* 140–43 ▪ *The Holy Family on the Steps* 184–85

Techniques for drawing, according to Leonardo da Vinci

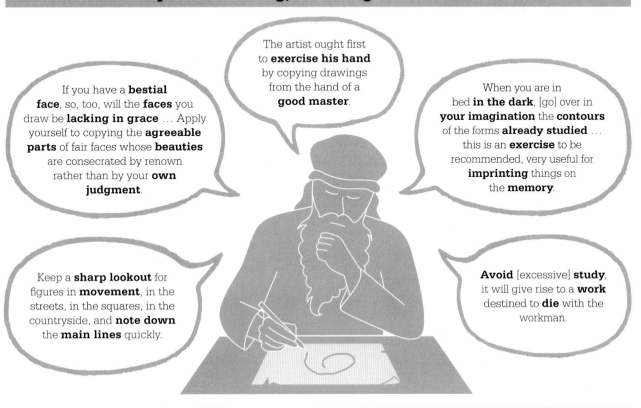

The artist ought first to **exercise his hand** by copying drawings from the hand of a **good master**.

If you have a **bestial face**, so, too, will the **faces** you draw be **lacking in grace** … Apply yourself to copying the **agreeable parts** of fair faces whose **beauties** are consecrated by renown rather than by your **own judgment**.

When you are in bed **in the dark**, [go] over in **your imagination** the **contours** of the forms **already studied** … this is an **exercise** to be recommended, very useful for **imprinting** things on the **memory**.

Keep a **sharp lookout** for figures in **movement**, in the streets, in the squares, in the countryside, and **note down** the **main lines** quickly.

Avoid [excessive] **study**, it will give rise to a **work** destined to **die** with the workman.

became known as a painter who created some of the most renowned works of Renaissance art, Leonardo was a brilliant polymath, who used his talent in drawing to explore ideas on many subjects, spanning engineering, geology, anatomy, optics, and architecture. He left notebooks filled with almost 2,500 drawings, which display his technical skill, his inventiveness, and the richness of his imagination, as he flitted from one subject to another, often within a single page.

Leonardo was fascinated with the notion of function, and used his drawings to record processes in the world around him—the flow of water and the flight of birds, for example—drawing inspiration for his inventions from these studies: some of his most famous jottings propose devices for flying or gliding. He also believed that "motions of the soul" could be perceived through close attention to human body language, gesture, and facial expression, dedicating himself to drawing faces and physiognomy in his sketches. Naturally, he also used preparatory drawings in the obvious sense—as preliminary studies for his ambitious artworks.

Exploring intent
One of the many sketches that elaborates Leonardo's working processes is a page of early studies

for *The Virgin and Child with St. Anne,* a theme that the artist explored several times. Now housed at the British Museum in London, this page of intricate, heavily worked sketches was made using a murky palette of brown ink, gray wash, and white and black chalk.

These studies for *The Virgin and Child with St. Anne* seem to be conceived in the round—more like sculpture than two-dimensional work. The figures interact and overlap, their somewhat hazy boundaries evoking something of the artist's mental processes in visualizing possible solutions to the chosen composition. The various characters appear as though »

Leonardo da Vinci

Leonardo da Vinci was born in 1452 near Vinci, Tuscany, the illegitimate child of a Florentine lawyer and peasant woman. In 1466, he moved to Florence, trained under Verrocchio, and later qualified as a master in the Brotherhood of St. Luke, an artists' guild. His *Adoration of the Magi* secured his reputation.

In 1482, he moved to Milan to start work for the court of the Sforza family. During his 16-year stay, he completed works such as *The Virgin of the Rocks* and *The Last Supper* for the refectory of Santa Maria della Grazie.

In 1499, Leonardo returned to Florence, where he painted the *Mona Lisa*, and furthered his enquiries into science and invention. He later settled in Château de Cloux (now Clos-Lucé) in Amboise, central France, at the invitation of Francis I, and died there in 1519, leaving most of his work to his pupil Francesco Melzi.

Other key works

1481 *Adoration of the Magi*
c.1495–98 *The Last Supper*
c.1503–19 *Mona Lisa*

blurred, captured mid-motion in an almost photographic way. Light markings at the peripheries of the drawing function as calculations—these are visible workings-out that are part of Leonardo's unique creative process—while additional drawings of figures and machinery litter the bottom of the page. The delicate outlines of isolated bodies sit side-by-side with intricately intertwined figures in more cohesive formations, in which it is possible to see Leonardo refining and recasting his poses, assessing each element for its autonomous merits as well as in the context of the larger composition.

The remarkable page of studies for *The Virgin and Child with St. Anne* is one of several existing drawings that are connected to Leonardo's unfinished painting of that name, which now hangs in the Louvre in Paris. Thought to have been commissioned by Louis XII of France, the painting was intended to celebrate the birth of the king's daughter, Claude, in 1499. Its subject matter is doubly apt, because Louis's wife was named Anne, and her saintly namesake in the painting was also the patron of pregnant women.

The painter or draftsman ought to be solitary, in order that the well-being of the body not sap the vigor of the mind.
Leonardo da Vinci

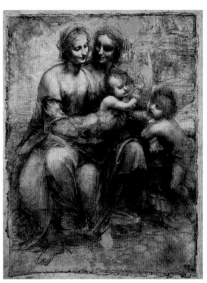

The Burlington House Cartoon (c.1499–1500) uses hazy contours created by soft charcoal and chalks to confer a sense of poetry and underpin an overall impression of gentleness.

Celebrated cartoons

In 1501 a large cartoon (a full-size preparatory drawing) of *The Virgin and Child with St. Anne* was exhibited in Florence to much public acclaim—an unprecedented reception for a drawing rather than a finished painting. Although that piece has been lost, another of Leonardo's cartoons—known as the Burlington House Cartoon—remains intact. Rendered in charcoal and chalks, it is unblemished by the pricked holes that are commonly used in the transfer of a cartoon onto a panel for painting, and was clearly never used to this end.

The Burlington House Cartoon composition resembles the British Museum sketch more closely than the Louvre painting. The cartoon includes the figure of John the Baptist on the right. St. Anne's slender hand points toward the sky in a symbolic gesture alluding to Christ's destiny. Like several of the extremities in the picture, the hand

seems flat and unfinished. Its incomplete appearance could be a symptom of the restless interest that was characteristic of Leonardo; once the gesture was resolved, perhaps he saw little point in pursuing it further.

The exact sequence in which Leonardo completed his various preparatory sketches for *The Virgin and Child with St. Anne* is uncertain, but it is clear that he revised the composition significantly between the British Museum drawing and the painting. The figures in the drawing are the Virgin Mary, St. Anne, and the infants Christ and John the Baptist. By the time of the painting, Leonardo had replaced John the Baptist with the Lamb of God (a symbol of Christ's sacrifice in the biblical narrative), removed Jesus from his mother's lap, and given more prominence to St. Anne, who became the axis of the triangular composition.

Leonardo was notorious for his tendency to leave work incomplete. His dedication to formulating a composition far outweighed his interest in finishing it. Frustrating for his patrons, this habit did nothing to diminish his reputation for genius. The various drawings for *The Virgin and Child with St. Anne* demonstrate the muscular nature of his intellect, charting an intricate map of a unique, incredible mind.

The rise of the sketch

The use of preliminary sketches as a key element of artistic practice was endorsed by Renaissance artists such as Raphael, Sandro Botticelli, and Titian, and later

confirmed by a number of revered artists, from J. M. W. Turner to Pablo Picasso and German painter and sculptor Anselm Kiefer. Preparatory notebooks and drawings have become an intrinsic part of the creative progress, synonymous with the vital and mysterious process that prefigures great work. Such drawings have now become an end in themselves; they are regularly composed and exhibited as finished pieces, valued for their immediacy, and recognized as offering an intimate connection with the artist. ■

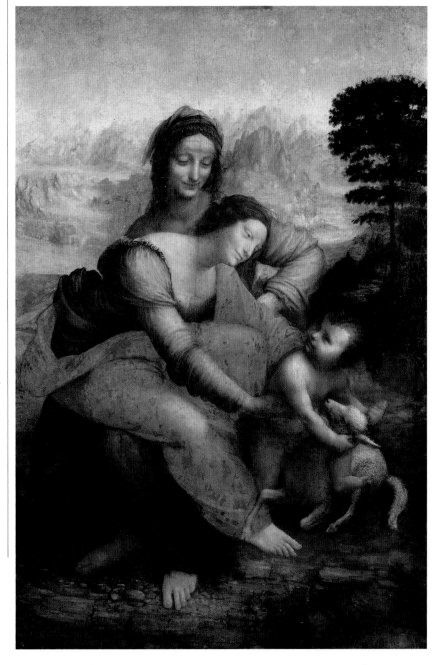

Leonardo's painting *The Virgin and Child with St. Anne* (c.1503–19) shows the figures in a dramatic landscape, teetering on the edge of a canyon, which brings tension to the scene.

TERRIFYING VISIONS OF THE HORRORS OF DOOMSDAY

THE FOUR HORSEMEN OF THE APOCALYPSE (1498), ALBRECHT DÜRER

IN CONTEXT

FOCUS
The print

BEFORE
1423 An anonymous artist makes the earliest known woodcut print, an image of St. Christopher.

c.1475–91 German printmaker Martin Schongauer produces his *Passion of Christ* series of 12 copperplate engravings.

AFTER
c.1510 In Rome, Italian artist Marcantonio Raimondi starts making engraved copies of Raphael's paintings.

c.1630 Rembrandt creates a group of self-portrait etchings in which he tries out different facial expressions.

1893 Primitivist Paul Gauguin experiments with crudely carved woodcuts of scenes from his Tahitian travels.

In 1498, the German artist Albrecht Dürer published a series of woodcuts depicting an apocalyptic descent of hellish fury upon the people. The series of 15 works plus a title page, along with the biblical text on which the prints were based, was published as a bound edition titled *Apocalypse*. Two versions—one Latin and one German—were printed. The series brought the artist fame, fortune, and independence, and set a new standard for printmaking that even today is technically unparalleled. Dürer's masterly manipulation of the woodcut is exemplified in his print *The Four Horsemen of the Apocalypse*, from the series.

See also: *Garden of Earthly Delights* 134–39 ▪ *A Rake's Progress:
The Levée* 200–03 ▪ *The Colosseum* 204–05 ▪ *The Disasters of War* 230–35

Prints, such as this woodcut from the Nuremberg Chronicle depicting Christ and the apostles, were often hand-colored. The style is far cruder than Dürer's work of just a decade later.

The growth of printing

Woodcut printing became popular in early 15th-century Europe, as paper became cheaper and more widely available. A way of rapidly disseminating images, prints were sold individually or as collections. Often hand-colored, they were eventually combined with movable type to illustrate text.

The painter and printmaker Michael Wolgemut, based in Nuremberg, Germany—a center of publishing and humanism—was instrumental in reinvigorating the woodcut after a decline in quality in the mid-15th century. With Wilhelm Pleydenwurff, Wolgemut produced more than 600 woodcuts to illustrate the *Liber chronicarum* (or Nuremberg Chronicle; 1493), one of the earliest printed books.

As a young man, Dürer was Wolgemut's apprentice, but his prowess with the woodcut was to far surpass that of his master. As well as being a superb draftsman, the techniques of woodcut and, later, engraving, came easily to him. The *Apocalypse* series was his first attempt at a full set of prints.

Working the wooden block

Dürer did not invent the Four Horsemen of the Apocalypse: the scene comes from the Book of Revelation, a popular source for biblical illustrations in the Middle Ages. The New Testament book describes the apocalypse—a time of catastrophic events, Christ's return to Earth, and the judgment of humankind—in vivid symbolic imagery. Many people believed that it prophesied the end times, and as the half-millennial year 1500 approached, images of violent events grew increasingly prevalent, cropping up in everything from manuscripts to frescoes. »

In harmony with that late medieval tradition, Dürer teaches that death finally makes equals of us all.
Robert H. Smith
Apocalypse: A Commentary on Revelation in Words and Images, 2000

Albrecht Dürer

Born in Nuremberg, Germany, in 1471, Albrecht Dürer was the son of a goldsmith. At age 15, he went to study with Michael Wolgemut, in whose workshop he learned the woodcut technique. In addition to creating prints on religious themes and nature studies, Dürer produced self-portraits and numerous drawings, watercolors, and prints of plants, animals, and the nude figure. In 1506 he painted the *Feast of the Rose Garlands* altarpiece in Venice. Its vibrancy was a response to Italian critics who believed him unable to handle color. He wrote several theoretical books, including one on geometry and *Four Books on Human Proportion*.

Dürer died in Nuremberg in 1528, the greatest figure of Renaissance art in northern Europe. He was the first artist of his caliber to devote so much time to printmaking.

Other key works

1502 *Young Hare*
1513–14 Three "Master Engravings": *Knight, Death, and the Devil*; *Saint Jerome in his Study*; and *Melencolia I*

He who would spread colors on Dürer's prints would injure the work.
Erasmus
Dialogues, 1529

The passage illustrated in this particular woodcut is part of "the opening of the seals" (6:1–8). It tells how the fastenings that seal shut a book, or scroll, held in God's right hand are broken by a lamb with seven horns and seven eyes. The opening of the first four seals releases the horsemen so vividly rendered in this woodcut—from right to left, Plague (or Conquest), War, Famine, and Death—thereby unleashing the divine apocalypse.

The viewer encounters these riders as they burst out of Heaven. The mouth of Hell opens up in the bottom left corner. The horror of this moment is depicted with unprecedented urgency. Broad white planes where no ink has transferred contrast with intricately cut dark ridges. The realistic depiction of people and horses alludes to the real world, but the galloping horror and exaggerated contrasts lend an uncanny atmosphere to the scene.

Dürer's extensive range of mid-tones between black and white, produced using hatching and a combination of thicker and thinner lines, enables him to suggest light, shadows, texture, and volume, creating convincing naturalistic effects. The difficulty of carving such delicate and closely packed lines from a section of wood has led some art historians to speculate that the artist might have carved these woodblocks himself, rather than working with skilled block-cutters as is usually supposed.

The parallel lines that make up much of the background form a contrast to the diagonal thrust of the horses, a trajectory emphasized by the sword held threateningly aloft by War. As the horsemen tear through the level plane of the earth, Dürer demonstrates structurally the irrevocable destruction of the status quo, exemplifying his careful marriage of subject and medium.

Dürer's characterization of each of the riders and victims is detailed and varied. This is a miraculous feat given the dexterity required to achieve this level of differentiation on the wooden block. The figure of Death, toward the bottom left corner, is particularly grotesque; from the weak, bony wrists to one long, drooping nipple, and from the

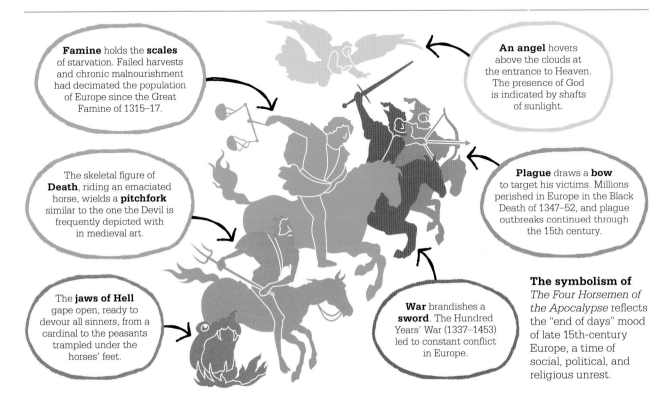

Famine holds the **scales** of starvation. Failed harvests and chronic malnourishment had decimated the population of Europe since the Great Famine of 1315–17.

An angel hovers above the clouds at the entrance to Heaven. The presence of God is indicated by shafts of sunlight.

The skeletal figure of **Death**, riding an emaciated horse, wields a **pitchfork** similar to the one the Devil is frequently depicted with in medieval art.

Plague draws a **bow** to target his victims. Millions perished in Europe in the Black Death of 1347–52, and plague outbreaks continued through the 15th century.

The **jaws of Hell** gape open, ready to devour all sinners, from a cardinal to the peasants trampled under the horses' feet.

War brandishes a **sword**. The Hundred Years' War (1337–1453) led to constant conflict in Europe.

The symbolism of *The Four Horsemen of the Apocalypse* reflects the "end of days" mood of late 15th-century Europe, a time of social, political, and religious unrest.

Knight, Death, and the Devil (1513) is one of Dürer's most accomplished engravings, full of complex symbolism. The artist's signature initials can be seen on the plaque at bottom left.

sinuous limbs to the wildly staring eyes, slack jaw, and tangled beard, every feature coheres to convey a personification of evaporated life. This rider embodies death in a horrifying but poignant way.

Expert engraving

After the success of his *Apocalypse*, Dürer went on to produce several series of woodcuts, mostly of religious subjects, in which he continued to expand the medium. The works were larger than was usual, bursting with imagery, and with a unique fineness of line. The influence of a visit to Italy in 1494–95, where he studied the new techniques of the Renaissance, can be seen in the way he shaped expressive, substantial figures and carefully positioned them within settings that used perspective to draw in the viewer's gaze.

In the early 1500s, Dürer started to make engravings as well as woodcuts. These were both secular and religious, synthesizing motifs he had picked up in Italy with the Germanic Gothic tradition.

Where woodcut printing is a relief method, involving paring away the areas not to be printed, an engraver incises lines into a metal plate. These hold the ink, which is pressed onto the paper. Engraving usually achieves finer lines and greater detail than woodcuts, a fact that gradually led it (and etching, a similar method) to become the favored printing technique among artists. Engraving allowed Dürer to experiment with subtle nuance, soft contrasts, and fine detail. He used hatching to produce effects of light and shadow, and expertly wielded his burin (engraving tool) to create texture.

A printmaking revolution

Dürer's woodcuts and engravings secured his reputation, and were widely copied and emulated. Engraving was an efficient way to make multiple copies of paintings, and many artists made careers as reproductive engravers, often in collaboration with the original artists. Marcantonio Raimondi worked with Raphael to make engraved copies of his paintings, while other artists, including Pieter Bruegel the Elder, made drawings with the intention of having them engraved. In the 17th century, Rembrandt produced numerous original engravings and etchings. These included landscapes and self-portraits, and show extensive experimentation. With his *Four Horsemen*, then, Dürer unleashed an important and enduring printing revolution on the world. ∎

A NIGHTMARE CAST WITHIN THE FEMALE FORM
GODDESS COATLICUE (1400–1500)

IN CONTEXT

FOCUS
The earth goddess

BEFORE
c.30,000 BCE Voluptuous "Venus" figurines appear in sites across Europe.

c.950–930 BCE The Egyptian Greenfield Papyrus shows Nut (goddess of the sky) arching her body over the Earth.

c.160–150 BCE A marble coffer lid from the temple of Athena Polias at Priene depicts Gaia, the Greek mother goddess.

AFTER
18th century Wooden statues of earth goddess Vasundhara, a Buddhist bodhisattva, in Southeast Asia show her wringing water from her hair.

1874 English artist Dante Gabriel Rossetti paints *Proserpine* (Persephone), the Roman goddess of fertility.

Since prehistoric times, earth goddesses have played a key role in the creation stories and iconography of cultures across the globe. From rock carvings and roughly hewn figurines to effigies, mosaics, and complex paintings and sculptures, representations of the goddess are among the oldest and most enduring traditions in art. In many cultures, the earth-mother figure celebrates life and death as key aspects of the rhythms of the natural world. The art created to celebrate female potency and creativity is a powerful response to the human need to make sense of the interconnectedness of birth, life, and death.

The nurturing goddess

Despite the importance of the earth goddess's dual nature, she is often seen in art in her more benign form, embodying the bounty of the earth. Demeter, Greek goddess of agriculture, is often shown with a crown of corn. Her daughter, Persephone, who governs the vitality of the land, is frequently shown holding a pomegranate, symbolic of plenty and fertility, or a sheaf of corn, as in the 5th-century BCE votive tablet pictured here. The Phrygian earth goddess, Cybele—known to the Romans as the Great Mother of the Gods—was associated by the Greeks with the fertility goddess Artemis and depicted in sculpture as the many-breasted, nurturing Lady of Ephesus.

Isis was the powerful ancient Egyptian mother goddess also associated with rebirth and the dead. Numerous small statues portray her suckling her son Horus, holding his head in her left hand and offering him her breast. This image may have influenced the early Christians in their depictions of Mary nursing the baby Jesus.

Creator and destroyer

The monumental basalt statue of the Aztec earth goddess Coatlicue (11 ft high/3.5 m), considered a masterpiece of Aztec sculpture, is a strong example of this complex role of the earth-mother figure.

Excavated in 1790 in Mexico City, the piece is symmetrical and would originally have been brightly painted. Coatlicue wears a skirt of intertwined rattlesnakes, reflecting the meaning of her name, "Skirt of Snakes"; the snakes may have been a symbol of fertility. She also wears a necklace of human hands and hearts, a belt stamped with a pattern of concentric circles, and a skull at the center of the belt. The repetitive pattern links to the Aztec belief that creation can be repeated by means of ritual re-enactment.

The goddess, a symbol of nature as both creator and destroyer, is depicted in her most fearsome form: she is shown decapitated, with two snakes coming out of her neck in place of her head—a convention in Aztec art to signify spurting blood. The snakes' heads face one another, each with a forked tongue, staring eye, and bared teeth; together the effect is of a broad mask in place of the goddess's face. The statue's visual references to decapitation, blood, and death may reflect the Aztec belief that human sacrifice was essential to propitiate the gods and continue the cycle of creation—a concept reinforced by the striking juxtaposition of Coatlicue's breasts with a skull. The human-looking breasts, partially obscured beneath the necklace and skull, have been sucked dry by hundreds of children.

The statue is skillfully carved, with great attention to detail, down to the scales on the snakes, and a roll of fat on the goddess's stomach that indicates she has given birth. She is sculpted in the round, and leans forward a little, emphasizing her tremendous, terrifying bulk.

Devourer and empowerer

Coatlicue was not the only earth goddess with a destructive side. In Hindu iconography, similar symbols of destruction and regeneration are assigned to Kali, who governs death, time, sexuality, and maternal affection—she is benevolent and nurturing as well as fearsome and chaotic. In paintings and statues she is frequently shown with a garland of skulls and numerous arms—the latter representing a full cycle of creation and destruction. Her hideous red tongue suggests bloodthirsty appetites, but her white teeth convey purity. ▪

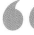

It is surely one of the most direct and most unequivocal pieces of art in history— nothing can mitigate its horror.
Burr Cartwright Brundage
The Fifth Sun: Aztec Gods, Aztec World, 1979

THE MASTER OF THE MONSTROUS

THE DISCOVERER OF THE UNCONSCIOUS

THE GARDEN OF EARTHLY DELIGHTS (c.1490–1510), HIERONYMUS BOSCH

Detail from *The Garden of Earthly Delights*

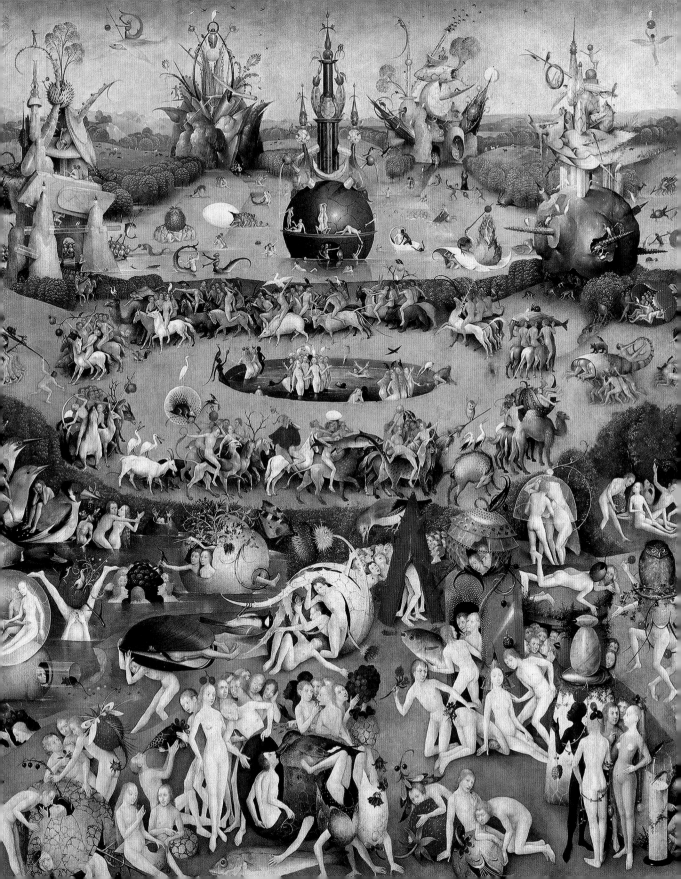

IN CONTEXT

FOCUS
Fantasy

BEFORE
c.700 Fantastical bronze dragons are cast by artists of the Tang Dynasty in the golden age of Chinese art.

From c.1200 Hybrid monsters and strange creatures peer out from bestiaries (books of beasts) and from the margins of illuminated manuscripts, influencing the fantasy art of later generations.

AFTER
1562 Among Bosch's many imitators is Pieter Bruegel the Elder, who populates his painting *The Fall of the Rebel Angels* with grotesque fantastical beings.

From c.1920 The Surrealists draw heavily on fantasy in their depiction of strange scenes, figures, and creatures, and dreamlike, alien worlds.

B osch's hallucinatory composition *The Garden of Earthly Delights* is a fantastical work of art. Utterly unconventional, it deviates substantially from mainstream Netherlandish art of the time. The idiosyncrasy of the work, combined with the mystery surrounding its creation—the artist left no letters to illuminate his thoughts—has led to speculation about how to read Bosch's fantastical motifs: were they intended to convey heretical or occult meaning, to shock and titillate, or—as most art historians agree—to work as orthodox morality tales? This explosive, sinister work uses fantasy to demonstrate the perils of earthly indulgence—especially lust—and its frightening consequences in the context of Christian faith.

Picturing the imaginary

In broad terms, fantasy is an ingredient in much visual art: any depiction that draws on the artist's imagination can be said to have an element of fantasy in it. However, in art theory, the term is more specific and is often used to describe representational—

If there are any absurdities here, they are ours, not his … they are painted satires on the sins and ravings of man.
Brother José de Sigüenza
History of the Order of St. Jerome, 1605

rather than abstract—works that have supernatural or imaginary themes. Depictions of heaven and hell, mythological or magical characters, grotesques, and invented landscapes can all be described as fantasy. Religious painting is generally excluded from the category, which makes this painting all the more unusual. Fantasy can be seen in many artistic movements throughout history, from ancient Egyptian, Romanesque, and Renaissance art to Surrealism.

Hieronymus Bosch

The Netherlandish artist Jerome van Aken—better known as Hieronymous Bosch—was born around 1450. He lived and worked in 's-Hertogenbosch, part of the former Duchy of Brabant. Bosch came from a family of artists: his grandfather was the painter Jan van Aken, his father was artistic adviser to a religious confraternity, and his uncles were also artists.

Highly enigmatic, he signed only a few of his works with his pseudonym, "Hieronymus" being Latin for Jerome, and "Bosch" the abbreviated name of his home town. Bosch was a member of the Brotherhood of Our Lady, a conservative religious group. Evidence suggests that he was a pious and respected figure and, while some of his paintings seem eccentric to modern eyes, they reflect traditional views. Records kept by the Brotherhood show that Bosch died in 1516.

Other key works

c.1480 *Crucifixion*
c.1480–90 *Tabletop of the Seven Deadly Sins*
c.1485–90 *The Haywain*
c.1500 *Temptation of St. Anthony*

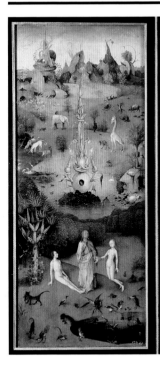
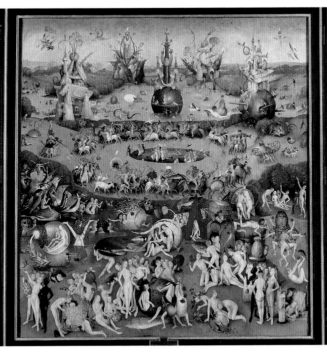

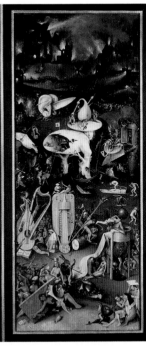

Bosch's extraordinary painting is a product of the very real beliefs and fears that found currency during a specific cultural period. The monsters might have crawled out of Bosch's imagination, but they were nevertheless an expression of conventional religious doctrine of the time. His fantastical subjects created distance from reality while also promoting a series of clear moralistic messages.

The three panels

The Garden of Earthly Delights is a triptych, meaning that it is made up of three separate panels. These are intended to be viewed and read in sequence, from left to right.

The first panel, on the left, depicts the Garden of Eden: God introduces Adam and Eve to one another and blesses their union. The landscape is lush and thriving. A strange pink fountain sits in the middle, with a scattering of glass vials, of the type used in scientific experiments, discarded around its base. This is the Fountain of Life, source of all rivers in Paradise.

A menagerie of real and fantasy animals populates the flourishing countryside in order to reveal God's boundless creativity, featuring

> 66
>
> [Bosch] succeeded in giving ... tangible shape to the fears that had haunted the minds of man in the Middle Ages.
> **E. H. Gombrich**
> *The Story of Art*, 1950
>
> 99

The Garden of Earthly Delights was probably commissioned for the home of a wealthy lay patron; its suggestive subject matter makes its use as an altarpiece unlikely.

everything from a unicorn and a two-legged dog to alligators and a porcupine. In this section, Bosch imagines a snapshot of the moment before the full force of sin and human procreation is finally unleashed on the world.

The central panel warns against sins of the flesh; rather than being a direct representation of the world, this is the "garden of earthly delights." An orgiastic atmosphere is expressed using a variety of fantasy symbols, including giant strawberries and an abundance of fruit in general. Strawberries had been linked to Christ's blood, but their plump fleshiness here suggests lust and sexual activity. »

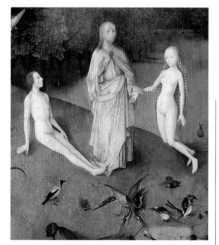

At the epicenter of this panel is a pool of naked women. The implied sexual vice here invites negative comparison with the Fountain of Life in the first scene. Women were often portrayed as temptresses in contemporary imagery and literature, a prejudice stemming from the story of Eve in the Garden of Eden; tricked by the serpent into tasting the Forbidden Fruit, she subsequently led Adam astray too. Bosch's women are surrounded by naked men mounted on frenzied animals—a blatant allusion to sexual intercourse.

The Garden of Eden, in the first panel, is rich with dark humor. Adam's expression has been read as lustful, suggesting that the seeds of humanity's fall were present from the start.

Fantasy is cleverly used by Bosch to draw a veil of metaphor over potentially shocking subjects. The artist is careful not to depict sin directly, but taps into forbidden sensual fantasies, such as gluttony and promiscuity. To the spectator of the time, weighted with religious belief, these moralistic allusions would have been all too clear.

The final panel—Hell—takes a sinister turn: horror lurks in unexpected places. Bosch paints for the viewer a hellish fantasy, unleashing monsters from the depths of his imagination. The theme that permeates this panel is of a great purge. Flames lick at the city walls and figures are bent double with vomiting. An enthroned bird-demon systematically ingests victims, excreting them through the base of a latrine chair. Torture is present everywhere. Limbs are repeatedly pierced with sharp instruments, and fantastical

Others try to paint man as he appears on the outside, while he alone had the audacity to paint him as he is on the inside.
Brother José de Sigüenza
History of the Order of St. Jerome, 1605

structures destroy bodies. On the left of the panel, beneath the skull of an animal, a bell with human legs protruding from it swings from side to side. The death knell tolls for humankind.

Sensory appetites

A common motif in the last panel is the musical instrument as a symbol of sensory distraction (lust was often referred to as "the music of the flesh"). Most prominent are a huge harp and lute, and two kinds of pipe. By exaggerating these objects to implausible proportions, the artist renders the familiar uncanny, implying a discordant symphony of horror. The instruments are complemented by two large severed ears and a sharp blade that protrudes out between them (see opposite, bottom)—an obvious phallic metaphor. The ears are also an allusion to the senses and to the temptation of overindulgence in

An expert in bird anatomy, Bosch displays an accurate knowledge of the subject in *The Garden of Earthly Delights*. Some 25 species of bird have been identified in the painting.

sensual pleasure: human beings' sensory appetites are far bigger than pious morality can ever permit.

Presiding over all of this is a conspicuously large monster: part tree, part egg, it balances bagpipes and a procession of smaller creatures on its human head (see below), and may be a metaphor for deranged psychological cognition. Some art historians support the belief that this is a self-portrait of Bosch himself, but there is no firm evidence to confirm the idea.

When the hinged side panels of the triptych are closed, their outside surfaces form a translucent image of Earth, painted in *grisaille*, or shades of gray. A minute figure of God can be discerned, along with a quotation from Psalm 33.9: "For he spoke and it was done; He commanded, and it stood fast." Some scholars believe that the outer surfaces represent the newly formed Earth before the creation of Eve. Others see it as a reference to the flood sent by God in the time of Noah.

Strange orthodoxy

Bosch's style—like his richly suggestive, surrealistic subject matter—differs from the smooth precision of other artists of the

time. His brushwork is lively and animated and his fluid application of thin layers of oil paint produces a loose, textured finish very different from the glossy finesse coveted by his contemporaries. While other artists strove to conceal the painter's presence, Bosch asserts himself in the execution of this work. This draws attention to the painting as a fantastical scene conjured by a human hand out of a human mind.

The earliest surviving response to *The Garden of Earthly Delights* dates from 1517, when Antonio de Beatis—secretary to the Cardinal of Aragon—encountered it in the palace of the Nassau Counts in Belgium. This palace was a political hub of the Netherlands, and regularly hosted high-profile diplomatic events. The painting

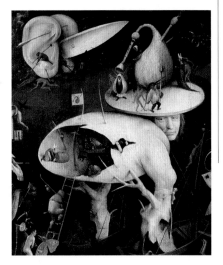

A creature with a human head, treelike legs, and a body formed from a broken egg dominates the grim final panel of the triptych. The bagpipe on his head is a symbol of carnal lust.

The damned are devoured, tortured, and tormented in the third panel. The extraordinary scenes seem to anticipate the alien landscapes and forms created by some 20th-century Surrealist artists.

was enthusiastically received by its distinguished audience. After Bosch's death the work was copied and translated into tapestries. It influenced other masters of spine-tingling unease, most notably Pieter Bruegel the Elder.

Fantasy and function

The fantasy genre, with its realistic depictions of unreal features, has served many purposes. Artists of the Surrealist movement, which began in 1920s Europe, painted bizarre scenes with photographic realism in order to express the "real functioning of thought." In stark contrast to Bosch, who used fantasy as a didactic tool, they explicitly distanced themselves from moral judgment, but, like Bosch, shocked viewers with their fascinating exuberance. ∎

A PAINTER MUST COMPENSATE THE NATURAL DEFICIENCIES OF HIS ART

THE MIRACULOUS DRAFT OF FISHES CARTOON (1515–1516), RAPHAEL

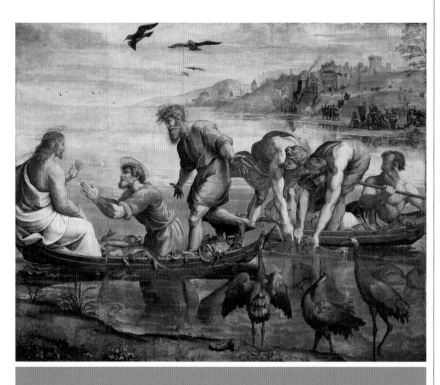

IN CONTEXT

FOCUS
The Grand Manner

BEFORE
Late 15th century
Michelangelo's work in
Florence signals the zenith
of the High Renaissance.

c.1502–03 Italian painter
Pietro Perugino produces
cartoons for stained-glass
windows in Florence. He
becomes a mentor to Raphael.

AFTER
Late 16th century The
Bolognese school of artists
references Raphael's grand
Renaissance style of painting.

17th century Giovanni Pietro
Bellori articulates his idea of
the Grand Manner.

1769–90 Joshua Reynolds
delivers his *Discourses on Art*
at the Royal Academy, London,
explaining the Grand Manner.

The Grand Manner is a term used in art criticism to describe the most serious and elevated works achievable—works that have as their goal the moral enrichment of the viewer. They may have as their subjects significant or instructive moments from myth, literature, or history, and they typically feature dignified compositions of multiple figures.

The concept of the Grand Manner was first articulated by the 17th-century Italian writer and collector Giovanni Pietro Bellori. He praised artists such as the French Baroque painter Nicolas Poussin and the Carracci brothers of the Bolognese school for producing works

See also: Apocalypse Tapestry 101 ▪ Studies for *The Virgin and Child with St. Anne* 124–27 ▪
The Holy Family on the Steps 184–85 ▪ *Captain the Honorable Augustus Keppel* 224

characterized by a grand subject, conceit, and structure. These artists owed a considerable debt to Raphael: Poussin was greatly inspired by the clarity of form in Raphael's work; and the Carracci brothers took blatant cues from Raphael's paintings, eschewing the fashionable theatrics of Mannerism in favor of reviving his lofty values and solid figures.

The nature of the Grand Manner, and Raphael's role as its originator, was explored in the 18th century by the president of the Royal Academy in London, the portraitist Joshua Reynolds. In his *Discourses on Art*, Reynolds argued that Raphael's genius lay in his unique ability to capture general "ideas" of reality. Rather than copying from life, he painted idealized versions of subjects from his imagination, using artistic licence to portray dignity, grandeur, and beauty, and to compensate for the deficiencies of reality. Raphael became known posthumously as father of the Grand Manner and inspired critics such as Bellori and Reynolds to study his formula for producing highbrow masterpieces.

Raphael was seen to have accomplished the perfect and harmonious composition of freely moving figures.
E. H. Gombrich
The Story of Art, 1950

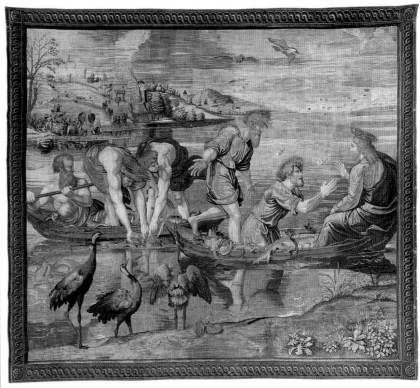

Among Raphael's greatest works, and exemplars of the Grand Manner, are his cartoons—full-size designs for a set of tapestries that were to cover the lower walls of the Vatican's Sistine Chapel in Rome.

Cartoons and tapestries

"Cartoon" is a Renaissance term for a full-size preliminary drawing for a large work in a different medium; it originates from the Italian *cartone*—a large piece of paper. Raphael's Vatican cartoons depicted the Acts of St. Peter and St. Paul (books of the Bible). Ten were commissioned in 1515 by Pope Leo X—an accolade for Raphael, since the tapestries made from them were to hang alongside frescoes by great artists such as Sandro Botticelli and Perugino, and below Michelangelo's ceiling, in the Sistine Chapel.

This tapestry of *The Miraculous Draft of Fishes* was made in Brussels, the textile capital of Europe. It is a mirror image of the cartoon because it was worked on from behind.

Raphael's cartoons are as grand in scale as in intention, qualifying as history paintings (paintings with subject matter drawn from history, mythology, or the Bible) in their own right. Each one is made up of about 200 sheets of paper glued together. Compositions were applied to the paper in charcoal and finished in distemper (water, pigment, and animal glue). The finished paintings were sent to a specialist workshop in Brussels, cut into strips, and distributed among a team of expert weavers. The woven pieces were then sewn together to produce a tapestry. »

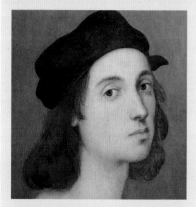

Raphael

Raffaello Sanzio, or Raphael, was born in Urbino, Italy, in 1483. His father, Giovanni Santi, was court painter to Renaissance prince Federico da Montefeltro, and gave the young Raphael a sound education in the arts; by 1500 the teenager was a master in his own right. He fulfilled commissions across Italy, spending his formative years in Florence, where he was influenced by Leonardo da Vinci and Michelangelo.

Raphael traveled to Rome in 1508 to produce frescoes at the Vatican. Partly because of his heavy workload, assistants often executed paintings after his designs: the cartoons for the Sistine Chapel were finished in this way. Raphael became a successful architect in 1512 and was appointed to plan a survey of Rome's antique monuments in 1517. Famed in his own life, Raphael died of a fever in 1520. He is considered one of the greatest painters in the history of art.

Other key works

1506 *Madonna of the Meadow*
1509–11 *The School of Athens*
c.1512–13 *Sistine Madonna*
1520 *Transfiguration* altarpiece

Raphael's *The Miraculous Draft of Fishes* deals with a noble biblical theme; it is moralistic, wholesome, and transcendent. In the episode depicted in the cartoon, Christ sends his fishermen apostles out into deep water to cast their nets, and their previously barren boats are soon overflowing with fish. Peter kneels at the feet of Christ, and the apostles forsake everything to follow Christ and become fishers of men. The morally instructive tone—a trademark of the Grand Manner—sets the example of unconditional loyalty for viewers to emulate. Through it, they can learn not only how they should act, but also the obvious redemptive rewards for doing so.

Divine presence

In the grand composition of *The Miraculous Draft of Fishes,* the fishermen all possess the same muscular body, purged of human flaws and fit to take on God's work. Reynolds describes Raphael's approach here as "poetic," because the physical defects of the apostles are explicitly documented in the Bible. In the cartoon, their bodies are concealed beneath simple tunics, showing strong limbs that exhibit a commitment to laboring in Christ's name. Such idealization of form typifies the Grand Manner.

Reynolds considered a simple color palette to be a key feature of the Grand Manner, and Raphael's painting contains just six basic colors: blue dominates the picture, present in everything from the distant town to the cranes to the water itself; white is used primarily for Christ's robe and lofty elements of the sky; green appears on the hillside and on the tunic of the apostle Andrew; and red runs through the warm brick buildings, is picked up in glowing skin, and is at its brightest in the fabric whipped around the apostle James by the wind. The boats are yellow, while gold is reserved for the haloes above Christ and two apostles.

For *The Triumph of Galatea* (1511–14) Raphael stated that he had invented "a certain idea" for the figure of Galatea—a representation of ideal beauty—rather than basing her on a real person.

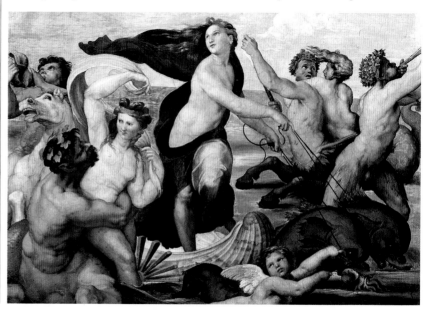

Animal symbolism in *The Miraculous Draft of Fishes*

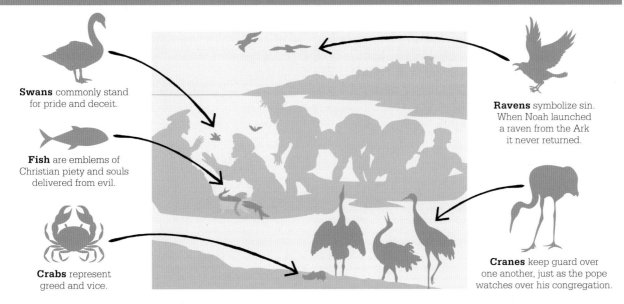

Swans commonly stand for pride and deceit.

Fish are emblems of Christian piety and souls delivered from evil.

Crabs represent greed and vice.

Ravens symbolize sin. When Noah launched a raven from the Ark it never returned.

Cranes keep guard over one another, just as the pope watches over his congregation.

The composition of the boats and the land leads the viewer's eye to the seated Christ on the left, while the activity of the apostles is also carefully choreographed to move in his direction. This activity peaks in the upright figure of Andrew and the birds above him, moves through the praying figure of Peter, and is resolved by Christ's calm blessing.

Eschewing extraneous detail, Raphael distills his story into a series of expressive bodies, all united in one undulating but balanced group. In Grand Manner style, balance is a key theme of the picture. Christ sits at one end of a boat, mirroring Zebedee on the opposite side. This demonstrates Christ's humility—the son of God balancing a rough mortal. The meanings conveyed through the harmonious composition are supported by the symbolism of color and of other elements, especially the animals, within the painting (see above).

Prestige and painting

The Grand Manner was the most prestigious style of art until well into the 19th century, and became embedded as such within the art establishment to the detriment of other genres, such as still life or scenes of daily life. Art students were schooled in this style, often by copying directly from Raphael's cartoons. Grand Manner style was applied not just to historical narratives, but also to portraiture, where visual metaphors, including classical poses and Arcadian settings, were used to indicate the high status of the sitter.

The Grand Manner exerted a huge influence over the evolution of European art, but during the 19th century the artistic vogue for flawless perfection petered out in favor of realism. However, its unashamedly constructed beauty remains the goal of many artists today, and similar values are widely embraced by photographers and image-makers in the 21st century. ◼

Joshua Reynolds' *Jane, Countess of Harrington* (1778) is typical of Grand Manner portraiture. It uses classical buildings and graceful landscapes to signify civilization and sincerity.

BY SCULPTURE I MEAN THAT WHICH IS DONE BY SUBTRACTING

YOUNG SLAVE (c.1530–1534), MICHELANGELO

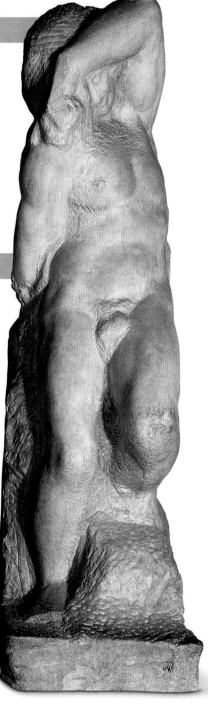

IN CONTEXT

FOCUS
Non-finito

BEFORE
Early 15th century Florentine sculptor Donatello pioneers *non-finito* in his bronze statues and relief works to intensify their spiritual impact and add dramatic effect.

Late 15th century Florentine artist Sandro Botticelli explores the use of *non-finito* techniques in painted figures.

AFTER
1875 French sculptor Auguste Rodin is inspired by Michelangelo's and Donatello's immensely expressive use of *non-finito* and travels to Italy to study their work.

Early 20th century Modernist sculptor Jacob Epstein revives the tradition of carving directly into stone, and champions the belief that form should be true to its material.

There are few works of art in which the struggle between material and subject is so viscerally apparent as in Michelangelo's *Slaves*, a set of marble sculptures of slaves originally intended to adorn the tomb of Pope Julius II. Four of the works are—to varying degrees—"*non-finito*" (unfinished): areas of each are carved to reveal parts of the head and body, while other sections are unworked or partly worked. The overall impression is of submerged, writhing bodies, locked into the stone, and tragically doomed to fight eternally for freedom.

Sculpture as God's work

Michelangelo was a deeply religious artist. Much of his sculptural work, indeed his entire working method, was a metaphor for the struggle of the soul to free itself of the body, of the spirit to escape from the confines of matter. He believed his role as an artist was to liberate the beautiful forms striving to burst out from the stone medium. To do this, he chose blocks of the finest marble from the quarries at Carrara, and worked on them freehand (often for days on end) with a mallet and chisel, "subtracting" the marble

that was superfluous to God's will. This contrasted with the procedure of other sculptors, who produced plaster models of a figure before transferring its measurements to a block of marble so that they knew precisely where to chip.

See also: *St. George* 162 ▪ Tomb of Henry VII and Elizabeth of York 164 ▪ *Greek Slave* 249 ▪ *Bird in Space* 309 ▪ *Recumbent Figure* 316–17 ▪ Tomb of Oscar Wilde 338

Michelangelo

Michelangelo Buonarroti was born near Arezzo, Tuscany, in 1475. In 1488, he was apprenticed to the painter Domenico Ghirlandaio. In 1489, at the age of 13, he entered a school of art sponsored by Lorenzo de' Medici. Here he demonstrated great admiration for Giotto and Masaccio, making drawings of their work that survive today.

Michelangelo settled in Rome, where his sculptures *Bacchus* (1496–97) and *Pietà* (1498–99) first launched him into artistic superstardom. By the beginning of the 16th century, he was the most famous artist of his day.

In 1508, he reluctantly embarked on painting the Sistine Chapel ceiling; he considered himself primarily a sculptor, but showed tremendous skill and endurance in finishing the ceiling.

Michelangelo was appointed architect to St. Peter's in Rome in 1546. He devoted his last years to this role, but refused payment. He died in 1564.

Other key works

1501–04 *David*
1508–12 Sistine Chapel ceiling
1536–41 *Last Judgment*

A powerful enigma

Work on *Young Slave* and three further slave sculptures was halted mid-process when Pope Julius II asked Michelangelo to work instead on decorating the Sistine Chapel. After the pope's death in 1513, his nephews reduced the amount to be spent on his grand tomb and, as a consequence of this, Michelangelo produced only a handful of what had been originally envisaged as some thirty figures for the tomb.

Although scholars are not certain whether or not *Young Slave*, *Awakening Slave*, and the other incomplete sculptures were intentionally left unfinished, their state seems likely to have been a combination of necessity—in the form of budgetary cuts—and artistic pertinence: the sculptures were *non-finito* as both a result of financial realities and an expression of the immense difficulty of aligning a magnificent artistic vision with working to commission.

Michelangelo did finish another two of the sculptures, *Dying Slave* and *Rebellious Slave* (both c.1513),

"entirely with his own hands" before funds dried up. However, the problem of funding was a continuing source of frustration for the sculptor, who later despaired that he had wasted his youth and energy on the project, struggling to free his creative vision from tedious earthly restraints.

Whatever the metaphors at play in the four unfinished *Slaves*, their *non-finito* condition is fundamental to the sculptures' hugely powerful depiction of individual struggle. ▪

Michelangelo always tried to conceive his figures as lying hidden in the block of marble.
E. H. Gombrich
The Story of Art, 1950

Awakening Slave (c.1520–23), perhaps the most *non-finito* of the *Slaves*, is a powerful, expressive work. Michelangelo's tool marks can be seen in the raw block of marble.

A PRINCE'S MISTRESS WHO BASKS IN THE WARMTH OF HER OWN FLESH

VENUS OF URBINO (1538), TITIAN

Detail from *Venus of Urbino*

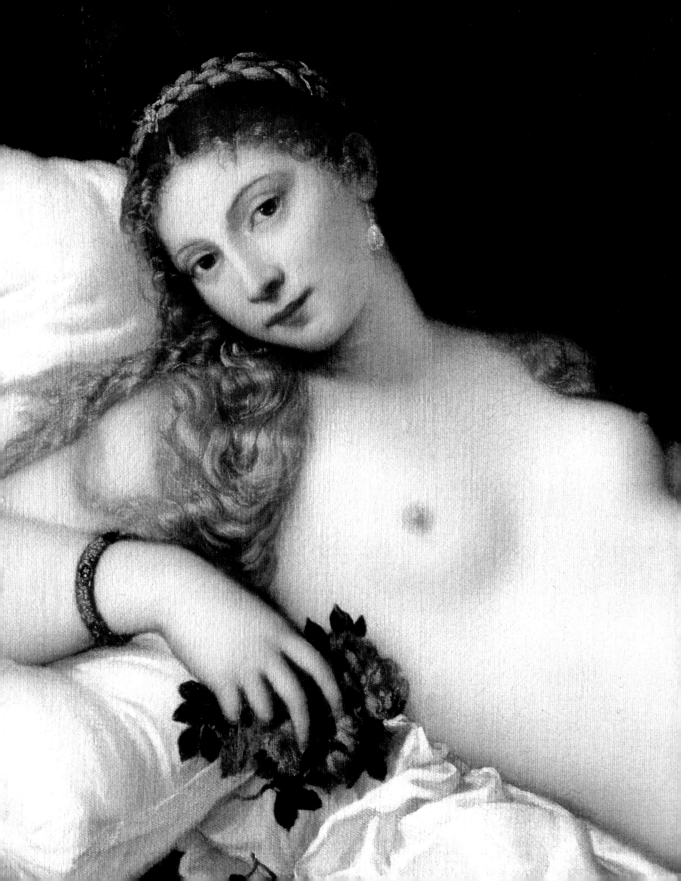

IN CONTEXT

FOCUS
The female nude

BEFORE
35,000 BCE The earliest known female nudes—small statuettes—were created in Europe as depictions of female sexuality and fertility.

c.350 BCE Praxiteles of Athens is the first sculptor to carve a life-size female nude, the *Aphrodite of Knidos*.

c.1508–10 The Venetian artist Giorgione paints *Sleeping Venus*, a work to which Titian alludes in his *Venus of Urbino*.

AFTER
1647–51 Diego Velázquez produces his *Rokeby Venus*.

1863 Édouard Manet paints *Olympia*, referencing Titian's composition but replacing Venus with a prostitute. The picture goes on to cause a scandal at the 1865 Salon.

The nude in art is almost never a straightforward image of a naked person. Nearly every representation of the unclothed human form is laden with philosophical, cultural, or erotic associations.

Although prehistoric peoples made exaggerated female forms as talismans of fertility, early artistic depictions of the nude in Western culture date back to the classical civilization of ancient Greece. There, sculptors produced superb nudes portraying their gods and heroes—with idealized proportions based on mathematical ratios—that were intended as a celebration of the human body. In Greece, where games and festivals were regularly held to celebrate athletic prowess, statues of male nudes in various states of contemplation, triumph, and fury appeared around the 6th century BCE, but it would be another two centuries before the nude female form became an acceptable subject for artists.

One of the first and most famous female nudes was a life-size statue of Aphrodite (known as Venus in ancient Rome), goddess of love and beauty. The sculptor, Praxiteles

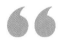

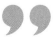

The painter must always seek the essence of things, always represent the essential characteristics and emotions of the person he is painting.
Titian

of Athens, reputedly made two versions of the figure—one nude, one clothed—in a commission for the island of Kos. Although the nude version of the goddess had Aphrodite protecting her modesty with one hand, it was rejected by the citizens of Kos, but was later installed in a shrine at Knidos. It became much visited, admired—Roman writer Pliny the Elder described it as the finest statue in the world—and copied. The statue began a new tradition for depictions of Venus and of the female nude, which would reverberate throughout art history.

Titian

Tiziano Vecellio, known as Titian, was born in the 1480s in Pieve di Cadore, Italy. In around 1507, he joined Giovanni Bellini's workshop in Venice, although his early style was more influenced by Giorgione. His *Assumption of the Virgin* altarpiece (1516–18) cemented his reputation and helped gain him many noble patrons in Italy, as well as King Francis I of France.

In 1533, Titian was knighted by Holy Roman Emperor Charles V, reflecting his status as the main painter of the imperial court. From 1550 to 1565 he painted seven mythological subjects, based on

Ovid's *Metamorphoses,* for Philip II of Spain. He mastered every genre—from portraits and religious works to mythological scenes and nudes—and became extremely wealthy. Titian died of the plague on August 27, 1576. He is considered the greatest painter of the Venetian school.

Other key works

1519–26 *Virgin and Child with Saints and Members of the Pesaro Family*
1530 *Death of St. Peter Martyr*
1548 *Charles V on Horseback*

Female nudes were often given the name "Venus" to lend them classical respectability. There is little suggestion that the woman depicted in the *Venus of Urbino* is the goddess herself.

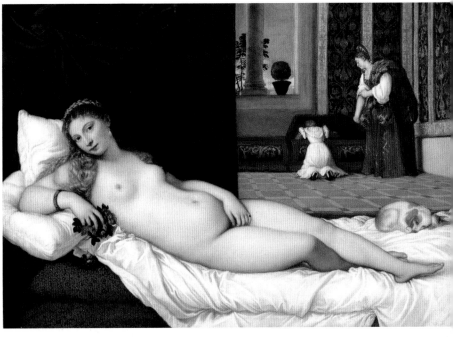

With the exception of a period in the Middle Ages when nudity was considered to be deeply sinful, these ancient bodily ideals were endlessly emulated. Greco-Roman statues were celebrated for their perfection of form and intellectual clarity. In classical symbolism there was a clear differentiation between male and female nudes; the male tended to describe active, noble values, and the female body held passive, erotic potential. This symbolism prevailed among Renaissance and Baroque artists.

Baring it all

Titian's adaptation of classical tradition in *Venus of Urbino* is a masterpiece of the female nude form. The artist is acutely aware of the sexual power of his work, and uses contrast between decorative sharpness and carnal softness to draw the viewer's eye to the

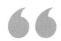

The eyes have it: Venus' eyes, which irresistibly hold our own, assert her character, her intellect, and her power to choose.
Rona Goffen
Titian's Women, 1997

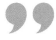

reclining body. Venus' flesh is rendered in warm tones that softly transition between light and shadow, and Titian treats the surface of the body like a buffed shell; soft, smooth, and luminous against the dark furnishings of the room. Gleaming skin and strands of hair are treated as inviting, tactile surfaces, and the bouquet of red roses held languorously in the spread fingers of Venus' right hand indicates metaphorically the genitalia concealed by her left. Fabrics are also sensually depicted, crumpled and draped to indicate their alluring textures.

Set against this soft eroticism is the hard metal jewelry that is in contact with parts of the woman's flesh. The accessories—a bracelet, a ring, and one visible earring—reinforce by contrast the smooth curves of the otherwise unbound body. Titian's technique enhances the sensuality of his subject. He

exercises crisp control, describing elaborate, decadent patterns and shaping glowing, firm contours from generous layers of paint.

The eyes have it

Titian's *Venus of Urbino* invites viewers to look at the beauty of the female form, but also challenges their motives for looking. The canvas is divided into two halves by the heavy, dark drapery behind the woman's torso. The curtain splits the scene into two distinct zones—public and private, licit and illicit, mundane and erotic—making the viewer aware of their intrusion. The woman's gaze also has subversive connotations: in the words of the American art historian Rona Goffen,"The eyes have it."

Rather than averting her eyes demurely and becoming a passive object for prurience, the woman stares directly at the viewer, unashamed by her nakedness. **»**

We know that she is revealing her body deliberately, and her gaze questions our voyeurism.

Symbol and identity

The naked figure represents the ideal Renaissance woman who, like Venus, becomes a symbol of love, beauty, and fertility. The identity of the woman pictured has long been debated. In the background, maids are packing or unpacking clothes for her, suggesting that she is of mortal status rather than a goddess. Contemporary letters describe her as la donna nuda—the naked woman—but do not give her name. Many have speculated that the model might have been Titian's mistress, rather than the wife of a patron. The overt expression of sexuality would not have been acceptable for a married woman of the upper classes.

A fact not lost to history is the identity of the woman for whom the picture was acquired. Guidobaldo II della Rovere, Duke of Urbino, gave the painting as a gift to his young wife, Giulia Varano, and it is likely that the Venus of Urbino was hung on a wall in her bridal chamber, at a time when such paintings were thought to stimulate couples. The

Justice is an element of beauty as much as color and outline on canvas.
Mary Richardson
Letter to the London *Times*, 1914

window is identical to one seen in a drawing of the duke's palace in Urbino—a further indication of the original owner's identity.

A myrtle tree on the window sill represents eternal commitment, and other elements in the painting are symbols of constancy: the spaniel on the bed represents faithfulness, and the posy of roses love. The two attendant maids might even be busy making nuptial preparations.

Changing attitudes

During the centuries that followed Titian's Venus of Urbino, attitudes toward the female nude continued to change. After the French

Revolution in 1789, the heroic male nude was overtaken in popularity by the female nude, which became a respected genre of painting. While Baroque and Rococo artists had reveled in the playfulness of blatant eroticism, later painters used the nude to explore changing attitudes toward sexuality: for example, Édouard Manet's Olympia (1863) is modeled on the Venus of Urbino, but the girl's hand appears to block rather than entice, reflecting her sexual independence.

Women's emancipation in the early 20th century brought about a radical reinterpretation of the nude; in 1914, suffragette Mary Richardson slashed Velázquez's Rokeby Venus with a meat cleaver at the National Gallery in London. This painting shows the goddess Venus from behind—a classically erotic pose— apparently absorbed in her own beauty, reflected in a mirror held by Cupid. The blurred rendering of her face may suggest she was meant to represent womanhood in general, rather than Venus in particular, or even hint at Velázquez's critique of the viewer's intentions toward the image. But whatever the artist's aims, Richardson saw this painting as a blatant example of women's

Female nudes that changed the course of Western art history

Aphrodite of Knidos (c.350 BCE), Praxiteles of Athens	*The Birth of Venus* (c.1484), Sandro Botticelli	*The Valpinçon Bather* (1808), Jean-Auguste-Dominique Ingres
The original statue, now lost, depicted the sensual goddess of love taken by surprise at her bath. It was widely known and copied; some of these copies survive today.	Botticelli's *Venus* broke with tradition to portray a nude at a size comparable to a large-scale religious work. His Venus summarizes Renaissance ideals of beauty; pale, long limbs, sloping shoulders, and a softly rounded belly.	The French painter, notorious for elongating limbs and eroticizing proportions, was inspired by ancient art and masters of the Renaissance to produce this graceful study of a seated female nude.

The sensual *Rokeby Venus* (1647–51) is the only surviving nude by Velázquez, who avoided the genre owing to censorship by the religious authorities in the artist's native Spain.

objectification in art. To her, it symbolized the consumption of female nudes by male viewers in galleries, and the larger social inequalities faced by women.

Continuing dialogue

In his travel book *A Tramp Abroad* (1880), American writer Mark Twain describes his encounter with the *Venus of Urbino* in the Uffizi Gallery in Florence. He calls it "the foulest, the vilest, the obscenest picture the world possesses," objecting to the eroticism implicit in the placement of the girl's arm and hand. Yet it is indicative of the changing place of art in society that modern feminist scholars have discussed how Titian, in his *Venus*, might have been trying to subvert the objectifying traditions of the female nude. We know that Giulia Varano was the original owner of the picture, and that it was later purchased by Vittoria della Rovere, Grand Duchess of Tuscany, for her bedroom in Florence. So perhaps the woman in the picture reveals her body in a domestic setting, surrounded only by women, to an ostensibly female viewer, and it could be interpreted as celebrating a woman's attitude toward her own body.

Interpretations of the nude will always fluctuate in response to changing attitudes, and will continue to supply a backdrop to discourses of gender and power. The nude is a remarkable constant against which we can measure ourselves. Unlike works that engage with particular cultural moments, or portraits that elaborately record contemporary fashion, the base subject of the nude will remain unchanged. Titian's Venus has reclined in the same pose for nearly five hundred years, but responses to her body will transform and evolve for as long as we engage in art-historical dialogue. ∎

**Olympia (1863),
Édouard Manet**

While clearly referencing Titian's *Venus of Urbino* in the figure's pose, Manet's *Olympia* was shocking for the model's challenging gaze and the fact that she was identifiable as a prostitute.

**Black and White in Contrast
(1939), Pan Yuliang**

Recalling Manet's *Olympia*, this revolutionary painting places a black female nude in a central position, confronting and addressing exclusionary attitudes to gender and race.

**Alison Lapper Pregnant
(2005), Marc Quinn**

This magnificent statue was installed on the Fourth Plinth in Trafalgar Square, London, as a celebration of the pregnant body and a representation of disability.

HIS MAJESTY COULD NOT SATIATE HIS EYES WITH GAZING UPON IT

SALT CELLAR (1540–1543), BENVENUTO CELLINI

The Florentine goldsmith and sculptor Benvenuto Cellini (1500–71)—said to be so arrogant and ruthless that in 1534 he murdered a rival artisan—relished the attentions of the high and mighty, pandering to their decadent tastes.

The exquisite golden salt cellar that Cellini made for King Francis I of France is a rare surviving example of his work. The male figure is symbolic of the ocean, in all its salty majesty. He holds a trident, presiding over a ship that is designed to hold the salt. The female represents the earth, and next to her is a richly decorated temple, in which pepper for the king's table could be stored. The object reveals Cellini's extraordinary ingenuity and inventiveness, and his knack for courtly grandeur. It is appropriate that the sculpture—in keeping with Cellini's notoriously tempestous life—was sensationally stolen in Austria in 2003, only to be recovered three years later. ∎

Mannerism, a term usually used to describe the "mannered" art of 16th- and 17th-century Italy, is a style that flourished in the royal courts of Europe, and especially in France, where many Italian artists found patronage. Stylish, decorative, and deliberately artificial, Mannerist art appealed to the elite and educated; its self-conscious sophistication was a departure from the harmony expressed by Renaissance artists.

For him to be an artist was no longer to be a respectable and sedate owner of a workshop: it was to be a 'virtuoso' for whose favor princes and cardinals should compete.
E. H. Gombrich
The Story of Art, 1950

BENVENUTO CELLINI COULD NOT HAVE CAST THEM BETTER

BENIN BRONZES (c.1500–1600)

IN CONTEXT

FOCUS
Brass casting

BEFORE
c.9th century Cast-bronze artifacts from Igbo-Ukwu, Nigeria, display a technical use of the lost-wax method.

1100–1500 The West African kingdom of Ife produces naturalistic cast-metal heads.

c.1400 Portuguese traders bring brass bracelets to Benin. Local artists recast the brass to make plaques to decorate the oba's palace.

AFTER
1914 Oba Eweka II is crowned in Benin. He revitalizes the craft trade, commissioning replacements for objects taken by the British in 1897. He also institutes the Benin Arts and Crafts School.

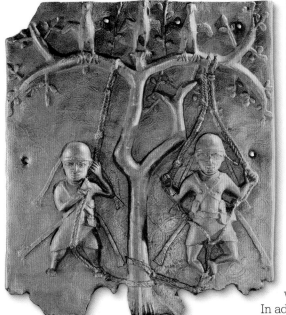

I n 1897, a British military force embarked on a mission to capture Benin City, the capital of the kingdom of Benin in what is now southern Nigeria, in response to the massacre of a previous British delegation. During the punitive expedition, the city was ransacked and burned, signaling the end of the kingdom. Thousands of bronzes were removed by the British from the palace of the oba, or king. They were of such fine quality that the Austrian archaeologist Felix von Luschan said that "Benvenuto Cellini could not have cast them better."

Benin "bronzes" are in fact made from brass, and the oba employed a guild of highly skilled brass casters to produce them using the lost-wax method (see p38).

In addition to body ornaments and freestanding sculptures, the artworks included around 1,000 relief plaques, which were fixed to walls and pillars in the palace. They depict court life and rituals as well as historical events.

The plaque that is shown here illustrates *isiokuo*, a ritual in honor of Ogun, the god of war and iron.

The figures are performing an acrobatic dance known as *amufi*, and the three birds perched above them are a reference to the story of Esigie, a Benin warrior king. On the brink of battle, a bird warned Esigie that disaster lay ahead. The king had the bird killed and proclaimed that such prophecies should be ignored in order to ensure success. To commemorate the event, Esigie commissioned a brass-cast staff, which incorporated an image of the bird. These staffs are still used today in a court festival known as Ugie Oro, which celebrates Esigie's victory over the adjacent Idah Kingdom in the 16th century. ■

See also: Chinese bronze ritual vessel 32 ▪ Riace Bronzes 36–41 ▪ Shiva Nataraja 76–77 ▪ Easter Island statues 78 ▪ Bernward Doors, Hildesheim 100

RARELY HAD LANDSCAPE BEEN GIVEN SUCH PRIDE OF PLACE AS SUBJECT MATTER

HUNTERS IN THE SNOW (1565), PIETER BRUEGEL THE ELDER

Detail from *Hunters in the Snow*

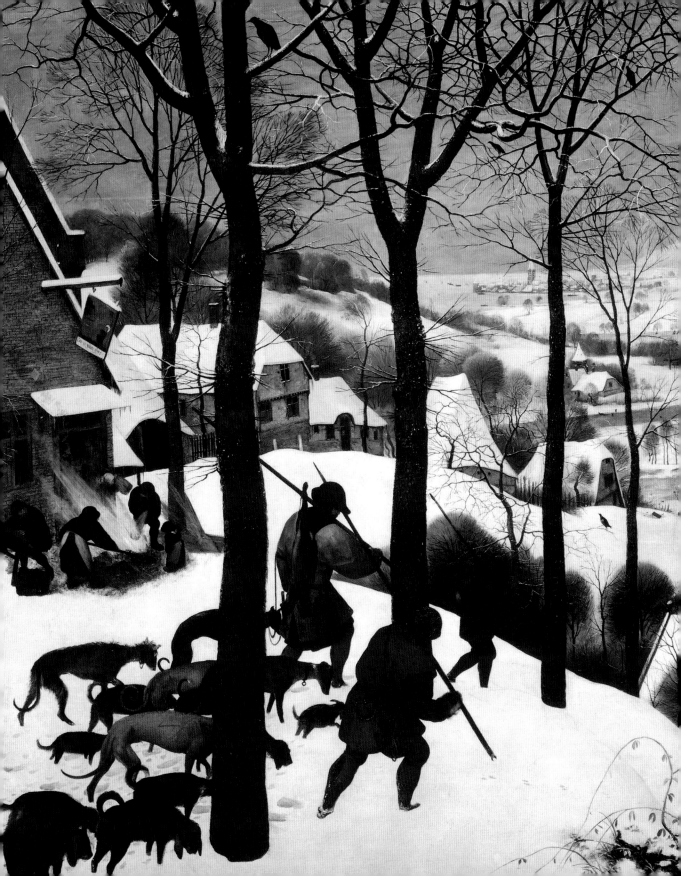

IN CONTEXT

FOCUS
Landscape and genre painting

BEFORE
c.1420 Miniatures in the *Turin-Milan Hours* illuminated manuscript apply experiments in perspective and realism to landscape scenes.

c.1515–20 Joachim Patinir of Antwerp, the first artist to be described as a landscape painter, produces *St. Jerome in the Desert*.

AFTER
1748 English artist Thomas Gainsborough's *Cornard Wood, near Sudbury, Suffolk* shows the influence of 17th-century Dutch landscape painting.

1851–52 The French artist Gustave Courbet paints *Young Ladies of the Village*, fusing the landscape of his native Ornans with genre painting's attention to human narrative.

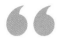

To look at almost any Bruegel painting … is to be at once transported back to life as it was known more than four centuries ago.
Robert L. Bonn
Painting Life: The Art of Pieter Bruegel, the Elder, 2007

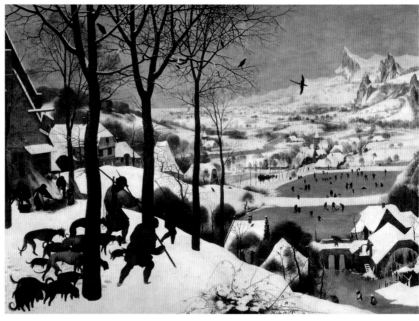

In *Hunters in the Snow* Bruegel shows the transformation of the countryside in the grip of winter. The panoramic view from a high vantage point is typical of his landscapes.

Pieter Bruegel the Elder was a groundbreaking pioneer of landscape painting. While Joachim Patinir of Antwerp (active 1515–24) is credited with being the first artist to specialize in landscape painting, it is in Bruegel's oeuvre that the natural world was promoted from backdrop to subject matter in an exceptional way. Topography dominated his compositions, both literally and thematically.

In the 14th and 15th centuries, artists had begun to use landscape in their pictures as a background to other elements. As the Renaissance progressed, painters depicted religious or mythological scenes in idealized, Italian-style pastoral settings, in which the landscape was finely rendered but remained subordinate to the historical or religious message.

By contrast, Bruegel's approach brought landscape itself to the fore, depicting not only landscape but also the activities of humans as an integral part of it. He was consistently interested in the sights, sounds, and commonplace experiences of living close to nature. His were landscapes that shaped—as they were also shaped by—the everyday lives of their human inhabitants.

The Little Ice Age

In the northern hemisphere, the mid-16th century saw a sharp drop in temperatures that signaled the beginning of a phase of perceptible change in the climate, which climatologists have called the "Little Ice Age." One of the coldest winters in collective memory was that of 1565, the year in which Pieter Bruegel the Elder painted *Hunters in the Snow*.

An interest in addressing contemporary anxieties about the changing weather and its impact on community living inspired Bruegel to create innovative

See also: *Wind among the Trees* 96–97 ▪ *Landscape with Ascanius* 192–95 ▪ *Tintern Abbey* 214–15 ▪ *Bentheim Castle* 223 ▪ *The Avenue at Middelharnis* 224

depictions of everyday scenes lived out in the newly snow-smothered countryside. He committed to canvas several snow scenes in response to the onset of this period of extreme cold, when the land was cloaked in brilliant white, rivers and lakes froze over, and all manner of creatures perished in the unusual conditions; the painter's works reflected the menace inherent in the landscape's beauty.

Living in the landscape

The snowy composition of the famous *Hunters in the Snow* demonstrates the intersection between landscape and everyday life, offering a window onto the joys and hardships of an ecologically turbulent moment in European history. Bruegel sets profound natural beauty and admirable community spirit against repressed but ominous anxiety, visible for example in the hunched figures of the returning hunters in the foreground. The daily struggle of combating such a fierce adversary as the natural world permeates the picture, reminding us that despite the cozy domesticity close by, survival is at stake.

Alpine influence

In 1552, Bruegel had journeyed over the Alps and through Italy. He sketched enthusiastically throughout this trip, and examples of these vital first impressions survive today, as well as more detailed pen-and-ink studies made when he returned home. The Alps influenced Bruegel's artistic style to a great extent, and make an appearance in *Hunters in the Snow*. Although the scenery is depicted in a naturalistic way, the vista is an invented scene based in part on the artist's Alpine memories.

The landscape in the picture is characterized by sharp, mountainous formations that slice up through the otherwise flat, distant prospect on the right of the composition. Great fields of ice and snow, perhaps even glaciers, have formed outside the village. This kind of topography is clearly uncharacteristic of the Low Countries, and yet here tall projections of ice and rock are a definitive, looming presence over the bustling town in the valley. In this vast, almost fantastical Alpine landscape, the cold is emphasized by the muted palette of chilly blue-greens, grays, and browns. »

Pieter Bruegel

Little is known about Pieter Bruegel the Elder's early years, but he may have been born near Breda, now in the Netherlands, around 1525. He probably trained in Antwerp, perhaps with Pieter Coecke van Aelst, and joined the Antwerp painters' guild in 1551. Soon after this he toured Italy, returning to Antwerp in 1554, where he designed engravings for print publisher Hieronymus Cock. During this time, Bruegel packed his compositions with figures, exploiting the demand for work in the style of earlier painter Hieronymus Bosch.

In 1563, Bruegel moved to Brussels, where he worked on larger figures in ambitious configurations. His finest work dates from this period, such as his 1565 series the *Months*. He died in 1569 in Brussels, having had a huge influence on Flemish painting both during his lifetime and posthumously. His sons Pieter Brueghel the Younger and Jan Brueghel the Elder were also painters.

Other key works

c.1555–58 *Twelve Large Landscapes*
1559 *Netherlandish Proverbs*
1565 *A Country Wedding*

Bruegel made numerous ink sketches of Alpine scenery, probably composites rather than real views. These fed into his major works, in the craggy mountains that characterize his otherwise typically Dutch landscapes.

The sharp points of the topmost slivers of the mountains seem to echo the shapes of two church spires below, demonstrating the huge contrast in size between the natural and the man-made world. Here Bruegel perhaps encourages a spiritual reading, in that he positions the vast immensity of nature as the uncontested and unpredictable master of human fate.

Changing routines

In the midst of this icy upheaval, Bruegel offers a positive footnote to offset the gloomy shadows cast by the unusual mountains. The community living in their shadow thrives and bustles in spite of—indeed because of—the intense cold. Everyday life is different from usual, but is burgeoning in many ways.

The painting suggests that human beings and the natural world are intertwined in a more complex relationship than a submission of one to the other. Instead of submitting to the big freeze, figures skate, sled, and play winter sports on the frozen lakes. Industrious, determined

> The one master of naturalistic landscape who comes between Bellini and the 17th century.
> **Kenneth Clark**
> *Landscape into Art*, 1949

men with loyal dogs tramp through the snow bundled up in abundant layers. On the left, a roaring fire burns, its brilliance rendered all the brighter in contrast with the whiteness of the landscape. There is the sense that the community has strengthened its collective resolve, unifying in the same way that the layer of snow visually unifies the landscape.

Yet the scene is tempered with a degree of melancholy. The hunters so functionally muffled against the

freezing temperatures are returning to their homes with only a single slaughtered animal between them. Unlike the people at leisure in the valley, these workers carry themselves with an air of hunched dejection. This is also represented in the broken sign swinging from the inn on the left; life is hanging on, but not quite with the robust stability of warmer days.

Genre painting

Bruegel's portrayals of people fall within the style known as genre painting, which showed ordinary people engaged in everyday pursuits in the home or community, or at work. This style was popular in the 16th and 17th centuries, particularly in the Low Countries, where it appealed to the newly well-off middle classes. Bruegel, a pioneer of genre art, painted many other lively scenes of peasant life, from weddings and dances to festivals and feasts. As seen in *Hunters in the Snow*, his landscapes often encompassed a genre element.

The *Months*

Hunters in the Snow is one of a series of six or 12 paintings known as the *Months*, of which five survive today. Commissioned by Bruegel's wealthy patron Niclaes Jonghelinck for his Antwerp mansion, each work represented a particular time of year, summarized by a robust pastoral scene that epitomized the season. Bruegel built this concept on the tradition of medieval "books of hours"—illuminated manuscripts or calendars in which the seasons and their labors were illustrated.

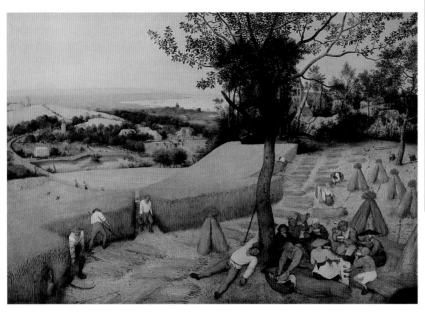

In *The Harvesters* (1565) Bruegel portrays a genre scene in a summer landscape with humor, but does not trivialize the figures. The mutual productivity of man and nature is clear.

Artists in the 15th and 16th centuries were fascinated with depicting seasonal landscapes, finding inspiration in changing colors and moods, and in the notion of the passing of time.

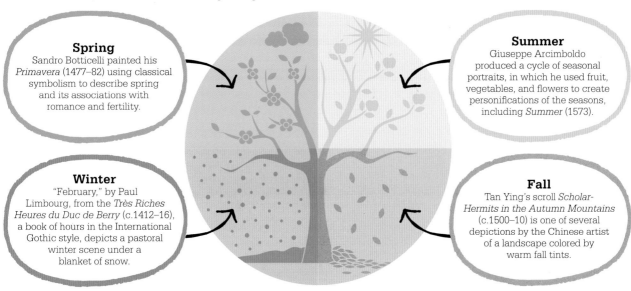

Spring
Sandro Botticelli painted his *Primavera* (1477–82) using classical symbolism to describe spring and its associations with romance and fertility.

Summer
Giuseppe Arcimboldo produced a cycle of seasonal portraits, in which he used fruit, vegetables, and flowers to create personifications of the seasons, including *Summer* (1573).

Winter
"February," by Paul Limbourg, from the *Très Riches Heures du Duc de Berry* (c.1412–16), a book of hours in the International Gothic style, depicts a pastoral winter scene under a blanket of snow.

Fall
Tan Ying's scroll *Scholar-Hermits in the Autumn Mountains* (c.1500–10) is one of several depictions by the Chinese artist of a landscape colored by warm fall tints.

In *The Gloomy Day* (February), a stormy sky, snowy peaks, and churning river rendered in wintry colors form a harsh backdrop to a warmer scene in the foreground, in which figures prune trees, gather wood, and repair their houses. Festive activities associated with Carnival—dancing, wearing paper crowns, eating waffles—are set against the gloomy landscape of the title. And yet, green creeps along the horizon, invoking the seasonal cycle; spring will bloom in its own time. And so the laborers celebrate under a dark sky, neither their communal joviality nor the landscape's impact lessened by the contrast. Bruegel succeeds in depicting both an insightful genre scene and an uncompromised landscape study.

Other panels in the *Months* series, for example *Haymaking* and *The Harvesters* (July and August respectively), offer panoramic views of summer landscapes with country folk engaged in seasonal tasks. As in all the paintings in the cycle, nature plays a dominant role, and human endeavor is shown as part of a greater whole.

Bruegel's legacy
Dutch landscape artists such as Jacob van Ruisdael continued to develop a naturalistic style in the 17th century. The way in which these artists envisioned the natural world remained a direct result of their relationship with the landscape around them: life and land were inextricably linked at a time when both seemed extremely volatile.

Bruegel's legacy is also evident in the realistic landscapes of Flemish Baroque artist Pieter Paul Rubens. It shaped the oeuvres of many other painters too, from Gillis van Coninxloo's vast panoramas to direct emulations by Roelandt and Jacob Savery and the village scenes of David Vinckboons. Bruegel's work also helped shape the course of the northern landscape tradition into the 19th century, when such artists as Gustave Courbet and Jean-François Millet depicted laborers within rural genre scenes.

Despite a far-reaching influence on northern European landscape and genre painting, Bruegel fell out of fashion for several centuries. His popularity revived in the 20th century, when he was lauded for his strikingly innovative compositions and profound human insight. ∎

Bruegel had discovered a new kingdom for art which the generations of Netherlandish painters after him were to explore to the full.
E. H. Gombrich
The Story of Art, 1950

PERFECTION IS TO IMITATE THE FACE OF MANKIND

YOUNG MAN AMONG ROSES (c.1587), NICHOLAS HILLIARD

IN CONTEXT

FOCUS
The portrait miniature

BEFORE
c.1526 Portrait miniatures are give a life beyond illuminated manuscripts when Jean Clouet paints King Francis I of France in miniature.

c.1526–27 Lucas Horenbout produces seven miniatures of King Henry VIII, among the earliest made in England.

c.1530s Hans Holbein the Younger paints court portraits in England. His work goes on to strongly influence the style of Nicholas Hilliard.

AFTER
1839 Photography offers affordable, accurate portraits to a much wider public and interest in painted miniatures falls into decline.

The painting of miniatures flourished in Europe from the 16th to the 19th centuries. One of the most skilled exponents of the art was the Englishman Nicholas Hilliard (1547–1619). Like his contemporary Shakespeare, Hilliard produced romantic and mischievously nuanced work. He was a firm favorite with Queen Elizabeth I, painting many portraits of the monarch and members of her court.

Elizabethan miniatures were normally full- or half-length portraits painted in watercolor on vellum—a parchment made from calf skin. Usually around 6 in (15 cm) tall, they were kept in decorative locked cabinets, ivory cases, or inside engraved lockets. They were designed as tributes to the monarch, to commemorate the dead, or as tokens of romantic affection—a form of currency in the elaborate game of courtship.

Love symbols
Hilliard's *Young Man among Roses* is rich in devotional symbolism. The young man is surrounded by a tangle of roses, each with five petals. This flower was known to the Elizabethans as the eglantine, and was the queen's personal bloom. Furthermore, black and white, the colors of his clothing, were the colors worn to honor Elizabeth's steadfastness and chastity. It therefore seems clear that the man depicted in the miniature is declaring his passion for the queen. Commitment to these feelings is emphasized by a tree, the symbol for loyalty.

In addition, a Latin inscription around the top of the miniature translates roughly as "my praised faith procures my pain."

Some scholars have suggested that the subject of the miniature is Robert Devereux, 2nd Earl of Essex, who became companion to Queen Elizabeth I in 1587. Later, when he had fallen out of favor with the monarch, the earl described himself as a bee no longer allowed to dwell upon the eglantine. *Young Man among Roses* is perhaps a relic from happier days, when Devereux was still permitted to settle on this distinguished blossom. ∎

See also: Cecilia Gonzaga medal 120–21 ▪ *Venus of Urbino* 146–51 ▪ Salt Cellar 152 ▪ *Akbar's Adventures with the Elephant Hawa'i in 1561* 161 ▪ *Vase of Flowers* 224–25

LIKE HIS IMPERIAL MENTOR, BASAWAN CREATED AS NATURALLY AS THE WIND BLOWS

AKBAR'S ADVENTURES WITH THE ELEPHANT HAWA'I IN 1561 (c.1590–1595), BASAWAN

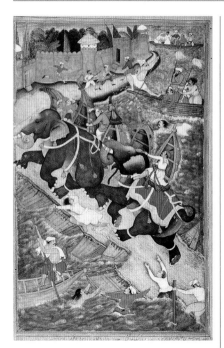

IN CONTEXT

FOCUS
The Mogul miniature

BEFORE
14th century Syrian and Egyptian illustrated manuscripts are preeminent, but are later overshadowed by Persian work.

1540s Safavid Shah Tahmasp I of Persia commissions numerous miniature paintings.

AFTER
c.1610–15 Manohar, son of Basawan, follows in his father's footsteps to produce notable miniatures.

c.1700–05 Delhi artist Rai Dalchand creates *Two Ladies on a Terrace*—an exquisite miniature painting of Gul Safa, the sweetheart of Prince Dara Shikoh, heir-apparent to the Mogul throne.

T he Mogul Empire prospered during the 16th and 17th centuries, bringing Muslim—and particularly Persian—culture to the Indian subcontinent, then inhabited by a Hindu majority. Its third emperor, Akbar I, who came to power in 1556, proved himself to be a skilled military leader, a shrewd administrator, and a dedicated patron of the arts. The art of his court—predominantly illustrated manuscripts—reflected the emperor's tolerance of other cultures, amalgamating Persian, Indian, and sometimes European influences. Under Akbar's reign, Mogul art developed into an identifiable style, in which realism and attention to detail joined with the aerial perspective that typified earlier Persian art.

In the late 16th century, Basawan, an artist from what is now Uttar Pradesh in northern India, joined Akbar's court. His hundred or so surviving works attest to his skill in depicting space and in using vivid tonal contrasts to render dynamic scenes and strong characterizations.

Basawan's painting *Akbar's Adventures with the Elephant Hawa'i in 1561* is taken from the *Akbarnama*, the emperor's official biography. It shows an episode outside Fort Agra in northwest India when the emperor mounted the most ferocious of the royal elephants, Hawa'i. In the painting, Akbar and Hawa'i charge across a pontoon bridge on the Jumna River in pursuit of an equally fearsome elephant, Ran Bagha. The chase leaves a trail of utter destruction, as boats collapse and servants flee.

Basawan's use of perspective to describe the receding fort suggests the artist was seeking inspiration from northern European techniques as well as from the Persian tradition. All schools of Mogul miniature painting revealed rich palettes, gold detailing, and fine brushwork such as this, but no one produced such a vivid sensory frenzy as Basawan. ∎

See also: Mihrab, Great Mosque of Córdoba 68–73 ▪ *Young Man among Roses* 160 ▪ *A Lion Hunt* 176–77 ▪ *Watson and the Shark* 225

PORTFOLIO

TRÈS RICHES HEURES DU DUC DE BERRY
(c.1413–1416), LIMBOURG BROTHERS

The *Très Riches Heures du Duc de Berry* is, by common consent, one of the most beautiful of all illuminated manuscripts. It combines loving naturalistic detail with exquisite decorative effect, making it a fine exemplar of the International Gothic style. This book of hours (private prayer book) is the unfinished masterpiece of Netherlandish manuscript illuminators the Limbourg brothers: Herman, Paul, and Jean. The French prince Jean, duc de Berry, commissioned the book, which includes miniatures of the months depicting seasonal agricultural labors. The Limbourg brothers died in 1416, probably of the plague, and the manuscript was added to in later years by other artists.

ST. GEORGE
(c.1415–1417), DONATELLO

This statue of the dragon-slaying St. George has always been one of the most admired works of Donatello. The marble figure was designed as part of the external decoration of Orsanmichele, an important building in Florence that was both a church and a municipal grain store. *St. George* was commissioned by the Florentine guild of armorers and swordmakers, of which George was the patron saint. The marble statue portrays the dragon-slayer in a confident stance, with delicate facial features, conveying courage and resolution, but also nervous tension, so that the saint seems a very human hero. Originally, the figure probably held or wore a bronze sword, lance, and helmet.

ADORATION OF THE MAGI (STROZZI ALTARPIECE)
(1423), GENTILE DA FABRIANO

Commissioned by the banker Palla Strozzi for his family chapel in the church of Santa Trinità, Florence, this is the greatest surviving work of Gentile da Fabriano (c.1370–1427) and one of the most sumptuous altarpieces of the 15th century. Gentile was a visitor to Florence from northern Italy and he brought with him the International Gothic style, of which this painting is considered a pinnacle. With its richly dressed figures and gold decorations, it conveys an air of sophisticated elegance. Gentile exerted considerable influence in Florence, notably on Fra Angelico.

SIR JOHN HAWKWOOD
(1436), PAOLO UCCELLO

The science of perspective was one of the cornerstones of Renaissance painting, and no artist used it with more enthusiasm than Uccello (c.1397–1475). He often deliberately emphasized effects of receding objects and figures and three-dimensionality to show off his ability. This huge fresco is a masterly flat rendering of a three-dimensional equestrian monument to an English general who had fought for Florence. The lower part of the painting depicts the elaborate architectural base of the statue with virtuoso skill.

THE BAPTISM OF CHRIST
(c.1450), PIERO DELLA FRANCESCA

In the 20th century, Piero became one of the most revered figures of Renaissance art. *The Baptism of Christ* is probably one of his earliest works, painted for an abbey in his

Donatello

The greatest Italian sculptor of the 15th century, Donatello (born Donato di Niccolò di Betto Bardi) lived a long life of extraordinary achievement. He was born in Florence in about 1386 and spent most of his career there, but he also worked in several other cities, notably Padua and Siena. Donatello was one of the founding figures of Renaissance art and had a huge influence on his contemporaries. He brought a new naturalism to sculpture and skillfully applied perspective in his relief carvings. No other sculptor of his time approached his versatility, inventiveness, and emotional range. He died in Florence in 1466.

Other key works

1408–15 *St. John the Evangelist*
c.1430–40 *David*
1447–53 *Gattamelata*

hometown of Borgo San Sepolcro. He was a mathematician as well as an artist, and this work—like others by the artist—has a geometric purity of form. Christ at the center forms part of a strong vertical axis that splits the painting in two, while the soft, luminous pastel colors demonstrate Piero's sensitivity to color and light.

PIETÀ OF VILLENEUVE-LÈS-AVIGNON
(c.1460), ENGUERRAND QUARTON

A masterpiece of the Provençal school of art, this painting shows the dead Christ mourned by his mother and three other figures. Christ's body arches across a resigned, aged Mary in a depiction of sorrow that is restrained and masterly. The painting takes its name from the town of Villeneuve-lès-Avignon in southern France, where it hung in the parish church. It is attributed to Enguerrand Quarton (c.1410–c.1466), one of the few French painters of the period who has a distinct artistic identity.

CAMERA DEGLI SPOSI
(1465–1474), ANDREA MANTEGNA

One of the great artists of the time in northern Italy, Mantegna (c.1431–1506) spent most of his career as court painter to the Gonzaga family, rulers of Mantua. His greatest work, for Ludovico Gonzaga, was the fresco decoration of what is now called the Camera degli Sposi (Bridal Chamber), in the city's Ducal Palace. It features a variety of scenes glorifying the family; its most famous part is the ceiling, which features a painted oculus, made to appear as if it is open to

Piero della Francesca

Piero della Francesca (c.1415–92) was born and died in the small town of Borgo San Sepolcro (now Sansepolcro) in Tuscany. While he worked at times in major art centers such as Florence and Rome, he always kept close links with his place of birth, and his most important works were mainly made for locations that were somewhat off the beaten path, which helps to explain the relative obscurity into which he slipped after his death. Outside San Sepolcro, his closest ties were with Urbino, which for a brief period, during the reign (1444–82) of Duke Federico da Montefeltro, was a leading center of Renaissance culture.

Other key works

c.1450–60 *The Flagellation of Christ*
c.1460–05 *The Resurrection*
c.1465–72 Portraits of the Duke and Duchess of Urbino

the sky. Foreshortened figures lean over a balustrade and peer down into the room. The first example of illusionistic ceiling painting since Roman times, it was highly influential, especially in the Baroque era.

PORTINARI ALTARPIECE
(c.1475–1477), HUGO VAN DER GOES

This large triptych depicting the Adoration of the Shepherds was made for Tommaso Portinari, agent for the powerful Medici family in Bruges, for his family chapel in Florence. Portinari and his family are depicted on the side panels, along with their name saints. The painting is notable for its naturalism, in particular in the figures of the shepherds, and for its emotional intensity. In its use of oil paints, the painting had considerable technical influence on Florentine painters.

ST. MARY ALTARPIECE
(1477–1489), VEIT STOSS

The most characteristic form of German sculpture during the Gothic period was the elaborate multi-figure altarpiece carved in lime, an easily worked wood that encouraged virtuoso naturalistic carving. The most spectacular altarpiece is in Cracow, Poland, created by the German sculptor Veit Stoss (before 1450–1533), who moved there from Nuremberg in 1477. The massive work is 40 ft (12 m) high, the main figures far larger than life-size. The huge central panel shows the Death and Assumption of the Virgin, and the side panels represent scenes from the lives of Mary and Jesus, ranging from bas-relief at the sides to almost completely rounded at the center. All the figures are painted with naturalistic coloring or gilded.

COLLEONI STATUE
(1481–1496), ANDREA DEL VERROCCHIO

The Italian painter and sculptor Verrocchio (c.1435–88)—who trained Leonardo da Vinci in his studio—worked mainly on religious subjects in Florence, but spent his final years in Venice creating one of the great secular masterpieces of the age—the equestrian statue of

Hans Holbein the Younger

Born in Augsburg, Bavaria, Hans Holbein (1497–1543) was the son of a painter, Hans Holbein the Elder, and spent most of his early career in Basel, Switzerland. His move to England was prompted by conflict between Catholics and Protestants in Basel, which damaged the market for art. Best known for his portraits, especially those painted in England, where he worked in 1526–28 and again from 1532 until his death, Holbein ranks among the leading artists of his time. He was outstanding in fields such as religious painting and book illustration. He left an unparalleled series of images of the court of King Henry VIII, producing portraits of many nobles and thinkers of the time.

Other key works

1521 *The Body of the Dead Christ in the Tomb*
1527 *Sir Thomas More*
1538 *Christina of Denmark*

the general Bartolomeo Colleoni. The statue, which was completed after Verrocchio's death, has a more vigorous sense of movement than its celebrated predecessor, Donatello's *Gattamelata* statue in Padua, and it had a profound influence on the equestrian monuments that followed it.

THE TEMPEST
(c.1505), GIORGIONE

Although he died tragically young, the Venetian painter Giorgione (c.1477–1510) became one of the most influential artists of his time. He specialized in small-scale pictures for private patrons rather than large public works, and was the first painter to make subject matter secondary to the evocation of mood. *The Tempest* is a highly poetic depiction of enigmatic figures—a woman suckling a child, and an apparently unconnected man—in a stormy landscape. Giorgione's contemporaries were unsure of the subject, and modern scholars have not reached any agreement on the picture's meaning.

TOMB OF HENRY VII AND ELIZABETH OF YORK
(1512–1518), PIETRO TORRIGIANO

The Florentine sculptor Torrigiano (1472–1528) was a belligerent man who broke Michelangelo's nose when they were students, and ended up in a Spanish Inquisition prison. In between, he worked in various countries. The Tomb of Henry VII and Elizabeth of York is his masterpiece. It features life-size gilt-bronze effigies of the king and his wife, who laid the foundations for Tudor rule in England. The tomb has Renaissance ornamentation of great beauty, but it had little immediate influence in England, as the Gothic style still flourished so vigorously.

ISENHEIM ALTARPIECE
(c.1510–1515), MATTHIAS GRÜNEWALD

Few depictions of the Crucifixion can rival the central scene of the Isenheim Altarpiece in tragic intensity. Christ writhes in agony, his hands distorted with pain, the sky dark behind him. The altarpiece was created for a monastic hospital at Isenheim in Alsace, now in France. Christ's pain showed the sick they were not alone in suffering. Grünewald (c.1475–1528) was a leading German painter of his time, but he was quickly forgotten after his death and not rediscovered until the early 20th century, when his emotional freedom particularly appealed to the Expressionists.

THE AMBASSADORS
(1533), HANS HOLBEIN THE YOUNGER

A stunning feat of realistic, life-size portraiture as well as a complex vehicle for ideas, this is one of the most discussed paintings of its time. It depicts Jean de Dinteville, French ambassador in England, and his friend Georges de Selve, Bishop of Lavaur, surrounded by an elaborate display of objects replete with symbolic meanings about the brevity of life, the turmoil and discord in contemporary events, and the hope offered by Christian faith. It famously contains an "anamorphic" skull—a distorted shape that must be viewed from the correct angle to be seen clearly.

ALLEGORY WITH VENUS AND CUPID
(c.1545), BRONZINO

The work of Florentine painter Bronzino (1503–72) exemplifies the Mannerist style at its most sophisticated, with its vivid colors and theatrical effects. He painted many religious pictures, but he was at his best in secular works—mainly portraits of the family and courtiers of Cosimo de' Medici, ruler of

Florence. The exact meaning of the allegory of the title has been much debated, but what is not in doubt is its powerful, chilling eroticism.

FONTAINE DES INNOCENTS RELIEFS
(1547–1549), JEAN GOUJON

French sculptor Jean Goujon (c.1510–68) received several royal commissions, including one for the the decoration of the Fontaine des Innocents, a public fountain built to mark King Henry II's triumphal entry into Paris in 1549. Goujon created six exquisite low-relief figures of nymphs. Their elongated forms show the influence of Italian Mannerism, but they also have a classical dignity and refinement that is quintessentially French.

MERCURY
(c.1565), GIAMBOLOGNA

Flemish by birth, but active in Florence for almost all his career, Giambologna (1529–1608) was one of the greatest sculptors of the later 16th century, with a reputation throughout Europe. His fame was spread partly via statuettes of his works—reduced versions of large-scale sculptures, or original small compositions—that were produced in large numbers in his studio. The superbly lithe and graceful *Mercury*, a depiction of the messenger of the gods in Roman myth, was Giambologna's most popular work to be disseminated in this way. The figure has wings on his heels, staff, and hat, and is raised on one foot as if by a puff of wind. The original, nearly 71 in (180 cm) high, dates from around 1565, but copies were made for centuries after this.

FEAST IN THE HOUSE OF LEVI
(1573), PAOLO VERONESE

This vast, sumptuous canvas is famous for bringing forth a defense of artistic license. After painting it for a Venetian church as a depiction of the Last Supper, Paolo Veronese (1528–88) was summoned before the Inquisition and accused of irreverence for including a host of indecorous details, including dogs, jesters, and drunkards. Veronese was instructed to make changes to the work, but he settled the matter by simply changing the picture's title, so that it represented a less solemn biblical meal.

THE DISROBING OF CHRIST
(1577–1579), EL GRECO

The subject of Christ being stripped of his clothes before the Crucifixion is fairly uncommon in art, but it is appropriate for the place in which this picture hangs—the sacristy (the room housing priests' ceremonial robes) of Toledo Cathedral. It is one of the first works that El Greco produced after settling in Spain and shows how in his adopted country the Greek artist blossomed into one of the most powerful and original painters of his time. His elongated forms owe something to Italian Mannerism, but the rapturous emotion of his work is deeply personal.

THE LAST SUPPER
(1592–1594), TINTORETTO

The last of the great Venetian painters of the 16th century, Tintoretto (1518–94) ended his titanic career with this dazzling depiction of the Last Supper. While this subject conventionally shows the table parallel to the picture plane, balanced and symmetrical, here the table thrusts back into the picture on a diagonal, introducing a dynamism and asymmetry typical of Mannerism. The solemn, dark scene is lit by two sources—a lantern and Christ's halo—creating drama and mysticism. The spiritual dimension is further enhanced by ethereal angels swirling overhead. Tintoretto's reputation declined after his death, but it revived in the 19th century, finding an eloquent champion in the British critic John Ruskin.

El Greco

The first famous personality in the history of Spanish art, El Greco was born on the Greek island of Crete in about 1541 and spent several years in Venice and Rome before settling in Spain in 1576. His real name was Domenikos Theotokopoulos, but he was known in Spain as El Griego or El Greco (the Greek) to avoid the difficult pronunciation. He was mainly a religious painter and the emotional intensity of his work perfectly suited the spiritual fervor of his adopted country during the Counter-Reformation period. He was also a superb portraitist. El Greco worked mainly in Toledo, where he died in 1614.

Other key works

1586–88 *Burial of the Count of Orgaz*
c.1600 *Christ Driving the Traders from the Temple*
c.1610 *View of Toledo*

BAROQUE
NEOCLAS

TO
SICISM

Rubens' altarpiece *The Raising of the Cross* is his first great success after he returns to Antwerp from Italy.

Philippe de Champaigne paints several dignified portraits of Cardinal Richelieu, the powerful chief minister to Louis XIII of France.

In Madrid, **Velázquez** completes *Las Meninas* (*The Maids of Honor*), a group portrait of the royal court.

The garden sculpture for the palace of Versailles includes **François Girardon's** *Winter*, a powerful figure of a bearded old man.

1610–11 c.1635–40 1656 1675–83

1624–33 1642 1665 1688–94

In St. Peter's, Rome, **Bernini** creates the Baldacchino, a huge bronze canopy in the Baroque style standing over the high altar.

In Amsterdam, **Rembrandt** completes *The Night Watch*, the most famous group portrait in Dutch art.

Charles Le Brun's enormous *Alexander the Great's Triumphal Entry into Babylon* pays flattering tribute to Louis XIV.

Andrea Pozzo's ceiling fresco in Sant'Ignazio, Rome, is one of the most spectacular examples of Baroque decoration.

At the beginning of the 17th century, Italy led Europe in the visual arts, as it had throughout the Renaissance, and religion was still the dominant subject in painting and sculpture, as it had been for more than a millennium. By the end of the century, however, the situation had changed. Paris had begun to challenge Rome as the chief center of artistic innovation, and, although religion still occupied a central role in art in most countries, it was now rivaled by a broadening range of secular themes, including landscape and portraiture. France consolidated its artistic leadership in the 18th century, with Jean-Antoine Watteau in particular leading the break from Italian influence with his theatrical style.

Roman dominance

In 1600, Rome acted as a magnet for artists from all over Europe, attracted by its past artistic glories as well as by the work to be seen decorating its numerous churches and palaces. Caravaggio came to Rome from his native north Italy, and the revolutionary style he created—blending dramatic lighting and earthy realism— was absorbed by foreign artists studying or working in Rome, who then carried it back to their own countries. In the first quarter of the 17th century, this style had an extraordinary impact throughout Europe and it lingered in some places into the 1650s.

Flemish artist Peter Paul Rubens spent some of his formative years in Rome, and took back to his home city of Antwerp not only

stylistic elements but also the technical innovation of the oil sketch. The two most illustrious French painters of the 17th century, Nicolas Poussin and Claude Lorrain, spent virtually all their mature careers in Rome, and were leading exponents of the ideal landscape—a type of picture that enjoyed enormous popularity for two centuries. In sculpture, Gian Lorenzo Bernini was such a commanding figure that his highly emotional Baroque style was a dominant influence not only in Rome but throughout Italy, and was felt in other Catholic countries, too.

A return to classicism

Bernini's influence continued into the 18th century, but a backlash against him came with the rationalism of the Enlightenment—

Camillo Rusconi, the leading Italian sculptor of his time, carves four massive marble apostles for the Lateran Basilica in Rome.

The internationally successful Swiss painter **Jean-Étienne Liotard** creates *The Chocolate Girl*, a masterpiece in pastel.

In the Villa Albani, Rome, **Anton Raphael Mengs** paints the ceiling fresco *Parnassus*, a pioneering work of Neoclassicism.

At the Paris Salon, **Jacques-Louis David** exhibits *The Oath of the Horatii*, which establishes him as the preeminent Neoclassical painter.

1708–18 **1744–45** **1761** **1785**

1729–32 **c.1750** **1778** **c. 1795–1805**

In Toledo Cathedral, **Narciso Tomé** creates a dazzling altarpiece-cum-chapel known as the *Transparente*.

Thomas Gainsborough paints one of his finest early works, the captivatingly fresh *Mr. and Mrs. Andrews*.

Jean-Antoine Houdon, the greatest portrait sculptor of the age, produces the first of several portraits of the philosopher Voltaire.

William Blake produces the monotype *Elohim Creating Adam*, a deeply personal interpretation of the biblical story.

a philosophical movement that spread across Europe. Renewed interest in the art of ancient Rome and Greece gave rise to the Neoclassical movement, which found some of its finest expression in the sculpture of Antonio Canova in Rome. By this time, however, Italy was renowned more for its past than its current achievements, inspiring the fashion for the Grand Tour, in which wealthy young men completed their education by making a lengthy cultural visit to the country. Canaletto and Piranesi were among the artists who catered for this tourist market.

Beyond Italy
Spain and the Dutch Republic enjoyed a golden age of the arts in the 17th century, and Britain came to a new prominence in the 18th

century, in line with its significant position in world affairs. Germany, too, experienced a revival in the arts, as it slowly recovered from the devastation of the Thirty Years' War, although the most impressive paintings produced in Germany in the 18th century are by an Italian artist—the glorious decorations at Würzburg by Tiepolo.

In Spain, religion was still by far the dominant subject in painting and even more so in sculpture. Highly realistic painted wooden sculptures were one of the most distinctive features of the country's art; they vividly exemplify the Counter-Reformation Church's insistence that artists should promote the Catholic faith by producing images with which the common man or woman could identify. At the royal court in

Madrid, however, various types of secular art also flourished: the greatest Spanish artist of the age, Diego Velázquez, was primarily a portraitist, and he also produced one of the supreme masterpieces of contemporary history painting.

Whereas Spain was devoutly Catholic, the Dutch Republic was predominantly Protestant, and religion played a smaller role in its art. Here, painters depicted a range of subjects for a growing middle-class clientele who sought works expressing pride in their newly independent country and in their own achievements—portraits, landscapes, scenes of everyday life, and so on. Such expansion of subject matter is also seen in British art, notably in the social satire of William Hogarth and the scientific scenes of Joseph Wright of Derby. ∎

DARKNESS GAVE HIM LIGHT

THE SUPPER AT EMMAUS (1601),
MICHELANGELO MERISI DA CARAVAGGIO

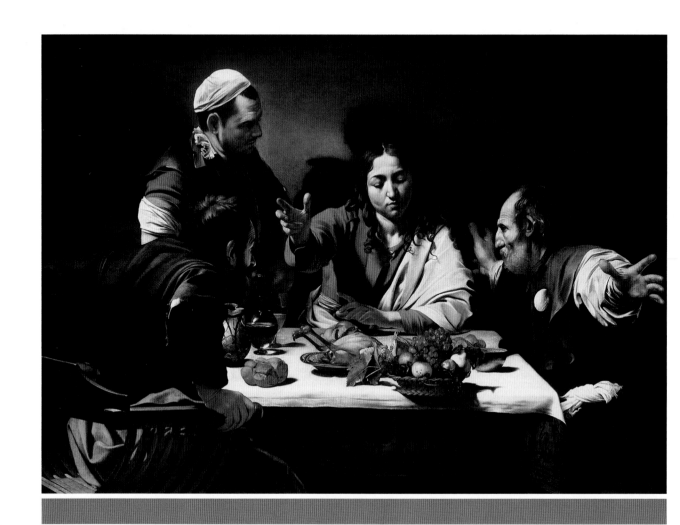

IN CONTEXT

FOCUS
Tenebrism

BEFORE
Early 16th century Leonardo da Vinci establishes the use of chiaroscuro in painting.

AFTER
c.1620–30 A number of Dutch artists from Catholic Utrecht, including Matthias Stom, Gerrit van Honthorst, and Hendrick ter Brugghen, are heavily influenced by Caravaggio's work.

1640s French artist Georges de La Tour experiments with tenebrism: his *Magdalen with the Smoking Flame* (c.1640) and *St. Joseph the Carpenter* (1642) are particularly striking for the use of candlelight against a dark backround to create an immensely powerful spotlight effect.

See also: *Holy Trinity* 108–11 ▪ *Christ of Clemency* 172–75 ▪ *Ecstasy of St. Teresa* 182–83 ▪ *Judith Slaying Holofernes* 222

The term "tenebrism," from the Italian word *tenebroso* (meaning "gloomy"), is used to describe overall darkness of tonality in a painting. The shade is punctuated by stark contrasts of light and dark, or "chiaroscuro" (from *chiaro*, "clear," and *oscuro*, "dark") to create a sense of depth and illumination in the picture.

Although Caravaggio was not the inventor of tenebrism, the term is particularly associated with him because his tenebrist paintings were so influential. The character of his work was well described in 1672 by Giovanni Pietro Bellori, one of his early biographers: "… he never brought his figures out into the daylight, but placed them in the dark brown atmosphere of a closed room, using a high light that descended vertically over the principal parts of the bodies while leaving the remainder in shadow in order to give force through a strong contrast of light and dark."

Flesh-and-blood figures

In *The Supper at Emmaus*, the resurrected Christ reveals his identity to two of his disciples who had failed to recognize him, while an innkeeper stands over the group. Caravaggio's precise direction of light makes his figures stand out forcefully against their backgrounds, and their physical presence is made more immediate by realistic detailing, such as in their tattered clothing, and their bold, theatrical gestures. The elbow of the figure on the left seems almost to burst out of the picture.

The figures appear as solid, flesh-and-blood people from the real world, rather than the idealized beings of traditional religious art. Some of Caravaggio's contemporaries thought that he was disrespectful in depicting holy figures in this way, but others were bowled over by his new way of representing the familiar stories, and his work became enormously influential in the first quarter of the 17th century. Many artists attempted to imitate Caravaggio's techniques, but most either coarsened or sweetened his style, missing his grandeur and emotional depth. However, a few were worthy heirs, notably the Italian Artemisia Gentileschi, the most famous female painter of the age, and Georges de La Tour, who was extraordinarily sensitive in his handling of nocturnal light. ▪

Michelangelo Merisi da Caravaggio

Michelangelo Merisi was born in Milan in 1571, but he grew up in the town of Caravaggio, from which he takes his name. After training in Milan, he moved to Rome in about 1592 and lived there for most of the rest of his short life. Initially, he painted erotic works for collectors, but after the turn of the century he concentrated on serious religious works. His altarpieces attracted acclaim and controversy, and he became the most talked-about painter of the day—in part for his violent personal life. In 1606 he fled Rome after killing a man in an argument. For the next four years he worked in Naples, Malta, and Sicily. Caravaggio died in 1610 of fever, "miserable and abandoned."

Other key works

c.1598 *Bacchus*
1600–01 *Conversion of St. Paul*
1603–06 *Madonna of Loreto*
1608 *The Beheading of St. John the Baptist*

THROUGH PAINTINGS OR OTHER REPRESENTATIONS THE PEOPLE ARE INSTRUCTED

CHRIST OF CLEMENCY (1603–1606),
JUAN MARTÍNEZ MONTAÑÉS

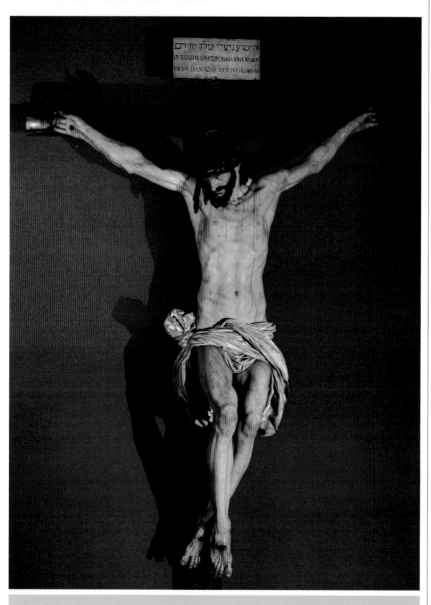

IN CONTEXT

FOCUS
Counter-Reformation art

BEFORE
1563 The 25th, and final, session of the Council of Trent debates the role that art is expected to play in religion.

c.1590–1630 The Bolognese school—the center for Italian painting at this time—rejects the contrived Mannerist style of painting, and aims for greater clarity of expression to fit new Catholic ideals.

AFTER
Early 17th century Flemish Catholic artists, such as Peter Paul Rubens and Anthony van Dyck, paint notable large religious works.

1649 Francisco Pacheco's book *Art of Painting* is published. It is an important source of information on Counter-Reformation iconography.

F rom the mid-16th century, the Roman Catholic Church fought to revitalize itself to oppose the spread of Protestantism, which had begun when German theologian Martin Luther launched the Reformation in 1517. This resurgence is known as the Counter-Reformation, and its policies were drawn up at the Council of Trent—a series of 25 meetings between Church officials held at Trento in northern Italy from 1545 to 1563. The final meeting included a discussion about the role of art in worship. Both painting and sculpture were recognized as effective means of bolstering belief: images of Christ and the saints could appeal

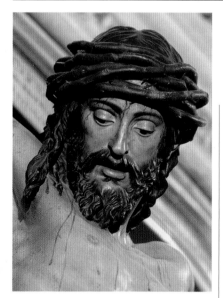

to the hearts and minds of the faithful, inspiring them "to adore and love God and to cultivate piety."

The Council's pronouncements about art were unspecific, but they were soon followed by a stream of writing (mainly by theologians rather than artists) elaborating on how they should be put into practice. One of the major books of this type was *Discourse on Sacred and Profane Images* (1582) by Gabriele Paleotti, Archbishop of Bologna. Paleotti condemned the kind of pictures that "are seen every day in churches, and which are so obscure and ambiguous that instead of illuminating … they confound and distract the mind … to the detriment of devotion." In contrast, he praised the kind of artist who "knows how to explain his ideas clearly … and to render

The Council of Trent (1545–63) sought to clarify Catholic teaching and practices. This painting shows its 23rd session, which was held in 1553 at Trento Cathedral.

Christ of Clemency's anguished face would have gazed down at a sinner kneeling in prayer; proximity to Christ's suffering would have stirred strong emotions in the faithful.

them intelligible and plain to see." The desire for realistic and readily understandable images was part of the background from which Baroque art emerged, replacing the somewhat artificial Mannerist style in which technique and form were frequently considered more important than the subject itself.

Throughout Europe, Catholic dogma specified the most favored subjects for Counter-Reformation art. Depictions of Christ's suffering, the apostle Peter's repentance, the Annunciation, and the Sacraments were greatly encouraged, while some artists—including Paolo Veronese and Michelangelo—were censured by the Church for what was thought to be their "impious" paintings of religious scenes.

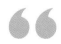

Holy images help give outward expression to the reverence we feel within.
Francisco Pacheco

In devout Spain, the master painter Diego Velázquez created profound religious works in a Baroque style that were designed to appeal to the senses of believers. Also in Spain, the Counter-Reformation found sculptural expression in large-scale polychrome statues. The material of choice for these carvings was wood, rather than bronze or stone. Sometimes the wood was left unpainted »

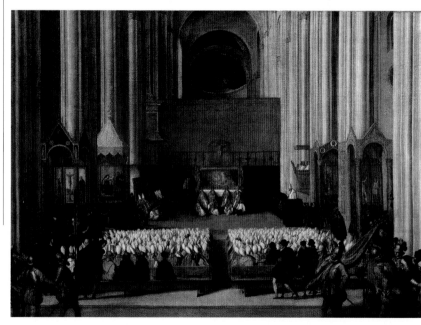

(particularly if it was a beautifully grained import from the colonies), but more often it was painted in naturalistic colors; sometimes the realistic effect was accentuated by using, for example, glass eyes, ivory teeth, and human hair for eyelashes.

A work of contrition

The greatest master of this form of art was Juan Martínez Montañés, known by his contemporaries as *el dios de la madera* (the god of wood). *Christ of Clemency* is Montañés' most celebrated work—not only because of its superb quality, but also because of the documentation that survives about its origins, which offers revealing insights into Counter-Reformation ideals.

Christ of Clemency was commissioned by Mateo Vázquez de Leca, Archdeacon of Carmona (a town near Seville) as an act of atonement for his sins. He is reputed to have led a dissolute life, consorting with prostitutes, until he had a visionary experience that caused him to change his ways. In this vision, a woman he was pursuing removed her veil and revealed herself to be a skeleton.

The archdeacon's commission set out the precise terms on which the sculptor should work. Vázquez de Leca wrote that "Christ is to be shown alive, at the moment before he expires, with his head inclined to the right, looking at any person who might be praying at his feet, so it will appear that Christ addresses him, saying that it is for him that he suffers. Therefore his eyes and face should have a certain severity, and the eyes should be completely open."

Montañés carried out the archdeacon's instructions with fidelity and sensitivity. He rendered Christ's body and face with realism, showing how thoroughly he had studied anatomy: the musculature and such details as the rib cage, knees, and feet are all convincing. But contrary to some of his Spanish contemporaries, Montañés tempered realism and emotional conviction with a sense of dignity and poise: the figure of Christ seems to float in front of the cross

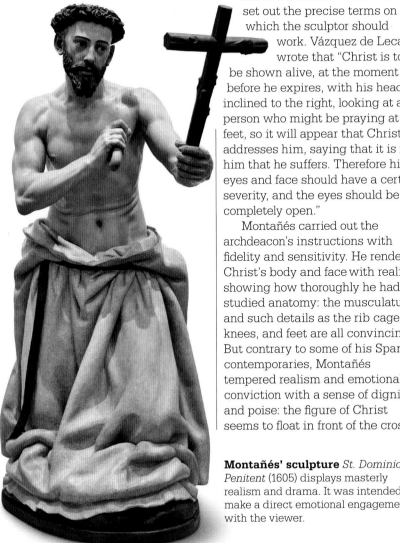

Montañés' sculpture *St. Dominic Penitent* (1605) displays masterly realism and drama. It was intended to make a direct emotional engagement with the viewer.

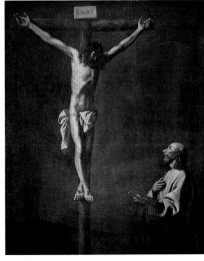

Francisco de Zurbarán's *St. Luke as a Painter before Christ on the Cross*, (c.1650), showing *St. Luke* with a palette, is thought by some to allude to the role of art in igniting religious devotion.

rather than hang from it. The only part of the sculpture that strikes a slightly discordant note is the loincloth: its elaborate folds suggest virtuosity for its own sake—an indication that his work retained traces of the Mannerist tradition.

Setting the rules

Montañés did not paint the sculpture himself—the artists' guilds dictated that such work could be carried out only by a qualified master painter. In this case (and also for many other of Montañés' sculptures) the painter was his friend Francisco Pacheco. Known mainly as a religious artist, Pacheco was, in 1618, appointed "overseer of sacred paintings" by the Inquisition in Seville, a body established to uphold Catholic orthodoxy in Spain. This gave him authority to censor work by fellow painters in the city to ensure that they presented views sanctioned by the Church and avoided subjects that could mislead the faithful.

For many years, Pacheco worked intermittently on a compendious book dealing with the theory and practice of painting, and it was eventually published in 1649, five years after his death. Entitled *Art of Painting*, it is the largest and most important artistic treatise produced in 17th-century Spain, embracing historical as well as theoretical and technical matters. The book demonstrates Pacheco's support for the ideals of the Counter-Reformation. He characterizes painting as primarily a means of defending and propagating the Roman Catholic faith and also provides quite detailed descriptions of how certain established subjects, including the Crucifixion, should, and should not, be represented.

Beyond Spain

The Counter-Reformation provided the impetus for great creativity in Europe's Catholic heartlands. Additions to St. Peter's Basilica and the Church of the Gesù, the mother church of the Jesuit order, brought the Baroque style to religious architecture, just as such artists as Bernini and Caravaggio did to painting and sculpture. Christian missionaries, especially the Jesuits, carried their iconography to colonies in the Americas; blending with native religious traditions, this art gave rise to phenomena such as the Virgin of Guadalupe—a vision of a dark-skinned Virgin Mary that spawned a colonial cult in Mexico, so transmitting the values of the Council of Trent to new lands. ∎

Key characteristics of Counter-Reformation art

Clarity
Works of art must be **easy to understand**. Allegory and **abstract ideas** are not forbidden, but they must be **intelligible**.

Realism
The artist must **aim for accuracy** and be prepared to **show** the **brutality** of Christ's Passion or the martyrdom of the saints.

The Church set out guidelines for Counter-Reformation art

Modesty
Unnecessary nudity must be avoided; **spiritual truth** and moral improvement must take precedence **over aesthetic pleasure**.

Emotionalism
The artist must aim to encourage the viewer to **empathize** with the holy figures represented, **sharing** their **bliss** or **pain**.

Juan Martínez Montañés

Juan Martínez Montañés was born at Alcalá la Real in 1568. He trained in the nearby city of Granada but spent almost all his career in Seville, a major cultural center and one of the most thriving cities in Europe, in part because it was the main port for Spain's highly profitable trade with the Americas. In addition to many commissions in Seville, Montañés' workshop created sculptures for ecclesiastical settings elsewhere in Spain, and also for the colonies in America. All Montañés' work was religious, apart from a portrait (lost) of Philip IV, which was probably produced to be sent to Italy as the model for the head of a statue of the king. Montañés was acknowledged as being the greatest Spanish sculptor of his day, and his work had wide influence. He died in Seville in 1649.

Other key works

1597 *St. Christopher*
1610 *St. Ignatius Loyola*
1628 *Virgin of the Immaculate Conception*
1634 *St. Bruno*

I HAVE NEVER LACKED COURAGE TO UNDERTAKE ANY DESIGN, HOWEVER VAST IN SIZE

A LION HUNT (c.1615), PETER PAUL RUBENS

IN CONTEXT

FOCUS
The oil sketch

BEFORE
c.1530 Italian Mannerist painter Polidoro da Caravaggio is one of the first artists to employ the oil sketch as a means of planning a painting.

c.1601 Rubens paints *Head of a Youth*, one of his first known oil sketches.

AFTER
1732 Italian painter Sebastiano Ricci writes of his work: "the sketch is the finished work … the altarpiece is the copy."

1888 Thirty oil sketches by John Constable are given to the Victoria and Albert Museum, London, by the artist's daughter Isabel.

1944 British painter Francis Bacon calls his figurative oil works "studies."

D uring time spent in Italy (1600–08), the Flemish artist Peter Paul Rubens immersed himself in the country's culture and way of life. He adopted an Italian technical innovation—the oil sketch—to the extent that it became a central feature of his art. No other artist produced such a rich body of work in the medium.

Oil sketches are usually small paintings, executed with rapid brushwork, as preliminary studies for a larger work. When Rubens worked on his large paintings, his procedure was to make an oil sketch of the composition, which—alongside his drawings of various details—formed a guide for a team

See also: Assyrian lion hunt reliefs 34–35 ▪ Studies for *The Virgin and Child with St. Anne* 124–27 ▪ *Watson and the Shark* 225 ▪ *The White Horse* 278

of highly trained assistants. They carried out the groundwork of the painting, before Rubens took over to finish the piece.

Vigor and fluency

The sketch for *A Lion Hunt* is one of Rubens' earliest known hunting scenes—a type of picture that was popular with aristocratic patrons, to whom hunting was not just a sport but a symbol of their privileged status. There is no known finished painting that is entirely based on the sketch, but several of its motifs (such as the rider being pulled from his horse by a lion) appear in other works. The dynamic, tightly knit composition, which captures the extraordinary energy and violence of the hunt—as well as its horror—shows the vigor of Rubens' style and the supreme fluency of his hand, his brush skimming and flickering over the wooden panel.

After Rubens, many painters began making initial oil sketches as part of their preparatory work. Such sketches soon became valued in their own right. Italian painter Luca Giordano, for example, made copies of his sketches for collectors and others who wished to own them.

The productions of Rubens … seem to flow with a freedom and prodigality.
Joshua Reynolds
A Journey to Flanders and Holland, 1797

The most remarkable development of the oil sketch, however, came from English landscape painter John Constable. In 1819, he began making full-size oil sketches for his most ambitious paintings, including such celebrated works as *The Hay Wain*. These trial runs were virtually unknown in Constable's lifetime, but their freedom of brushwork has greatly appealed to modern taste. The same is true of Rubens' oil sketches, in which—in contrast to the finished works—the master's hand is apparent in every touch. ▪

Peter Paul Rubens

Peter Paul Rubens was born in 1577 in Westphalia (now part of Germany). He trained in Antwerp, in the Low Countries, but his real artistic education came from eight years spent in Italy. On his return to Antwerp, he became established as the leading artist of northern Europe and produced paintings for eminent patrons throughout Europe. Rubens also worked as a diplomat and was knighted by the kings of England and Spain.

Other key works

c.1609 *Self-portrait with Isabella Brant in the Honeysuckle Bower*
1614 *The Descent from the Cross*
1629–30 *Peace and War*

THE VALOR OF THE VANQUISHED MAKES THE GLORY OF THE VICTOR

THE SURRENDER OF BREDA (1634–1635), DIEGO VELÁZQUEZ

Depictions of contemporary history in art have mainly been concerned with glorifying the deeds of powerful men (and sometimes women) and justifying them to posterity. War, being so constant a feature of human history, is a recurring subject. In ancient Rome, for example, immense columns to commemorate the emperors Trajan and Marcus Aurelius were erected, adorned with sculpture depicting their military triumphs; and one of the most remarkable works of art to survive from the Middle Ages is the Bayeux Tapestry, recording William of Normandy's conquest of England in 1066.

See also: Marcus Aurelius 48–49 ▪ Trajan's Column 57 ▪ Bayeux Tapestry 74–75 ▪ *Watson and the Shark* 225 ▪ *Napoleon on the Battlefield of Eylau* 278 ▪ *The Defense of Petrograd* 338–39

During the Renaissance, paintings of battle scenes were frequently commissioned to form part of the interior schemes of major buildings. In 1503–04, Leonardo da Vinci and Michelangelo each began a huge picture for the Palazzo Vecchio (the seat of government in Florence) depicting a battle, although neither completed his work. In England, the defeat of the Spanish Armada in 1588 was commemorated with 10 magnificent tapestries for the House of Lords in London.

History through myth

It was common to show the participants in such scenes as if they were involved in an episode from myth rather than real life, often accompanied by allegorical devices. The leading exponent of this approach was Peter Paul Rubens, notably in his series of 25 huge canvases on the life of Marie de'

In *The Victory at Jülich* (1622–25), Rubens uses allegorical figures to glorify Marie de' Medici and to mark her celebration of a military achievement.

Medici (mother of Louis XIII of France), which was painted in 1622–25 for the Luxembourg Palace, her residence in Paris. Marie's political career was lackluster and she ended her life in exile, but Rubens depicts her as a glorious model of queenship. For example, in *The Victory at Jülich* (a scene that, just like *The Surrender of Breda*, celebrates the capturing of a city), Marie is shown mounted on a magnificent steed, wearing a helmet like the one associated with the goddess Athena, and accompanied by flying figures representing Victory (about to place a laurel wreath on her head) and Fame (trumpeting her praises).

Rubens' grandiose way of depicting contemporary history remained part of the mainstream of European art well into the next century. In the hierarchy of genres later laid down by the influential French Academy, the heroic or allegorical history painting was the highest genre. Yet Diego Velázquez, in *The Surrender of Breda*, takes a radically different approach from Rubens.

Pride of a nation

The Surrender of Breda was one of a series of 12 large paintings celebrating Spanish military successes in the reign of Philip IV; the events represented took place from 1622 to 1633. The paintings were designed for the king's new palace, Buen Ritiro—specifically, for the main ceremonial room, the Salón de Reinos ("Hall of Realms").

In the mid-16th century, Spain had been at the height of its power and prestige, ruling extensive areas of Italy and northern Europe, as well as huge colonial territories in the Americas. But by the time Philip came to the throne in 1621, **»**

Diego Velázquez

Diego Velázquez was born in 1599 in Seville. He trained there under the artist Francisco Pacheco, whose daughter he married in 1618. Velázquez settled in Madrid in 1623, after painting an acclaimed portrait of King Philip IV. He became Philip's favorite artist and was unrivaled in this position for the rest of his life. Philip appointed him to various administrative court posts that carried great prestige but limited his time for painting. Velázquez worked mainly as a portraitist (especially of the royal family and court), occasionally painting religious and other subjects. He died in Madrid in 1660.

Other key works

c.1620 *The Waterseller of Seville*
1630 *The Forge of Vulcan*
1649–50 *Pope Innocent X*
c.1656 *Las Meninas*

The Surrender of Jülich (1635) by José Leonardo marks the capture of the Dutch fortress of Jülich by the Spanish. Its depiction of the surrender is more conventional than that of Velázquez.

the country was in serious decline. Despite this, Spain was enjoying a Golden Age in the arts, which continued until around 1680. Velázquez' painting was intended to glorify the king and bolster the nation's waning image.

Although *The Surrender of Breda* completely outclasses the other paintings in the series, it shares with them an important characteristic: they all depict events in a more or less naturalistic way, with the figures wearing normal clothes and behaving as they might actually have done. At the time, this was an unusual approach to representing contemporary history.

An unaffected style
Breda is a city in the Netherlands, near today's border with Belgium. It played an important role in the Dutch struggle for independence against Spain, being captured and recaptured several times. Velázquez' painting celebrates the Dutch surrender of the city to Spanish

forces on June 5, 1625, following a 10-month siege that had left the defenders on the brink of starvation.

The governor of Breda, Justin of Nassau, is shown handing over the key of the city to the victorious Spanish general, Ambrogio Spinola. On the left, a group of bedraggled Dutch soldiers contrasts with the tight assembly of Spanish troops on the right. Their fierce array of pikes has given the picture its popular name in Spanish—*Las Lanzas* ("The Lances"). Behind the figures is a wide landscape, with smoke rising from the conquered city.

Velázquez depicts the scene with extraordinary force and conviction. The faces of victors and vanquished are graphic portraits, conveying diverse feelings and reactions; the two horses are magnificent animal studies; and from foreground to far distance the setting is infused with light and atmosphere. The meeting of the commanders is unforgettably poignant, as the gracious Spinola

places a kindly hand on Justin's shoulder—one old soldier consoling another. Compared with the visual splendor and psychological insight seen here, even the best of the other 11 paintings in the series (shared among nine other Spanish artists) look rather formulaic.

Sources of information
Velázquez' version of events at Breda is persuasive, and is a soaring feat of the imagination that draws on several literary and pictorial sources. The capture of Breda was commemorated in various ways: paintings and prints (including a panoramic etching by French artist Jacques Callot); an eyewitness account by Spinola's chaplain Herman Hugo; and a play by Pedro Calderón de la Barca, one of the greatest Spanish writers of the age. It is possible that Velázquez used these works to inform his painting.

The handing over of a captured city's key was a well-established convention in depictions of sieges,

There was no other way of representing the death of a hero but by an Epic representation of it.
Benjamin West
in *The Farington Diary*, 1806–07

but such an event did not happen at Breda. Traditionally the vanquished commander was shown on bended knee in front of the victorious general, mounted on a horse. In fact, Spinola is shown in this way in another painting in the Salón de Reinos series—*The Surrender of Jülich* by José Leonardo. In his play *The Siege of Breda*, Calderón broke away from this convention, having Spinola dismount from his horse before accepting the surrender from Justin, and Velázquez followed him in this detail.

Spinola was renowned for his chivalrous behavior (the terms of the Dutch surrender were recognized as notably generous), so although the meeting shown is not literally true, it is poetically true. By the time the work was painted, both commanders were dead, but the portrayal of Spinola was based on the artist's personal experiences. Velázquez made two visits to Italy and on the first of these (1629–31) he sailed with the famous general on the outward journey, and may have gotten to know him during the voyage.

Naturalism in history

Like most of Velázquez' paintings, *The Surrender of Breda* was in the Spanish royal collection, and was little known to the world at large. It became more accessible when the Prado Museum opened in Madrid in 1819. The museum showed 331 paintings from the royal collection, among them 44 by Velázquez, including *The Surrender of Breda*. For the first time, the artist's genius could be appreciated by the public, and his fluid brushwork became an inspiration to other artists.

For 150 years after *The Surrender of Breda*, history painting remained a genre in which the allegorical and heroic mode prevailed over naturalistic depiction, but a more realistic manner of depicting events gradually gained ground. In Britain, a history painting using modern costume first achieved conspicuous success in 1771. This was Benjamin West's *The Death of General Wolfe*, which was acclaimed when it was shown at the Royal Academy. ■

Benjamin West's *The Death of General Wolfe* shows the British general fatally wounded by a musket in the Battle of Quebec of 1759, in which British and French forces clashed.

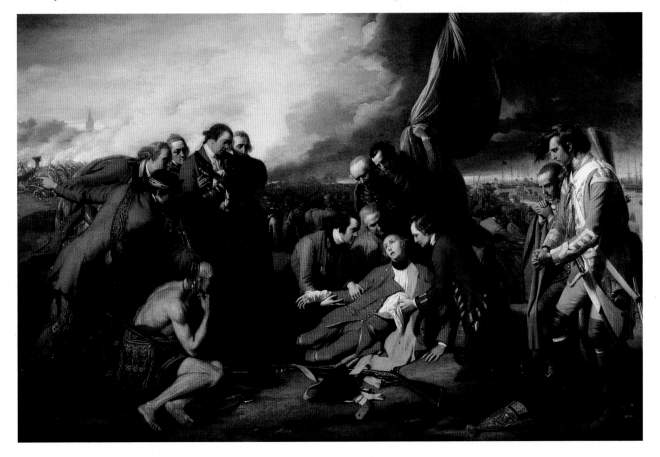

IF THIS IS DIVINE LOVE, I KNOW IT

ECSTASY OF ST. TERESA (1647–1652), GIANLORENZO BERNINI

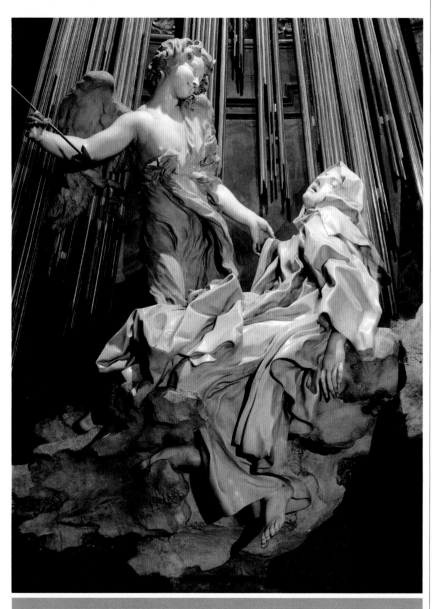

IN CONTEXT

FOCUS
Mysticism

BEFORE
c.1500 Sandro Botticelli's
Mystic Crucifixion shows the
penitent Mary Magdalene in a
scene inspired by the visionary
priest Girolamo Savanorola.

c.1520 *Mystic Bath of Souls*
by Flemish painter Jean
Bellegambe the Elder depicts
the Eucharist as a physical
experience of bathing in
Christ's purifying blood.

1522–24 Ignatius of Loyola
writes his *Spiritual Exercises*,
meditations that encourage
a direct experience of God.

AFTER
c.1757–1827 English artist
William Blake paints his visions
of angels and is inspired by
spiritual guides.

1910–1944 The mystical
mood of Wassily Kandinsky's
work reflects his belief that art
can act as a spiritual anchor.

During a tour of Italy in
1739–40, the French
scholar Charles de Brosses
showed insatiable curiosity about
cultural matters of all kinds, which
he described in his witty letters.
One famous comment was about
Bernini's statue of St. Teresa in
the Cornaro Chapel of Santa Maria
della Vittoria, Rome: "If this is
divine love, I know it"; to his eyes,
the saint's rapture seemed sexual.
Yet Bernini was a deeply religious
man, and in *St. Teresa* he expresses
a spiritual experience with passion
and sincerity.

See also: *Renunciation of Worldly Goods* 86–89 ▪ *Adoration of the Name of Jesus* 223 ▪ *Fortitude* 224 ▪ *Greek Slave* 249

> One could believe his chisel had been cutting wax rather than marble.
> **Filippo Baldinucci**
> *Life of Bernini*, 1682

Intuition and exaltation

St. Teresa of Ávila (1515–82) was a Spanish nun who was co-founder, with St. John of the Cross, of the austere order of Discalced (or "barefoot") Carmelites. She was a mystic—someone who believes that personal communication or union with God can be achieved through intuition, ecstasy, or sudden insight, in ways beyond usual physical or mental processes. In her autobiography she describes an encounter with an angel who was carrying "a long spear of gold tipped with fire." This he seemed to thrust into her heart and "to pierce my very entrails, leaving me all on fire with a great love of God. The pain was so great it made me moan … but so sweet I did not wish to be rid of it."

This is the episode depicted by Bernini in his sculpture in Santa Maria della Vittoria, a church belonging to the Discalced

A detail from Bernini's sculpture shows the saint with eyes closed and mouth agape in a sublime blending of the physical and the spiritual that expresses a state of divine joy.

Carmelites. Bernini took on an extraordinarily difficult task in attempting to represent in solid marble so strange and subjective an experience, but he succeeded triumphantly, conveying through the saint's ecstatic swoon, flowing drapery, and dramatic setting a sense of her exalted inner state.

St. Teresa is often regarded as Bernini's supreme masterpiece, but in a later work, *Blessed Ludovica Albertoni* (1672–74, San Francesco a Ripa, Rome), he went even further in representing mystical experience. While it is said that this sculpture shows the death of Ludovica, rather it seems to depict an earlier blissful state when she believed she had been granted a foretaste of Heaven.

Many other artists have tried to depict mystical states, and some have aimed to reveal through their work their own mystical experiences. Perhaps foremost among them was English Romantic poet and artist William Blake, who claimed to see angels and believed that he was guided in his work by the soul of his dead brother. ▪

Gianlorenzo Bernini

Gianlorenzo Bernini was born in Naples in 1598, but moved to Rome as a child and spent almost all his life there. He was the son of a sculptor and from an early age showed astonishing skill in cutting marble. This was his favorite material, but he was highly versatile. In addition to being acknowledged as the greatest sculptor of the 17th century, he was also a leading architect and an outstanding painter (although he painted mainly as a private pleasure). By the time he was 25 he was the foremost artist in Rome and he made a great impact on the appearance of the city, with his statues, fountains, and buildings commissioned by popes and cardinals. In 1665, he visited Paris to work for Louis XIV, but his designs for the east front of the Louvre were rejected (one of his rare failures). Bernini died in Rome in 1680.

Other key works

1622–25 *Apollo and Daphne*
1628–47 Tomb of Pope Urban VIII
1648–51 *Fountain of the Four Rivers*
1665 Bust of Louis XIV

MY NATURE CONSTRAINS ME TO SEEK AND TO LOVE WELL-ORDERED THINGS

THE HOLY FAMILY ON THE STEPS (1648), NICOLAS POUSSIN

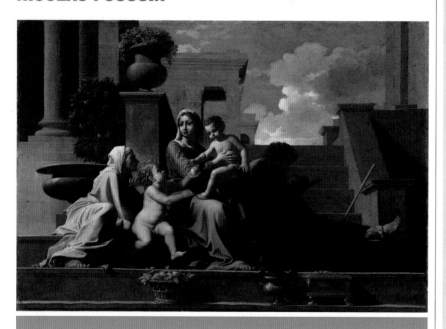

IN CONTEXT

FOCUS
Academic art

BEFORE
1563 The first formal art academy, the Accademia del Disegno, is founded in Florence by Cosimo I de' Medici.

1577 The Accademia di San Luca is established in Rome, although it does not operate regularly until 1595.

AFTER
1666 The French Academy in Rome is established by King Louis XIV. Artists who win the prestigious Prix de Rome may study at the Rome Academy at the French state's expense.

1768 The Royal Academy of Arts, London, is founded by King George III.

1860s Realist artists, such as Gustave Courbet, criticize Academic art for its stiff, idealized style and for ignoring social concerns.

In 1648, the year in which Nicolas Poussin painted *The Holy Family on the Steps*, the Royal Academy of Painting and Sculpture was founded in Paris. Although Poussin spent most of his mature career in Italy, he became a hero and guiding light of the Academy. His highly intellectual approach to painting—he was nicknamed "the philosopher painter"—enshrined the belief that art was primarily a matter of rational thought rather than self-expression, with definite ideas and methods that could be taught and learned.

The development of academies in Europe was initially linked with a struggle to raise the status of the visual arts. In the Middle Ages, painting and sculpture had been regarded as crafts. During the Renaissance, artists began to stress that they worked with the mind as well as the hands, and to claim that their work deserved to rank in prestige alongside music and poetry. Leonardo da Vinci and Michelangelo were at the forefront of this movement: Michelangelo was one of the honorary heads of the first formal art academy, the Accademia del Disegno in Florence.

The French Academy
France's Royal Academy was the first major art academy to be established outside Italy, and it became the most influential in Europe. It formed part of King Louis XIV's state policy to create a national artistic style appropriate for glorifying himself and the country. It became the arbiter of what was good and bad in art, and its methods of shaping the training, ambitions, and career structures of artists were imitated in many other academies. By 1800, there were more than a hundred such institutions throughout Europe.

See also: Santa Trinità *Madonna* 101 ▪ Studies for *The Virgin and Child with St. Anne* 124–27 ▪ *Landscape with Ascanius Shooting the Stag of Sylvia* 192–95 ▪ Tomb of Maria Christina of Austria 216–21 ▪ *The Romans of the Decadence* 250–51

One paints with the head, not with the hands.
Michelangelo

The French Royal Academy prescribed certain typical features for the art produced under its auspices. Works were expected to be intellectual and rational—traits expressed in a painting through, for example, its serious subject matter and classical references. Art should convey a moral message; history paintings were much valued for this reason, as was allegory. Forms and colors were naturalistic, while brushwork was invisible and the surface of the painting smooth.

Precision in art
Poussin painted *The Holy Family on the Steps* for French collector Nicolas Hennequin, master of the royal hunt. Its shows Poussin at his peak of classical dignity—serious, lucid, and harmonious. The figural grouping with its triangular format reflects the influence of artists of the High Renaissance such as Raphael. With its carefully contrived composition and its background of classical architecture, the picture is the perfect embodiment of the Academy's ideals.

Once, when he was asked how he achieved such clarity and balance in his painting, Poussin replied: "I have neglected nothing."

Charles Le Brun was First Painter to Louis XIV and a consummate Academic artist. He developed strict theories about drawing so as to depict human emotions accurately.

His working procedure was methodical and painstaking, involving not only preparatory drawings, but also small wax models, which he arranged so that he could study composition and lighting. Everything was formulated according to reason—a word that occurs repeatedly in his letters.

Poussin continued to inspire many French artists in the 18th and 19th centuries. The French Post-Impressionist painter Paul Cézanne, for example, said he would like to "bring Poussin back to life through nature." However, during the 19th century, academies lost much of their prestige among progressive artists, particularly in the wake of Romanticism, a movement that stressed emotion and individuality.

Many of the original academies still exist, some of them with superb art schools, but the phrase "academic art" has different connotations now, usually suggesting work that is complacently conventional. ▪

Nicolas Poussin

Nicolas Poussin was born in or near the town of Les Andelys, Normandy, in 1594. His early artistic career was halting and it was not until he settled in Rome in 1624 that he found his feet. He was an intellectual, and in his adopted city he perfected a painting style of austere nobility that reflected his deep love of the ancient world. He worked for a small circle of discerning patrons, and established a formidable reputation. In 1640, he reluctantly submitted to pressure and returned to France to work for King Louis XIII. The grandiose commissions he was given were unsympathetic to his style, and in 1642 he returned to Rome. In his final years he lived almost like a hermit, but when he died in Rome in 1665 he was acknowledged as one of the greatest artists of his time.

Other key works

1626–28 *The Death of Germanicus*
c.1640 *The Arcadian Shepherds*
1650 *Self-Portrait*
1660–64 *The Seasons*

LIFE ETCHES ITSELF
ONTO OUR FACES AS WE GROW OLDER,
SHOWING OUR VIOLENCE,
EXCESSES
OR KINDNESSES

SELF-PORTRAIT WITH TWO CIRCLES
(c.1665), REMBRANDT

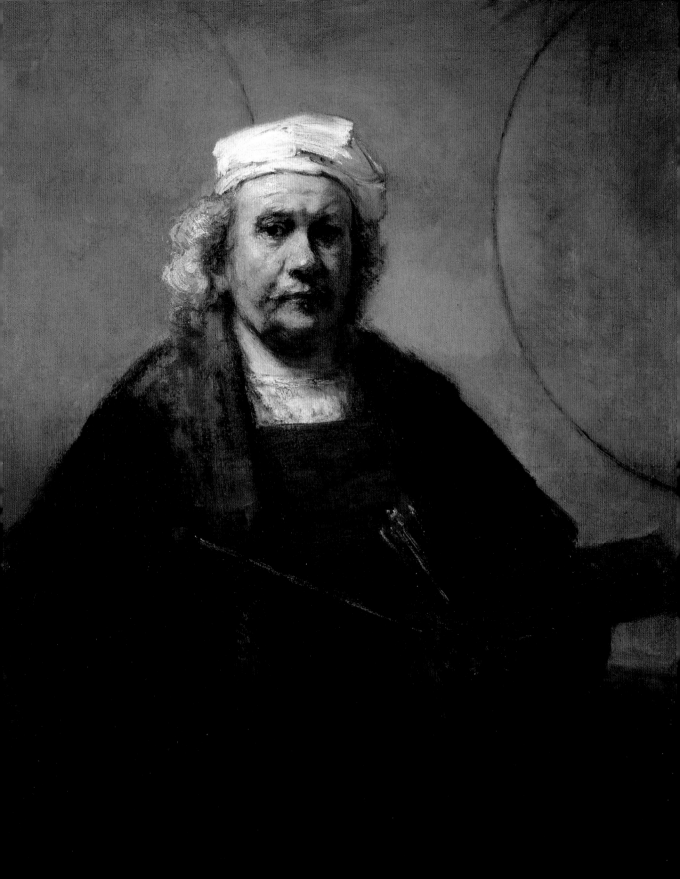

IN CONTEXT

FOCUS
Self-portraiture

BEFORE
1484 At age 12 or 13, Albrecht Dürer produces his first self-portrait, an exquisite silverpoint drawing; an inscription reads "drawn from myself from the looking glass."

c.1490 The first engraved self-portrait is made by the German printmaker Israhel van Meckenem.

1664 Leopoldo de' Medici starts to collect artists' self-portraits. After his death this pioneering collection will form the basis of the unrivaled display of self-portraits in the Uffizi Gallery, Florence.

AFTER
1854–55 *The Painter's Studio* by Gustave Courbet is a monumental canvas showing the artist among a host of friends and allegorical figures.

Many great artists have created images of themselves, but Rembrandt towers above all others for the range and depth of his self-scrutiny. In drawings and etchings, as well as in paintings, he depicted himself throughout virtually his whole career, as he developed from unruly youth to resilient old age. There are some 40 known painted self-portraits by Rembrandt, 30 or so etchings, and about 10 drawings. In addition, he sometimes included a small likeness of himself among the subsidiary figures in his historical and religious paintings.

Rembrandt's painted self-portraits include several works that are acknowledged masterpieces, but none is more revered than *Self-Portrait with Two Circles* (1665), completed when he was about 60 years of age. In many of his early self-portraits Rembrandt portrayed himself flamboyantly—sometimes with dramatic lighting or in fanciful costume; here he calmly asserts the nobility of his profession. By the time he painted this work, he had become much more inward-looking. He had suffered the loss of his wife, three children, and his mistress,

Self-Portrait in a Cap (1630) shows Rembrandt trying out an expression: wide-eyed, open-mouthed, and with raised brows, the young artist appears startled.

and was insolvent. Yet a feeling of massive authority is conveyed by the powerful simplicity of the frontal pose, the masterly breadth of the brushwork, and the steadfast dignity of the facial expression. Totally lacking in ostentatiousness, Rembrandt looks battered by time and tragedy, but undefeated.

Nothing is known about the circumstances in which Rembrandt painted this picture and there is

Rembrandt

Rembrandt Harmenszoon van Rijn was born in 1606 in Leiden in the Netherlands and spent his early life there before settling in Amsterdam in 1631 or 1632. He soon became the most sought-after artist and portraitist in the city, and was also renowned as an art teacher. However, in middle age his fortunes declined, partly because of his own extravagance, partly because he painted more to please himself than his clients, and partly because the Dutch economy was badly hit by war with Britain. In 1656, he was declared insolvent, and he lived

the rest of his life in modest circumstances. He continued to be respected as an artist, receiving important commissions. Rembrandt worked until his death in 1669, his art growing in pictorial splendor and depth of feeling until the end.

Other key works

1632 *The Anatomy Lesson of Dr. Nicolas Tulp*
1642 *The Night Watch*
c.1655 *The Polish Rider*
c.1668 *The Return of the Prodigal Son*

a similar lack of contemporary information about his other self-portraits. He left no explanation as to why he produced so many. Very little is known even about who owned the works in his lifetime. Charles I of England (1600–49), one of the greatest art collectors of his age, owned one as early as 1633, but apart from that the record is virtually blank.

Reasons to reflect

Modern writers have speculated widely about Rembrandt's motives for producing his self-portraits. It was once common to interpret the works as a kind of painted autobiography, in which Rembrandt charted his journey—moral as well as physical—through life. This approach is now generally regarded as sentimental and unhistorical.

More prosaically, it has also been suggested that he produced at least some of his self-portraits as a form of publicity. He earned his living mainly as a portraitist, and by keeping samples of his self-portraits on hand he could perhaps

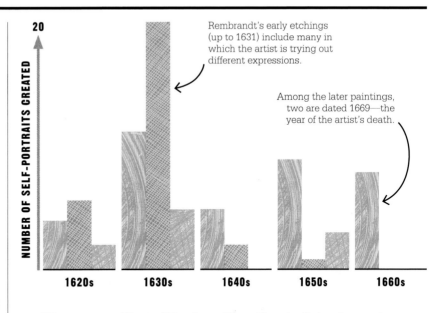

Rembrandt's early etchings (up to 1631) include many in which the artist is trying out different expressions.

Among the later paintings, two are dated 1669—the year of the artist's death.

Paintings
Etchings
Drawings

Most of Rembrandt's self-portrait drawings and etchings come from early in his career, but the paintings are fairly evenly distributed over a 40-year span. The earliest of his dated self-portraits is a painting of 1629.

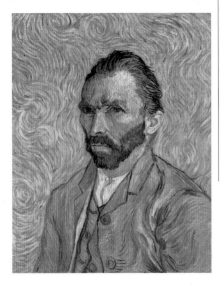

show how good he was at capturing a likeness: a potential client could simply compare the real Rembrandt with his painted image.

Rembrandt was a profound and many-sided artist, so it seems likely that he produced his self-portraits for a variety of reasons in a range of circumstances, rather than for one overriding motive. Several of the earliest self-portraits, particularly the etchings, show him with exaggerated facial expressions, and there can be little doubt that at this time he used his own features to try out ideas. Many artists before and since have done exactly the same. The impoverished Vincent

In *Portrait of the Artist* (1889), van Gogh depicts himself looking stern and anxious. He wrote to his sister: "I am looking for a deeper likeness than that obtained by a photographer."

van Gogh, for example, used himself as a convenient free model in his later years, as he explained in a letter to his brother Theo in 1888: "I have bought a mirror to work from myself in default of a model." He went on to say that if he could manage to depict himself successfully, "I shall likewise be able to paint the heads of other good souls—men and women."

In some of Rembrandt's self-portraits from the most prosperous part of his career—around 1640—he justifiably seems to celebrate his success. In these works, he is expensively dressed and well groomed—especially compared with his unkempt appearance in several early pictures—and presents himself in a way that consciously pays homage to portraits by the great Renaissance masters Raphael and Titian. Other self-portraits »

Self-Portrait with Wine Bottle
(1906) by Edvard Munch makes clear
allusions to the artist's heavy drinking.
The empty tables contribute to the
sense of isolation and melancholy.

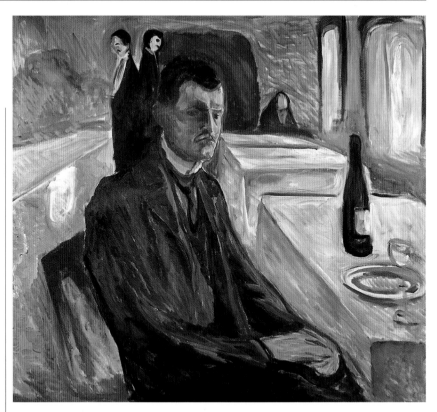

depict the artist taking on roles.
Rembrandt casts himself variously
as the Prodigal Son in a tavern
(along with his wife, Saskia); as
St. Paul, complete with the saint's
attributes of manuscript and sword;
and possibly as the ancient Greek
artist Zeuxis, who is said to have
died laughing while painting "a
wrinkled, funny old woman."

Painting the self

Self-portraiture was not, of course,
wholly unknown before Rembrandt.
Several artists in ancient Greece
are recorded as having created
images of themselves, although
these works have not survived. In
the Middle Ages, Western art was
overwhelmingly devoted to religion,
and the few portraits made were of
eminent and powerful people, such
as rulers or leaders of the Church.
It was in the Renaissance that the
self-portrait emerged as a distinct

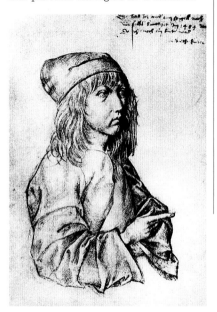

feature. One reason for its rise was
technical: improvements in glass
technology during the 15th century
made mirrors easier to produce,
and, although they were expensive,
they were available to artists.

Another reason was sociological
change: the subject matter of art
began to expand, and portraiture
started to become popular farther
down the social scale. A successful
merchant could commission a
portrait of himself, and an artist
could similarly express pride in
his profession and achievements
through a self-portrait.

Jan van Eyck's *Portrait of a Man*
(1433) is generally believed to be a
self-portrait—not least because the

Albrecht Dürer was a 12- or 13-year-
old apprentice in his father's jewellery
shop when he made this self-portrait in
1484. His great skill as a draughtsman
is evident in this early work.

loose ends of the red hood, or
chaperon, worn by the subject are
tied over his head, possibly to keep
them away from the paint on the
artist's palette. If this supposition
is correct, van Eyck's work is
perhaps the earliest independent
painting of its type. Two or three
generations later, Albrecht Dürer
was the first artist to create a series

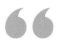

The psychological truth in
Rembrandt's paintings goes
beyond that of any other artist.
Kenneth Clark
Civilisation, 1969

of self-portraits (three paintings and several drawings) rather than isolated examples.

Ego and introspection

Vanity and self-promotion were compelling reasons for artists to paint self-portraits. The Flemish Baroque painter Anthony van Dyck, for example, painted himself several times, portraying himself as dashing, cultured, and effortlessly graceful, and reveling in his good looks and worldly success. Van Dyck's self-portraits bear out what contemporary accounts tell us about his personality: one of his early biographers wrote that "his manners were those of a lord rather than an ordinary man."

On the other hand, the Norwegian painter Edvard Munch was exceptionally handsome, even in old age, but in his self-portraits he was much more concerned with examining his feelings than in showing off his looks. Anxious introspection is a thread that runs through his self-portraits, which cover a period of some 60 years, from teenager to old man. After Rembrandt's, it is perhaps the most powerful and poignant series of self-portraits ever created; and, like Rembrandt's, it includes drawings, paintings, and prints.

Inner emotions

During the 20th century, as the relatively new medium of photography largely took over the functional business of recording appearances, artists began to use self-portraits to explore personal ideas and concerns. Perhaps the

most remarkable contribution to self-portraiture in recent art came from Mexican painter Frida Kahlo. About 150 paintings by her are known, and more than a third are self-portraits. In them, as well as chronicling her striking appearance, she expresses the physical and emotional traumas of her life.

Kahlo took up painting aged 18 after a bus crash that left her disabled and often in severe pain. In addition, her emotional life was characterized by extremes, involving marriage, divorce, and remarriage with Mexico's most famous painter, Diego Rivera, and numerous affairs. In her self-portraits she freely mixes realism, nightmarish fantasy, and influences from Mexican popular art. They have helped make her a feminist hero, acclaimed for her refusal to let great suffering quash her passion for life.

The *Self* project by British artist Marc Quinn is an extreme take on the self-portrait, comprising casts of the artist's head made out of his own frozen blood. Since 1991, he has made a new version every five years, showing his face changing over time. The works, which are displayed in special refrigerated cabinets and would simply melt if the electricity failed, are said to evoke "the fragility of existence." ■

Frida Kahlo was unable to bear children after a bus accident, and the pet monkeys that she frequently includes in her self-portraits are often interpreted as surrogate children.

THE CALM SUNSHINE OF THE HEART

LANDSCAPE WITH ASCANIUS SHOOTING THE STAG OF SYLVIA (1682), CLAUDE

See also: *Hunters in the Snow* 154–59 ▪ *The Holy Family on the Steps* 184–85 ▪ *The Flight into Egypt* 222 ▪ *The Wanderer above the Sea of Fog* 238–39

IN CONTEXT

FOCUS
Ideal landscape

BEFORE
1st century BCE–c.400 CE
Landscape painting flourishes as an art form in Rome, but falls from favor with the decline of the Roman Empire.

c.1635 Nicolas Poussin and Claude are among several artists who supply landscapes for Philip IV's new Buen Retiro Palace in Madrid, Spain.

AFTER
1800 The book *Elements of Practical Perspective,* by French artist Pierre-Henri de Valenciennes, promotes the study of nature in creating "historic landscape" paintings.

1969 The first large exhibition of Claude's work is shown in Newcastle upon Tyne and London, England, bringing his work back into the spotlight.

The picturesque gardens at the 18th-century Stourhead Estate in England are thought to have been designed to create views that resemble those seen in Claude's paintings.

Claude's reputation as Europe's most famous and admired landscape painter extended beyond his lifetime and into the 18th and 19th centuries. His paintings belong to a branch of the art known as ideal (or classical) landscape. In such pictures, nature is depicted in a calm, lucid manner, with imperfections smoothed away and the elements of the landscape harmoniously arranged to create a serene and noble vision.

Claude's dreamlike painting *Landscape with Ascanius Shooting the Stag of Sylvia* takes its subject from Virgil's epic poem, the *Aeneid* (29–19 BCE). The painting depicts Ascanius, the son of Aeneas, the legendary ancestor of the Romans, shooting the favorite stag of Sylvia, daughter of the herdsman of a local king. This sparks a war, resulting in Aeneas winning territory that eventually becomes the center of the Roman Empire.

Landscape painting was often, as in Claude's picture of Ascanius, given moral weight and intellectual respectability by providing highly dignified settings for stories and characters from literature, classical mythology, or the Bible. Such links confirmed that the genre could be a vehicle for ideas, and not just attractive decoration.

The art of landscape

When Claude began his career in the 1620s, landscape painting was relatively new, but the genre developed quite rapidly along two contrasting strands in 17th-century Europe. In northern Europe, and especially in the Dutch Republic, a naturalistic approach was favored: artists sought to paint scenes that accurately represented the "real world," or at least conveyed a strong sense of it. In Italy, where Claude spent most of his working life, the ideal landscape was the dominant type. The latter genre can be traced to six paintings commissioned in about 1603 by Cardinal Pietro Aldobrandini from Annibale Carracci. Each painting depicts a biblical scene within a landscape. The paintings were intended to decorate a chapel in the cardinal's family palace in Rome and were painted mainly by Annibale's assistants. But one of the works—*The Flight into Egypt*—is an archetype of ideal landscape from Annibale's own hand. It shows »

He conducts us to the tranquillity of Arcadian scenes and fairy land.
Joshua Reynolds
Discourses on the Fine Arts, 1786

Claude used similar motifs again and again in his paintings, but he subtly varied the way in which he combined them to create different harmonies in his compositions.

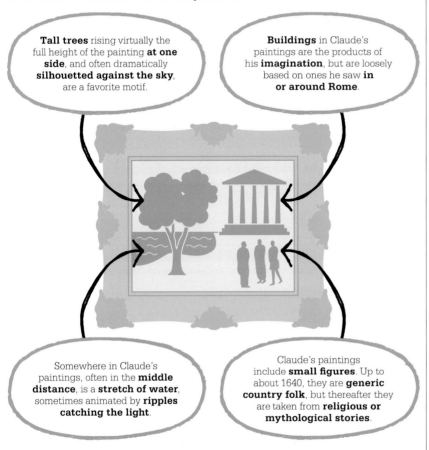

Tall trees rising virtually the full height of the painting **at one side**, and often dramatically **silhouetted against the sky**, are a favorite motif.

Buildings in Claude's paintings are the products of his **imagination**, but are loosely based on ones he saw **in or around Rome**.

Somewhere in Claude's paintings, often in the **middle distance**, is a **stretch of water**, sometimes animated by **ripples catching the light**.

Claude's paintings include **small figures**. Up to about 1640, they are **generic country folk**, but thereafter they are taken from **religious or mythological stories**.

best available materials, including very expensive ultramarine blue (made from the semiprecious stone lapis lazuli). He usually painted only a few pictures each year, and demand for his work far outstripped supply. In 1665, Sicilian nobleman Don Antonio Ruffo tried to buy a painting by Claude, only to be informed by the artist's agent that "There is no hope of getting anything from Claude, as he is all booked up for life."

Claude's patrons included three popes, several cardinals, King Philip IV of Spain, and aristocrats such as Prince Lorenzo Onofrio Colonna, who commissioned *Landscape with Ascanius Shooting the Stag of Sylvia*. The Colonna family claimed to be descended from Ascanius, which explains the choice of subject.

Composed in harmony

Throughout his career, Claude stayed true to certain pictorial concerns and methods. Harmony and balance were always of prime importance in his compositions, although later in his career his style became more ethereal, almost dreamlike.

In spite of the magical beauty of *Landscape with Ascanius*, the painting has an air of foreboding.

the Holy Family moving through a grand, solemn landscape that forms an idyllic background for their stately procession.

At this time, landscape ranked low in the pecking order of subjects in painting. "History painting," showing heroic figures engaged in exalted scenes from the Bible or other serious literary sources, was regarded as the preeminent type of painting, as it was the most challenging intellectually and the most difficult technically.

Landscape paintings such as Claude's often made reference to mythological or biblical stories. Even when they did not illustrate a

particular story, they often evoked, in a more general way, the idyllic country life described in the pastoral poetry of Virgil, the most famous of ancient Roman writers. The idea of a lost golden age of peace and contentment took a firm grip on the imagination, and ideal landscape became one of its main channels of transmission.

Claude's work appealed to wealthy, educated patrons not just because of such resonances, but also because of their sheer quality. They were unmistakably luxury products, available only to the social elite. Claude was a slow, fastidious worker who used the

He has been deemed the most perfect landscape painter the world ever saw.
John Constable
Lecture at Hampstead, 1834

Claude rarely depicts outward drama, but he is aware that the order of his poetic world can be shattered by human actions. The light in the sky is thundery, and it is easy to imagine that the wind stirring the trees is a chill one.

Claude was a friend of Nicolas Poussin, another great French painter of ideal landscapes. The two shared a sense of dignity and harmony, but their styles differed. Poussin's work was more solid, severe, and geometrical, and he did not have Claude's extraordinary feeling for light and atmosphere. The paintings of Poussin's brother-in-law, Gaspard Dughet, occupy a middle ground—more earthy than Claude's, but less austere than Poussin's, and between them, the three artists provided inspiration for exponents of ideal landscape well into the 19th century.

Landscape (c.1655) by Gaspard Dughet shows an ideal Arcadian scene. Although French by ancestry, Dughet lived in Italy and was part of its landscape-painting tradition.

Reputation and critics

Claude was known as the "prince of landscape painters," and his reputation was particularly high in the period from about 1750 to 1850, especially in Britain. Young aristocrats on the Grand Tour (a cultural tour of Europe) in Italy, where Claude lived, collected his paintings so avidly that there are more Claudes in British collections than in those of any other country. However, cracks appeared in his reputation in the mid-19th century, when he was censured by the English critic John Ruskin for being repetitive and lacking real feeling. In 1925, another British critic, Roger Fry, claimed that Claude had produced "counterfeit bad pictures."

Nevertheless, the artist continued to have numerous admirers, and following World War II his reputation underwent a revival. Subsequently, Claude has been the subject of many books and exhibitions, and has been securely restored to his position as one of the supreme figures in the history of landscape painting. ∎

Claude

Claude Gellée was born in about 1604 in the village of Chamagne, Lorraine (at that time an independent duchy, but now in northeast France). He is sometimes known as Claude Lorrain after his place of birth, but usually simply as Claude—a measure of his great fame. He moved to Rome in about 1618 and, after periods working in Naples and back in Lorraine, had settled there permanently by 1627. Over the next decade he established himself as the leading landscape painter in Italy, and his reputation soon became international. In spite of his success, he lived modestly, quietly devoted to his art. Contemporary biographers testify to his amiability and integrity. He never married, but in 1653 he had an illegitimate daughter, who looked after him in his old age. Although he suffered a good deal of ill health, he worked with undiminished skill until his death in 1682.

Other key works

1631 *The Mill*
1641 *Seaport with the Embarkation of St. Ursula*
1664 *The Enchanted Castle*

HE IS EVERY INCH A KING

LOUIS XIV (1701), HYACINTHE RIGAUD

In the days before photography, there was a steady demand for paintings of monarchs and prominent aristocrats. These portraits were used to decorate royal residences, to impress visiting heads of state, to give as diplomatic gifts, and also to present to royal favorites. The court artists who created these likenesses were expected to make a recognizable image that also flattered the subject and conjured a suitable impression of majesty.

For Louis XIV, who ruled France from 1643 to 1715, portraiture was part of an elaborate propaganda campaign to magnify his status as the most powerful king in Europe. His rule was based on a belief

See also: Salt Cellar 152 ▪ *Young Man among Roses* 160 ▪ *The Holy Family on the Steps* 184–185 ▪ *Death of Marat* 212–213 ▪ *Head of Charles I in Three Positions* 223

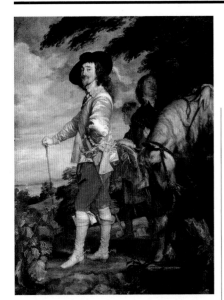

in the divine right of kings. Taking the sun as his emblem, he wielded absolute power, having squashed constitutional attempts to curb his authority. France enjoyed something of a cultural golden age during his 72-year reign, the culmination of which was the construction of the magnificent palace at Versailles, inaugurated in 1682. Hyacinthe Rigaud's portrait of Louis in full regalia is the quintessential image of the Sun King's era, conveying the full force of French supremacy, as well as extravagant opulence.

Royal magnificence
The monumental canvas shows the 63-year-old monarch full length. Louis XIV was not a tall man, but his stance is such that he appears to be looking down at the spectator. He is clad in the swirling drapery of his coronation robe, which—lined with ermine and printed with the royal emblem of the fleur-de-lis— adds considerably to his stature. The composition is calculated to present an image of ideal kingship.

Charles at the Hunt (1635), by the Flemish painter Anthony van Dyck, conveys the English king's sense of superiority through his confident stance in the landscape he reigns over.

A billowing red curtain above the king forms a kind of canopy; his crown is perched on the stool beside him; his royal sword is at his hip and he holds the royal scepter. The column behind him rests on a base that is decorated with a relief subtly referencing the rule of the Roman emperors.

The king's haughty expression is tempered by the naturalistic sagging of his features, but it is difficult to believe that the artist's rendering of the king's shapely legs and balletic pose is anything but flattery—Louis had prided himself on his dancing ability as a youth.

Rigaud's portrait of Louis XIV certainly had the desired effect of pleasing his patron: Louis had commissioned the work to present to his grandson, Philip V of Spain, but he liked it so much that he kept it for himself.

> *L'État c'est Moi*
> (I am the state).
> **Louis XIV**
> **1655**

Continuity of style
The composition of *Louis XIV* shows the conservatism of the royal portrait genre. The work is similar in many respects to the portrait of Charles I of England by Flemish painter Anthony van Dyck. Rigaud himself had used a near-identical pose for an earlier portrait of Louis XIV in full armor. Bringing a notable Baroque stateliness to the understated elegance of Titian and van Dyck, Rigaud perfected the art of state portraiture in a style that survived well into the 18th century. ▪

Hyacinthe Rigaud

Born in the French town of Perpignan in 1659, Hyacinthe Rigaud trained in Montpellier before moving to Paris in 1681. Here, he developed a flourishing practice as a portraitist, taking commissions from Parisian aristocrats. Rigaud cemented his reputation in 1688 with a portrait of the brother of King Louis XIV and became the leading painter to the French court. His 1694 portrait of Louis XIV as a war hero on the battlefield pleased the king so much that 34 copies of it were made. Rigaud was elected to, and taught at, the Royal Academy. He died in Paris in 1743.

Other key works

1689 *Philippe II, Duke of Orleans*
1694 *Portrait of Louis XIV in Full Armor*
1700 *Philip V of Spain*
1708 *Cardinal de Bouillon*

HOW GLADLY WE ACCEPT THIS GIFT OF SENSUOUS PLEASURE!

PILGRIMAGE TO THE ISLE OF CYTHERA (1717), JEAN-ANTOINE WATTEAU

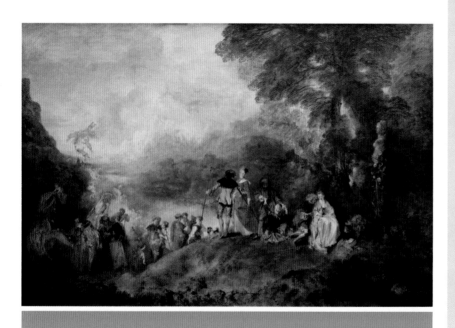

IN CONTEXT

FOCUS
The *fête galante*

BEFORE
c.1509–11 *The Pastoral Concert*, attributed to Titian, features two nude women and two musicians in a landscape.

1633 Rubens' *Garden of Love* depicts flirting and feasting in an idyllic garden setting.

1700 *Les Trois Cousines*, a play by French dramatist Florent Dancourt, which contains a pilgrimage to Cythera, is first performed.

AFTER
c.1759–52 Jean-Honoré Fragonard paints *The Musical Contest*, showing a woman and two rival suitors in a park.

1863 Édouard Manet's *Le déjeuner sur l'herbe* depicts two women (one of them nude) and their admirers in a park. Like Watteau, Manet lights his subjects theatrically.

Paintings of *fêtes galantes* (amorous parties)—popular in 18th-century France—depict gatherings of elegant people flirting, chatting, or listening to music in poetic park settings. These lighthearted, small-scale canvases reflected the prevailing mood of entertainment under King Louis XV (reigned 1715–74). They took the decorative elements of the Rococo style, and applied them to themes of love, often with aristocrats in ball dress or masquerade costumes.

The term "*fête galante*" was coined in 1712 at the French Royal Academy of Painting and Sculpture to describe Jean-Antoine Watteau's unfinished *Pilgrimage to the Island of Cythera*. Watteau submitted this initial version as his entrance piece to join the Academy, completing the work in 1717. Since it did not fit into any existing category of art, it was referred to as "*une fête galante*" by the institution's secretary.

Art of celebration
Despite defying categorization by the Academy, Watteau's painting had a clear artistic pedigree. It grew out of a long-established tradition in Western art of *fêtes champêtres* (outdoor parties), where idyllic landscapes were peopled with shepherds, courtiers, nymphs, or muses. Such scenes were most famously painted by the Venetian Renaissance artists Giorgione and Titian as complex allegories of music and poetry or of the union of the spiritual and natural worlds. However, in the hands of northern European painters of the 17th century, such as Peter Paul Rubens, the themes became a celebration of the customs of the wealthy upper classes, who were shown enjoying music or feasting in beautiful gardens or country estates.

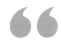

Building with a few brushstrokes a world of grace, youthfulness, love, and freshness …
Théophile Gautier
Fine Arts in Europe, 1855

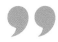

Myths of love

In antiquity, the Greek island of Cythera was thought to be the birthplace of Aphrodite (Venus in Roman mythology), the goddess of love, so it is an appropriate destination for the courtly couples in Watteau's canvas. However, it is not entirely clear in the painting whether the couples are embarking on a voyage to the island of Cythera or returning from it. What is clear is that the composition represents different stages of courtship. In the foreground, overlooked by a statue of Venus, one couple is engaged in romantic conversation. The man and woman next to them are getting up to leave, while the third couple have already embarked on their journey, the woman looking back wistfully at the others. In the background, more couples process toward a ship decked with blossom and silk, flirting and making merry along the way as cupids frolic around them.

The composition is a dreamy evocation of a mood, tinged perhaps with a gentle melancholy, rather than a depiction of a specific event or place. There is something theatrical about it, and Watteau's choice of theme and arrangement of the figures may well have been influenced by the theater of the time: the central characters appear illuminated, as if by stage lighting.

Watteau's art inspired two contemporary imitators, Jean-Baptiste Pater and Nicolas Lancret, and later artists, including François Boucher and Jean-Honoré Fragonard, produced their own versions of the theme. But *fêtes galantes* fell out of fashion during the French Revolution, when they were seen to embody the frivolous ideals of the ancien régime. It was not until well after a century had passed following Watteau's death that they were appreciated again, when his art drew praise from luminaries such as Victor Hugo, the Goncourt brothers, and Marcel Proust. ■

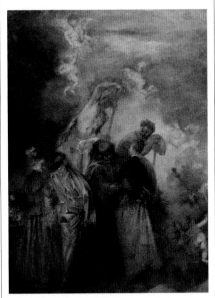

The oarsmen in Watteau's *Pilgrimage to Cythera* are ready to set sail to or from Cythera, the island of love; *putti* (cupidlike angels) hover above the boat to guide the lovers on their journey.

Jean-Antoine Watteau

Jean-Antoine Watteau was born in Valenciennes, then part of Flanders, probably in 1684. His health was fragile, and he is said to have had a melancholy temperament. By around 1705, he was working in the Paris studio of Claude Gillot, whose depictions of the Italian actors of the commedia dell'arte inspired Watteau to paint several of his own theatrical scenes, often drawing upon his own collection of costumes. He later worked for decorative painter Claude Audran.

Around 200 paintings are ascribed to Watteau—*fêtes galantes*, mythological works, and contemporary scenes, such as *L'Enseigne de Gersaint*, a late masterpiece showing a fashionable art shop. Watteau also produced sketches and figure studies in chalks, which reveal him to have been a draftsman of enormous talent. He died in France in 1721, at just 36.

Other key works

c.1716–17 *The Love Lesson*
1718–19 *Les Fêtes vénitiennes*
c.1718–19 *Pierrot (Gilles)*
1721 *L'Enseigne de Gersaint*

OTHER PICTURES WE SEE, HOGARTH'S WE READ

A RAKE'S PROGRESS: THE LEVÉE (c.1735), WILLIAM HOGARTH

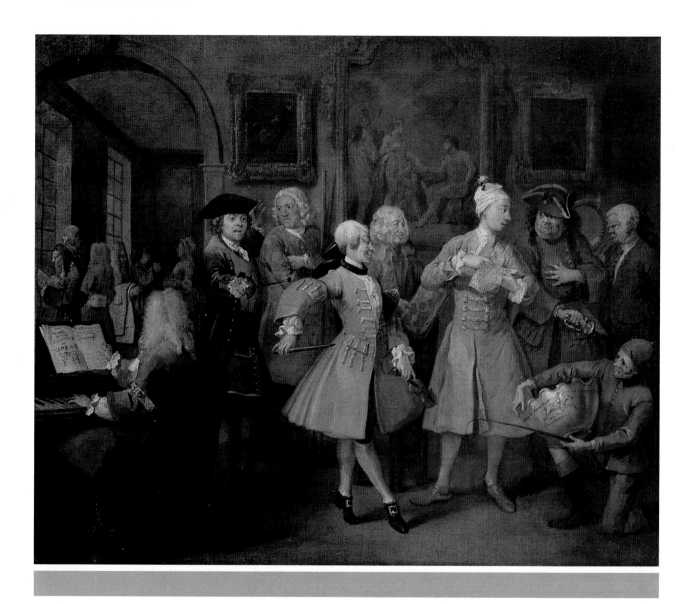

See also: The Bayeux Tapestry 74 ▪ *The Milkmaid* 223 ▪ *Captain the Honorable Augustus Keppel* 224 ▪ *The Disasters of War* 230–35

IN CONTEXT

FOCUS
Social satire

BEFORE
1523–26 German artist Hans Holbein the Younger produces 41 wood engravings, entitled *The Dance of Death*, which satirize the pope, priests, and nuns, as well as wealthy and powerful secular figures.

1559 Flemish artist Pieter Bruegel the Elder paints *The Fight between Carnival and Lent*, satirizing human follies.

AFTER
1792 English caricaturist and printmaker James Gillray publishes *A Voluptuary under the Horrors of Digestion*—a satirical cartoon focusing on the greed of George, Prince of Wales (later King George IV).

1812 English satirist Thomas Rowlandson publishes his *Tour of Dr. Syntax in Search of the Picturesque*, which pokes fun at the craze for sketching tours and the search for the Picturesque landscape.

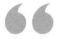

Those subjects which will both entertain and improve the mind, bid fair to be of the greatest utility.
William Hogarth

Satire—the ridicule of human or institutional vices, follies, abuses, and shortcomings—has provided rich material for artists and writers since antiquity. Its tone can vary from gently humorous to abrasively scornful, but it often has as its ultimate goal the improvement of individual behavior, politics, or society at large.

Satirical humor is a constant undercurrent in British culture, but the early 18th century was its golden age, thanks in no small part to the work of the artist William Hogarth. He produced paintings and engravings with satirical intent, the best known of which are what he called "modern moral subjects." These use wit to pass comment on the social customs of the day as well as to critique snobbishness, selfishness, and the faddishness of fashion. Hogarth's pictures are full of comical details

Gin Lane (1751) presents Hogarth's vision of London in decline under the influence of cheap gin. His goal was not horror for its own ends, but the promotion of social reform.

that amplify the message of the paintings. Like literary vignettes, these details illuminate Hogarth's works and lead the viewer deep into the lives of his characters.

A fall from grace

A Rake's Progress is a series of eight paintings (reproduced as engravings from 1735) that can be read a bit like a novel, charting the decline of a fictional wealthy young man, Tom Rakewell, into poverty and madness.

The first scene depicts Tom, who has just inherited a fortune from his miserly father, being measured for new clothes. He tries to pay off his pregnant and tearful fiancée, Sarah Young, who »

William Hogarth

Born in London in 1697, William Hogarth played an essential part in establishing a distinctively British school of painting that was free from foreign domination. After training as a silver engraver, Hogarth took up painting in the 1730s, and in the 1740s established himself as a successful portraitist. He is best known for his satirical works, which were founded on his strong desire to improve society in a time of corruption and urban poverty. Hogarth involved himself in charitable work: he painted the staircase walls of St. Bartholomew's Hospital, London, for free, and also supported the Foundling Hospital, which was set up in 1739 to house abandoned children. The institution also served as an art gallery for British painting. Hogarth became ill in 1762 and died in London in 1764, at age 67.

Other key works

1731 *A Scene from "The Beggar's Opera" VI*
c.1743 *Marriage A-la Mode*
1745 *Self-Portrait with a Pug*
1751 *Gin Lane* and *Beer Street*
c.1754 *The Election*

is shown holding a wedding ring. In the background, a lawyer steals gold coins; servants find treasures in the fireplace and money behind wall hangings; and a cat searches for food in a chest full of silver.

The Levée

In the second scene, called *The Levée* (a morning gathering for the wealthy and their entourage, held at home), Hogarth shows Tom holding a grandiose reception in his London house. Tom is very eager to acquire the social graces of the upper class, and hangers-on—including a music master at a harpsichord, a fencing teacher with a sword, and a dancing master with a violin—offer their services. Hogarth's stylistic exaggerations reveal his satirical intent—for example, he makes a dig at Continental customs in the dancing master's prancing pose; and the Italian paintings hanging on the walls hint at Hogarth's dislike of the English habit of acquiring Old Masters (paintings by famous European artists from c.1200), at the expense of works by living British artists.

Descent into madness

By the third scene, Tom is on the road to debauchery; drunk, he is relieved of his watch by prostitutes. In the fourth scene, two bailiffs arrive to arrest him for debt while a thief steals his gold-topped cane. He narrowly escapes imprisonment when his loyal former fiancée offers to post bail for him using her meager earnings as a milliner. To save himself from his financial mess, Tom marries a wealthy but ugly old woman—a scene depicted in the fifth canvas in the series. His bride appears to have only one eye, and in a grotesque parody of the match, two dogs, one of which has lost an eye, pose next to the couple. Sarah Young and her mother are held back at the door of the church.

In the next scene, Tom is on his knees having gambled away his wife's money at a club; and by the

Contemporary references in *A Rake's Progress*

Gambling		Gambling, as Tom did, was rife in Georgian Britain. The prince regent had to ask Parliament for money to help him pay off the debts he had run up through his extravagant habits.
The debtors' prison		Hogarth's father, like Tom, had been in a debtors' prison, so Hogarth had personal knowledge of them: conditions were unsanitary and inmates were often treated badly and given little food.
Social climbing		Tom's attempts to mimic the aristocracy, by holding a *levée* and going to St. James's Palace, reflect the social ambitions of the middle classes, who had been enriched by mercantile activity.
Brothels and inns		Hazards were all around for Tom: London had around 10,000 prostitutes and 450 taverns. In *Gin Lane* and *Beer Street* (both 1751), Hogarth contrasts the evils of gin with the benefits of beer.

> My picture is my stage, and men and women my players exhibited in a 'dumb' show.
> **William Hogarth**

seventh scene, Tom is in debtors' prison, where he is still harassed by his many creditors. He stares gloomily into space while the faithful Sarah Young, who has visited him with their child, faints with distress. The prisoners dream of escape; above a bed is a set of fake wings—perhaps Tom or his fellow debtors hope to fly away from their problems.

The final scene shows Tom's descent into complete madness. He lies, seminaked and shackled, on the floor of Bethlem Hospital (Bedlam), comforted by Sarah. Two fashionable women look on the scene for entertainment—a common pastime in Hogarth's day. Ironically, in seeking to live like the upper classes, Tom has ended up as an amusement for them.

Human flaws

A Rake's Progress was one of a number of such series by Hogarth. Its immediate predecessor was *A Harlot's Progress* (the paintings, dating from around 1731, were later destroyed, so the series is now known only from its engravings). This tells the story of a vulnerable country girl seeking employment in London, who is tricked into prostitution and suffers a wretched death. The success of this series encouraged Hogarth to experiment further with similar narratives. His six-part *Marriage A-la Mode* (c.1743) follows the fate of an ill-matched couple in a loveless arranged marriage, and their illicit affairs, which end in syphilis, a duel, and a suicide. In his next large series, *The Election* (c.1754), Hogarth aimed his satire at English politics in four canvases that were also reproduced as engravings. Basing his observations on the Oxfordshire elections that took place that year, he portrayed bribery, corruption, and mob violence.

Satirical prints

Hogarth's works reached a large audience as printed engravings, which the artist produced himself. Pirated versions of his works led Hogarth to lobby successfully for changes to Britain's copyright law, which were enacted in 1735.

The wide reach of the print medium later proved significant for a younger generation of British satirical artists, including James Gillray (1756–1815) and George Cruikshank (1792–1878). The relative freedom of the press, combined with the absence of an absolutist monarchy, meant that they could target those in power (even politicians and royalty) with impunity. These later artists felt perfectly at liberty to exaggerate, deform, or transform their subjects into objects of total ridicule and they were more aggressive in their approach than Hogarth, who portrayed characters rather than caricatures. Hogarth's satires also concentrated more on universal character flaws than specific personalities. His sincere desire was to point out the consequences of the greed, depravity, and self-delusion that blighted his era. ∎

The final scene in *A Rake's Progress* shows Tom in the mental asylum of Bedlam. Other inmates suffering from delusions include a tailor, a musician, an astronomer, and an archbishop.

I HAVE THEREFORE DRAWN THESE RUINS WITH ALL POSSIBLE EXQUISITENESS
THE COLOSSEUM (1756), GIOVANNI BATTISTA PIRANESI

IN CONTEXT

FOCUS
Art of the Grand Tour

BEFORE
1711 Giovanni Paolo Panini, from northern Italy, settles in Rome, where he becomes the foremost painter of city views.

1752–55 British artist Richard Wilson paints views of ancient Roman sites aimed at English and Irish aristocrats.

1754 French painter Hubert Robert arrives in Rome and paints ruined buildings, both real and imaginary.

AFTER
1772 German Neoclassical painter Johann Zoffany paints his *Tribuna of the Uffizi*, depicting Grand Tourists admiring antique sculptures.

1786 Wilhelm Tischbein paints *Goethe in the Roman Campagna*, showing the famous German writer and philosopher Goethe posing by antique fragments.

From the mid-16th century, young upper-class men from northern Europe began to undertake lengthy Continental journeys as a means of finishing off their education, polishing their manners, and acquiring works of art and antiquities. The custom was particularly popular among the English nobility. Generally accompanied by tutors, they usually followed a route that took them through France or Germany and over the Alps to Italy, where the highlight of the trip would be a stay in Rome and a tour around the city's classical remains.

The fashion for this journey, which often took a year or more, reached a climax in the 18th century, but stopped at the end of that century when the Napoleonic Wars made most travel abroad difficult.

Opportunities for artists
The Grand Tour created a large market for illustrated guidebooks and cultural souvenirs such as paintings and sculptures, which artists were happy to fill. Some, such as Richard Wilson, traveled as part of the Grand Tourists' retinue to record their travels, while others, such as Pompeo Batoni, satisfied the demand for portraits, which were traditionally completed at the end of the Tour. Artists including Giovanni Paolo Panini, French landscape painter Claude-Joseph Vernet, and Canaletto specialized in producing views of the important sites. For the less well-off gentleman, etchings formed an affordable way to take home a souvenir. The great printmaker Giovanni Battista Piranesi made an excellent living selling his prints of Rome to the Grand Tourists.

Piranesi based himself in Rome from the 1740s and set about recording the city's buildings in

See also: Trajan's Column 57 ▪ Arch of Constantine 57 ▪ *Tintern Abbey* 214–15 ▪ *The Stonemason's Yard* 224 ▪ *Goethe in the Roman Campagna* 225

Giovanni Battista Piranesi

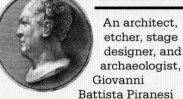

An architect, etcher, stage designer, and archaeologist, Giovanni Battista Piranesi had a lifelong obsession with architecture. He was born near Venice in 1720, the son of a mason and master builder, and received his early training as an architect in the city before studying the arts of perspective and stage design. He went to Rome as part of the retinue of the Venetian ambassador in 1740, and over the next few years turned his hand to creating etched views of the city, which proved immensely popular. His most original works are the 16 prints in the series *Imaginary Prisons* (*Carceri d'invenzione*), which were later admired by the Surrealists. Piranesi was also an important theorist who wrote polemics on the superiority of Roman architecture. He died in 1778.

Other key works

1745 *Views of Rome*
1750 *Imaginary Prisons*
1761 *On the Magnificence of Roman Architecture*
1777–78 *Remains of the Edifices of Paestum*

a series of engravings—his famous *Vedute di Roma* (Views of Rome)—which he published from 1745 until his death. He was especially knowledgeable about classical architecture, and based his prints on close study of each monument. Piranesi's detailed antiquarian research earned him a reputation among architects and designers internationally. His four-volume *Le antichità Romane* (Antiquities of Rome, 1756) contained more than 250 plates, combining precise observation with visual impact.

Enhanced reality

A great feat of engineering, the Colosseum was constructed in the 1st century CE, and is the largest amphitheater ever built. Although it fell into disuse in the Middle Ages and was later plundered for building material, it was the ultimate symbol of imperial Rome; it was therefore inevitable that Piranesi should create an etching of it. A master of perspective, Piranesi often used the technique to make buildings look even grander than they really were, as he has done with the Colosseum. Indeed, the German writer Johann Wolfgang von Goethe, who knew Rome first through Piranesi's prints, was reportedly rather disappointed on seeing the city for the first time in real life.

In the print, the Colosseum looms out of the background, dwarfing the figures in front of it. The treatment of the building, whose dark outer wall bulges out toward the viewer, is highly dramatic, but the details of the structure are perfectly discernible: it is possible to see how different orders of column are used on the façade—Tuscan on the lowest level, Ionic one stage above, and Corinthian on the third level.

Piranesi's highly popular prints of classical remains, buildings, and artifacts firmly established Rome as an essential stop on the Grand Tour. They also influenced such British architects as Robert Adam and Sir John Soane, playing a major part in the development of the Neoclassical style in architecture. ▪

View of the Ducal Palace (c.1730) was one of many luminous paintings made by Canaletto for Grand Tour buyers: the view over the lagoon in Venice was one of the artist's favorites.

HIS ART IS THAT OF THE THEATER, WITH A STAGE THAT IS DELIBERATELY ELEVATED ABOVE US

APOLLO AND THE CONTINENTS (1752), GIAMBATTISTA TIEPOLO

IN CONTEXT

FOCUS
Illusionistic ceiling painting

BEFORE

1465–74 Andrea Mantegna paints an illusionistic oculus in the ceiling in the Camera degli Sposi in Mantua.

1524–30 Antonio Allegri, known as "il Correggio" paints the *Assumption of the Virgin* fresco in the cupola of Parma Cathedral. The painting gives an impression of infinite space.

1560–61 Paolo Veronese paints a series of illusionist interiors, including ceilings, at the Villa Barbaro in the Veneto, designed by Andrea Palladio.

1731 Tiepolo's Austrian contemporary Paul Troger paints an illusionistic ceiling at Melk Abbey, one of many 18th-century examples of such work in Austria and Bavaria.

See also: Camera degli Sposi 163 ▪ Palazzo Farnese ceiling 222 ▪ *Adoration of the Name of Jesus* 223

I llusionistic ceiling painting relies on clever visual effects, such as foreshortening, the manipulation of perspective, and the use of trompe l'oeil ("trick the eye"), which can create startling illusions of depth in a flat image.

The technique first developed in Italian Renaissance art in the late 15th century and was notably used to great comic effect by Andrea Mantegna on the ceiling of the Camera degli Sposi (Bridal Chamber) in the Ducal Palace in Mantua. Mantegna created the illusion of a window, or oculus, open to the sky, through which people and cherubs could be seen looking down on the spectator below. This particular technique, in which foreshortened figures look as though they are seen from below, is known as *di sotto in su*. Antonio Allegri da Correggio took this illusionistic method a step further in his fresco for the cupola of Parma Cathedral, where figures and clouds seem to float in a firmament that spirals upward into infinite space above the viewer's head.

Heavenly views

Churches in the 16th and 17th centuries—especially those of the Jesuit order—often featured ceiling paintings that were designed to inspire a sense of God's presence in the congregation. They were intended to impart a real sense of drama to certain biblical scenes, notably the Ascension of Jesus. To enhance the illusion, artists would introduce painted architectural elements into their composition to give the impression that Heaven itself was a physical continuation

The corners of the cornice are embellished with stucco figures by Tiepolo's collaborator, Antonio Bossi, contrasting playfully with the trompe l'oeil figures above them.

of the building—a technique known as *quadratura*. By the early 18th century, there were many skilled practitioners of illusionistic fresco painting in Italy, but it was the Venetian Giambattista Tiepolo who took the art to new heights in his brilliantly colorful, light-filled decorative schemes.

Tiepolo enjoyed an outstanding reputation throughout Europe, and in 1750 he was offered the most prestigious commission of his career—to decorate the palace of Carl Philipp von Greiffenclau, the newly installed Prince-Bishop of Würzburg, Germany. This great Baroque palace was designed by the Bohemian architect Balthasar Neumann and completed in 1744 to great acclaim. »

Giambattista Tiepolo

Giambattista Tiepolo was born in Venice in 1696. His art developed from the traditions established by his Venetian predecessors Tintoretto and Veronese. He gained fame for his altarpieces for Venetian churches, which led to a major commission for a fresco cycle in the Archbishop's Palace (c.1727–28) in Udine, Italy.

Tiepolo's frescoes in Würzburg, painted in the 1750s at the peak of his career, attracted commissions for further fresco cycles in the Villa Valmarana near Vicenza and the Villa Pisani in Stra, both in the Veneto, Italy. In 1762 the Spanish king Charles III invited him to decorate the Royal Palace in Madrid. Having created three ceiling frescoes glorifying Spanish power, Tiepolo died in the Spanish capital in 1770.

Other key works

1726–29 *The Fall of the Rebel Angels and the Judgment of Solomon*
1739 *Way to Calvary*
1757 Fresco cycle with scenes from Homer, Virgil, Ariosto, and Tasso
1760 *The Apotheosis of the Pisani Family*

Tiepolo began by decorating the Kaisersaal (Imperial Hall) of the palace. He painted the ceiling with an exuberant evocation of an episode from medieval German history in which the bride of the 12th-century Holy Roman Emperor Frederick Barbarossa is carried across the heavens by the god Apollo. The prince-bishop was so impressed by this work that he asked Tiepolo to take on an even more ambitious task—to decorate the grand staircase leading up to his apartments with an enormous ceiling fresco.

Flights of fantasy

The main purpose of the ceiling painting was to glorify and immortalize the prince-bishop. At its apex is the figure of Fame, bearing the ermine-draped portrait of the prince-bishop toward the god Apollo; personifications of the four continents around the edge pay tribute. Although such self-aggrandisement may be considered overblown, the fresco is a triumph of skill and imagination.

It is also a masterpiece of illusionism, in the way that its composition was designed to take account of the changing viewpoints of visitors as they climbed the staircase. In a masterly display of perspectival virtuosity, the figures are all painted to be seen from specific angles, or from below.

A visitor's initial view of the ceiling from the first flight of stairs reveals the continent of America, represented by a squaw adorned with a feathered headdress, sitting on top of a crocodile, while a pile of severed heads rests on the cornice to one side. A man in European dress holding a drawing board and scrambling over the cornice is evidently an artist recording the customs of the New World.

At the top of the first flight, visitors can turn right or left as the staircase divides, and encounter a view of the continents of Africa or Asia, one on each of the long sides; the perspective is carefully adjusted to the viewer's position. Africa is shown as a semi-naked, turbaned woman seated on the back of a camel. She is observed by a white-bearded river god symbolizing the Nile, while Turkish merchants oversee the loading of goods onto a boat. An elephant and ostrich add a further touch of exoticism. On the

The greatest decorative painter of 18th-century Europe, as well as its most able craftsman.
Michael Levey
Giambattista Tiepolo, 1986

In his depiction of the continents Tiepolo presented Europe as the height of Western civilization, the others—America is seen here—as existing in varying degrees of barbarism.

and other figures and emblems amid the swirling clouds include Diana, goddess of the hunt, and Vulcan, god of fire.

Working practices

Because Tiepolo's frescoes were deliberately intended to be seen from a distance they did not require the same high degree of finish as his paintings. They could rely for their impact on composition, manipulation of perspective, broad tonal contrasts, brilliant color, and dazzling light effects. The artist and his assistants evidently worked at some speed on this ceiling, as it is divided into 218 *giornate* (areas representing a day's work). This

suggests that Tiepolo took less than a year to complete it. Surviving oil sketches and studies for the ceiling indicate that he modified his composition as he went along, making changes to suit the site.

A pinnacle of the form

Tiepolo's work was esteemed during his lifetime, and he was praised by one contemporary as the equal of Nicolas Poussin and Raphael. His reputation waned after his death and in the early 19th century many critics saw his work as cold and superficial. Critical reevaluation followed during the Belle Époque of the late 19th and early 20th centuries, when a taste for the decorative resurfaced. Tiepolo's exuberant frescoes, with their masterly illusions, are now seen as the final flourish of a monumental painterly tradition that had begun centuries earlier with Giotto. ∎

opposite side of the ceiling, Asia sits atop an elephant in front of two of her subjects. A tiger hunt takes place in the background while a European packs goods for export.

Ascending to the top of the staircase, the visitor sees Europe enthroned and holding a scepter, the embodiment of the triumph of civilization and the arts. She is shown against an architectural backdrop, attended by a bishop and two acolytes and musicians, as well as the architect of the palace, Balthasar Neumann. Tiepolo also included a portrait of himself and his son Giandomenico, who helped with the frescoes.

Tribute from the planets

Above the allegorical figures representing the four continents, the gods gather in celebration of Tiepolo's patron. Apollo, in a blaze of light, comes forth from his temple to make his daily journey with the sun across the sky. Two female figures carry his attributes—a lyre and a torch. The gods who govern the planets—Venus, Mars, Mercury, and Jupiter—are in attendance,

The prince-bishop is identified with the sun god **Apollo**.

The prince-bishop's **oval portrait** is crowned by Truth and accompanied by Fame.

Banks of **clouds** swirl around the center, directing the viewer's eye to the heavens.

Figures from the pagan world and the **zodiac** pay tribute to the Prince-Bishop.

The entire complex iconographical scheme of *Apollo and the Continents* was created to glorify Prince-Bishop Carl Philipp von Greiffenclau.

Exotic animals are laden with produce to emphasize bounty and abundance.

THE SPIRIT OF THE INDUSTRIAL REVOLUTION

AN IRON FORGE (1772), JOSEPH WRIGHT

IN CONTEXT

FOCUS
Art and the Industrial Revolution

BEFORE
1765–1813 The Lunar Society—British intellectuals and friends of Joseph Wright—meets for talks about science and technology.

AFTER
1801 Philip James de Loutherbourg's *Coalbrookdale by Night* shows furnaces at Ironbridge, an early center of industrialization in Britain.

1872–75 German artist Adolph von Menzel paints *The Iron-Rolling Mill*, conveying a sense of backbreaking toil.

1874 Eyre Crowe's *The Dinner Hour, Wigan* is an idealized portrayal of women workers at a mill in Lancashire, England.

From its beginnings in Britain, the Industrial Revolution began to spread across Europe from the late 18th century. It brought seismic changes to work and to the landscape, which artists responded to in a number of different ways. Some artists retreated into contemplation and nostalgia; others, including the visionary artist and poet William Blake, were critical of the effects of industrialization; while others still were excited by both the sense of hope and progress it created, and its potential for visual drama.

One such artist was Joseph Wright (1734–97), who spent most of his life working in his native Derby, an important center of British manufacturing. Many of his key works convey the exhilaration of scientific discovery and of advances in mechanized production. Wright knew many of the eminent scientists and manufacturers of his day, including Josiah Wedgwood, Erasmus Darwin, and James Watt. His firsthand knowledge of scientific instruments and machinery enabled him to depict the new technology accurately.

In the 1770s, Wright painted five accomplished "night pieces" portraying local blacksmiths' shops, which for him emphasized the heroic aspect of labor. *An Iron Forge* shows a man placing a glowing ingot beneath a new water-powered tilt hammer, of the type that had replaced earlier handheld blacksmiths' tools. The iron founder takes a break from his work to gaze at his family, who, like him, is bathed in the warm glow of the forge. His smart striped vest and relaxed attitude hint at the prosperity and ease brought by new technology. In the foreground an older man, probably the owner's father, contemplates the scene: the three generations in the picture will all be affected by industrialization in different ways. ∎

See also: *The Supper at Emmaus* 170–71 ▪ *Tintern Abbey* 214–15 ▪ *The Flight into Egypt* 222 ▪ *The Death of Sardanapalus* 240–45 ▪ *Nighthawks* 339–40 ▪ *Cubi XIX* 340–41

HE HOPED TO WARD AWAY THE SPIRITS THAT INVADED HIS MIND

BAD-TEMPERED MAN (c.1770–83), FRANZ XAVER MESSERSCHMIDT

W orks of art are created for numerous different reasons, but many artistic creations are expressions of intense inner turmoil, suffering, or "madness."

Bad-Tempered Man is one in a series of 69 remarkable character heads carved in alabaster or cast in lead alloy by the German-Austrian sculptor Franz Xaver Messerschmidt (1736–83). Some of the heads are fairly naturalistic, but others have bulging eyes, furrowed brows, protruding lips, stretched neck tendons, and disheveled hair, and convey extreme emotional states, ranging from hilarity, angst, sadness, and rage to catatonic blankness.

Various attempts have been made to understand why the artist produced this fascinating series. The heads may have been intended as physiognomic studies, linked with the theories of Swiss pastor Johann Kaspar Lavater, who popularized the notion that a person's character can be discerned in their physical appearance. The works have also been associated with the experiments of Anton Mesmer, a friend of Messerschmidt and the inventor of mesmerism, similar to hypnotism. One commentator even linked the series to chronic indigestion. However, the creation of the heads appears to have coincided with a decline in the sculptor's mental health.

Expressions of "madness"

Up to the 1770s, Messerschmidt had enjoyed a successful artistic career in Vienna, with portrait commissions from imperial and aristocratic clients and a teaching post at the Academy. However, he began to suffer from paranoia and hallucinations, which alienated his colleagues and potential patrons. One theory is that he created his heads to ward off the spirits he believed were pursuing him. Most of the busts seem to be modeled on the artist's own features, so they may embody emotional states that he had experienced himself—a compulsive record of his mental contortions and his inability to understand them.

Messerschmidt's powerfully expressive heads remain as an extraordinary body of work produced "outside" mainstream art, in a tradition that continues to parallel conventional artistic practice. ∎

A LIGHT IN THE STORM OF REVOLUTION

DEATH OF MARAT (1793), JACQUES-LOUIS DAVID

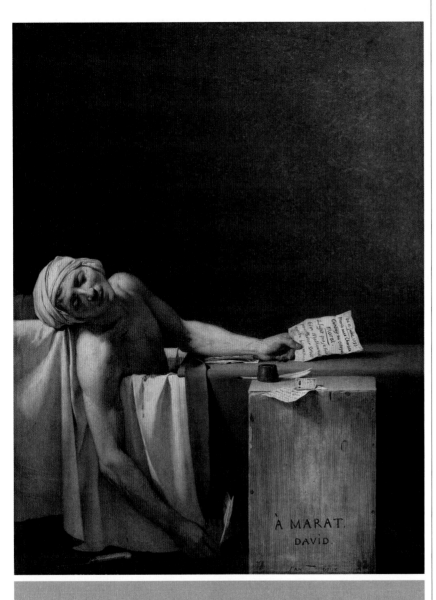

IN CONTEXT

FOCUS
Revolutionary idealism

BEFORE
1775 American artist John Trumbull paints *The Death of General Warren at Bunker Hill*, recording an event in the American Revolutionary War.

AFTER
1830 Inspired by the Paris uprising of 1830, Eugène Delacroix paints *Liberty Leading the People*, evoking the Revolutionary spirit of 1789.

1848 French artist Ernest Meissonier paints *The Barricade, Rue de la Mortellerie*, showing the corpses of rioters in the 1848 Revolution.

1848 In the aftermath of the 1848 Revolution, Realist artists such as Courbet start to depict working-class subjects.

1917 The *Proletkult* is established in Russia, which aims to harness art to a radical working-class aesthetic.

On July 13, 1793, the French Revolutionary leader and journalist Jean-Paul Marat was taking one of his customary long baths to ease his painful eczema, when Charlotte Corday, a royalist sympathizer, burst into his bathroom and stabbed him to death. His friend Jacques-Louis David organized his funeral, and immortalized Marat in this painting.

Marat is shown drawing his last breath. The pens and paper reveal his habit of using his bathroom as an office, and in his left hand he holds the note given to him by his

See also: *The Surrender of Breda* 178–81 ▪ *Louis XIV* 196–97 ▪ *The Death of Sardanapalus* 240–45 ▪ *Napoleon on the Battlefield of Eylau* 278

David's *The Tennis Court Oath* (the preparatory drawing is seen here) immortalizes the defiant meeting of the deputies of the Third Estate (commoners) in 1789 to draft a new constitution.

murderer, which says: "Given that I am unhappy I have a right to your help." The scene is an evocation of martyrdom rather than an accurate record of the event: there is no trace of Marat's skin condition on his body; the knife is by the side of the bath rather than stuck in Marat's chest; and Corday, who did not flee from the scene of the murder, is not included in the composition. The focus is all on the dying radical, whose pose recalls the dead Christ in Michelangelo's *Pietà*, cradled by Mary. By such idealization David elevates a simple portrait into a depiction of universal tragedy.

Ideas and actions

David had an established artistic career before the outbreak of the French Revolution, but both he and his art became intimately bound up with the political events that were to follow. A Republican sympathizer, David joined the influential antiroyalist Jacobin Club, painted Revolutionary themes and characters, and helped to stage Republican pageants. His austere Neoclassical style referenced the noble and patriotic ideals of ancient Greece and Rome, and rejected the lighthearted Rococo diversions of the aristocracy. Combined with his preference for themes that exalted civic virtue, his work perfectly suited the ethics and atmosphere of the new French Republic.

Artists have often promoted political causes they believe in, whether through active personal involvement or through their art. David's compatriot Gustave Courbet (1819–77) played an active part in the Paris Commune (a radical socialist government) of the 1870s, while his art broke new ground in its realistic but heroic depiction of workers and peasants. During the Russian Revolution of 1917, several avant-garde artists, including Kazimir Malevich (1878–1935), who pioneered the abstract Suprematist style, offered their services to the cause, particularly since it appeared to offer liberation from more bourgeois forms of artistic expression. ▪

If there's ever a picture that would make you die for a cause, it is … *Death of Marat.* That's what makes it so dangerous.
Simon Schama
Power of Art, 2006

Jacques-Louis David

A key figure of Neoclassicism, Jacques-Louis David was born in Paris in 1748 and trained under the history painter Joseph-Marie Vien and at the Royal Academy of Painting and Sculpture. After a spell in Rome in the 1780s, he returned to Paris, where he set about perfecting an art free from Rococo frivolities and with an austerity suiting his themes of duty and self-sacrifice. He was also an influential teacher. A sympathizer with the aims of the French Revolution, David served on committees and used his art to enshrine its moral code. He was briefly jailed after the fall of his friend Robespierre, the Revolutionary leader. He later became an ardent supporter of Napoleon, producing art that glorified the French emperor's exploits. After Napoleon's defeat, David went into exile in Brussels, where he painted outstanding portraits. He died in 1825.

Other key works

1784–85 *The Oath of the Horatii*
1794–99 *The Intervention of the Sabine Women*
1800 *Madame Recamier*
1801 *Napoleon Crossing the Alps*

A VERY INCHANTING PIECE OF RUIN. NATURE HAS NOW MADE IT HER OWN

TINTERN ABBEY (1794), JOSEPH MALLORD WILLIAM TURNER

IN CONTEXT

FOCUS
The Picturesque

BEFORE
1783 English artist and cleric William Gilpin publishes his *Observations on the River Wye*, a visitors' guide containing reflections on the "rules of picturesque beauty."

AFTER
1795 *Sketches and Hints on Landscape Gardening* by English landscape designer Humphrey Repton shows how gardens might be adapted to Picturesque taste.

1798 Poet William Wordsworth writes "Tintern Abbey," a Romantic reflection on the rustic scenery of the Wye Valley.

1812 English caricaturist Thomas Rowlandson lampoons sketching tours in his popular prints *Dr. Syntax in Search of the Picturesque.*

Toward the end of the 18th century, tourism gripped the British imagination, with the wilder parts of Wales, Scotland, and the Lake District becoming popular with visitors. Writers and artists grappled with ways of depicting these regions, as they did not fit comfortably into the two main aesthetic categories of the time that were used to classify landscape—namely, the "Sublime" (exemplified by the awe-inspiring Alps) and the "Beautiful" (such as the pretty Italian lakes). British landscapes fell in between these two categories, in a newly invented class, the "Picturesque," meaning "from a picture."

See also: *Wind among the Trees on the Riverbank* 96–97 ▪ *Hunters in the Snow* 154–55 ▪ *An Iron Forge* 210 ▪
Bentheim Castle 223 ▪ *The White Horse* 278

J. M. W. Turner

The great genius of English landscape painting, Joseph Mallord William Turner, was born in London in 1775, the son of a barber. He entered the Royal Academy Schools in 1789, and exhibited his watercolors there from the following year. In 1791, he made the first of his annual sketching trips outside London, and by the early 1800s his work was becoming increasingly Romantic. Turner traveled and painted widely in Europe. He died in 1851. Many of his works are displayed in Tate Britain.

Other key works

1815 *Dido Building Carthage*
1838 *The Fighting Temeraire*
1842 *Peace: Burial at Sea*
1844 *Rain, Steam, and Speed*

I don't paint so that people will understand me. I paint to show what a particular scene looks like.
J. M. W. Turner

Picturesque landscapes were characterized by their roughness, variety, multiple textures, and shaggy and overgrown features. Ruins, especially medieval ones, embodied all these qualities, and travel literature of the time urged visitors to view such scenes from specific spots, from where they could be best appreciated. The experience could be enhanced by using a "Claude glass"—a tinted mirror that reflected the landscape and made it look as though it had been painted by an Old Master.

Sketching tours

A number of painters, including J. M. W. Turner and his friend and rival Thomas Girtin, embarked on sketching tours to record Britain's sights and monuments with a view to selling watercolors or prints. Tintern Abbey, a ruined Cistercian monastery on the bank of the river Wye between England and Wales, was a favorite subject. Turner first saw and sketched the abbey in 1792, at the tender age of 17, when he was touring Wales. He produced several pictures of it, including one that was exhibited at the Royal Academy in 1794. Far from being a straightforward topographical depiction, it is infused with a Picturesque sensibility: the ruined building is in the process of being reclaimed by nature and a growth of abundant foliage softens the austere lines of the architecture. The dynamism of the composition, which emphasizes the sweep of the crossing arches receding in different directions, signals the energy of Turner's mature works.

Turner is considered by many to be Britain's greatest landscape painter. His style evolved profoundly through his long career: his early watercolors were luminous and precisely drafted, but he soon embraced oil painting and took on more ambitious historical subjects. He began to focus less on detail, and more on the effects of color and light, anticipating the later work of the Impressionists. From the 1830s, his work became much freer, and he developed an obsession with the elemental forces of nature, depicting fog, sunrise, and sunset, steam, rain, wind, and storms. The watercolors seen in his late sketchbooks, in which he studied sky effects, are strikingly modern-looking in their near-abstraction. ▪

John Constable shared with his contemporary Turner an emotional response to landscape. However, Turner's work developed more drama and involved historical elements; Constable's work, including *Arundel Mill and Castle*, tends to be calmer and more representational.

NOBLE SIMPLICITY AND CALM GRANDEUR

TOMB OF MARIA CHRISTINA OF AUSTRIA (1798–1805), ANTONIO CANOVA

IN CONTEXT

FOCUS
Neoclassicism

BEFORE
1709 and 1748 The ancient Roman cities of Herculaneum and Pompeii, buried by the volcanic eruption of Mount Vesuvius, are rediscovered.

1748–74 Giovanni Battista Piranesi produces a series of etchings of the monuments of ancient Rome that emphasize their grandeur.

1755 Johann Joachim Winckelmann publishes his *Reflections on the Painting and Sculpture of the Greeks.*

AFTER
1784–85 Jacques-Louis David completes *The Oath of the Horatii*, a noble subject painted with Neoclassical simplicity.

1804 Napoleon is crowned emperor of France, modeling his image on the emperors of imperial Rome.

Neoclassicism—or "new classicism"—was a style in art and architecture that flourished in Europe in the late 18th and early 19th centuries. It was inspired by renewed interest in the civilizations of ancient Greece and Rome, which had been sparked by some remarkable architectural discoveries, notably the excavations at the buried Roman cities of Pompeii and Herculaneum.

The wall paintings and furniture recovered from these ancient cities were recorded in engravings and published throughout Europe, allowing people to gain an extraordinary insight into Roman decoration and design. Books such as *Reflections on the Painting and Sculpture of the Greeks* (1755) by the German art historian Johann Winckelmann encouraged artists to translate the art and values of classical Greece and Rome into contemporary life.

However, Neoclassicism was more than just a revival of antique forms: it expressed the thinking of Enlightenment figures such as French philosopher Denis Diderot, reflecting their desire to promote what was rational, progressive, and

An emotionally touching yet stoical lament for the mortality of all humanity.
Hugh Honour
Neo-classicism, 1968

serious. It coincided with a growing feeling that the lighthearted and frivolously decorative approach prevalent in Rococo art should be replaced by a more serious art of moral commitment that embodied nobility, clarity, and purity and depicted the heroic figures of the classical pantheon.

These values are beautifully expressed in Antonio Canova's Tomb of Maria Christina of Austria, a sculpture that conveys the very essence of Neoclassicism, encapsulating the noble calm and simplicity for which Winckelmann felt artists should strive.

Antonio Canova

The son of a stonemason, Antonio Canova was born in Possagno near Treviso in 1757. He worked in Venice for the early part of his career but in 1779 moved to Rome, where he could see and study superb examples of classical sculpture, and where he set up a large workshop. Following early success with his sculpture *Theseus and the Minotaur* (1781), he was much in demand, and was asked to work for the papal court. Canova was an international celebrity, and although courted by various heads of state—Napoleon invited him to Paris, Catherine the

Great to Russia, and Holy Roman Emperor Francis II to Vienna— he preferred to stay in Rome, close to his source of inspiration. He retired to Possagno in 1816, dying there in 1822. His studio there is now a temple to his art.

Other key works

1783–87 Tomb of Clement XIV
1783–92 Tomb of Clement XIII
1787–93 *Psyche Revived by Cupid's Kiss*
1805–08 *Paulina Borghese Bonaparte as Venus*
1814–17 *The Three Graces*

See also: Marcus Aurelius 48–49 ▪ Sarcophagus of Junius Bassus 51 ▪ Pisa Baptistery pulpit 84–85 ▪ Tomb of Henry VII and Elizabeth of York 164 ▪ *The Colosseum* 204–05 ▪ Portland Vase 225 ▪ *Greek Slave* 249 ▪ Tomb of Oscar Wilde 338

Neoclassical artists held that human characteristics remained constant over time, and that art should strive to depict immutable and general human nature. The essence of Neoclassicism is evident in Canova's sculpture.

Purity
The smooth **white Carrara marble** of Canova's monument is a perfect complement to the **clarity of intent**.

Simplicity
With its **free-flowing line** and lack of unnecessary decoration there is **no superfluous detail** in the sculpture.

High moral seriousness
The monument invites meditation on the **path into the unknown** that everyone will ultimately face.

Idealization
The **freestanding** figures clad in **classical robes** have generalized features reminiscent of classical sculptures.

A return to Rome

Canova was one of the many progressive artists who flocked to Rome in the second half of the 18th century in order to experience the glories of classical art firsthand. Others included the architects Robert and James Adam, the painters Jacques-Louis David and Joshua Reynolds, and the sculptors John Flaxman and Bertel Thorvaldsen. The city was already an established stop on the Grand Tour—the trip around Europe's cultural highlights traditionally taken by young upper-class gentlemen. These aristocratic travelers would become important patrons for Neoclassical artists, architects, and designers.

In Rome, Canova studied some of the greatest relics of antiquity, and gradually established himself as a leading sculptor. He developed his Neoclassical style over many years while living in the city. His earliest works have a Baroque, exuberant flavor, which had become visibly modified by the time he sculpted *Theseus and the Minotaur* in 1782. In this life-size work, Canova chose to depict Theseus (the mythical king of Athens) in a moment of tranquillity after he has killed the Minotaur— half bull, half man—rather than in the heat of the struggle. Theseus's body is idealized (emphasizing the most important characteristics) rather than naturalistic. Although Canova was both fascinated and inspired by classical depictions of myths, he never merely imitated antique sculptures but strove to reinterpret the classical past to suit the concerns of his own day. »

Theseus and the Minotaur
(1782), was praised by the French critic Quatremère de Quincy, who hailed it as the first Roman example of the resurrection of antiquity.

Viennese commission

On a visit to Vienna in 1798, Canova was commissioned by widower Prince Albert of Saxony, Duke of Teschen, to create an appropriately impressive tomb for his recently deceased wife, Maria Christina, the daughter of the Austrian empress, Maria Theresa. The monument was created not for Rome, but for the Augustinian church in Vienna. The design of Maria Christina's tomb was adapted from earlier plans Canova had made for a monument to Titian, which had been intended to occupy the Frari church in Venice but had been canceled for political reasons.

Sculpted in Carrara marble, the tomb recalls the materials of classical sculpture. Its chilly whiteness is wholly appropriate for a group of figures that expresses controlled, dignified grief. Powerful emotions are contained within a strict geometrical framework: a cortege of mourning figures enters a sepulcher, whose form resembles both the pyramids of ancient Egypt and the tomb of Caius Cestius (a prominent magistrate) in Rome, which was built around 12 BCE.

Ideal humanity

The sculpture draws very clear inspiration from the pre-Christian world. Maria Christina's image is shown on a medallion, which is held aloft not by an angel—as would be expected in Baroque Christian art—but by a figure of Happiness. Furthermore, the portrait is shown encircled by a snake eating its tail, an ancient symbol of immortality.

Such radical departures from convention set Canova's aims at odds with those of the duke. His patron wished the figures in the sculpture to be identified with the virtues of his deceased wife; Canova wanted them to represent the theme of death itself—humanity's common fate. Canova was obliged to accede to the duke's desire to assign specific allegorical meanings: the female figure carrying the ashes is usually seen as a personification of Piety or Virtue, while the woman on the left represents

The Three Graces was sculpted by Canova from white marble and is typical of his work in its poise, coolness, and harmony.

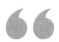

> What I am most impatient about is the effect the work will produce on the souls of this public.
> **Antonio Canova**

Beneficence, a quality for which Maria Christina was known. However, other meanings can be found—for example, the three figures on the left can be read as symbolizing the three ages of man, while the fact that the figures in classical dress are not recognizable as individuals gives the work a more universal significance: all humanity must pass through the door of death.

To the right, the genius (spirit) of Death rests against the lion of Fortitude. Whereas medieval tomb sculpture might have represented Death as a skeleton, here it is a classically inspired nude youth. The duke was eager to include Habsburg heraldry and a detailed inscription in the sculpture; Canova agreed, but he placed the heraldic symbols on the pyramid behind the lion, where they are almost hidden.

A new classicism

Most of Canova's other work depicts subjects drawn from classical literature or history, reaching its apogee in *The Three Graces*. This sculpture, made for the Duke of Bedford in 1814–17 after an earlier version for the Empress Josephine, shows these daughters of Zeus in an intricate embrace. Even Canova's portraits often present

their sitters in classical guise: when Napoleon commissioned him to produce a portrait sculpture, he created a life-size statue of the naked emperor as Mars the Peacemaker. His statue of George Washington (whom he never met) showed the American president as a Roman general, wearing a tunic, body armor, and a cape, penning his farewell address on a tablet.

Canova was known for his funerary monuments. By the time the Tomb of Maria Christina was installed in its Viennese church, he had already designed tombs for several leading figures, including two popes (Clement XIV and Clement XIII), the Venetian naval hero Admiral Angelo Emo, and Bishop Nicola Antonio Giustiniani. These last two revived the form of the Greek stele, or gravestone.

Republican art

Other artists who were inspired by Winckelmann's love of classical antiquity included the German court painter Anton Raphael Mengs; American artist Benjamin West, whose social connections brought Neoclassicism to an

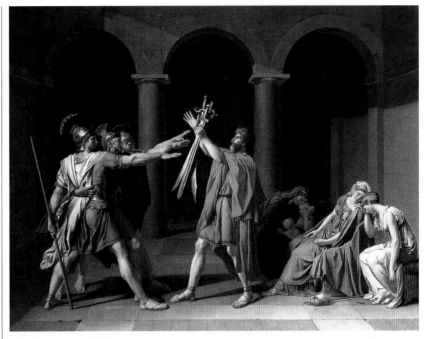

audience in Britain and America; and the French painter Joseph-Marie Vien, whose pupil Jacques-Louis David became one of the most celebrated artists in France.

David extended Neoclassical ideals to narrative painting, and used the genre to political ends, by associating republicanism in France with the Roman values of heroism, stoicism, and austerity. In David's work, the Neoclassical commitment to seriousness and simplicity was perfectly aligned with a political ideology that called for self-sacrifice and service to the State.

Canova's work received critical praise during his lifetime, and he was seen as an artist who realized Winckelmann's aspirations for art. His life and dedication to art also seemed to exemplify high moral

The Oath of the Horatii (1784–87) by Jacques-Louis David depicts three brothers swearing to protect Rome. The work celebrates the classical virtues of stoicism and patriotism.

seriousness. His work fell out of favor during the Romantic period later in the 19th century, when Neoclassical art was often seen as cold and static. It was only in the second half of the 20th century that Canova's art was reappraised and his reputation revived. ∎

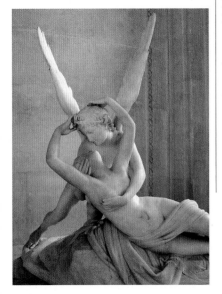

In *Psyche Revived by Cupid's Kiss*, Canova enshrines the Neoclassical ideals of beauty and grace. He often made replicas of his figures and groups to satisfy demand from patrons.

To take the ancients for models is our only way to become great.
Johann Winckelmann

PORTFOLIO

PALAZZO FARNESE CEILING
(1597–1608), ANNIBALE CARRACCI

Annibale Carracci ranks alongside Caravaggio as a key figure in early 17th-century painting. His most famous work is the frescoed ceiling in the Palazzo Farnese in Rome. The frescoes depict mythological scenes concerning the loves of the gods, set within an elaborate architectural-seeming framework. The center panel portrays Bacchus and Ariadne escorted to bed in a riotous procession. Like Caravaggio, Annibale brought renewed energy and conviction to Italian art after the rather artificial Mannerist style. Whereas Caravaggio's work had an earthy realism, however, Annibale's paintings revived the classical spirit of the High Renaissance, but with a new exuberance. It greatly influenced the development of the Baroque style.

THE FLIGHT INTO EGYPT
(1609), ADAM ELSHEIMER

The German painter Elsheimer (1578–1610) was famed for his night scenes, and *The Flight into Egypt* is his masterpiece. Painted in oil on copper, it depicts the night sky more accurately than ever before: the Milky Way is prominent, and several constellations can be clearly identified. Elsheimer was interested in lighting, and in this picture he innovatively uses four sources of light, including the moon. Elsheimer spent most of his career in Rome, where he died in poverty. However,

he had many admirers, including his friend Rubens, and his work had extensive influence.

JUDITH SLAYING HOLOFERNES
(c.1620), ARTEMISIA GENTILESCHI

The greatest female painter of the 17th century, Gentileschi (1593–c.1653) presents a scene of brutal murder with almost shocking naturalism. Judith and her young maid hold down the Assyrian general, who struggles while Judith cuts his throat, the spurting blood echoing the red of his robe and her sleeves. The influence of Caravaggio is evident in the extremes of dark and light. Gentileschi, a spirited character who led an independent life, was the daughter of a painter, and worked mainly in her home city of Rome, as well as in Florence and Naples. She was raped by the painter Agostino Tassi, who was pardoned; the bloodthirsty rendering of her *Judith Slaying Holofernes* has

been interpreted as stemming from anger at her abuse. Her paintings typically feature strong women in central roles.

THE LAUGHING CAVALIER
(1624), FRANS HALS

The Laughing Cavalier shows the lively characterization and vigorous brushwork for which Hals (c.1582–1666) is renowned; the portraitist injects his subject with confidence and bravado. The sitter, who is not laughing but smiling, is dressed in a lavish, richly colored silk doublet, with many emblems depicted in the detailed embroidery. Better than any other artist, Hals epitomizes the optimistic spirit of the early days of the Dutch Republic. For most of his life, Hals was the leading portraitist in Haarlem, but he died in poverty, partly because he had a large family to support, and his reputation declined after his death. Hals became hugely popular again in the late 19th century.

Annibale Carracci

Born in Bologna, Italy, in 1560, Annibale Carracci founded a teaching academy in the city in the 1580s, along with his brother Agostino and cousin Ludovico. Their method stressed drawing from the live model, and had a great influence on the next generation of painters. In 1595, Annibale moved to Rome, where he created the majestic religious and mythological paintings for

which he is best known. He was also an excellent portraitist, produced some highly original scenes of everyday life, and is regarded as the inventor of both caricature and ideal landscape. In the years before his death he painted little. He died in 1609.

Other key works

c.1582 *The Butcher's Shop*
1593 *The Resurrection of Christ*
c.1604 *The Flight into Egypt*

HEAD OF CHARLES I IN THREE POSITIONS
(c.1635), ANTHONY VAN DYCK

Van Dyck created an indelible image of the English monarchy at the time of Charles I, painting several memorable portraits of Charles himself, including an equestrian portrait and this unusual painted study of the king's head from three viewpoints. With a pensive expression, the king stares out from a background of storm clouds. The painting was made to be sent to Rome as a model for a marble bust by Gianlorenzo Bernini, which was then lost in a fire in England in 1698.

BENTHEIM CASTLE
(1653), JACOB VAN RUISDAEL

Ruisdael (c.1628–82) is among the greatest Dutch landscape painters of the 17th century, unrivaled in the range and power of his work. *Bentheim Castle* shows him in heroic vein, stressing the rugged grandeur of nature; mixing fantasy with reality, he depicts the castle in an imagined mountainous scene. Ruisdael's work was influential not only in the Netherlands but also in England, where the Romantic painter John Constable revered him.

THE MILKMAID
(c.1660), JOHANNES VERMEER

Many Dutch artists made paintings of everyday life superficially similar to those of Vermeer (1632–75), but his are raised to a different level by their exquisite harmony of color, shape, and texture, and by his attention to detail, as seen in *The Milkmaid*. Here, a kitchen maid is portrayed with detailed realism, pouring milk into a bowl. Dressed in a yellow bodice and blue apron, she has her sleeves rolled up and a faint smile on her face. Although she appears the embodiment of wholesomeness, aspects of the image, such as the tipped-forward pitcher, were conventional symbols of eroticism. Vermeer's name was virtually forgotten for two centuries after his death, but his paintings continued to be admired, although wrongly attributed to other artists.

ADORATION OF THE NAME OF JESUS
(1674–1679), GIOVANNI BATTISTA GAULLI

The Jesuit order, founded in 1540, was one of the spearheads of the Counter-Reformation, and a leading patron of art. The ceiling of the Gesù in Rome—the mother church of the Jesuits—is decorated with a spectacular example of the art of the Catholic revival, depicting a heavenly vision of saints and angels adoring a symbol of Christ. Painted in perspective as if seen from below, the fresco is a masterpiece of illusionism. Gaulli (1639–1709) was a protégé of Gianlorenzo Bernini, who helped secure the commission for him and advised him on how to carry it out.

Anthony van Dyck

Born in the city of Antwerp in 1599, Anthony van Dyck was precocious, becoming Rubens' chief assistant by the time he was 18, and embarking on his own international career a few years later. Van Dyck became one of the greatest Flemish painters of the 17th century. In portraiture, his major activity, he outshone Rubens himself. He worked in Italy, France, and notably England, where he spent his final years as court painter to Charles I, who knighted him. He died in 1641. The aristocratic grace and seductive beauty of his work inspired portraitists for centuries. Thomas Gainsborough and John Singer Sargent were among his greatest admirers.

Other key works

c.1618–20 *Samson and Delilah*
1623 *Marchesa Elena Grimaldi*
1635 *The Three Eldest Children of Charles I*

IMMACULATE CONCEPTION OF LOS VENERABLES
(c.1678), BARTOLOMÉ ESTEBAN MURILLO

The Immaculate Conception is a Catholic doctrine that the Virgin Mary was conceived free of the "original sin" that taints all other humans. This was a favorite subject with Spanish artists, above all Murillo (c.1617–82), who painted it more than two dozen times. As in this painting, he usually shows a full-length figure of Mary dressed in blue and white, her arms crossed over her chest; here she stands on the moon, floating among clouds, baby angels hovering around her. These images were hugely popular in his lifetime and were widely copied. In the 18th and early 19th centuries Murillo was seen as one of the greatest of painters, but the sugary imitations of his work later caused his reputation to plummet.

Canaletto

Born in 1697 in Venice, Giovanni Antonio Canal—better known by his nickname Canaletto, or "little Canal"—began his career by assisting his father Bernardo Canal, a theatrical scene-painter. In the early 1720s, Canaletto turned to painting views, or *vedute*, specializing in scenes of his native Venice, and became the most famous exponent of this kind of picture. Most of his work was bought by wealthy British visitors on the Grand Tour. In 1746, when the War of Austrian Succession made such travel around the European continent difficult, he moved to London—where he continued to paint views—and did not return permanently to Venice until about 1756. He died there in 1768.

Other key works

1730 *Entrance to the Grand Canal*
1744 *Piazza San Marco*
1747 *Windsor Castle*

THE AVENUE AT MIDDELHARNIS
(1689), MEINDERT HOBBEMA

Hobbema's most famous painting, *The Avenue* is a late work regarded as one of the final flourishes of the Golden Age of Dutch painting. Deceptively simple, it shows a dirt road and an avenue of trees receding toward the middle of the picture, where a village and church spire are visible; the view has hardly changed today. Hobbema (1638–1709) was a pupil of Jacob van Ruisdael, but after taking a job as a wine-gauger in 1668 he painted mainly in his spare time.

FORTITUDE
(1714–1717), GIACOMO SERPOTTA

Perhaps the greatest of all sculptors in stucco, Serpotta (1656–1732) spent virtually his whole life in Palermo, Sicily, where he worked in numerous churches. His graceful, enchanting, inventive creations are among the purest expressions of the Rococo style in Italian art. Fortitude, one of the four cardinal virtues, is usually represented as a serious and robust woman, but in Serpotta's hands she is a delightful coquette, with ostrich feathers adorning her head rather than the traditional helmet.

THE STONEMASON'S YARD
(c.1725–1730), CANALETTO

Most of Canaletto's paintings depict the public face of Venice, with its grand buildings, imposing canals, and colorful festivities, but early in his career he painted a few intimate behind-the-scenes views, such as *The Stonemason's Yard*— a lively glimpse of everyday life. Probably painted for a Venetian patron rather than a tourist, it shows the Campo San Vidal transformed into a temporary workshop.

DIANA AFTER THE BATH
(1742), FRANÇOIS BOUCHER

Boucher (1703–70) was the dominant French artist of the mid-18th century. He was a superb painter of the female nude, and *Diana after the Bath*, depicting with frank sensuality the goddess Diana resting after the hunt, is often seen as his masterpiece. With its elegant draftsmanship, depiction of glowing skin, and lightness of touch, the painting typifes the Rococo style. Boucher was also a prolific designer of porcelain and tapestries, and was director of the French Royal Academy of Painting and Sculpture. By the end of his career, taste was turning to Neoclassicism, and after the French Revolution his work was dismissed as frivolous.

CAPTAIN THE HONORABLE AUGUSTUS KEPPEL
(1752–1753), JOSHUA REYNOLDS

This is the painting with which Reynolds (1723–92) established his reputation in London after a lengthy study visit to Italy. The dynamic pose of its figure, a rising naval star, is based on a famous antique statue, the *Apollo Belvedere*, and was chosen to reflect the character and status of the sitter. Reynolds' work elevated painting to a new status in Britain, and his standing as the leading portraitist of his day was acknowledged when he was appointed president of the Royal Academy on its foundation in 1768.

VASE OF FLOWERS
(c.1760), JEAN-SIMÉON CHARDIN

Although documents of the time mention various flower paintings by Chardin (1699–1779), this is the only one known to survive. The flowers, in a blue-and-white Delft vase against a somber background, are rendered with a remarkable freshness of vision and sureness of touch. Chardin more usually painted still-life subjects, including household utensils and dead game, which he treated with similar inspired simplicity, in contrast

to the flamboyance of much French art of his time. Chardin's work was largely forgotten after his death, but rediscovered in the mid-19th century.

THE SWING
(1767), JEAN-HONORÉ FRAGONARD

Fragonard (1732–1806) initially hoped to achieve success with large-scale history paintings, but he realized that his talents lay with lighter material. In his celebrated work *The Swing*, a girl in a frothy cream and pink dress is pushed on a swing by an older man, while her ardent young lover admires her from his hiding place in the bushes. The work sums up the playfully erotic spirit of French Rococo art more completely than any other. The French Revolution swept away the aristocratic pleasures that provided Fragonard's subject matter; he stopped painting in about 1792, took an administrative job at the Louvre (which opened as a museum in 1793), and died in obscurity.

WATSON AND THE SHARK
(1778), JOHN SINGLETON COPLEY

The outstanding portraitist of the American colonies, Copley moved to London in 1775. His greatest works in his adopted country were multi-figure history paintings, of which the first and most important was *Watson and the Shark*. Based on a real event, this shows a boy being rescued from a shark attack in Havana harbor, Cuba. The image has a shocking immediacy, with the monstrous shark lunging toward the naked boy and the rescuers straining to reach him. It was highly original in depicting a subject simply because it was exciting, not because of historical or moral weight, anticipating the full-blooded Romanticism of such works as Théodore Géricault's *Raft of the Medusa*.

GOETHE IN THE ROMAN CAMPAGNA
(1786–1787), WILHELM TISCHBEIN

Wilhelm Tischbein (1751–1829) was one of a dynasty of Tischbein artists, several of them women, who were active in the 18th and 19th centuries. The family is remembered mainly for Wilhelm's portrait of the German writer Johann Wolfgang von Goethe, whom the artist got to know in Rome. Goethe is portrayed in an idealized way, sitting outside with Roman ruins in the background. Letters show that the painting was intended as a kind of meditation on the transitory nature of human achievements, represented by the fragmentary relics of ancient Rome.

PORTLAND VASE
(c.1790), JOSIAH WEDGWOOD

Wedgwood (1730–95) was a key figure of Neoclassicism in Britain. His tableware and ornamental objects spread the taste for the style and he employed excellent artists as designers, above all the sculptor John Flaxman. It was Flaxman who drew Wedgwood's attention to the Portland Vase, an ancient Roman piece of white-on-black cameo glass decorated with mythological and historical figures. Wedgwood spent four years working on methods of replicating the vase in jasperware, a dense, hard stoneware. He regarded the copy he eventually produced as his finest achievement.

HAMBLETONIAN, RUBBING DOWN
(1799–1800), GEORGE STUBBS

The greatest of all horse painters, Stubbs (1724–1806) produced this work—one of his largest and most powerful—when in his mid-70s. It depicts a famous racehorse in a state of exhaustion after winning a race. Stubbs' ability to bring horses to life—giving a sense of muscles rippling under their shiny coats—was based on anatomical study. He spent more than a year researching his illustrated book *The Anatomy of the Horse* (1766).

John Singleton Copley

Born in Boston in 1738, John Singleton Copley worked there as a portrait artist while still in his teens. He quickly became successful and prosperous, and one of his portraits was admired by Joshua Reynolds when it was exhibited in London in 1766. Copley was torn between the security of Boston and the challenge of London, but eventually moved to Europe in 1774, realizing that war was imminent in America. For about a decade he enjoyed great success in England, too, but his career declined, and he squabbled with patrons and other artists. In his final years he was feeble in body and mind, and he died in London, in debt, in 1815.

Other key works

1768 *Paul Revere*
1783 *Death of Major Peirson*
1785 *Daughters of George III*

ROMANTI
TO SYMB

CISM
OLISM

Francisco de Goya's celebrated portrait *The Naked Maja* lands him in trouble with the Inquisition in Spain, as he is accused of being morally depraved.

Théodore Géricault's *Wounded Cuirassier* proves controversial when shown at the Paris Salon, where it is regarded by many as a symbol of Napoleon's defeat.

Eugène Delacroix's stirring painting *Liberty Leading the People*, inspired by the July Revolution in France, exemplifies the rebellious spirit of the Romantics.

Rain, Steam, and Speed is **J. M. W. Turner's** paean to the emergence of the railroads, which bring transportation and communications into the modern age.

1800 **1814** **1830** **1844**

1806 **1821** **1836** **1857**

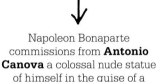

Napoleon Bonaparte commissions from **Antonio Canova** a colossal nude statue of himself in the guise of a Roman god, reflecting his lofty ambitions.

Although painted in a London studio, **John Constable's** *The Hay Wain* conjures up an idyllic image of rural tranquillity.

Thomas Cole, a co-founder of the Hudson River School, produces *The Oxbow*, one of the earliest masterpieces of American landscape.

Jean-François Millet's Realist masterpiece *The Gleaners* highlights the poverty and harsh working conditions of the French peasantry.

The 19th century was a period of rapid social and technological change, which brought with it an increasing fragmentation of the arts. Painters became more willing to explore new paths and new ideas and, as the century wore on, this led to the emergence of an impressive variety of styles and techniques.

The dominant historical figure early in the century was Napoleon Bonaparte, whose armies swept across Europe, changing the course of thousands of lives. They invaded Spain, prompting Francisco de Goya to produce his brutally realistic images of war, and they occupied Dresden, adding a patriotic tinge to Caspar David Friedrich's paintings (the model for *The Wanderer above a Sea of Fog* may have been a veteran of the Wars of Liberation).

The imperial ambitions of Napoleon fueled the final expressions of the Neoclassical style, and his defeat was accompanied by the emergence of Romanticism, a huge, wide-ranging movement that had effects that extended deep into the 20th century. In terms of style, it encompassed the restless violence of Théodore Géricault, Antoine-Louis Barye, and Eugène Delacroix, the exoticism of Jean-Auguste-Dominique Ingres, and the serene spirituality of Friedrich.

Romanticism championed the cause of individual freedom, encouraging independent thought and a greater questioning of authority. Artists reacted against the rules of the academies—the art establishment—and state-sponsored exhibitions, such as the Salon in Paris. Increasingly,

the painters with the most enduring reputations did not flourish in institutions of this kind, but made their names through breakaway groups or shows.

The impact of Realism

Gustave Courbet and the Realists spearheaded the first of the attacks on the art establishment. Their aim was not simply to make pictures more lifelike; they also wanted to undermine the conventions of the day. These conventions included a focus on "artificial" subjects—myths, allegories, and history painting—along with the idealized figures and grandiose poses that were taught in the art schools.

Realism coincided with major changes in society: industrialization revolutionized working practices and the railroads facilitated easy

Jan Matejko's brooding portrayal of the jester Stańczyk symbolizes the growing sense of nationalism in his native Poland.

Claude Monet's harbor scene *Impression, Sunrise* is mocked by the critics, and gives its name to the Impressionist movement.

The Swiss painter **Arnold Böcklin** produces his haunting *The Island of the Dead*, describing it as "a picture for dreaming over."

Henri de Toulouse-Lautrec's portrayal of a cabaret star at the Moulin Rouge, *La Goulue*, is a pioneering example of a new type of artwork—the poster.

1862 **1873** **1880** **1891**

1866 **1877** **1888** **1893**

In his oil painting *Prisoners from the Front*, **Winslow Homer** depicts a moving scene from the American Civil War.

In *The Rehearsal*, **Edgar Degas** produces a relaxed and informal behind-the-scenes view of one of his favorite pastimes, the ballet.

Vincent van Gogh paints his life-affirming *Sunflowers* pictures and uses them to decorate the room of his friend and fellow painter Paul Gauguin.

Edvard Munch's famous painting *The Scream*, inspired by a terrifying panic attack, will provide a major source of inspiration for the Expressionists.

travel to the countryside, and so fueled interest in outdoor painting. The development of photography by Louis-Jacques-Mandé Daguerre and William Henry Fox Talbot had a profound impact on painting, and not just because it replaced the portrait miniature as a way of preserving a likeness.

Initial attitudes to photography were mixed. Courbet and Delacroix based some figures on photographs; the latter argued that the invention could help artists toward a better understanding of nature. However, an exhibition of photographs at the Salon in 1859 prompted fury from a group of prominent artists who described photography as a "series of entirely manual operations" that could not be "compared with works that are the fruit of intelligence and of the study of art."

However, by the 1870s, the mood had changed. The Impressionists engaged more positively with the process and Nadar, the most famous photographer of the day, mixed with artists from the group at the Café Guerbois and loaned them his studio for their first exhibition. The Impressionists used photography in a variety of ways. Claude Monet's *Women in the Garden* was probably based on a photograph and some of his views of Parisian boulevards were inspired by the shots that Nadar took from a hot-air balloon.

Widening influences

As the technical qualities of photography improved, there was less demand for paintings that were very detailed and realistic. Instead, artists experimented with other ways of making an impact. Many drew inspiration from Japanese prints by artists such as Utagawa Hiroshige and Katsushika Hokusai, whose work was widely available in the West by the mid-1870s. James Abbott McNeill Whistler's misty scenes of the Thames owed much to their example. Some artists, such as Georges Seurat, made use of scientific theories about color and perception in their quest for novelty while others, like Edvard Munch, delved into the psyche for symbols of universal significance. The insatiable urge for new modes of expression gave rise to a fertile period of creativity in the last years of the century. Artists discovered new ways of arranging form, color, and composition and, in the process, laid the foundations of modern art. ■

THE SLEEP OF REASON PRODUCES MONSTERS

THE DISASTERS OF WAR (c.1810–1820), FRANCISCO DE GOYA

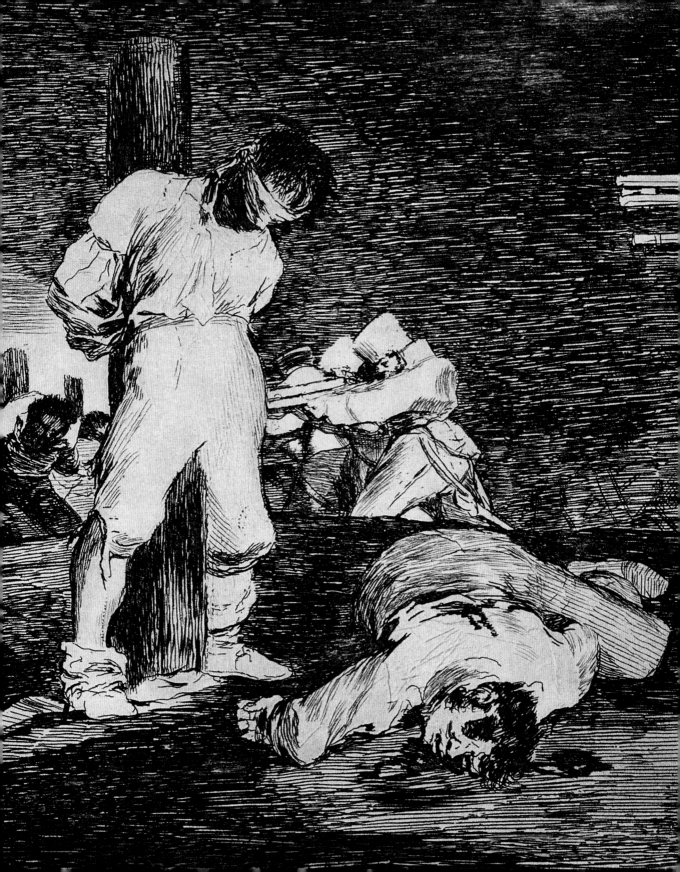

IN CONTEXT

FOCUS
War art

BEFORE
1633 French printmaker Jacques Callot publishes a series of etchings, *The Great Miseries of War*.

1808 Antoine-Jean Gros's *Napoleon on the Battlefield at Eylau* displays an unusual degree of realism for the Napoleonic period.

1812 Théodore Géricault exhibits *The Charging Chasseur*, the first of his dashing military portraits.

AFTER
1849 Ernest Meissonier's depiction of dead rioters in *The Barricade, rue de la Mortellerie, June 1848* echoes the raw brutality of Goya's prints.

1867 Édouard Manet's *Execution of Emperor Maximilian* is directly influenced by Goya's war art.

Artists have been depicting scenes of warfare for as long as men have wielded weapons. Memorable ancient examples were produced by the Akkadians (the victory stele of Naram-Sin, c.2250 BCE), the ancient Egyptians (wall reliefs of the Battle of Kadesh, 1274 BCE), and the Picts (the Aberlemno Stone, c.710), and the tradition has been maintained through to the official and unofficial war artists of today. While the style and approach of war artists have varied over the years, in tune with shifts in social attitudes and developments in art, the Spanish painter and printmaker Francisco de Goya's stance was unique for his time. His works are remarkably free from partisan influences and instead display the devastating consequences of war for all of its participants.

To the victors, the spoils

It is often said that history is written by the victors. By and large, the same can be said of war art, much of which is—and has always been—commissioned by rulers and military leaders to celebrate their achievements. In Goya's time, the

The act of painting is about one heart telling another heart where he found salvation.
Francisco de Goya

dominant figure was Napoleon Bonaparte, who employed the finest artists in France to document his military campaigns. Historical accuracy was rarely their chief concern; when Jacques-Louis David was asked to produce a portrait of Bonaparte leading his army across the Alps, for example, he was instructed to depict him "calm on a fiery steed," even though Napoleon had undertaken the journey on the back of a mule.

The war art of French painter Antoine-Jean Gros, a member of Napoleon's entourage, had similar aims. Gros had good access to firsthand information about the

Francisco de Goya

Francisco de Goya was born in 1746 near Saragossa, in Aragon, Spain. The son of a gilder, he trained initially under Baroque painter José Luzán, before moving to Madrid to study with Francisco Bayeu, his future brother-in-law. Through this connection, Goya gained a post at the royal tapestry factory in Madrid. He worked there until 1792, producing designs in a charming Rococo manner. At the same time, he was also gaining a reputation as a portraitist and this led to his appointment as painter to the king in 1786. Goya's blossoming career received a

setback in 1793, when he was struck down with a serious illness, which left him totally deaf. After this, his art acquired a darker edge. Goya gave his imagination even fuller rein in the so-called Black Paintings of his later years. He died in France in 1828.

Other key works

1797–98 *The Sleep of Reason Produces Monsters*
Before 1800 *The Naked Maja*
1812 *The Duke of Wellington*
1814 *The Third of May, 1808*

See also: Bayeux Tapestry 74–75 ▪ Bonampak murals 100 ▪ *The Surrender of Breda* 178–81 ▪ *Napoleon on the Battlefield of Eylau* 278 ▪ *The Defense of Petrograd* 338–9 ▪ *Totes Meer (Dead Sea)* 339

The Third of May, 1808 records the brutal French response to the Spanish revolt. Goya highlights the inhumanity of war: the slain appear grotesque; their killers faceless.

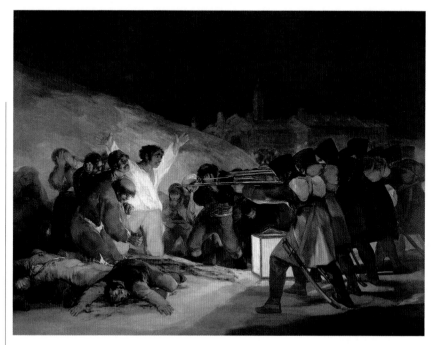

fighting, but his work was still geared toward public relations. His painting *Napoleon Visiting the Plague Victims at Jaffa* (1804) showed Bonaparte touching the sores of one of his soldiers— a scene designed primarily to counter accusations in the British press that he wanted to have the sick men killed.

At the time, uncommissioned war art was far less common. With the advent of Romanticism, though, some painters were drawn to depict the suffering caused by war. For example, Eugène Delacroix's *Massacre at Chios* (1824) presents the forlorn spectacle of helpless victims in its foreground, while the fighting is relegated to the background; similarly, his *Entry of the Crusaders into Constantinople* (1840) avoids triumphalism, instead showing the weary soldiers looking almost embarrassed as they survey the misery that they have caused.

War in Spain

Goya lived in Madrid during the Peninsular War (1808–14), when Napoleon's France invaded Spain— its former ally—and imposed as king Joseph Bonaparte, the brother of the emperor. On May 2, 1808, the people of Madrid rose against the French, triggering years of conflict, which was known in Spain as the War of Independence. More than one million people died in the war, a huge number considering that Spain's population at the time was only 11 million.

In 1814, the devastation of the war was over and the Spanish king, Ferdinand VII, had been restored. In Madrid, public mourning took place for the events of May 2 six years previously and the brutal reprisals that had followed it. The authorities organized a memorial service for the "martyrs" and made money available for commemorative pictures of the episode.

And so the record proceeds, horror after horror.
Aldous Huxley
The Complete Etchings of Goya, 1947

Goya responded with two large paintings—*The Second of May, 1808* and *The Third of May, 1808* (both 1814). The latter, with its nightmarish vision of a firing squad, is especially memorable. At the time, however, the pictures met with a lukewarm reception. The artist was given some money, but the paintings were not exhibited and were largely ignored. There are several possible reasons for this. Unlike many of the other commemorative painters, Goya did not emphasize the heroism of the Spanish, instead portraying them as grotesque, bloodied, even shambolic victims. There may also have been some doubts about the painter's loyalties. Goya had steered a diplomatic course through the difficult years of foreign occupation, accepting honors and commissions from the French authorities, although he depicted the horrors of war with an even hand. »

Themes of *The Disasters of War*

Plates 2 to 47 illustrate the horrors of the guerrilla war involving the French army and the Spanish civilian population.

Plates 48 to 64 highlight one of the consequences of the war—a terrible famine in Madrid, in which more than 20,000 people died.

Plates 65 to 82 satirize and criticize the repressive attitude of the Spanish civil and religious authorities after the war.

It is very unlikely that Goya actually witnessed the May uprising or its aftermath, so he used a measure of artistic license when composing the two pictures. *The Second of May* appears to have been loosely based on a bullfighting scene, while *The Third of May* was partly inspired by propaganda prints that the British (fighting on the Spanish side) had circulated during the conflict. In the latter, Goya also exaggerated some features to heighten the emotional impact of the painting. The kneeling figure in white, for example, who is about to be executed, is much larger than his companions—if he stood up, he would dwarf them all. Similarly, a corpse prominent in the foreground would in reality have been thrown backward if he had been struck by a volley of bullets.

The Disasters of War

The use of artistic license is far less apparent in Goya's other great contribution to the field of war art— *The Disasters of War*—in which he recorded with unflinching realism the atrocities committed during the Peninsular War.

The Disasters of War consists of a series of 82 etchings, which fall into three broad categories: horror, famine, and satire. Goya may have conceived the idea for the series as early as 1808, when the Spanish governor of Saragossa, General Palafox, invited him to witness the devastation caused there by a recent siege, in which the people had defended the city against the French for 61 days. The artist

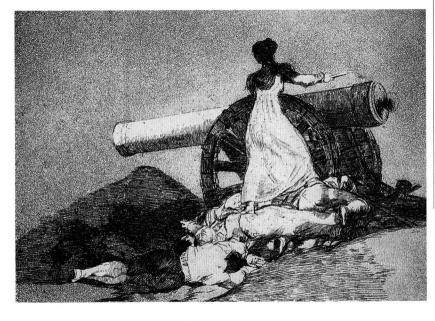

What courage! (plate 7) uses the stark contrast of the woman's white dress against the darkness of the cannon to show her virtue and heroism in taking a stand against the French.

The flesh-eating vulture (plate 76) shows a huge, ugly bird—thought to be a parody of the French imperial eagle—being chased by a single soldier, who is unaided by a jeering, or oblivious, crowd.

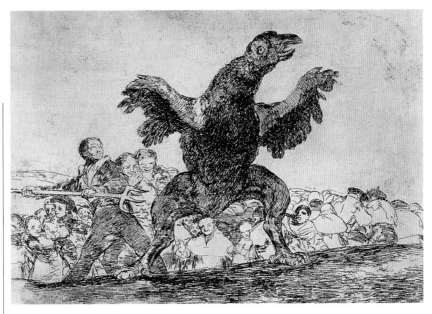

accepted, although he remained in the city only briefly, as the French returned to resume the siege.

The first dated prints are from 1810. Goya's commitment can be gauged from the fact that he was willing to cut up and reuse the plates of some of his finest aquatint etchings, owing to the shortage of materials caused by the conflict.

Goya's graphic depiction of the cruelty and brutality of war in this work was unprecedented. There are no organized battle scenes, no heroic duels or portraits of generals, and no appeals to a sense of justice or patriotism—just a depressing confirmation of the depths to which humanity can sink: rape, torture, mutilation, and murder. In the entire series, there is only one reference to a recognizable incident from the war. This is *What courage!* (plate 7), which depicts Agustina of Aragon, the heroine of Saragossa, who fired a cannon at the French during the siege when all the men around her had been killed. Agustina was regaled in verse by Byron and painted by numerous artists; Goya's version is typically understated. She is shown from behind, little more than a silhouette, standing on a pile of corpses.

Horrors of conflict

Goya may have derived inspiration for his *Disasters* from *The Miseries and Misfortunes of War*, a series of etchings about the Thirty Years' War produced by Jacques Callot in 1633. Like the earlier Frenchman, Goya included a few short narrative sequences in *The Disasters of War* to underline the futile cycle of violence. A rapist in one scene is castrated a few plates later; a soldier who bayonets an unarmed man is stoned by peasants shortly after. The most chilling aspect of the series, though, is the sheer anonymity of the aggressors. In *I saw this* (plate 44), mothers and children flee from an unseen enemy, while in *You cannot look at this* (plate 26), a group of figures cower as a row of rifle barrels appears, pointing ominously at them.

As an unshrinking portrayal of the horrors of war, *The Disasters of War* represents a genuine landmark in the history of art, but its impact on contemporary painting was minimal. The etchings proved too controversial and were seen only by the artist's friends. They were not officially published until 1863.

By this time, the business of depicting military conflicts had moved on. The rise of illustrated newspapers brought demands for more immediate forms of war art, which were satisfied by lithographers such as William Simpson and by early war photographers, such as Roger Fenton and Mathew Brady, who generated pioneering coverage of the Crimean War (1853–56) and the American Civil War (1861–65). ∎

The object of my work is to report the actuality of events.
Francisco de Goya

My work is very simple. My art reveals idealism and truth.
Francisco de Goya

A MODE FOR DEFINING THE PRESUMED CULTURAL INFERIORITY OF THE ISLAMIC ORIENT

GRANDE ODALISQUE (1814), JEAN-AUGUSTE-DOMINIQUE INGRES

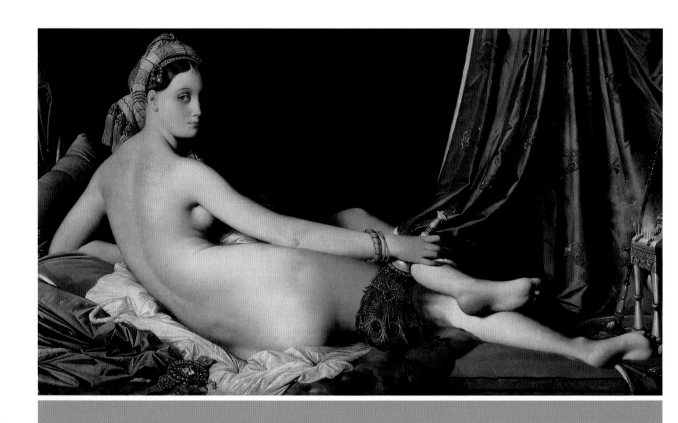

IN CONTEXT

FOCUS
Orientalism

BEFORE
1799 The Rosetta Stone, a stele inscribed in Egyptian hieroglyphs and Greek, is discovered during Napoleon's expedition in Egypt.

1800 Jacques-Louis David paints a portrait of Madame Récamier, with which Ingres assists. The model's pose informs Ingres' later odalisque.

1802 Baron Vivant Denon publishes engravings of ancient Egyptian sites.

AFTER
1834 Delacroix paints *Women of Algiers* following a lengthy stay in North Africa.

1846 Ingres' favorite pupil, Théodore Chassériau, paints Orientalist themes, following a visit to Algeria.

O rientalism was a popular trend in 19th-century Western art and design that drew inspiration from the lands, people, and motifs of the Near or Middle East, particularly their real or imagined exoticism.

Its initial impetus came from Napoleon's campaigns in Egypt (1798–1801), when scholars and archaeologists accompanied the expeditionary forces. On their return to France, the explorers' observations were soon reflected in the arts. The decorations in Napoleon's new home at Malmaison included numerous Egyptian motifs, and the fashion for Eastern subject matter was swiftly taken

See also: *Venus of Urbino* 146–51 ▪ *Diana after the Bath* 224 ▪ *The Death of Sardanapalus* 240–45 ▪ *Olympia* 279

up by painters of the day. For them, the "Orient" was an exciting and novel source of inspiration. In this era of colonialism, however, the exotic "Oriental" world was mainly depicted as highly eroticized, chaotic, or violent, in scenes that were rooted more in preconceived Western fantasy than reality.

The Orientalist painters fell into two main camps. Some, such as Eugène Delacroix and the English aristocrat Frederic Leighton, recorded their impressions after visiting the Middle East and North Africa, while others, including Jean-Auguste-Dominique Ingres (1780–1867), a champion of Academic art, relied on secondhand accounts and borrowed accessories for their props.

Exotic subjects

Subjects favored in Orientalist art included exotic landscapes, slave markets, bath scenes, harems, and odalisques—concubines of the harem. Ingres' *Grande Odalisque* was an early example of this form, commissioned by Napoleon's sister, Queen Caroline of Naples. The Oriental odalisque was a pretext for depicting the female nude, much as the goddess Venus had been in earlier work, and Ingres shows the figure in a provocative pose surrounded by richly sensual fabrics, in a scene designed to evoke a sense of hedonism. The woman plays with a feathered fan while looking suggestively over her shoulder. An opium pipe at the bottom right indicates further pleasures available to the Western viewer, while the artist's deliberate elongation of the woman's spine— it is no mistake as Ingres was an excellent draftsman—reinforces her air of sensual Eastern langor. ▪

Jean-Auguste-Dominique Ingres

Born in southern France in 1780, Jean-Auguste-Dominique Ingres studied art in Toulouse and later in Paris under the tutelage of Jacques-Louis David. He won the prestigious Prix de Rome in 1801, but his departure for his studies in Rome was delayed by political instability in France. He later became known as a portrait painter, a genre that he disliked, instead preferring historical painting. He produced two such works for Napoleon's palace in Rome. After four years in Florence, in 1824 Ingres returned to Paris—where his work had been condemned as savage— eventually winning critical approval for his Neoclassical paintings. Ingres taught at the schools of art in Paris and Rome, and died in Paris in 1867.

Other key works

1806 *Napoleon I on his Imperial Throne*
1827 *The Apotheosis of Homer*
1863 *The Turkish Bath*

I HAVE TO STAY ALONE IN ORDER TO FULLY CONTEMPLATE AND FEEL NATURE

THE WANDERER ABOVE THE SEA OF FOG (c.1818), CASPAR DAVID FRIEDRICH

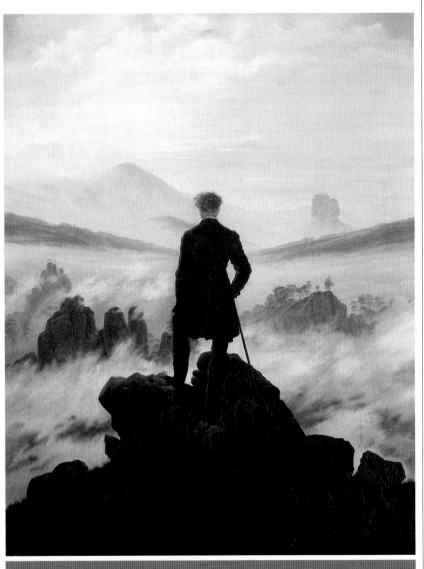

IN CONTEXT

FOCUS
German Romantic landscapes

BEFORE
1802 The works of German Romantic poet Novalis are published posthumously.

1808 Romantic painter Philipp Otto Runge produces his masterpiece, *Morning.*

1810 Johann Wolfgang von Goethe's influential *Theory of Colors* is published.

AFTER
1823 Norwegian artist J. C. Dahl moves into Friedrich's house and the close friends work together.

1831 Carl Gustav Carus writes *The Nine Letters on Landscape Painting*, summarizing the teachings of Friedrich.

1832 Carus paints his famous *Monument to Goethe.*

In the early years of the 19th century, Romantic artists began to breathe new life into the genre of landscape painting, in reaction to the rational formulas of Neoclassical art. Romantic painters in Germany, as elsewhere, were impelled by ideas of emotion and the centrality of the individual. But whereas in England and France, man was often depicted in conflict with nature, the German style was more meditative and introspective, representing man as alienated and alone in nature. In particular, Caspar David Friedrich and his circle suffused their pictures with spiritual intensity—landscapes of the soul rather than the eye.

See also: *Wind among the Trees* 96–97 ▪ *The Tempest* 164 ▪ *The Death of Sardanapalus* 240–245 ▪ *Mountains and Sea* 340

Close your bodily eye, that you may see your picture first with the eye of the spirit.
Caspar David Friedrich

Friedrich's style stemmed in part from his austere religious upbringing, which did much to shape his gloomy, inward-looking personality. He may also have been influenced by the open-air sermons of Gotthard Kosegarten, who claimed that nature's wonders were akin to divine revelations, which could be revealed to humanity at large by artists and poets. These notions were echoed by Friedrich's literary acquaintances in Dresden and helped him to develop his approach to the landscape. "The only true source of art is our heart," he declared. "It is not the faithful depiction of air, water, rocks, and trees that is the task of the artist, but the reflection of his soul and emotion in these objects."

Romantic imagination

The Wanderer above the Sea of Fog exemplifies the ideal of art created from the heart and soul. It does not depict a single location, but was assembled from mountain views that Friedrich had sketched, linked together with swathes of mist— an element that Friedrich believed heightenened the sublimity of the landscape. The painting focuses on the experience of the wanderer— confirmed by its unusual vertical format and its view of a prominent figure seen from behind. Friedrich may possibly have intended the landscape as a Christian allegory, with the difficult terrain in the middle representing the travails of life, and the distant mountain the hope of ultimate salvation. Some critics have also seen the painting as a *Gedächtnisbild*, a memorial to a recently deceased person—here, a high-ranking infantry officer, Friedrich von Brincken.

Friedrich's approach was not unique. In Germany, Philipp Otto Runge and Carl Carus followed a similar path; in England, Samuel Palmer and the Ancients produced implausibly fecund landscapes as evidence of God's bounty. No one, however, matched the haunting quality of Friedrich's art. ▪

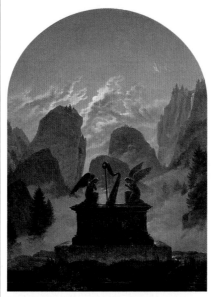

The Monument to Goethe (1832) was Carus's posthumous tribute to the great German writer. Carus was clearly influenced by the style of his teacher, Friedrich, in his depiction of the tomb.

Caspar David Friedrich

The son of a manufacturer of soap, Caspar David Friedrich was born in 1774 in the Baltic port of Greifswald. He trained at the Academy in Copenhagen where he was taught by the landscapist Jens Juel. In 1798, Friedrich settled in Dresden, where he remained for the rest of his life. The city was one of the leading centers of Romanticism—the "German Florence"—and he absorbed all the latest artistic theories.

Friedrich's breakthrough painting was *Cross in the Mountains* (c.1807), which he produced for a private chapel. In 1810, he became a member of the Berlin Academy of Art. His haunting blend of religious allegory and serene, mystical landscapes was popular, but as Romanticism fell from favor, he led a solitary life, favoring symbolic depictions of death in his works. After suffering a number of strokes, he died in Dresden in 1840.

Other key works

c.1807 *Cross in the Mountains*
1818 *Chalk Cliffs on Rügen*
1824 *The Sea of Ice*
1836 *Seashore by Moonlight*

I HAVE NO LOVE OF REASONABLE PAINTING

THE DEATH OF SARDANAPALUS (1827), EUGÈNE DELACROIX

Detail from *The Death of Sardanapalus*

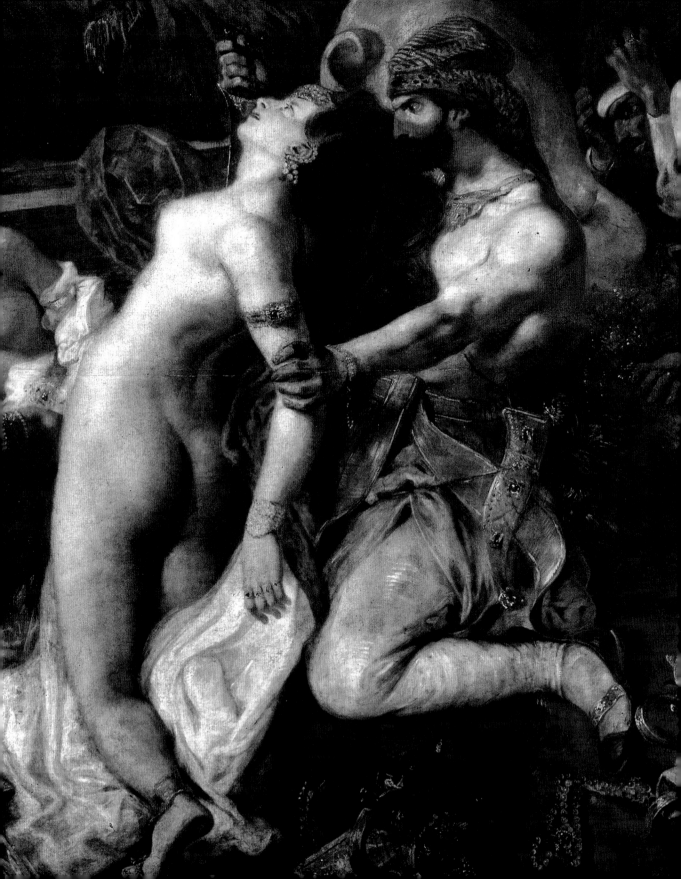

IN CONTEXT

FOCUS
Romanticism

BEFORE
1615–16 Peter Paul Rubens uses vivid colors and bustling drama in *Hippopotamus and Crocodile Hunt*.

1818 Théodore Géricault depicts individual struggle in *The Raft of the Medusa* and later in paintings of the insane.

1821 John Constable paints *The Hay Wain*, which makes a huge impression on Delacroix when it is exhibited at the Salon in Paris.

AFTER
c.1880 Pierre-Auguste Renoir is intrigued by Delacroix's Moroccan pictures and makes a copy of his *Jewish Wedding*.

1930–55 British Neo-Romantic artists including Graham Sutherland and John Piper are influenced by earlier Romantic works.

In **The Hay Wain** (1821) John Constable took Romantic ideas about nature to his native Suffolk, using broad brushstrokes and layering of colors to achieve depth and realism.

Romanticism was a wide-ranging artistic and literary movement that arose in Europe in the latter part of the 18th century and dominated the first half of the 19th century. A reaction against the Enlightenment values of rationality and order and their expression in Neoclassical art, Romanticism was the art of independence and individualism.

An emphasis on subjectivity, feelings, and imagination over reason and didacticism is common to many Romantic works, but the movement found a huge variety of expression, taking diverse forms in different countries. In Britain, it encompassed the fantasy of William Blake, the dark imagination of Swiss-born Henry Fuseli, and the bright color of the Pre-Raphaelites; in Spain, it was visible in the scenes of madness and witchcraft of Francisco de Goya's work; while in Germany, a group of Romantic painters called the Nazarenes looked back for inspiration to medieval art. In France and later in Britain, a fascination with the exotic East gave Romanticism an Orientalist flavor. In the field of landscape painting, Romanticism emerged from the earlier aesthetic of the Sublime. It was dominated by the radically new approaches of Caspar David Friedrich, J. M. W. Turner, and John Constable. Friedrich, in particular, broke new ground with the spiritual intensity of his views of the Pomeranian countryside, which are suffused with a lyrical blend of melancholy and deep religious feeling.

Eugène Delacroix's *Death of Sardanapalus* brings together many elements typical of the movement in one enormous canvas, which depicts the legendary Assyrian king Sardanapalus watching as his mistresses, slaves, and animals are slaughtered. Painted with warm, rich colors, it is awash in sensuality and violence: both beautiful and cruel, the painting summons up conflicting emotions in the viewer.

Romanticism is precisely situated neither in choice of subject nor in exact truth, but in a way of feeling.
Charles Baudelaire

See also: *Death of Marat* 212–13 ▪ *The Disasters of War* 230–35 ▪ *Grande Odalisque* 236–37 ▪ *The Wanderer above a Sea of Fog* 238–39 ▪ *Romans of the Decadence* 250–51 ▪ *The White Horse* 278

A battle of generations

The stark differences between the restraint of Neoclassical painting and the emotionalism of the new Romantic trends in art were embodied in the persons of Jean-Auguste-Dominique Ingres and Delacroix, two great giants of 19th-century French art. A rivalry emerged between them—fueled principally by writers and critics—in which Ingres, the elder of the two, represented values of tradition, conservatism, and authority, while Delacroix was seen as the wild young upstart. This was a contest not just between the generations, but also between contrasting styles. Where Ingres stressed the central importance of drawing and clarity in artistic expression, Delacroix was, before all else, a colorist, who used highly expressive brushwork to portray passions and movement.

The Romantic controversy in France erupted in the 1820s. Delacroix caused uproar when his *Massacre at Chios* was shown—in the same room as a work by Ingres—at the Salon of 1824. The painting depicts a scene of ruin and despair after the massacre on the Greek island of Chios, when Ottoman forces killed more than 20,000 inhabitants in the Greek War of Independence. The work was attacked for both its subject and its style. The atrocity on Chios had taken place just two years previously, and while the event became a cause célèbre for the Romantic artists, it was considered far too topical by conservative critics, who thought it to be more appropriate for journalism than art.

Novel technique

However, it was the novelty of Delacroix' technique more than the subject of his painting that caused the real storm. Just before the opening of the Salon, Delacroix had seen John Constable's *The Hay Wain*, which was awarded a gold medal by King Charles X when it was exhibited in France in 1824.

We need to be very bold. Without daring, without extreme daring even, there is no beauty.
Eugène Delacroix

The English painter juxtaposed short brushstrokes of color to give his picture an added sense of freshness and vitality. Inspired by this new technique, Delacroix repainted the background of *Massacre at Chios*. In doing so, he broke with the classical convention of blending paint to a smooth finish, a technique that made a scene appear realistic, even when viewed close up. Viewers were instead »

Neoclassical versus Romantic values

Neoclassical

Logical and informed by science and observation.
Inspired by classical art and philosophy.
Emphasizes harmony and balance.
Reflects human mastery over nature.

Romantic

Fueled by individualism and emotion.
Informed by medievalism and folk traditions.
Highlights change and radicalism.
Celebrates the savagery of nature.

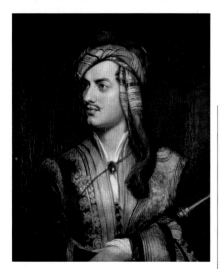

A portrait of Romantic hero Lord Byron (1813) by Thomas Phillips shows him in traditional Albanian costume. The Oriental style of the velvet jacket and headdress reflects Romantic taste.

confronted with a vivid array of tiny flecks of pigment. One critic dubbed the work "a massacre of painting" and many regarded the work as little more than a sketch. This view became a common criticism of Delacroix's brand of Romanticism: although it was believed that he could produce glorious passages of color in his canvases, his works were seen as essentially unfinished.

Byronic inspiration

After Chios, the Greek War of Independence continued to attract the attention of the intellectual and artistic elite of the Romantic movement, and some traveled to Greece to offer their support. The English poet Lord Byron set off, intending to join the battle, but died of a fever at Missolonghi before seeing any action. Byron's death, however, raised him to the status of a hero in Romantic circles, and Delacroix was certainly one of his most fervent admirers. The artist drew inspiration from Byron's writings and based his next two major paintings—*The Execution of the Doge Marino Faliero* and *The Death of Sardanapalus*—on Byron's plays.

Byron's tragedy *Sardanapalus*, published in 1821, was loosely based on an account by the Greek historian Diodorus Siculus that told the tale of a semi-mythical king of Assyria, who reigned in the 7th century BCE. He lived a life of luxury, but roused himself to action when his nation came under threat from a serious uprising. A devastating battle ensued, in which the king's forces were defeated. Retiring to his palace, Sardanapalus built a pyre under his throne, determined to sacrifice himself rather than fall into the hands of his enemies.

In Byron's play, Sardanapalus meets a noble end, joined on the pyre by his favorite concubine, but Delacroix invented a gorier end for him. In his depiction, the king orders his treasures to be destroyed and his concubines, servants, and horses put to death. Nothing that brought him pleasure during his lifetime is allowed to survive him.

The painting exploited the public's taste for Orientalism—popular in France since the campaigns of Napoleon—and pandered to preconceptions about the East, namely its association with luxury, opulence, and cruelty. Delacroix drew on diverse sources to create his vision of ancient Assyria, including accounts of the Near East by his friend the painter Charles-Emile Champmartin, and William Daniell's engravings of India, which provided architectural detail.

Critical reaction

The Death of Sardanapalus was Delacroix's most overtly Romantic picture and was greeted with near-universal hostility when shown at the Salon in Paris in 1828. Critics mocked the hopelessly confused composition and deplored the artist's apparent relish for violence and eroticism: "The Romantics have invaded the Salon," wrote one appalled reviewer.

A major objection was to the picture's air of chaos. Objects appeared to be scattered around at random; figures crowded into the painted space, but it was often

Eugène Delacroix

Eugène Delacroix was born on the outskirts of Paris in 1798. His father was a diplomat, although Eugène was rumored to be the illegitimate son of the French statesman Talleyrand. Delacroix trained under the renowned painter Pierre Guérin, but was more heavily influenced by his friend Théodore Géricault, and by his own admiration for Rubens. He found fame in the 1820s with a series of controversial Romantic paintings, culminating in the dynamic *Liberty Leading the People*, but his style became more serene after he traveled to Morocco and Algeria in 1832. In the latter part of his career, he produced large-scale murals. Delacroix died in Paris in 1863.

Other key works

1824 *Massacre at Chios*
1834 *Women of Algiers*
1840 *The Taking of Constantinople*

unclear what they were standing on; the positions of some limbs was unexplained. The location of the scene also confused viewers. In the upper right-hand corner, they could see parts of the city on fire, yet the king's lavish couch suggested that the foreground was indoors. Only after careful observation did blocks of wood become apparent, which indicated that the couch had been placed on top of a pyre.

Critics of the time claimed that the confusion in the painting was due to its rushed and negligent composition. However, Delacroix made numerous sketches for this picture, testing out the dynamic of the group, and its apparent "chaos" was very carefully planned.

The French poet Charles Baudelaire was an admirer of Delacroix and referred obliquely to Sardanapalus in his poem "Spleen," which highlighted perhaps the most chilling aspect of the painting: the attitude of the king himself. Sardanapalus is at the center of a maelstrom of his own creation—objects are being destroyed and living creatures put to death, all at his bidding. Yet, amid the horror, the king reclines languidly, impervious to the screams and pleas of those around him. The chief protagonist in any classical painting would never have behaved with such apathy. The king's world-weariness, his sense of ennui, is far more typical of the Romantics. To paraphrase Baudelaire: "Nothing can cheer him. Not his game, not his hunting birds, nor the subjects who die before his eyes… His couch, adorned with lilies, has become his tomb." ∎

The king's appetite for cruelty and violent sacrifice is made evident in *The Death of Sardanapalus*. A guard slits the throat of a naked concubine, while the king looks on impassively.

FROM TODAY, PAINTING IS DEAD

BOULEVARD DU TEMPLE (1838), LOUIS-JACQUES-MANDÉ DAGUERRE

See also: *Street, Dresden* 290–93 ▪ *Hurrah, the Butter is Finished!* 339 ▪ *Woman Descending the Staircase* 341

IN CONTEXT

FOCUS
Photography and art

BEFORE
1819 English scientist John Herschel discovers one of the first photographic fixers.

1827 Nicéphore Niépce fixes a view from a camera obscura onto a pewter plate.

1835 Henry Fox Talbot creates his earliest negative, *Latticed Window in Lacock Abbey.*

AFTER
1839 Alphonse Giroux obtains a license to produce the first daguerreotype camera.

1844 Fox Talbot publishes his *Pencil of Nature*, the first book illustrated with photographs.

1850s onwards Artists including Gustave Courbet and Paul Gauguin use photographs for inspiration and reference, or as source material.

T he invention of photography did not destroy art, as some had predicted. It did, however, offer inspiration to artists, encouraging them to explore new ways of seeing and portraying their environment, experiences, and ideas. Photography also simplified the process of copying the material world and corrected several long-held visual assumptions.

There was no single inventor of photography. In the 1820s, Joseph Nicéphore Niépce developed a process called heliography ("sun drawing"), which allowed him to permanently fix images formed in a camera obscura, although the exposure times were impractically long. Niépce partnered with Louis Daguerre in 1829 and developed the "daguerreotype," which was made public in January 1839. Also in France, Hippolyte Bayard devised a direct positive process that was regarded by many as superior to the daguerreotype, but his efforts were spurned by the authorities.

Seizing the light
Daguerre's *Boulevard du Temple* was a demonstration piece—taken from his apartment—which he sent to various distinguished figures. The image is reversed, left to right, and is an interesting record of Paris before Haussmann's public works. The usually busy area appears deserted: the daguerrotype often required more than 10 minutes' exposure time, so anything moving would not have been captured. The most fascinating feature of the shot is the man having his shoes shined at the street corner—the two figures were presumably posed by the photographer and asked to stay still. They are the very first people to be depicted in a photograph.

Daguerre's process captured a single, non-reproducible image with fine tonality and detail on

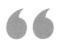

> You see only what is interesting, whereas the instrument puts in everything.
> **Eugène Delacroix**
> *Journal*, 1853

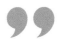

a polished metal plate. However, in England, Henry Fox Talbot had devised a photographic process called the "calotype"—crucially, multiple copies could be made from the negative, so the English inventor's process prevailed.

A number of artists soon took up portrait photography, providing a service to those unable to afford the high cost of a painted portrait. Artists also often used photographs as aids, referring to them while painting a picture: for example, for accuracy of depiction and—in the case of portraiture—to minimize the time and difficulties involved in employing a live model. ▪

Louis-Jacques-Mandé Daguerre

Born in 1787, Louis-Jacques-Mandé Daguerre began his career as a painter and set designer. In 1822, he opened the Diorama, a theatrical spectacle in which panoramic landscapes were transformed by clever lighting. This led to his working with Nicéphore Niépce on photography. After Niépce died in 1833, Daguerre completed the project with Niépce's son, Isidore. The French government purchased his daguerreotype in 1839, and he was showered with honors. However, his continued research was hampered by a fire at the Diorama, which destroyed much of his work and most of his daguerreotypes. He died in 1851 near Paris.

OBSERVE NATURE. WHAT OTHER TEACHER DO YOU NEED?

LION CRUSHING A SERPENT (1832), ANTOINE-LOUIS BARYE

IN CONTEXT

FOCUS
Animal symbolism

BEFORE
1762 English painter George Stubbs produces *A Lion Attacking a Horse*, continuing an earlier tradition of depicting animal fights in art.

1825 Eugène Delacroix portrays animals in their most savage guise in his *Horse Attacked by a Tiger*.

AFTER
1858 English artist Edwin Landseer is commissioned to produce four bronze lions, a symbol of Britain's empire, for the base of Nelson's Column in Trafalgar Square, London.

c.1860 French sculptor Christophe Fratin creates *Lion Clenching a Wild Boar*, echoing Barye's style.

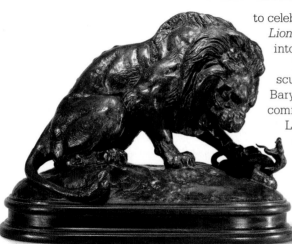

to celebrate political success. *Lion Crushing a Serpent* falls into the latter category.

Its creator, the French sculptor Antoine-Louis Barye (1796–1875), was commissioned by King Louis Philippe to create a monument to his dramatic rise to power in the July Revolution of 1830. The events of this time had seen the reactionary Charles X replaced by Louis Philippe as "King of the French," with the intention of reconciling monarchy with the liberalism of revolution.

Layers of symbolism
Barye specialized in naturalistic bronze sculptures of animals, and had honed his skills through drawing and dissections at the zoo in the Jardin des Plantes in Paris. A true Romantic, he portrayed animals in their wildest state, killing or devouring each other. These states often symbolized human emotions.

The use of animal symbolism in art can be traced back as far as shamanistic images in the prehistoric rock art of southern Africa and to the illustrated bestiaries of medieval Europe.

In the 18th and 19th centuries, this symbolism was employed in a political context. British caricaturists such as James Gillray would often mock contemporary politicians by drawing their heads on animal bodies, while other artists borrowed from the animal kingdom in order

The lion had long been a symbol of kingship. Here, the lion of monarchy grapples with the evil serpent, but in this instance the subject also had an astrological significance: the king's victory in the July Revolution had taken place under the constellations of Leo (the lion) and Hydra (the sea serpent), and so the work hints at celestial approval.

Although *animaliers* ("animal artists") were rated low at the Salon, they were extremely popular with the public. Barye's 1832 sculpture elevated the genre, and was placed in the Tuileries Garden, close to the palace that had been sacked in the bloody uprising two years earlier. ∎

See also: Assyrian lion hunt reliefs 34–35 ▪ *Laocoön and his Sons* 42–43 ▪ Marcus Aurelius 48–49 ▪ *A Lion Hunt* 176–77 ▪ *The Death of Sardanapalus* 240–45

THERE SHOULD BE A MORAL IN EVERY WORK OF ART
GREEK SLAVE (1845), HIRAM POWERS

Sculptor Hiram Powers (1805–73) was raised in Cincinnati, Ohio, but he spent most of his career in Italy, where he was inspired by classical sculpture. He made his reputation with a series of striking portrait busts. However, *Greek Slave* was his most celebrated work, winning acclaim when it was shown in London at the Great Exhibition of 1851, and drawing crowds in his native America.

Purity and nudity
In Neoclassical style, the marble statue depicts a Greek slave stripped naked for sale by her Turkish captors. An artistic convention of the period equated clothed figures with a civilized culture, while nude figures suggested a more primitive one. *Greek Slave* created a frisson by contravening this convention: the naked woman is from Greece—the cradle of Western civilization— and is Christian (there is a cross below her right hand). Powers encouraged the statue to be understood as representing the triumph of Christianity over the heathen: a slave, she remains pure and chaste, patient, and rising above her suffering. The moral message of the statue was so strong that some American pastors urged their congregations to view the work.

Despite its success, the statue proved controversial in a different moral arena. Critics noted the irony of an American sculptor portraying a European slave at a time when the Abolitionist movement was gathering pace in the US. "We have the Greek Captive in dead stone—why not the Virginian slave in living ebony?" ironized satirical magazine *Punch* in 1851. ∎

See also: Riace Bronzes 36–41 ∎ *Young Slave* 144–45 ∎ *Venus of Urbino* 146–51 ∎ Tomb of Maria Christina of Austria 216–21 ∎ *Olympia* 279

IN CONTEXT

FOCUS
Art and morality

BEFORE
1837 Sculptor Henry Weekes portrays the bishop of Madras in voluminous robes, while a native convert is almost naked.

c.1844 With his *Lady Godiva*, the sculptor William Behnes employs a classical style on a non-classical subject, as Powers does with *Greek Slave*.

AFTER
1853 John Bell's *A Daughter of Eve* is directly inspired by Powers' work.

1862 John Gibson creates controversy at the London International Exhibition with his *Tinted Venus*—whereas uncolored nudes command respect, the painted statue is considered semipornographic.

How perfect the emblems of the divine and the devilish—of the beautiful and brutish—in human nature are thus presented!
Letter in *The North Star*
(Abolitionist newspaper), 1850

THERE'S SCARCELY A NOVICE WHO FAILS TO SOLICIT THE HONORS OF THE EXHIBITION

THE ROMANS OF THE DECADENCE (1847), THOMAS COUTURE

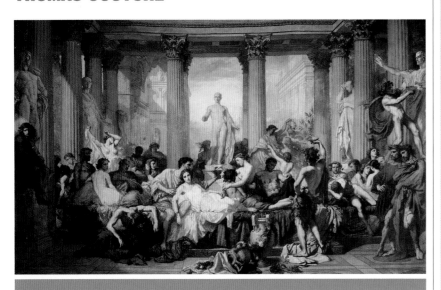

IN CONTEXT

FOCUS
Salon painting

BEFORE
1667 The Royal Academy of Painting and Sculpture stages its first official exhibition.

1725 Exhibitions begin to be staged at the Salon Carré in the Louvre.

Early 1800s Jean-Auguste-Dominique Ingres establishes himself as a successful Salon painter, but after criticism of his work in 1806 he vows never to exhibit again.

AFTER
1859 Jean-Léon Gérôme's *Ave Caesar! Morituri te salutant* typifies the vision of antiquity that is so popular at the Salon.

1863 Édouard Manet's *Le déjeuner sur l'herbe* is rejected by the Salon jury.

1881 The School of Fine Arts gives up its control of the Salon to a new group, the Society of French Artists.

For much of the 19th century, the conventional route to artistic success in France lay through the Salon—an officially sanctioned art exhibition in Paris staged by the School of Fine Arts—which took its name from the Salon Carré, the room in the Louvre where the show was held. The Salon had first been staged in 1667, when Louis XIV lent his support to an exhibition of works by artists of the Royal Academy of Painting and Sculpture. It was then held at irregular intervals until 1737, when it became a fixture held annually and later biennially, and was opened to all artists. Despite this, painters of the Academy continued to dominate the Salon. From 1748, the art submitted was approved or rejected by a jury made up principally of Academy members, who favored a certain type of art that was conservative in both style and content.

Decadent splendor

The Salon reached its zenith in the first half of the 19th century, as a place where reputations were made or broken; its walls were crowded with paintings by ambitious artists who were seeking lucrative commissions or wishing to have their work bought by the state.

The Romans of the Decadence by Thomas Couture has many features typical of the art that flourished at the Salon. It is a history painting—a genre considered to be the noblest type of art in the 19th century, encompassing themes from classical history or mythology, as well as allegories, and generally incorporating a moral message. Accordingly, Couture's picture adopts a moralizing tone: it shows the effect of vice on the once-great Roman civilization as it declined.

Thomas Couture

Born in 1815, Couture moved with his family to Paris when he was 11 years old. He studied art in the city and won the prestigious Prix de Rome in 1837. In the 1840s, he made his mark at the Salon with a series of lively, moralizing scenes, culminating in *The Romans of the Decadence,* his best-known painting. Couture then started on his second major history painting, *Enrolment of the Volunteers of 1792*, which he failed to complete. Couture's later career was filled with disappointments and promised commissions that never came to fruition. Even so, he was a fine portraitist and an influential teacher, whose pupils included Édouard Manet. He died in 1879.

Other key works

1840 *Young Venetians after an Orgy*
1848–58 *Enrollment of the Volunteers of 1792*
1857 *The Duel after the Masked Ball*

The debauched antics of the revelers are at odds with past glories; statues of long-dead Roman heroes seem to look down with disapproval. Parisians were swift to recognize the work as an allegory in which Couture satirized the scandals of the July Monarchy (a period of liberal monarchy under Louis-Philippe that lasted from 1830 to 1848). As one critic put it, Couture's real subject was "the French of the Decadence."

The Romans of the Decadence caused a sensation at the Salon of 1847, admired for its grand scale and technical bravura. Physically imposing, it measures 186 in x 304 in (472 cm by 772 cm). Its composition is theatrical, built on a central group of figures. The artist's brushwork is smooth, to create an illusion of realism. The work was acquired by the state, but the artist and his style of painting, which harked back to classicism, soon fell out of fashion as the new Realist movement took hold. Couture himself saw the signs. In *The Realist* (1865), he mocked the new trends, portraying an artist of the new school made popular by Gustave Courbet: sitting on a classical bust, the artist is painting a pig's head, an emblem of squalor and ignorance.

Beyond the Salon

As the 19th century wore on, progressive critics began to ridicule the kind of conservative art that was favored at the Salon, dubbing it *l'art pompier* ("firefighter art")—supposedly because nude models would often wear firemen's helmets when they were posing as soldiers in ancient battle scenes. In 1863, a furore occurred when the Salon jury rejected 3,000 paintings, including works by Édouard Manet and Paul Cézanne. A separate exhibition of the declined art was set up, known as the Salon des Refusés, which drew huge crowds. Although the response to the rival show was largely critical, it diminished the status of the official Salon, and started a trend for independent exhibitions of avant-garde artists. In 1881, the government withdrew its sponsorship of the Salon. ▪

The Salon Carré in the Louvre Palace, shown here in a painting from around 1870, was the location of the prestigious Paris Salon from 1725, under the sponsorship of Louis XV.

SHOW ME AN ANGEL AND I WILL PAINT ONE

A BURIAL AT ORNANS (1849–1850), GUSTAVE COURBET

The term "realism" can be used to describe any art that is highly naturalistic, but it also refers more specifically to a movement that arose in France in the middle years of the 19th century. It is chiefly associated with the artist Gustave Courbet, who was born in the French town of Ornans, and whose *A Burial at Ornans* provided his breakthrough in the Parisian art scene.

Courbet chose to paint scenes of everyday life from the world that he knew, rather than focusing on the more uplifting, imaginary, and moralizing themes of the Salon—

the French art establishment. His matter-of-fact approach would not in itself have been particularly controversial, except that he decided to produce a number of his pictures on a monumental scale, which was traditionally reserved for grandiose scenes of heroism, history, tragedy, and mythology. In doing so, Courbet—who possessed a rebellious spirit—considered he was striking a blow for artistic liberty. His attitude caused concern in the wake of the 1848 Revolution, which had seen the overthrow of the Orleans monarchy and the installation of the conservative

Second Republic in France. Under these ideological conditions, the establishment viewed any signs of rebellion or calls for liberty as politically inflammatory.

A question of size

When *A Burial at Ornans* was shown at the Paris Salon in 1850, it was heavily criticized. Courbet's figures were not the idealized forms of the Salon, but friends, relatives, or ordinary townsfolk from Ornans, whom Courbet had painted from life, making no attempt to flatter them. Some critics even suggested that he had gone out of his way to

IN CONTEXT

FOCUS
Realism

BEFORE
c.1640s Works of the French
Le Nain brothers, such as
Peasant Meal (1642), were
important precursors of
Courbet's realist style.

1848 *The Winnower* by French
painter Jean-François Millet
causes a stir at the Salon, with
its focus on ordinary people.

AFTER
c.1862–64 French artist Honoré
Daumier's painting *The Third-
Class Carriage* chronicles
modern life, following the
precepts of the Realists.

1872 Illustrations of city slums
by the French artist Gustave
Doré in *London, A Pilgrimage*
help create an important work
of social journalism.

1885 The somber painting
The Potato Eaters, by Vincent
van Gogh, owes a debt to the
Realists' peasant scenes.

See also: *Hunters in the Snow* 154–59 ▪ *The Angelus* 279 ▪ *Barge Haulers on the Volga* 279 ▪ *The Gross Clinic* 280

Gustave Courbet

Born in Ornans,
France, in
1819, Gustave
Courbet moved
to Paris in 1839,
where he soon
developed his own artistic style.
In the 1850s he was hailed as
the leader of the Realist school,
and in 1855 he organized a
landmark one-man show at the
World's Fair, showcasing his
most famous work, *The Painter's
Studio*. In later years, Courbet's
rebellious spirit landed him in
trouble. In 1871, he played an
active role in the Commune,
the short-lived revolutionary
government of Paris. Reprisals
followed. He was imprisoned
briefly, before going into exile in
Switzerland, where he remained
until his death in 1877.

Other key works

1849 *After Dinner at Ornans*
1854–55 *The Painter's Studio*
1857 *Young Ladies on
the Banks of the Seine*

make them appear ugly. Size was
the issue. Courbet had depicted a
simple country funeral on an epic
scale: the canvas measured 260 in
x 122 in (660 cm x 310 cm). Critics
expected a large painting to stir
the imagination or their emotions,
but Courbet's subject-matter was
considered banal, its participants
too ordinary for the scale.

Radical painting

Although Courbet mixed with
a bohemian crowd that included
anarchists, free thinkers, and
republican activists, it is not
clear whether he saw himself
as a radical. Courbet maintained
that his position as the "leader" of
the Realist school had been thrust
upon him, and that any so-called
radical features—such as "ugly"
depictions of poverty and manual
labor—are more evident in the
paintings of other Realist artists
than in his own work. Indeed, *A
Burial at Ornans* presents a faithful
record of French funerary customs
at the time: how male and female
mourners were segregated; the
broad-rimmed felt hats of the pall-
bearers; and the pall itself, with its
black crossbones and black tears.

However, some aspects of the picture
are less than factual. The bare-
headed figures at either side may
represent Courbet's grandparents,
both of whom had recently died,
while the skull that is shown in the
foreground is an allegorical touch,
representing Everyman. The open
grave is placed directly in front
of the spectator and, significantly,
the identity of the deceased person
is not disclosed. The picture is a
meditation on death—all the more
moving because it is conveyed
by ordinary people rather than by
ancient gods or heroes. ■

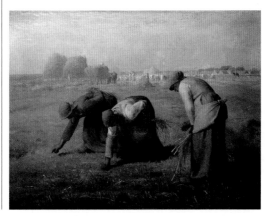

**Jean-François
Millet's** *The Gleaners*
(1857) addresses the
reality and social
inequality of rural labor.
Three women stoop low
to pick the remnants of
the harvest, while a
horseman (far right)—
thought to be the
landowner's overseer—
monitors their progress.

ONE CAN ALMOST HEAR THE CRACK OF THUNDER

SUDDEN SHOWER OVER SHIN-OHASHI BRIDGE AND ATAKE (1857), UTAGAWA HIROSHIGE

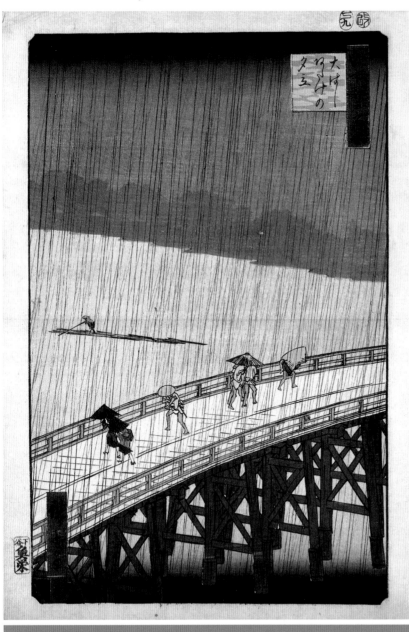

IN CONTEXT

FOCUS
Japanese prints

BEFORE
Late 17th century
Hishikawa Moronobu develops the *ukiyo-e* style in more than 100 illustrated volumes.

1765 Suzuki Harunobu makes the first full-color woodblock prints, known as *nishiki-e*.

1826–33 Katsushika Hokusai makes the print series *Thirty-Six Views of Mount Fuji*.

AFTER
1887 Vincent van Gogh paints a copy of Hiroshige's *Sudden Shower*. Artists including Edgar Degas and Claude Monet are influenced by Japanese prints.

1904 With his print *Fisherman*, Kanae Yamamoto initiates the *sosaku-hanga* ("creative prints") artistic movement.

Japanese prints made a huge impact on European art in the second half of the 19th century, when Japan was opened up to the West after centuries of isolation. Progressive European artists, always on the lookout for new sources of inspiration, were impressed by the bright colors and fresh, uncluttered look of the prints as well as the novelty of the culture that they revealed.

Woodblock printing flourished in Japan in the Edo period (1603–1868), the peaceful era presided over by the Tokugawa shoguns that saw a proliferation of arts and culture. The late 18th century was the golden age of printmaking, when mass-produced, inexpensive

See also: Nio Temple Guardians 79 ▪ Wind among the Trees on the Riverbank 96–97 ▪ The Four Horsemen of the Apocalypse 128–31 ▪ Women in the Garden 256–63 ▪ Under the Wave off Kanagawa 278

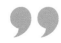

Hiroshige is a marvelous Impressionist.
Camille Pissarro
Letter to his son, 1893

prints made art available to all. A few great print masters—including Kitagawa Utamaro, famed for his prints of beautiful women, Katsushika Hokusai, and Hiroshige—created outstanding work that became highly collectable.

The simplicity of the prints that European artists so admired was partly a practical response to the complexity of the printmaking process—a collaborative effort between a publisher, an artist, a block cutter, and a printer. The artist's design on paper was transferred to a block of cherrywood by a skillful cutter, and the print was then made by the printer, sometimes using 20 or 30 separate blocks—one for each color—so simple designs worked best.

The floating world
The most popular prints were the *ukiyo-e,* or "pictures of the floating world." This world revolved around the hedonistic entertainments of the "pleasure districts" of big cities, with their kabuki theaters, teahouses, brothels, fireworks displays, and sumo tournaments. *Ukiyo-e* prints popularly depicted actors, geisha, and courtesans, subjects later joined

Plum Orchard in Kamada (1857) from Hiroshige's *One Hundred Famous Views of Edo* is a typical composition, using large foreground elements to frame the background.

by landscape and cityscape scenes, which appeared as background settings before becoming independent genres.

Hiroshige was a native of Edo—the city that became Tokyo in 1868, when the capital was moved there from Kyoto. He portrayed his home in each season and under different weather conditions. *Sudden Shower* comes from his last great collection of prints, *One Hundred Famous Views of Edo.* In this print, he effectively conjures up the ferocity of a summer storm through the dark, threatening *bokashi* (the line of graduated color at the top) and his ingenious depiction of rainfall. He used two separate blocks to convey the rain, drawing the lines at slightly different angles and in slightly different colors. In common with many other Japanese artists, Hiroshige did not employ the geometric perspective favored in the West, preferring to use such devices as the bridge and the high viewpoint to create a sense of depth. This, together with the extraordinary economy of the figures, hunched under hats and umbrellas, produced a scene that was both thoroughly convincing and utterly charming. ▪

Utagawa Hiroshige

Born in Edo in 1797, Utagawa Hiroshige was the son of a fire warden—a job that he later inherited. He studied art under the *ukiyo-e* master Utagawa Toyohiro, gradually developing his own style, and his works were first published in 1818. His early prints featured subjects such as warriors and kabuki actors, but he later focused on natural forms and landscape prints, which often documented his travels. Hiroshige was prolific, producing thousands of prints. He became influential in the West, where his work informed the experiments of the Impressionists. He died in a cholera epidemic in 1858.

Other key works

1833–34 *Fifty-Three Stations of the Tokaido* series
1837 *Sixty-Nine Stations of the Kisokaido* series

I WOULD LIKE TO PAINT AS A BIRD SINGS

WOMEN IN THE GARDEN (1866–1867), CLAUDE MONET

Detail from *Women in the Garden*

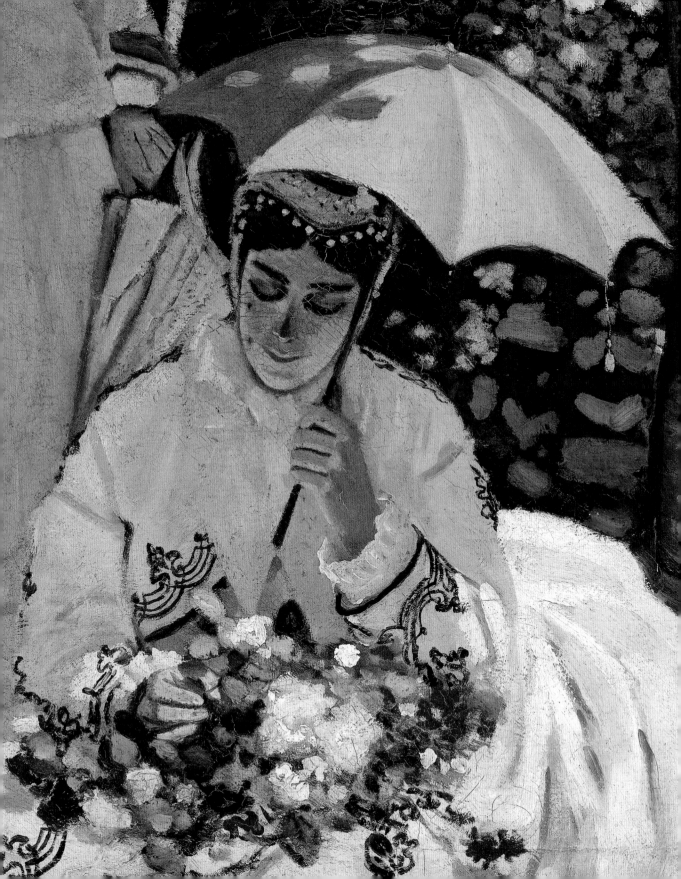

IN CONTEXT

FOCUS
Impressionism

BEFORE
1858 Eugène Boudin paints breezy beach scenes and introduces Monet to the practice of *plein air* painting.

1863 Édouard Manet's *Le déjeuner sur l'herbe* scandalizes viewers.

1864 Dutch artist Johan Barthold Jongkind paints light-filled landscapes in Normandy.

AFTER
1867 *The Artist's Family* by Frédéric Bazille is infused with the bright colors and vivid light of the Mediterranean.

1869 Monet and Pierre-Auguste Renoir influence one another when they work side-by-side at La Grenouillère.

From 1899 Monet paints a series of canvases of water lilies in his garden at Giverny.

Impressionism was a hugely influential movement, and is one of the cornerstones of modern art. It originated in the 1860s in France, reaching its fullest development there, but variations of the style eventually flourished in many other parts of Europe, as well as in the US and Australia. The Impressionists never had a precise manifesto, but they had in common a number of aims and ideals that set them in opposition to the Salon—the exhibition of the Academy that embodied beliefs of the French art establishment of the 19th century.

In the mid-19th century, the Salon reserved its greatest plaudits for artists who depicted uplifting themes from history or mythology. These scenes included idealized figures rendered using a detailed, highly finished technique in which brushwork was invisible. Gustave Courbet and other Realist painters challenged the orthodoxy of the Salon in the 1850s by depicting prosaic rather than the accepted "noble" subjects, but opposition to Academic art crystallized in the work of Édouard Manet. In two of his most famous pictures, *Le déjeuner sur l'herbe* and

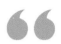

Work at the same time on sky, water, branches, ground … Don't be afraid of putting on color … Paint generously and unhesitatingly, for it is best not to lose the first impression.
Camille Pissarro

Olympia, he borrowed traditional themes, but translated them into a modern idiom that shocked visitors to the Salon.

Members of the group

The nucleus of the Impressionist group met as students in the early 1860s in Paris, either at the Académie Suisse (Claude Monet, Camille Pissarro, Paul Cézanne, and Armand Guillaumin) or in the private teaching studio of Swiss-born artist Charles Gleyre (Monet, Pierre-Auguste Renoir, Alfred Sisley, and Frédéric Bazille). Manet and Edgar Degas, also considered founders of the movement, were slightly older than the others and retained a foot in the establishment camp, not wishing to prejudice their chances of conventional success; Manet never exhibited at any of the Impressionist exhibitions. Mary Cassatt was introduced to the circle through her friendship with Degas, while Berthe Morisot met them through her links with Manet.

Paint what you see

Manet's maxim that "One must be of one's time and paint what one sees" was applauded by the younger

Claude Monet

Claude Monet was born in 1840, the eldest son of a shopkeeper. He attended both the Académie Suisse and Gleyre's studio, but his real teachers were Boudin and Jongkind, who instilled in him a love of painting outdoors. After military service in Algeria, he worked in Paris, achieving some success at the Salon. During the Franco-Prussian War (1870–71), he fled to London, where he met the dealer Paul Durand-Ruel, who helped to launch his career. In 1890, Monet bought a house at Giverny, where he created the water garden that became his favorite subject in his declining years. He died there in 1926.

Other key works

1869 *La Grenouillère*
1873 *Wild Poppies*
1877 *Gare Saint-Lazare*
1892–95 *Rouen Cathedral* series

See also: *Landscape with Ascanius Shooting the Stag of Sylvia* 192–195 ▪ *Sunday on La Grande Jatte* 266–73 ▪ *Olympia* 279 ▪ *La Loge* 279–80 ▪ *Absinthe* 280 ▪ *The Child's Bath* 281

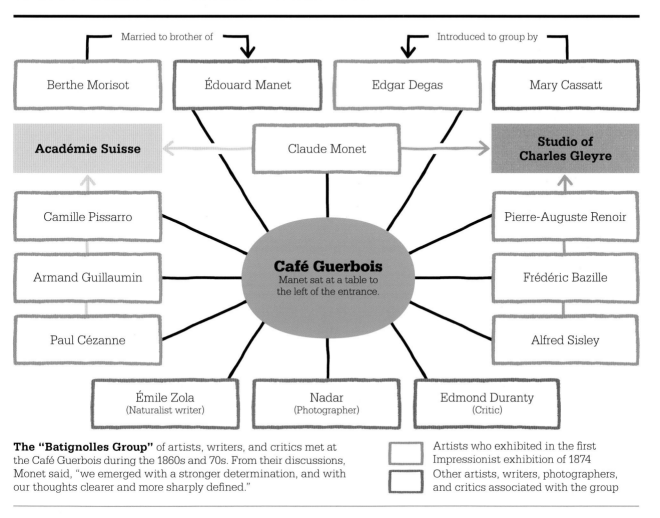

Married to brother of → Édouard Manet
Berthe Morisot

Introduced to group by → Edgar Degas
Mary Cassatt

Claude Monet

Académie Suisse

Studio of Charles Gleyre

Camille Pissarro

Armand Guillaumin

Paul Cézanne

Café Guerbois
Manet sat at a table to the left of the entrance.

Pierre-Auguste Renoir

Frédéric Bazille

Alfred Sisley

Émile Zola
(Naturalist writer)

Nadar
(Photographer)

Edmond Duranty
(Critic)

The "Batignolles Group" of artists, writers, and critics met at the Café Guerbois during the 1860s and 70s. From their discussions, Monet said, "we emerged with a stronger determination, and with our thoughts clearer and more sharply defined."

☐ Artists who exhibited in the first Impressionist exhibition of 1874
☐ Other artists, writers, photographers, and critics associated with the group

Impressionists, who responded by celebrating the city of Paris. At the time, this was being dramatically remodeled by Baron Haussmann, who swept away the narrow medieval streets, replacing them with wide boulevards, open squares, and parks. The Impressionists turned their backs on classical scenes, instead showing Parisians enjoying themselves—drinking and socializing in cafés, boating and picnicking by the Seine, or in the countryside, newly accessible via the railroads. Degas painted ballet dancers at the Paris Opera, and captured the atmosphere of the horse racing at Longchamp Racecourse. Morisot and Cassatt, meanwhile, reflected aspects of women's lives, painting visits to the theater or to the dressmaker. Ironically, Monet, Renoir, Sisley, and Pissarro all lived in poverty while conjuring up carefree scenes of people enjoying life's pleasures.

Outdoor painting
The Impressionists were concerned with conveying fleeting moments, and one key element of the style was painting in the open air (*en plein air*). Traditionally, landscapes had been composed in the studio by artists who put them together from different sketches, but the Impressionists sought a more direct relationship with nature.

Painting outdoors was not a new idea. Artists of the Barbizon school, such as Jean-François Millet, had begun working outside in the Forest of Fontainebleau in the 1830s, although they still tended to finish their pictures in the studio. Other artists had been careful to record precisely the weather conditions in their »

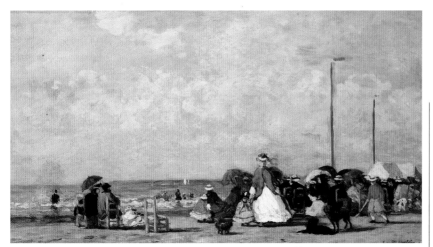

Eugène Boudin painted numerous scenes of the beach at Trouville in the 1860s and 1870s. His brushwork conveys the crisp light and brisk wind at the popular seaside resort.

landscapes. The English painter John Constable—whose work had inspired the Barbizon artists—made many oil studies of clouds and skies, noting the prevailing weather conditions and the time of day; and, in his sketches of the Normandy coast, Eugène Boudin analyzed the shape of waves and clouds, adding the time and the wind direction in the margins.

The Impressionists went further, and decided that the only way to capture natural phenomena fully was to complete a painting outdoors. This approach raised the practical problem of how to complete a picture under shifting light and weather conditions. The Impressionists addressed this by working quickly and often keeping their paintings relatively small; they also devised ways of simplifying their forms. They did not paint extraneous details or firm outlines, and avoided using black in the shadows; instead, they used an optical system of colors: every color that appeared in a painting tinted

In *Le déjeuner sur l'herbe* (1863), Manet subverted convention by ignoring the rules of perspective, and by depicting men in modern attire enjoying a picnic with a naked woman.

neighboring forms with its complementary, or opposite, shade (red with green, orange with blue, and so forth). When viewed at a suitable distance, these colors would fuse in the spectator's eye, creating a vibrant optical effect.

The advantage of this system was that the Impressionists did not need to spend so much time mixing colors on the palette, but simply juxtaposed short dabs and

brushstrokes of complementary color to achieve their desired effects. The disadvantage was that their compositions could appear sketchy or formless, which initially attracted adverse critical comment.

The practice of painting outdoors was facilitated by two technical advances. The rapid development of synthetic pigments meant that artists had a far greater range of colors to choose from. Still more critical was the advent of portable metal paint-tubes, which were far more convenient than the skin bladders or syringes in which paint had previously been supplied.

Trial and error

Monet painted his *Women in the Garden* at an early stage of his career, when he was still exploring

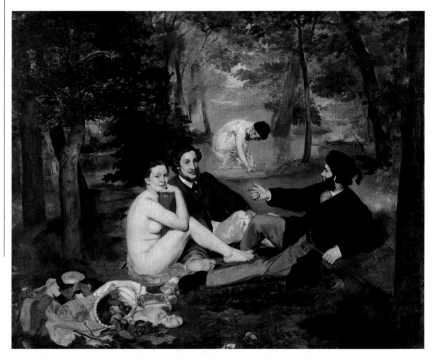

Women in the Garden is not a portrait piece—the faces of the women are unclear; it is concerned more with the color of light, and the relationship between light and shadow.

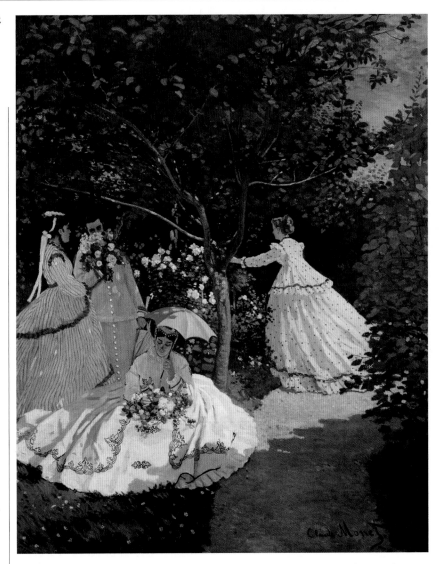

different ways of painting outdoors. His ultimate inspiration came from Manet's *Le déjeuner sur l'herbe*, a painting that had achieved a huge *succès de scandale* at the 1863 Salon des Refusés (an exhibition of works that had been rejected by the official Salon). Monet was eager to emulate the success of Manet's picture, but less so its scandal. Accordingly, he omitted the nude when he embarked on a series of images of figures in a landscape.

The landscape in Manet's *Le déjeuner sur l'herbe* had been composed entirely in the studio, but Monet was determined to execute his scenes outdoors. He was already quite experienced in this practice, and had gained instruction while sketching in Normandy with Eugène Boudin and Johan Barthold Jongkind.

Garden light

Monet's first attempt at the work—also titled *Le déjeuner sur l'herbe*—proved to be a failure. He began work on the giant painting, which measured 158 in x 236 in (400 cm x 600 cm), in 1865, but abandoned it when he was forced to use it as a security deposit for his landlord in 1866. He revived the work as *Women in the Garden*, which although still large, was around half the size of his *Déjeuner* and far less unwieldy.

In order to make the painting, Monet dug a trench and rigged up a complicated pulley system that enabled him to raise and lower the picture. In this ingenious way, he was able to work on different parts of the composition without changing his overall viewpoint.

Women in the Garden was painted in the garden of the house that Monet rented at Ville d'Avray, in the Paris suburbs. It depicts four women gathering flowers, and its composition is rumored to have been based on a photograph of the family of Monet's friend and colleague Bazille. Monet's mistress (and later wife) Camille Doncieux posed for the female figures, but the real subject of the painting is the play of light on the women's dresses. The brilliance of the reflected sunlight on the skirt of the woman in the foreground is enhanced by its contrast with the subtly colored shadows cast by the foliage on the right as well as by the woman's parasol.

Monet encountered serious problems with the picture. He had hoped to complete it while working outdoors but, with the onset of winter, he was obliged to finish it in his studio. In addition, the cost of the materials for such a large painting soon mounted and drove him deep into debt. But worst of all, the jury of the 1867 Salon »

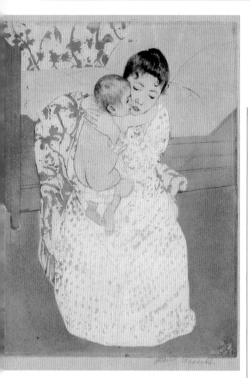

Maternal Caress (1890–91), one of US artist Mary Cassatt's series of 10 drypoint etchings, shows clear Japanese influence in its flat, decorative planes, which appear almost as cutouts.

rejected *Women in a Garden*, condemning its lack of narrative content and its careless brushwork.

The failure of *Women in a Garden* marked a critical turning point in Monet's career. He steered away from the compromise of producing paintings that were suitable for the Salon but also allowed him room to experiment. He became ever more committed to the principle of open-air painting, and devised more efficient ways of working. Instead of spending months on a single picture, Monet began to concentrate on much smaller canvases, working quickly so that he could record minute changes in the light or the weather.

Creative influences

In addition to open-air painting, the development of Impressionist art was shaped by two other major factors—Japanese art and photography. From around the 1850s, Japanese prints began to appear in the West, and their fresh, decorative approach proved a great inspiration. Japanese artists did not follow the Western conventions of perspective and were not too concerned about individual details. They tended to rely more on bold compositional devices—flattened forms, unusual angles, and startling close-up views—for their impact.

Most of the Impressionists were influenced to some degree by the style of Japanese prints, but Degas and Cassatt were the most affected. Both produced extraordinarily inventive graphic art of their own. In the case of Cassatt, the Japanese influence is most evident in a remarkable set of 10 drypoint etchings that she produced in the early 1890s. Indeed, the influence was so profound that her depictions of some of the models even had a pronounced Japanese appearance.

The development of photography also had a great impact on some of the Impressionists. Several of the artists used photographs as an aid, although they were wary of revealing

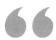

Works painted directly on the spot invariably have a power and vivacity which cannot be recaptured in the studio.
Eugène Boudin

They do not render a landscape, but the sensation produced by the landscape.
Jules-Antoine Castagnary
Le Siècle, 1874

the full role photography played in their work. Some drew inspiration from the "happy accidents"—odd crops or angles of view—that were often seen in early photographs. Degas' *School of Ballet* provides a good example: before the invention of photography, no artist would have thought of depicting a pose that was as ungainly as that of the dancer in the center, bending down to lace up her shoe. Nor would they have used a device like the spiral staircase on the left, which allows only the legs of the descending dancers to be seen. This type of composition was radically new and brought genuine freshness and spontaneity to the scene.

Independent exhibition

The Impressionists discussed and refined their ideas in the cafés and bars of Paris. The Café Guerbois on the Avenue de Clichy, close to Manet's studio in the Batignolles district, was a favorite venue for meetings between artists, writers, musicians, and critics, including Edmond Duranty, who championed their work. Monet later described the stimulating sense of exhilaration and ambition that stemmed from these gatherings. As a result of such discussions, the group of

artists decided to hold an exhibition of its own, entirely free from the constraints of the Salon and its rigorous selection committee. This exhibition opened on April 15, 1874, in the studio of the photographer Nadar. The group described itself as the Cooperative and Anonymous Association of Painters, Sculptors, and Engravers, although its more familiar name did arise from this show. Writing in the satirical magazine *Le Charivari*, the critic Louis Leroy penned an unfavorable review of the exhibition, in which, seizing on the title of one of Monet's paintings, *Impression, Sunrise*, he referred to the group mockingly as "Impressionists." He meant the term as an insult, but it was rapidly adopted by the artists themselves.

Public approval

There were eight Impressionist shows in all, between 1874 and 1886, although not all the exhibitors were fully committed to the new Impressionist style; Paul Gauguin, Georges Seurat, and the Symbolist painter Odilon Redon were among the other participants. The first exhibition was savaged by most critics, but over the years, public attitudes to the style were gradually transformed. The same can be said of attendances. The initial show drew only around 3,500 visitors in total; by the final exhibition, about 500 people a day were attending.

By 1886, the exhibitions had served their purpose. The success achieved by the Impressionist shows had effectively undermined the near-monopoly of the Salon as an arbiter of taste, and had encouraged other groups. While members still met up for "Impressionist dinners," they had largely gone their separate ways in terms of style. In 1884, a group of artists held the Salon des Indépendants, which dispensed entirely with a selection committee. Others soon followed, notably the Salon d'Automne—inaugurated in 1903—which showcased the controversial beginnings of many of the avant-garde art movements to emerge in the early 20th century. ∎

School of Ballet (1873) by Edgar Degas is a daring composition that shows dancers in non-classical poses. Degas painted many scenes of dancers and horses, as well as portraits.

SUBJECT MATTER HAS NOTHING TO DO WITH THE HARMONY OF COLOR

NOCTURNE IN BLACK AND GOLD: THE FALLING ROCKET (1875), JAMES ABBOTT McNEILL WHISTLER

IN CONTEXT

FOCUS
Aestheticism

BEFORE
1848 Dante Gabriel Rossetti co-founds the Pre-Raphaelite Brotherhood in England, rejecting the commonplace and conventional in art.

1854 Japanese art, with its flattened spaces and limited palette, begins to exert an influence on Western painters.

AFTER
1880 Edward Burne-Jones exhibits the dreamlike *The Golden Stairs*, which owes a debt to Whistler's ideas about painting and music.

1880s Walter Greaves, pupil of Whistler, produces river scenes that closely resemble the master's *Nocturnes*.

1892 Epitomized by his painting *Neptune's Horses*, artist and illustrator Walter Crane's work is influenced by the Aesthetic movement.

A estheticism was an art movement that evolved in the second half of the 19th century from the basic principle of "art for art's sake." The slogan, which had been popularized earlier in the century by the French critic Théophile Gautier, was used to promote the idea that art should be entirely autonomous—painters should feel under no pressure to produce pictures that were moral or didactic, that illustrated any kind of narrative, or indeed that looked realistic. James Abbott McNeill Whistler saw parallels

The Peacock Room was painted by Whistler between 1876 and 1877 for the home of Frederick Leyland, a shipping magnate. It was strongly influenced by Japanese art.

in London, he befriended Dante Gabriel Rossetti and the Pre-Raphaelite circle, combining their style with his increasing interest in Japanese art and prints.

The Falling Rocket was by no means the best of the *Nocturnes*, but it was the most momentous: it triggered an infamous trial when, in 1877, John Ruskin, the celebrated critic of his day, delivered a damning review of the picture. An outraged Whistler sued for libel. The ensuing trial was conducted in the full glare of national publicity. The painter won his case, but was only awarded a farthing in damages and no costs. For both men, the affair was a personal tragedy. Ruskin's mental state deteriorated, while Whistler went bankrupt. In the broader sense, though, it was a landmark ruling in favor of artistic freedom. ▪

between painting and the abstract art of music, and gave his works musical titles. His pictures—even his portraits—are "harmonies," "arrangements," "symphonies," or "nocturnes" (musical compositions suggestive of the night).

Pictures of the night

Most of Whistler's *Nocturnes* are misty, twilight evocations of the Thames River in London. Whistler would often spend many hours on the water, using his studio assistants, Walter and Henry Greaves, as oarsmen. He sketched his chosen scene and memorized it, but executed the actual painting inside his studio, where he would work with his runny "sauce"—paints thinned with linseed oil, turpentine, and copal—applying it in thin, transparent layers to create delicate and harmonious arrangements of tone and color.

Only occasionally did Whistler portray scenes on the shore: *The Falling Rocket* shows Cremorne pleasure gardens in Chelsea, where entertainment included a nightly firework display. Although at first glance the picture may appear

virtually abstract, it is possible to make out a winding path with three blurred human figures—an effect Whistler may have borrowed from the ghostly imagery of early photography. He took other cues from diverse sources far beyond his formal studies: he was a lifelong admirer of the work of the great 17th-century Spanish painter Diego Velázquez and, while in France, met the Realist painter Gustave Courbet, who exerted a strong influence on his early style. Settled

James Abbott McNeill Whistler

James Abbott McNeill Whistler was born in 1834 in the US, the son of an army engineer. He entered the Military Academy at West Point, but did not last the course. Switching to art, he moved to Paris in 1855, where he enrolled at the studio of Charles Gleyre. Whistler began painting his *Nocturnes* in the 1870s, but they were generally too avant-garde for the public's taste; his portraits, however, were in demand. In 1879, he retreated to Venice, where he produced a superb series of etchings. He divided his later years between Paris and London, where he died in 1903.

Other key works

1862 *Symphony in White, No 1: The White Girl*
1871 *Arrangement in Grey and Black: Portrait of the Artist's Mother*

A WORK OF ART
WHICH DID NOT BEGIN IN
EMOTION
IS NOT ART

SUNDAY ON LA GRANDE JATTE (1884), GEORGES SEURAT

Detail from *Sunday on La Grande Jatte*

IN CONTEXT

FOCUS
Post-Impressionism

BEFORE
1879 Ogden Rood's highly influential book *Modern Chromatics* explores the scientific aspects of color.

1881 Seurat makes a copy of *Poor Fisherman* by Pierre Puvis de Chavannes, an artist whose work he greatly admired.

1884 Seurat meets fellow colorist Paul Signac through the Salon des Indépendants.

AFTER
1888 Paul Gauguin joins Vincent van Gogh in Arles, but leaves abruptly after van Gogh suffers a breakdown.

1891 Gauguin leaves France for the island of Tahiti to escape the "artificiality" of Europe.

1904 The Salon d'Automne hosts a special exhibition of Cézanne's work.

By the time of their final exhibition in 1886 in Paris, the Impressionists had established a new style of painting that had transformed French art. Following Édouard Manet's famous dictum "one must be of one's time and paint what one sees," they had sought to capture the fleeting moment—motion, light, and reflection. Their focus on the visual facets of their subjects, however, provoked a reaction from artists who wished to pursue themes more imbued with intellectual, spiritual, or emotional charge. Such work is often labeled "Post-Impressionist," a term that does not refer to a specific philosophy or approach but encompasses the artists who followed on from Impressionism and at the same time reacted against it. In particular, it describes the work of four giants of late 19th-century art—Georges Seurat, Paul Gauguin, Vincent van Gogh, and Paul Cézanne—along with their respective circles.

Post-Impressionist show
None of these artists would have recognized the term "Post-Impressionist," which was coined

Impressionism was a blind alley, as far as I was concerned … If the painter works directly from nature, he ultimately looks for nothing but momentary effects.
Pierre-Auguste Renoir

in 1910 by the English critic Roger Fry, when he needed a title for a show at the Grafton Galleries in London. The exhibition, "Manet and the Post-Impressionists," was dominated by the works of Manet, Gauguin, van Gogh, and Cézanne.

Fry worked with a young literary critic, Desmond MacCarthy, on the preface to the catalog. Together they attempted to pinpoint and describe characteristics that linked the members of their group. Fry and MacCarthy noted that the painters shared a reaction against

Georges Seurat

Seurat was born in Paris in 1859, the son of a wealthy but eccentric legal official. From an early age, he showed a talent for drawing and trained at the School of Fine Arts, but he learned more from his time with the Symbolist painter Pierre Puvis de Chavannes. Seurat's first major picture was *Bathers at Asnières*; it was exhibited in 1884 and, coupled with the success of *Sunday on La Grande Jatte*, secured his reputation in progressive art circles. Seurat asserted his claim to have invented the Neo-Impressionist technique, applying

it not only in his Parisian scenes, but also in an atmospheric series of pictures of deserted harbors in Normandy. He experimented with many ideas, and, at the time of his tragically early death from an undiagnosed illness in 1891, was busy exploring new theories about the psychological effects of expressive coloring and line.

Other key works

1883–84 *Bathers at Asnières*
1887 *The Circus Sideshow*
1890 *Woman Powdering Herself*
1890 *The Harbor at Gravelines*

See also: *Women in the Garden* 256–63 ▪ *The Dance of Life* 274–77 ▪ *Olympia* 279 ▪ *La Loge* 279–80 ▪ *Self-Portrait with Bandaged Ear* 280 ▪ *Day of the God* 281 ▪ *Bathers* 281 ▪ *Woman with a Hat* 288–89

The Post-Impressionists variously used a scientific approach (Seurat and Cézanne) or took a more intuitive path (Gauguin and van Gogh) to experiment with simplified forms and non-naturalistic colors.

Seurat employs a **Divisionist** or **Pointillist** technique, breaking his forms down into tiny, separate **colored dots**. Figures are often reduced to simple sillhouettes.

Cézanne emphasizes the **geometrical structure** of his landscapes and still lifes, famously writing: "Treat nature in terms of **the cylinder, the sphere, the cone**."

Nature comes **alive** in van Gogh's canvases. Giant **spirals swirl** through the sky; **trees flicker** like dark flames; and thick **slabs of color** give presence to **simple forms**.

Gauguin uses **flat colors** and **rhythmic, flowing lines** to convey the underlying message in his paintings.

the naturalism of the Impressionists and instead preferred to look for the "emotional significance that lies in things." After toying with a number of names for the group, they settled on "Post-Impressionists," little thinking that the term would still be in use more than a century later.

The exhibition itself caused a considerable stir. Many of the reviews were unfavorable, but this did not deter the Grafton Galleries from staging a second Post-Impressionists show in 1912.

Initial steps

Fry did not regard Seurat as a core member of the group he had just defined, and the artist was represented by just two works at the 1910 exhibition. Nevertheless, it was Seurat who had taken the first decisive steps away from the principles of Impressionism. His huge painting of the park at La

Grande Jatte was the center of attention at the final Impressionist exhibition in 1886. Superficially, it displayed a number of features that linked it to Impressionism— it was a modern scene that showed Parisians enjoying themselves in an outdoor setting, and Seurat was also deeply concerned with the treatment of light.

Some say they see poetry in my paintings; I see only science.
Georges Seurat

However, where Claude Monet and Pierre-Auguste Renoir had dealt with light and color intuitively, painting quickly in the field, Seurat applied scientific theories about optics and color precisely and systematically, believing it would make his colors more vibrant and luminous. And, unlike the sense of movement typical of Impressionist works, *Sunday on La Grande Jatte* has a palpable air of stillness. The figures are stiff and static, and the shadows appear permanent, giving the painting a dreamlike quality.

Sunday on La Grande Jatte is a highly structured picture, which Seurat planned in detail. He made numerous charcoal drawings of individual figures and motifs, and a series of oil sketches helped him to design the layout of the composition. One of the oil studies was detailed enough to exhibit in its own right. It depicted the landscape setting »

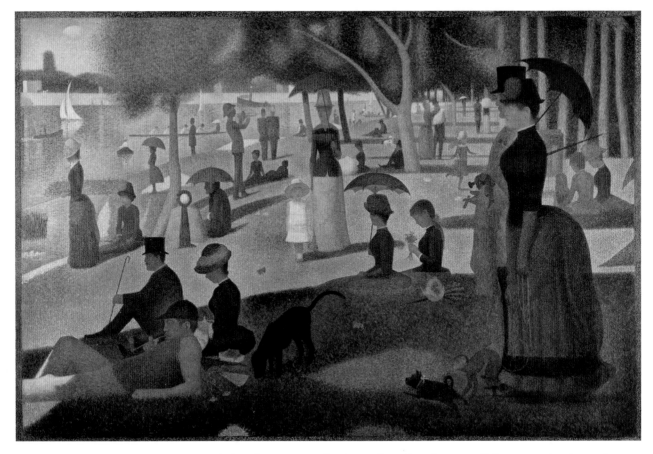

La Grande Jatte is an island in the Seine River, near Paris. Seurat's painting of people relaxing in its park is seen by some as a comment on the posturing falseness of French society.

of La Grande Jatte without any of the figures included in the final painting. Seurat used this work to fix the placement of the shadows. These were a key element of the composition; the large shadow in the foreground, for example, leads the viewer's eye into the picture.

The final painting was executed entirely in the studio, in contrast to the characteristic Impressionist method of painting swiftly in the open air. The large canvas— 122 in (310 cm) across — may have caused Seurat problems because he could not stand far back enough to view

the picture properly. A number of discrepancies in scale have been noted in the final work; for example, the lady in the center is too large, since she is on the same plane as the woman fishing on the left.

Color theory

Like other artists of the period, Seurat was aware of the latest theories about color perception, and he made deliberate use of them in his work. From *Grammaire des Arts du Dessin* (1867), a book by the critic Charles Blanc, he learned about the color theorist Michel Chevreul's law of simultaneous contrast. This rule indicated that "complementary" colors, such as red and green, gain intensity when they are placed side by side and, conversely, lose much of their

power if they are mixed together. Seurat also read *Modern Chromatics* (1879) by American physicist and amateur painter Ogden Rood. Geared toward artists, this highly influential book updated Chevreul's ideas about color contrasts. It divided color according to three parameters—luminosity, hue, and purity—and included a detailed color-wheel, which showed the complementary tones for 22 colors.

Seurat found that his color work was most effective when he applied paint with a dotted touch, using the tip of his brush. He called this technique "divisionist" to emphasize that he kept his dots of color separate, although many of his contemporaries preferred the term "pointillist," in reference to the tiny points of color.

Do not paint too much after nature. Art is an abstraction; derive this abstraction from nature while dreaming before it.
Paul Gauguin

Seurat's technique was distinct from the improvisational approach of the Impressionists, whose short brushstrokes of complementary color would often overlap. The term "Neo-Impressionist" was applied to describe Seurat's reinvention of Impressionist principles, using them in a more scientific and systematic manner.

At the water's edge

Sunday on La Grande Jatte was remarkable not only for its shimmering color but also for its strange, almost childlike forms. Critics commented on the rigidity of Seurat's figures, one comparing them to toy soldiers, while another noted how the "Promenaders dressed up in their Sunday best … take on the simplified and definitive character of a cortege of pharaohs." In a rare comment on the painting, Seurat explained that he aimed to make his figures resemble those in the Parthenon on the Athens acropolis: "I want to make modern people … move as they do on those friezes." In other words, he wished to combine the modernity of the Impressionists with the structured forms of classical art to achieve a sense of timelessness.

Sunday on La Grande Jatte was, in many respects, a companion piece to *Bathers at Asnières*, a painting that Seurat had completed a couple of years earlier. The two locations were directly opposite each other on the banks of the Seine, and many of the figures are shown in profile, gazing across the water at one other; the same little ferry-boat also appears in both paintings.

Seurat specified Sunday in the title of the painting because this was the one day of the week when different classes mingled on the island of La Grande Jatte. There are well-heeled figures, looking faintly ridiculous in their exaggerated finery, as well as members of the lower classes, such as the soldiers (upper center) and the wet nurse (seated on the left, wearing her distinctive orange headgear).

Seurat's style proved popular for a time as other artists experimented with similar techniques, and at the final Impressionist show in 1886, he shared a room with three of the most notable exponents of Neo-Impressionist painting—Paul Signac, Camille Pissarro, and Pissarro's son Lucien. Seurat also publicized the style by displaying *Sunday on La Grande Jatte* at two other influential exhibitions—the Salon des Indépendants in Paris and Les Vingt in Brussels. Even so, the vogue for Neo-Impressionism was relatively short-lived, not least because the technique required a slow and painstaking approach.

Gauguin and Synthetism

Other forms of Post-Impressionism proved more enduring. Paul Gauguin started working in an Impressionist style after he gave up his job as a stockbroker to be a full-time painter. He participated in several of the Impressionist exhibitions, where his pictures were generally well received, »

In *Vision after the Sermon* (1888), also known as *Jacob Wrestling with the Angel*, Gauguin's use of flat color, with little shading, represents a stark move away from earlier naturalism.

but was overshadowed at the final show by Seurat. Gauguin disdained the Pointillist style and was a little resentful of the success of the "young chemist."

Gauguin shared Seurat's concerns about the limitations of Impressionism, but his solution was very different. In 1886 he joined an artists' colony in Brittany, where, in collaboration with Émile Bernard,

Starry Night (1889) is van Gogh's obsessive study of the variety of blues that he saw in the night sky. He stated: "Often it seems to me night is even more richly colored than day."

he developed a style known as Synthetism. The "synthesis" that they proposed was to combine visual impressions of nature with simplified forms and expressive coloring to give more force to the ideas behind the painting. In direct contrast to the Impressionists, who reveled in modernity, Gauguin also drew inspiration from the "primitive" art of older cultures—initially from the Celtic folk traditions in Brittany and, later, from the old legends of Tahiti.

Gauguin's ideas crystallized in his first true masterpiece, *Vision after the Sermon*, which shows a

Breton congregation meditating upon a sermon they had just heard about Jacob wrestling with an angel. The struggle is portrayed as an actual event, but one that takes place in a strange, almost surreal, red landscape, separated from the congregation by a large bough (a device that Gauguin borrowed from Japanese prints). The overall effect is one of mystical wonderment.

Van Gogh and Cézanne
In 1887, Gauguin and Bernard met Vincent van Gogh in Paris. They exhibited together, and van Gogh absorbed many of the features of

their new style. Van Gogh's early paintings had been in a somber and naturalistic style, typified by *The Potato Eaters* (1885), but his palette lightened after he arrived in Paris in 1886, when he produced several pictures of Montmartre windmills in an Impressionist manner. This was only a brief interlude, however, before he discovered Japanese prints, which had a profound effect on his style.

Van Gogh's increasing contact with other artists also affected his painting, even though he did not always share their aims. He had no wish to use expressive forms and color purely as a means of exploring new ideas. The pull of the visual world was too strong. Van Gogh considered himself "a man of nature, led by nature's hand," and in his later years, in the heat of the South of France, he channeled his emotions into startling images of his immediate surroundings.

For van Gogh, nature could, at times, seem miraculous—as in his celebrated *Starry Night*, for example, in which the sky is filled with swollen stars and spirals of energy—while on other occasions, a simple field of golden corn could appear threatening.

> Instead of trying to render what I see before me, I use color in a totally arbitrary manner in order to express myself more powerfully.
> **Vincent van Gogh**

Paul Cézanne, like van Gogh, often worked in the South of France, tending to isolate himself from other artists. He was associated with the Impressionists at the start of the movement, participating in the first and third Impressionist exhibitions. This link was largely due to his friendship with Camille Pissarro; the pair painted in the open air together at Pontoise in the early 1870s. Painting in situ—a guiding principle of the Impressionist movement—became a mainstay of Cézanne's own working methods, although he was never content with some aspects of the style. He disliked the emphasis on transitory effects, saying he wanted to make "something solid and enduring, like the art of the museums."

Like Monet, Cézanne developed a preference for painting the same subject over and over again. He created more than 60 pictures of Mont Sainte-Victoire, in his native Provence. However, while Monet used his series of paintings as a way of focusing on surface effects—light, shadows, or

Cézanne's views of Mont Sainte-Victoire tended more and more toward abstraction; the late images (this one is from 1902–06, just before his death) dispensed with realism altogether.

atmospheric conditions—Cézanne probed beneath these distractions. He gradually stripped away details such as houses and roads, until the landscape was reduced to patterns of form and color.

Post-Impressionist legacy
The Post-Impressionists were united in their desire to challenge Impressionism while building on it, yet they were stylistically diverse in their responses. The abstract tendencies and interest in pure form of all the Post-Impressionists proved a major source of inspiration for the pioneers of abstract art. With its emphasis on structure and optical color effects, the art of Cézanne was the primary precursor of Cubism, while the more personal and expressive style of both van Gogh and Gauguin influenced the Expressionists. ∎

SEEKS TO CLOTHE THE IDEA IN A PERCEPTIBLE FORM

THE DANCE OF LIFE (1899–1900), EDVARD MUNCH

See also: *Nocturne in Black and Gold* 264–65 ▪ *The Gates of Hell* 280 ▪
The Beethoven Frieze 286–87 ▪ *Street, Dresden* 290–93 ▪ *The Last Supper* 338

IN CONTEXT

FOCUS
Symbolism

BEFORE
1884 *Against Nature* by
French writer J. K. Huysmans,
a landmark in Symbolist
thinking, is published.

1886 Greek-born poet Jean
Moréas publishes the *Symbolist
Manifesto* in Paris.

1890 Belgian painter James
Ensor's *Intrigue* displays the
same mix of haunting imagery
and autobiographical detail
that is found in Munch's work.

AFTER
Early 20th century Munch's
work influences Expressionism,
in which images are distorted
to express subjective feelings.

1937 The Nazis confiscate
82 of Munch's works from
German galleries, labeling
them "decadent."

Edvard Munch

Edvard Munch
was born near
Christiania
(now Oslo),
Norway, in
1863. His early
life was overshadowed by the
death of his mother and sister
from tuberculosis and by his
father's strict Christian faith.
After studying at the Royal
School of Art and Design in
Christiania he began to work
and exhibit in the city. Finding
realist styles too superficial,
he began to draw on his own
psychological state for his work.
Munch lived in France from 1889
to 1892, in what was to be his
most productive period, and
later worked in Germany, but by
the early 1900s he was in poor
mental health compounded by
excessive drinking. In 1908 he
suffered a nervous breakdown;
after treatment, he returned
to Oslo and later led a life of
solitude. He died in 1944.

Other key works

1885–86 *The Sick Child*
1893 *The Scream*
1893–95 *Vampire*
1894–95 *Madonna*
1899–1902 *Girls on the Jetty*

Symbols in art are a visual
shorthand that help to
convey meaning, often
indirectly. In many Christian
paintings, for example, saints can
be identified by their attributes—
St. Peter carries the keys to Heaven
and St. John holds a book. Human
virtues and even entire narratives
can be conveyed symbolically;
white lilies stand for purity, while
an apple can signify the temptation
of Adam and Eve in the Garden of
Eden. Both allegory and myth can
also work as symbols to represent
different levels of meaning in art.

This type of symbolism is
distinct from Symbolism (with a
capital S), which was a literary and
artistic movement that reached
its height in the late 19th century.
The artists of this movement had
little interest in symbols with static
codified meanings. They wanted
their pictures to function more like
poetry, conjuring emotions and
ideas through evocative imagery.

Themes in Symbolism

Symbolism flourished in France,
fueled by the ideas of poets such
as Stéphane Mallarmé, Charles
Baudelaire, and Jean Moréas, but
it was soon taken up by artists
farther afield, including Norwegian
painter Edvard Munch. Rooted
in Romanticism's emphasis on
emotion, it began as a reaction to
the objectivity of Naturalism and
Impressionism, although it was not
confined to a single visual style and
its artists pursued various means
to achieve their desired goals.

These artists modified line and
color, used unusual combinations
of imagery, and expressed a wide
range of themes, including fear,
death, decadence, love, and desire.
Many were drawn to subjects
with musical associations: in part,
this stemmed from the theory of
"correspondences" expounded
by Baudelaire, in which colors were
related to musical notes. Other
common images included *femmes
fatales*, androgynous figures,
severed heads, and the kiss; »

Illness, insanity, and death
were the black angels that
kept watch over my cradle and
accompanied me all my life.
Edvard Munch

and paintings were often flavored with esoteric or mystical ideas, fueled by a revival of interest in theosophy (a philosophy seeking a direct knowledge of the divine through ecstasy and intuition).

The pioneering French Symbolist artists were Gustave Moreau, Pierre Puvis de Chavannes, and Odilon Redon. The reclusive Moreau produced masterpieces springing from mythological and religious themes, such as *The Apparition* (1874–76), a watercolor that evokes an Oriental palace in which Salome is haunted by the severed head of John the Baptist.

Puvis, meanwhile, inspired a younger generation of Symbolists with his famous painting *The Poor Fisherman* (1881). In contrast with the prevailing realism, his use of rhythmic line and flat, washed-out color reflected the grinding poverty of a fisherman's family in a bleak, desolate landscape.

In *Melancholy* (1894), Munch uses expressive, somber colors and undulating contours to evoke the depressed mood of his friend Jappe Nilssen during an unhappy love affair.

In *The Apparition* (1876), Gustave Moreau deployed paint effects to highlight emotion and allusion in his theatrical composition of Salome facing the severed head of John the Baptist.

The dreamlike imagery in Redon's charcoal drawings and lithographs was a fusion of his interest in such eclectic areas as botany, insects, and the writings of Edgar Allan Poe. His extraordinary work was described by one contemporary critic as "extremely odd ... like so many riddles, nightmares, morbid visions, and hallucinations."

States of mind

In his native Norway, Munch was removed from the mainstream of Symbolist activity. He was initially drawn to Naturalism and in the mid-1880s joined the Bohemians, a controversial group of writers and artists based in Christiania (now Oslo). They drew up a playful set of "Commandments," but Munch took the first of these—"Thou shalt write thine own life"—very seriously. The phrase could have served as a slogan for his artistic career.

From the late 1880s on, Munch traveled and exhibited widely and began to absorb Symbolist ideas. He was particularly influenced by Paul Gauguin's Synthetist style—in which form is synthesized with feeling—and the haunting fantastical imagery of Swiss-born painter Arnold Böcklin. Munch soon began producing his own Symbolist paintings, exemplified by *Melancholy, Yellow Boat* (1892), which depicts a state of mind rather than a narrative or realistic subject. Many of Munch's paintings are named after abstract concepts, and are usually informed by his own experiences or those of his friends. His most famous work, *The Scream*, was his representation of "a scream passing through nature," which the artist felt on a walk in Nice, France.

Frieze of Life

From an early stage in his career, Munch conceived the idea of producing cycles of paintings that he hoped would be exhibited together. *The Dance of Life* belongs to a cycle of paintings generally known as the *Frieze of Life*. This

Munch's troubled relations with women are reflected in his art. In *Love and Pain* (1893–95) he paints a **female vampire**, biting into a man's neck.

In his *Madonna* (1895–1902) Munch subverts the normal depiction of the **Virgin**, showing a woman with a **shriveled embryo**, and sperm decorating the border.

In Georges Rodenbach's Symbolist novel *Bruges-la-Morte* (1892) the *femme fatale* has **long, flowing hair**— which may be a mark of beauty, or a lethal weapon.

The *femme fatale*

A favorite theme with Munch and other Symbolist painters, writers, and musicians, the figure of the *femme fatale* was borrowed from myth or history, or summoned from the artist's own experience and imagination.

Gustave Moreau, English artist Aubrey Beardsley, and Irish writer Oscar Wilde are all entranced by **Salome**, the **dancing girl** who asked for the head of John the Baptist.

Sirens and mermaids were creatures of enticement for the Symbolists. Arnold Böcklin and Gustav Klimt portray these **temptresses** in their paintings.

Symbolist painters used many examples of the *femme fatale* from Greek mythology. **Medusa**, the **Sphinx**, and the enchantress **Circe** are particular favorites.

and paintings—notably *Eye to Eye* and *Attraction*, in both of which the woman is the dominant figure. In one version of *Attraction*, the woman's hair coils around the man's head like an insect ensnaring its prey, and in *The Dance of Life*, the woman's dress plays a similar role, wrapping around the man's feet.

Many of the figures in Munch's paintings were based on women in his life. The central young woman in *The Dance of Life* was probably inspired by his cousin, with whom he had a passionate affair before she broke it off, leaving Munch heartbroken. Similarly, the women on either side may well represent Tulla Larsen, a wealthy, liberated woman who pursued Munch relentlessly, but whom he ultimately rejected.

Enduring inspiration

Frieze of Life was Munch's greatest legacy. He tried in vain to sell it as a unit, hoping that it would find a permanent home in a single exhibition space. Nonetheless, the cycle has had an enduring effect. Munch is widely acknowledged as Norway's most important painter and his unique brand of Symbolism provided one of the major sources of inspiration for the Expressionists. ∎

> A work of art is like a crystal—like the crystal it must also possess a soul and the power to shine forth.
> **Edvard Munch**

project evolved over several years; it was comprised of 15 works when first exhibited in 1893; and when it was shown at the Berlin Secession 1902 exhibition, it consisted of 22 pictures, divided into four main sections: *The Seeds of Love*, *The Flowering and Decay of Love* (which included *The Dance of Life*), *Life Anxiety*, and *Death*.

The shortest night

The Dance of Life was inspired by the Midsummer celebrations that take place throughout Scandinavia on the shortest night of the year. The setting is Åsgårdstrand, the little town where Munch spent several summers. The shoreline in the picture represents the passage of time and the progress of life, while the reflection of the moon in

the water becomes phallic in both shape and color, underlining a prevailing theme of sexuality. As in a number of his other canvases, Munch adopts a three-part structure as the basis of his composition. In his diaries, he hinted at the meaning of the three principal elements. In the center, the artist is shown dancing with his first true love. On the left, an innocent young woman approaches, wishing to pluck the flower of love, "but it won't allow itself to be taken." On the right, an older woman looks on bitterly, unable to join the dance, while in the background, "the raving mob is caught in wild embraces."

Munch's image is both universal and highly personal. He used the motif of a couple gazing directly at each other in several other prints

PORTFOLIO

NAPOLEON ON THE BATTLEFIELD AT EYLAU
(1808), ANTOINE-JEAN GROS

Gros's *Napoleon on the Battlefield at Eylau* shows Napoleon visiting the battlefield the day after a victory against the Russians, and was intended to project an image of the emperor as a humane conqueror. Napoleon was no connoisseur of

Katsushika Hokusai

Perhaps the most revered of Japanese artists, Katsushika Hokusai (1760–1849) lived a long life of great achievement, pouring out work as a painter, draftsman, and printmaker, and excelling at virtually every genre practiced in his time—from plant studies to erotica. He was born in Edo (modern-day Tokyo) and spent the majority of his life there. For richness of imagination, sureness of eye and hand, and wealth of human feeling (including abundant wit), he ranks among the world's supreme artists. On his deathbed (at nearly 90), he is said to have begged the heavens to grant him just five more years so that he could perfect his art.

Other key works

1814 *The Dream of the Fisherman's Wife*
c.1838 *One Hundred Poems by Master Poets*
1839 *Self-Portrait*

art, but appreciated its propaganda value, and Gros (1771–1835), who combined a flair for movement and color with accuracy of detail, was his favorite painter. He won the commission for the huge *Battlefield at Eylau* in a competition against 25 other artists. Among the countless works of art inspired by Napoleon, few are as memorable as this.

THE WHITE HORSE
(1819), JOHN CONSTABLE

With *The White Horse*, English landscape painter Constable (1776–1837) made a deliberate attempt to attract attention in the crowded annual exhibitions of the Royal Academy. Like many of the artist's paintings, *The White Horse* shows working life on the Stour River in Suffolk, where the painter was born and lived. He made a full-size sketch of it before embarking on the final version. Thanks in part to its large size—it measured 71 in x 47 in (180 cm x 120 cm)—the painting received favorable reviews, and later in 1819 Constable was elected an Associate of the Academy.

UNDER THE WAVE OFF KANAGAWA
(c.1830–1833), KATSUSHIKA HOKUSAI

The most famous of all Japanese works of art, this print has been appropriated countless times for use in advertising and popular culture. It is part of a series entitled *Thirty-Six Views of Mount Fuji*,

although here the mountain is dwarfed by the giant wave, which is about to crash down onto three fishing boats. In the polychrome (multicolored) print, Hokusai skillfully manipulates perspective to frame the snow-capped peak of Mount Fuji in the hollow of the massive cresting wave. Thousands of copies of the print were produced before the woodblock became worn out; several hundred still survive.

NAPOLEON AWAKENING TO IMMORTALITY
(1845–1847), FRANÇOIS RUDE

The cult of Napoleon continued after his death in 1821, and one of its most powerful expressions was this bronze monument. It was erected on the land (now a public park) of a former soldier in the Grande Armée who had become a wealthy vintner. The bronze shows the emperor casting off his burial shroud as he rises from a rocky platform. Rude (1784–1855), the outstanding French sculptor of his time, was an admirer of Napoleon and made the model for this work free of charge.

THE GIRLHOOD OF MARY VIRGIN
(1849), DANTE GABRIEL ROSSETTI

This painting—the first exhibited by Rossetti (1828–82)—is one of the key works of the Pre-Raphaelite Brotherhood, a group formed in 1848 by seven idealistic young English artists and writers who wanted to recapture the simplicity

Ilya Repin

Ilya Repin (1844–1930) was born at Chuguyiv, Ukraine, and studied in St. Petersburg. In the peak years of his career (from the late 1870s to the early 1890s) he lived mainly there and in Moscow, but he also traveled in rural Russia researching historical paintings, and visited western Europe several times. In addition to the full-blooded depictions of Russian life for which he is best known, Repin painted many portraits. He died on his estate at Kuokkala, which at the time was in Finland, but is now within Russia and named Repino in his honor.

Other key works

1881 *Portrait of Modest Musorgsky*
1880–83 *Religious Procession in the Province of Kursk*
1884 *They Did Not Expect Him*

of early Italian art. Rossetti depicts a youthful Virgin Mary, the epitome of female virtue, embroidering a lily with her mother, St. Anne, while her father, St. Joachim, cuts a vine. The scene brims with symbolic detail: the lily alludes to the purity of the Virgin, the vine to truth, a lamp to piety, and a dove to the Holy Spirit. Rossetti rarely exhibited his work in public again after this, but he went to become highly successful, mainly with his portrayals of beautiful women.

AUTUMN LEAVES
(1856), JOHN EVERETT MILLAIS

English artist Millais (1829–96) soon moved away from the Pre-Raphaelite idiom in which he created his first major works. His *Autumn Leaves* represented a conscious effort to do something different—to turn from "storytelling" subjects to a work that was concerned with mood and the suggestion of ideas. The dead leaves being burned by a group of children, the rising smoke, and the fading evening light suggest transience and mortality. Critics found the work difficult, and thereafter Millais concentrated

on more obviously popular subjects, becoming probably the best-known British painter of his time.

THE ANGELUS
(1859), JEAN-FRANÇOIS MILLET

French painter Millet (1814–75) was one of the great portrayers of rural life. *The Angelus* shows two peasants in a field who have halted their labors to pray; a church is just visible in the background. The painting possesses the imposing solemnity and strength of design that typifies Millet's work. It was sold several times between 1860 and 1890, increasing greatly in price; by the end of the century, it had become one of the most celebrated paintings in the world. Later, its pious sentimentality went out of favor, but it was a work of obsessive interest to Salvador Dalí.

OLYMPIA
(1863), ÉDOUARD MANET

Olympia is clearly based on Titian's revered painting *Venus of Urbino*, but Manet (1832–83) replaced Titian's Venetian goddess with a high-class Parisian prostitute, who gazes blatantly at the spectator. Its unabashed sexuality, as well as the boldness of its brushwork, outraged visitors to the 1865 Salon in Paris, where the work was first shown. By the end of his life, however, Manet had earned grudging respect in the official art world, and began to be recognized as one of most influential painters of his time—an inspiration to the Impressionists, even though he never exhibited with them.

BARGE HAULERS ON THE VOLGA
(1870–1873), ILYA REPIN

Ilya Repin was the most famous Russian artist of the 19th century, and was noted for the realism of his scenes of everyday life. *Barge Haulers on the Volga*, painted soon after the emancipation of the serfs in 1861, is a vivid depiction of the barge haulers' backbreaking labor. Although each of the 11 men—except for the golden-haired youth in the center—appears defeated, Repin portrays them as individuals rather than merely types, endowing them with stature and dignity. The painting was Repin's first great success and won a medal at a major international exhibition in Vienna in 1873. His work became a great inspiration to other Russian artists of his time and later to the Socialist Realist artists of the Soviet Union.

LA LOGE
(1874), PIERRE-AUGUSTE RENOIR

Renoir's painting, a study of class and status, depicts an elegant couple on show in their theater box (*loge*): the woman in an eye-catching black-and-white dress; the man

spying on the audience with his binoculars. When Renoir (1841–1919) showed the work at the first Impressionist Exhibition in Paris in 1874, it was one of the few to receive favorable comments. At the time the theater box was a novel theme in art, but it soon became part of the Impressionists' repertoire of the "spectacle of modern life."

THE GROSS CLINIC
(1875), THOMAS EAKINS

The Gross Clinic is an intensely dramatic, realistic painting of an instructive surgical procedure by renowned surgeon Dr. Gross. Eakins (1844–1916)—whose work recorded the intellectual life of his native Philadelphia—is now generally regarded as the greatest American painter of the 19th century; this work is considered his masterpiece. But Eakins' career was dogged by controversy, not least with this work. He painted it for the Philadelphia Centennial Exhibition in 1776, but although the selection committee of the art section praised it as a great picture, they rejected it because of its unsparingly graphic nature.

ABSINTHE
(1876), EDGAR DEGAS

Absinthe portrays an intoxicated couple sitting beside each other in a Parisian café—bored, isolated, and unhappy. A glass of highly alcoholic absinthe sits on a table in front of the woman. The image conveys such a realistic sense of desolation and the hopelessness of everyday life that it outraged many. However, Degas (1834–1917) was regarded by critics as the acceptable face of modernity—perhaps for his superb draftsmanship—and he achieved success earlier than the other Impressionists.

THE GATES OF HELL
(1880–c.1900), AUGUSTE RODIN

The Gates of Hell, Rodin's most ambitious work, was commissioned for a museum of decorative arts in Paris that was never built. It was not until after his death that the work was cast in bronze. Loosely based on Dante's *Inferno*, it features about 180 figures that express a tragic view of humanity. Several

of the figures were later developed into independent sculptures, notably *The Thinker* and *The Kiss*. Rodin's expressive and symbolic interpretation of human experience opened up new paths for his art.

MADAME X
(1884), JOHN SINGER SARGENT

A scandal created by *Madame X* almost blighted the successful career of the great American society portrait artist John Singer Sargent (1856–1925). Although the portrait was exhibited at the Paris Salon under this title, it was well known that the sitter was Virginie Gautreau, the American-born wife of a French banker. Many visitors to the Salon thought she looked brazenly sexual in the picture and her mother pleaded with the artist to remove it. He refused, but the scandal led him to move from Paris to London, where he was based for the rest of his life.

SELF-PORTRAIT WITH BANDAGED EAR
(1889), VINCENT VAN GOGH

Van Gogh is one of the archetypes of the tormented genius, and this self-portrait commemorates a key incident in his life: in 1888, in a fit of mental instability, he cut off his ear after quarreling with Paul Gauguin. The painting shows the artist with a bandaged right ear and a melancholy expression, in his studio, wearing a coat and hat. The long brushstrokes and discordant colors seem expressive of the artist's inner turmoil. In the first decade of the 20th century a number of exhibitions cemented van Gogh as a major figure—one of the chief progenitors of Expressionism.

Auguste Rodin

Auguste Rodin (1840–1917) was born in Paris and spent most of his life there. He struggled early on in his career, but achieved recognition in 1877 with *The Age of Bronze*, a nude male figure. Thereafter his success grew rapidly and by 1900 he was generally acknowledged as the greatest living sculptor. His work was often controversial, because of both its expressive distortions and in some cases its eroticism. In addition to major public monuments, he created portrait busts, and—especially late in life—was a prolific draftsman. He ran a busy studio, with numerous assistants, who produced many copies of his work, in bronze and marble.

Other key works

1884–89 *The Burghers of Calais*
1891–98 *Monument to Balzac*
1906 Bust of George Bernard Shaw

Vincent van Gogh

Vincent van Gogh (1853–90) was born at Zundert in the Netherlands. He spent his early career working first for a firm of art dealers (in which his uncle was a partner) in The Hague, London, and Paris, and then as a preacher in England and Belgium. In 1880 he took up art—he saw it as a means of bringing consolation to suffering humanity. Van Gogh's artistic career lasted only 10 years, but in that time he produced a tremendous amount of work, in spite of frequent poverty and bouts of mental disturbance. In 1885 he moved to Paris, then in 1888 to Arles, and in 1890 to Auvers-sur-Oise, where he committed suicide (although according to a recent theory he was shot accidentally).

Other key works

1885 The Potato Eaters
1888 The Night Café
1889 The Starry Night

SURPRISED!
(1891), HENRI ROUSSEAU

Surprised!—the first jungle scene of French naive painter Rousseau (1844–1910)—depicts a tropical storm and a tiger that is poised to pounce on its prey. Rich, vibrant color and pattern dominate; a silver glaze across the canvas conveys the violent downpour, adding a distinctive, dreamlike quality to the work. The freshness of Rousseau's vision in fantasy paintings such as this, and his unique, primitive painting style, had a marked impact on his contemporaries, and won him the admiration of avant-garde artists, including Pablo Picasso.

THE CHILD'S BATH
(1893), MARY CASSATT

The Child's Bath characterizes the work of US artist Mary Cassatt (1844–1926) in its tender intimacy and strength of design; her liking for unusual viewpoints and strong patterning was influenced by Japanese prints. Here, the bold stripes of the mother's robe are juxtaposed with chintz wallpaper and an Oriental carpet. The viewer looks down upon the figures from above, drawn into the intimate scene via the unorthodox, elevated vantage point. Alongside Berthe Morisot, Cassatt ranks as the most distinguished woman Impressionist. She spent most of her life in France, where a favorite subject for her art was mother and child (or children).

DAY OF THE GOD
(1894), PAUL GAUGUIN

Set in a landscape on a Tahitian beach, this painting by Gauguin (1848–1903) depicts an idol of the Polynesian goddess Hina. At the edge of a pool are three women, who are thought by some scholars to represent life, birth, and death. The brilliant contrasting colors that predominate in the foreground suggest reflections in the water, and are typical of the artist's Post-Impressionistic use of vibrant color to create flat, curved shapes. The imaginary depiction draws on ideas from Polynesia, representing the artist's experience of living in the South Pacific region. Gauguin was largely responsible for making primitivism—and the associated departure from naturalism—a key strand in modern art.

BATHERS
(c.1895–1906), PAUL CÉZANNE

In Bathers, an abstract rendering of 11 female nudes in a landscape, French artist Cézanne (1839–1906) focuses the viewer's attention on the relationship between the figures and the natural environment. The entire surface of the canvas is alive with vibrant but subtle touches, and figures, trees, and sky are skillfully harmonized. The use of solid, subtly rendered geometric forms creates harmony between the figures and the landscape. Late in life, Cézanne became a hero to a generation of avant-garde artists, so much so that he has been dubbed "the father of modern art." A key aspect of his work was the idea that the surface of a picture has its own integrity, regardless of what it depicts.

SARAH BERNHARDT
(1896), ALPHONSE MUCHA

Czech artist Mucha (1860–1939) based several of his works on the French actress Sarah Bernhardt. This poster of her is a magnificent expression of the sinuous and luxuriously flowing lines that are characteristic of the Art Nouveau style, of which Mucha was a key representative. Art Nouveau was an attempt to create a new idiom that departed from the historicism of much 19th-century art; the style was expressed mainly in design and architecture, but also in painting and sculpture. The style flourished in much of Europe and the US from about 1890 to World War I.

THE MOD

ERN AGE

Fauvism
is launched in Paris and the first **German Expressionist** group, Die Brücke, emerges in Dresden.

↑

1905

American **John Singer Sargent**, best known as a portraitist, paints one of the greatest of all war pictures, *Gassed*.

 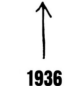

↑

1918–19

The **International Surrealist Exhibition** in London marks one of the high points of the movement.

↑

1936

Broadway Boogie-Woogie shows the vibrant style that Dutch-born painter **Piet Mondrian** developed in New York.

↑

1943

1914

↓

In Moscow, **Vladimir Tatlin** starts making relief constructions that are perhaps the first purely abstract sculptures.

1926

↓

The Belgian **René Magritte** paints *The Menaced Assassin*, the first work in which he reveals his distinctive Surrealist voice.

1937

↓

In Paris, **Picasso** paints *Guernica*, an impassioned response to the inhumanity of the Spanish Civil War.

1947

↓

The Swiss sculptor **Alberto Giacometti** creates *Man Pointing*, showing the fragile, "existentialist" style for which he became famous.

The period between 1900 and the outbreak of World War I in 1914 was a time of unrivaled artistic experimentation. The questioning and rejection of long-standing ideas that had been a feature of progressive art in the late 19th century intensified in the early 20th century with a succession of innovative styles and movements, including Fauvism and Cubism—which developed in Paris, then the capital of world art—German Expressionism, and the international phenomenon of abstract art. The traditional notion that painting and sculpture were fundamentally concerned with representing outward reality was decisively laid to rest.

The term "Modernism" is sometimes used to describe these movements, but their beliefs were highly diverse and lacked a consistent ideology. Pioneers of abstract art, such as Russian-born Wassily Kandinsky, felt an intense vocation, believing that their art could help to create a better world. For other artists, the horrors of World War I generated a contrasting spirit—of anarchy or nihilism—giving rise to the Dada movement, which originated in about 1915.

Dada was perhaps the most radical of these movements, because it went beyond stylistic innovation and questioned the whole meaning and value of art. One of the leading lights of the movement was Marcel Duchamp, whose career was mainly divided between Paris and New York. Even before the launch of Dada he had shown his iconoclastic stance with the invention of the "readymade."

Duchamp's ideas were enormously influential, setting the tone for much subsequent undermining of established artistic values.

Embracing the irrational

Dada was one of the sources of Surrealism, the most widespread avant-garde art movement in the period between the two world wars. Like Dada, Surrealism was envisaged as a way of life, not just a matter of style, but Surrealism was positive rather than nihilistic in outlook. Its essential aim was to release the power of the unconscious mind and thereby oppose the excessive rationalism and materialism of the modern world. Surrealist artists varied greatly in the way they expressed such ideas. Salvador Dalí's highly detailed dreamlike visions are the

Dutch-American artist **Willem de Kooning** paints *Woman I;* its frenzied brushwork makes it one of the sensations of **Abstract Expressionism**.

An exhibition entitled "**The Responsive Eye**" at the Museum of Modern Art, New York, puts **Op art** on the map.

The exhibition "**A New Spirit in Painting**" at the Royal Academy, London, helps launch **Neo-Expressionism**.

Tracey Emin's installation *My Bed* is one of the most controversial works of the Young British Artists.

1952 **1965** **1981** **1998**

1955 **1977** **1983** **2010**

American **Jasper Johns** produces his first *Flag* painting; its deliberate banality points the way from Abstract Expressionism to Pop art.

Jean-Paul Riopelle, Canada's leading abstract artist, visits the Arctic, inspiring his *Iceberg* series of paintings.

Anselm Kiefer's *Shulamite* is one of the powerful works in which he addresses dark aspects of Germany's recent past.

A huge abstract ceiling painting by the American artist **Cy Twombly** is installed in the Salle des Bronzes of the Louvre, Paris.

best-known images of the movement, but it also embraced automatism (which involved suppressing conscious control of the hand) and abstraction.

The Surrealists were skillful at promoting their work, through such means as exhibitions and magazines, and many artists of the time were influenced by their strange imagery, even if they did not accept their philosophy of life: Henry Moore and Paul Nash in Britain are examples. However, there were also artists, such as the American Scene Painters, who deliberately turned away from avant-garde ideas; and progressive art was banned in Hitler's Germany and Stalin's Soviet Union. Such tyranny usually crushed artistic individuality and enterprise, but certain Soviet painters, notably

Alexander Deineka, were able to produce outstanding work within the repressive system.

Postwar art
The Nazi regime and World War II caused many European artists to flee across the Atlantic, and after the war their stimulating presence was one of the factors that helped New York to replace Paris as the center of avant-garde art. In the 1950s, the huge critical and financial success of Abstract Expressionism meant that, for the first time, the US was the world leader in painting. The movement was a major watershed, inspiring offshoots but also reactions against its emotionalism, in the form, for example, of the jokey slickness of Pop art and the cool clarity of Minimal art.

Conceptual art, in which the artist's idea was considered to be more important than the finished artwork, began to take shape as a movement in the 1960s. Since then, much avant-garde art has departed from traditional materials and methods; in land art, for example, elements of the landscape are incorporated or arranged into an artwork; and new video and digital technologies have been adopted by others to make time-based works.

Painting and sculpture have continued to flourish alongside the new. In the US and Europe, Neo-Expressionism, with its raw imagery and intense color, emerged in the 1980s as a reaction to conceptual art; and the figurative paintings of East German artists of the New Leipzig School have helped revive interest in more traditional values. ■

A TEMPLE CONSECRATED TO THE CULT OF BEETHOVEN

THE BEETHOVEN FRIEZE (1902), GUSTAV KLIMT

IN CONTEXT

FOCUS
The *Gesamtkunstwerk*

BEFORE
1849 Richard Wagner coins the term *Gesamtkunstwerk*.

1897 The Secession, whose members include painters, architects, designers, sculptors, and craftsmen, is founded. Its magazine *Ver Sacrum* attempts to produce a *Gesamtkunstwerk* in print.

AFTER
1903 The *Wiener Werkstätte*, or Vienna Workshop—where diverse applied art is created under one roof—is set up.

1909 Sergei Diaghilev founds the Ballets Russes, which brings together costume and set design, choreography, music, and dance.

1919 Walter Gropius founds the Bauhaus in Weimar, Germany. He promotes the idea of a community of artists, architects, and designers.

A *Gesamtkunstwerk*, or "total work of art," is one in which many arts combine to create a unified experience. The idea can be traced back to the tomb complexes of ancient Egypt, which were decorated with paintings, carvings, and sculpture that served one purpose only—the glorification of a ruler. The concept also lay behind the kind of religious experience offered in Baroque churches, designed as a unified whole in which the Latin Mass was celebrated with orchestras, choirs, and incense. It can also be seen in modern installation art.

However, the term itself was first used in the 19th century, notably by the German composer Richard Wagner, who applied the concept to his synthesis of poetry, music, and drama in his operas.

The Seccession

The notion of *Gesamtkunstwerk* was enthusiastically embraced in the early 20th century by a group of young Viennese artists who had broken with the art establishment to form their own group, known as the Vienna Secession. In 1902, they opened their 14th collective exhibition, in their recently designed headquarters. The exhibition was conceived as a complete work of art in which music, architecture, decoration, painting, and sculpture united to create a homage to the German composer Ludwig van Beethoven (1770–1827). Its layout resembled a secular temple, with a "nave" and two "side chapels." The central highlight was a statue of Beethoven by Max Klinger, complemented by Klimt's frieze and other works. At the opening, Austrian composer Gustav Mahler conducted his own arrangement of motifs from Beethoven's Ninth Symphony.

See also: Mosaics of Justinian and Theodora 52–55 ▪ *The Garden of Earthly Delights* 134–39 ▪ *Nocturne in Black and Gold* 264–65 ▪ *The Dance of Life* 274–77

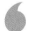
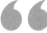

> Artistic man can be wholly satisfied only by the unification of all forms of art in the service of the common artistic endeavor.
> **Richard Wagner**

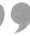

Klimt's vast frieze was created to celebrate the symphony and, specifically, its interpretation by Wagner as an embodiment of the human desire to attain happiness. Running around three walls, the frieze is intended to be read in linear fashion—just as one would listen to a symphony.

A synthesis of forms

The frieze begins with a minimal composition in which three female figures—representing genii, or guardian spirits—symbolizing humanity's longing, float above the Earth. The work continues with representations of suffering, ambition, and compassion, and then with a depiction of the human struggle to defeat negative forces such as sickness, madness, death, grief, and intemperance. The narrative ends on the final wall with salvation through the arts. A heavenly choir accompanies a figure playing the lyre; the genii reemerge, enraptured; and a naked couple embrace, wrapped in a golden cocoon (see opposite). Their kiss references the "Kiss to the whole world" in the poem "Ode to Joy" by German writer Friedrich Schiller, part of which is set to music in the intense culmination of Beethoven's symphony. This melding of artistic forms perfectly exemplifies the *Gesamtkunstwerk*.

Klimt also created three mosaic friezes for Palais Stoclet, a mansion in Brussels that was built between 1905 and 1911 by architect Joseph Hoffmann in collaboration with other architects, as well as artisans and artists. Hoffmann's vision was that every element of the building should be in total harmony, "like the organs of a living being." ▪

Klimt's frieze, 111 ft (34 m) long and 6 ft 6 in (2 m) high, was painted directly onto the walls of the Secession Building in Vienna in 1902. Klinger's statue of Beethoven can be seen on the right.

Gustav Klimt

Gustav Klimt was born in Vienna in 1862 and died there in 1918. He trained in the city's School of Applied Arts, and absorbed influences from Impressionism, Symbolism, and Art Nouveau. Klimt undertook a number of decorative projects for public buildings before discontent with the Viennese artistic establishment led him and a group of friends to set up their own organization, the Secession. After a scandal in which murals painted for Vienna University were deemed obscene, Klimt's official commissions dried up, but there was always demand for his work from private patrons. Klimt's work was diverse, taking in posters and wall decorations as well as "high art" landscapes, portraits, and allegories. Many pieces are embellished with decorative details from Byzantine mosaics, Celtic design, and Oriental textiles.

Other key works

1898 *Pallas Athene*
1905 *The Stoclet Frieze*
1907 *The Kiss*
1907 *Portrait of Adele Bloch-Bauer*

A POT OF PAINT HAS BEEN FLUNG IN THE FACE OF THE PUBLIC
WOMAN WITH A HAT (1905), HENRI MATISSE

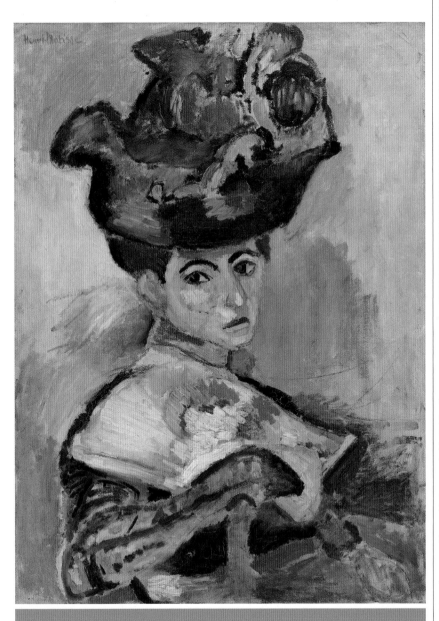

IN CONTEXT

FOCUS
Fauvism

BEFORE
1886–90 Vincent van Gogh paints in pure, brilliant hues.

1891–1903 Paul Gauguin uses anti-naturalistic colors arranged in flat planes.

1892 Paul Signac moves to St-Tropez, France, and works in a Neo-Impressionist style.

AFTER
1905–13 Work by German Expressionist group Die Brücke is typified by extreme emotion and high-key color.

1907 Pablo Picasso's *Les Demoiselles d'Avignon* heralds the beginnings of Cubism.

1912 The term "Orphism" is used to describe the colorful work of František Kupka and Robert and Sonia Delaunay.

Early in the 20th century, the established, naturalistic approach to painting was challenged by artists who were driven by innovation, expression, and experimentation. These artists spearheaded the avant-garde Fauve movement, producing works that were characterized by brilliant colors (often applied to the canvas straight from the tube), simplified forms, and bold execution.

The movement had no explicit manifesto—its aesthetic was adopted by a loose association of friends, of whom Henri Matisse was recognized as leader. Others included André Derain, Maurice de Vlaminck, Albert Marquet, Georges Rouault, and Georges Braque.

The movement gained its name in 1905, at the third Salon d'Automne art exhibition in Paris, where a room full of Fauvist works created uproar. Scandalized by their violent distortions of color and line, the critic Louis Vauxcelles described the artists as *fauves* ("wild beasts"), and the name stuck. Matisse's *Woman with a Hat* was singled out for particular criticism, because its colors did not correspond to reality, and its composition, with large areas of bare canvas, looked unfinished to contemporary critics.

A Fauvist summer

Matisse produced *Woman with a Hat* in the summer of 1905, during the weeks he spent painting in the company of Derain in the fishing village of Collioure, in the South of France. It is a portrait of his wife, Amélie, dressed in a traditional ensemble, holding a fan in her gloved right hand and sporting an outsize hat. However, there is nothing traditional about the color scheme. When asked about the color of the dress his wife wore for her portrait, Matisse famously replied, "Black, of course." Whether

that was true or he was simply being ironic, he depicts Amélie's costume as a riot of blues, greens, violets, and pinks. The elaborate hat may have been made by Amélie herself as she was a skilled milliner; its dominance in the image has a special poignancy, because the income from Amélie's millinery

The Fauves were drawn to the fishing village of Collioure by its intense light. Derain's painting *The Fishing Port* (1905) employs the flat, bright colors that typify the movement.

business kept the family afloat during the precarious years when Matisse was embarking on his artistic career. *Woman with a Hat* was bought by American collectors Leo and Gertrude Stein, who became the artist's first patrons. Many more would follow, boosting Matisse's morale and finances.

Fauvism to Expressionism

Fauvism was in many ways a transitional phase for the artists involved, but its free and expressive use of color was embraced by the German Expressionists as well as by a younger generation of artists that included the French painters Sonia and Robert Delaunay. ▪

Henri Matisse

Born in 1869 in France, Henri Matisse first trained in law, and took up painting in 1891. After discovering the work of the Impressionists in 1896, he began to brighten his formerly somber palette. He adopted the Neo-Impressionist technique of broken brushwork, dashes, and dots. Unlike his friend Pablo Picasso, Matisse always aimed for an art of "balance, of purity and serenity." He was highly versatile, producing drawings, sculpture, cutouts, and murals. He died in Nice in 1954.

Other key works

1904 *Luxe, Calme et Volupté*
1909–10 *Dance*
1949–51 The Chapel of the Rosary, Vence

AN AGONIZING RESTLESSNESS DROVE ME OUT ONTO THE STREETS DAY AND NIGHT

STREET, DRESDEN (1908), ERNST LUDWIG KIRCHNER

See also: *The Dance of Life* 274–77 ▪ *States of Mind: Those Who Go* 298–99 ▪ *The Last Supper* 338 ▪ *Nighthawks* 339–40

IN CONTEXT

FOCUS
Expressionism

BEFORE
1515 Matthias Grünewald completes the Isenheim Altarpiece, whose violent distortions and extreme emotionalism later appeal to the German Expressionists.

1893 Edvard Munch's *The Scream* embodies the angst of a figure alienated in the world.

AFTER
1910 Viennese artist Egon Schiele begins to produce turbulent works characterized by anatomical distortions that express sexual anxieties.

1920s New Objectivity (*Neue Sachlichkeit*) emerges in Germany as a challenge to Expressionism. It focuses on depictions of the external world, often with a savagely satirical flavor.

The characteristics of Expressionism

Strong, unnaturalistic, and sometimes violent colors.

Simplified, distorted forms.

Emphasis on subjective feeling rather than objective observation.

Exaggerated emotional effects, with expressions of fear, anxiety, and alienation, or love and spirituality.

O n June 7, 1905, four young architecture students from Germany—Ernst Ludwig Kirchner, Fritz Bleyl, Erich Heckel, and Karl Schmidt-Rottluff—formed a new art group in Dresden. They called it *Die Brücke* (the Bridge), a name that reflected their eagerness to cross into a new artistic future, and that also paid tribute to the philosopher Friedrich Nietzsche, who had written "The great thing about man is that he is a bridge and not a goal." Undeterred by the fact that none of them had formal artistic training, they wanted to revolutionize art by rebelling against the naturalism of late 19th-century painting and instead painting in

a way that expressed the artist's emotions. To achieve this, the members of this close-knit group studied recent developments in international modern art, and built up skills in drawing, painting, and printmaking. The human figure— often depicted in motion—was central to their work, adding to the emotionally charged feel.

The Brücke artists drew on a diverse range of sources, including the "tribal" art of Africa and the South Seas, and—from a much earlier era—the prints of Albrecht Dürer and the paintings of Matthias Grünewald. They were also inspired by the intensely expressive art of Paul Gauguin, Vincent van Gogh, and Edvard Munch, which employed pure color, powerful lines, and dynamic brushwork. The artists of the Brücke group adopted strong, often "primitive," distorted forms

to express emotional and subjective responses to the external world, and to explore the psychological pressures of modern life.

In 1911, another group with very similar objectives—*Der Blaue Reiter* (the Blue Rider)—was formed »

Art gives us an inner superiority, for it has scope for every sensation of which human beings are capable ...
Ernst Ludwig Kirchner

in Munich. Led by Franz Marc and Wassily Kandinsky, it placed more emphasis on a search for a harmonious spirituality than Die Brücke did, although the work of the two clusters of artists came to be known as "Expressionism."

In *Five Women in the Street* (1913), Kirchner uses agitated, coarse lines and intense colors to picture street prostitutes in Berlin provocatively as though they are dancers on a stage.

Together, they crystallized a wider tendency in German art, literature, and drama to seek new ways of describing inner life: intensity of expression was given precedence over form and balance.

Street life

In his 1908 painting *Street, Dresden*, Die Brücke founder-member Ernst Ludwig Kirchner depicts the city's fashionable Königstrasse avenue. The work conveys a profound sense of alienation. Kirchner knew the work of the French Fauves, and his colors may superficially resemble the brilliance of Matisse's palette, but they are deployed in a jarring manner that is intended to express discord rather than harmony. The vivid, almost fluorescent coloring conveys the brashness of artificial streetlights that cast a sickly glow over objects and figures.

There is little repose in the composition itself, which is dominated by the lurid pink of the empty—and improbably sloping—street that culminates in a street car seen from behind. The figures on the left-hand side, jammed together on the sidewalk, seem to be rushing toward the top of the canvas, while the women at the front have blank expressions. Their features—which reveal Kirchner's fascination with African masks—are delineated in violent oranges and greens. No one communicates; the women are solitary, holding themselves in by clutching at their garments. A girl in the center of the canvas seems lost in space, while the sole recognizably male figure, on the far right of the picture, is abruptly cut off by the edge of the canvas, his facial expression carrying a hint of menace.

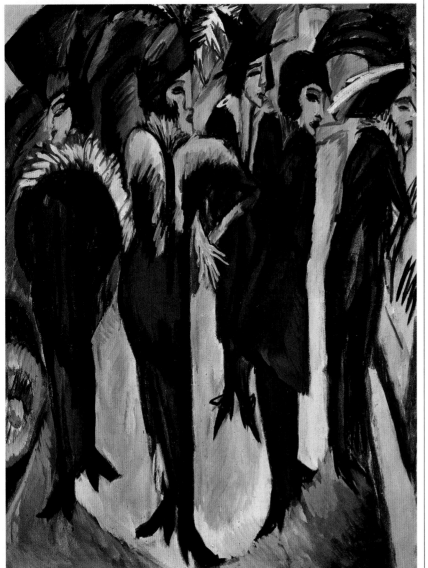

Form is a mystery to us
for it is the expression of
mysterious powers.
Auguste Macke
**'Masks,' in *Der Blaue Reiter
Almanach*, 1912**

>
> Art is creative for the sake of realization, not for amusement: for transfiguration, not for the sake of play.
> **Max Beckmann**

In 1911, Kirchner moved to Berlin, where his fascination with urban city scenes continued. His Berlin canvases depicted streets peopled with prostitutes, or women meeting their lovers, and conveyed an even deeper sense of unease than his earlier works—perhaps intensified by the psychological pressures of the period just before World War I.

The soft forms of the artist's early style became more angular and filled with nervous cross-hatching, echoing the woodcuts and wooden sculptures that he had begun to make.

Personal disagreements between members of Die Brücke came to the fore, and the publication in 1913 of Kirchner's account of the movement, in which he failed to credit his colleagues adequately, led to its final dissolution. Der Blaue Reiter also disintegrated around this time. However, Expressionism appeared in countries other than Germany, most notably in Austria, in the psychologically penetrating portraits and angst-filled paintings of Egon Schiele, Oskar Kokoschka, and Richard Gerstl.

Legacy and influence

The legacy of Expressionism continued to be felt in Germany after the war. The work of such artists as Otto Dix, Max Beckmann, and George Grosz—members of the New Objectivity movement—was primarily concerned with social criticism and satirizing the external world rather than depicting the internal world of the artist, yet their sharp forms and intensity of expression showed the influence of Kirchner and his colleagues.

The late 1970s saw the rise of a Neo-Expressionist school, which flourished in Germany, the US, and

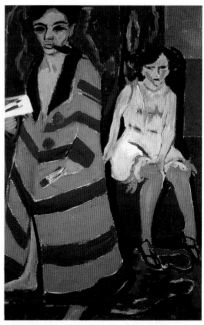

Kirchner's *Self-Portrait with Model* (1910) uses warm colors to create a sensuous atmosphere. It has strong echoes of the "primitive" art that the artist admired for its directness.

the UK, partly as a reaction against Minimalism. German artist Georg Baselitz led the Expressionism revival, producing emotionally charged, large-scale paintings with raw surfaces and distorted forms. ∎

Ernst Ludwig Kirchner

Born in Bavaria, Germany, in 1880, Ernst Ludwig Kirchner studied architecture in Dresden, before his interest in painting led him to form Die Brücke in 1905. He worked as a painter, printmaker, and sculptor, and was instrumental in the revival of the woodcut. During his early years his favorite subjects were urban scenes of Dresden and Berlin; he also painted prostitutes, models, and his friends. Kirchner experienced a nervous breakdown while serving in World War I, and in 1917 was sent to convalesce in Switzerland, where he remained for the rest of his life, finding

inspiration in the mountain scenery. Later in life he turned increasingly toward abstraction in his art. Kirchner was one of the many artists whose work was declared "Degenerate" by the Nazis in 1937. Depressed and in poor health, Kirchner committed suicide in 1938.

Other key works

1910 *Self-Portrait with Model*
1912 *Figures Walking into the Sea*
1913 *Five Women in the Street*
1915 *Self-Portrait as a Soldier*

THE SENSES DEFORM, THE MIND FORMS

ACCORDIONIST (1911), PABLO PICASSO

IN CONTEXT

FOCUS
Cubism

BEFORE
1904–06 Paul Cézanne's views of Mont Sainte-Victoire disrupt perspective and use color to suggest form.

1906 Picasso discovers and is influenced by African tribal art.

1907 A posthumous exhibition of Cézanne's work proves inspirational to future Cubists.

1907 Picasso completes *Les Demoiselles d'Avignon*, which is seen as a proto-Cubist work.

1908 Georges Braque shows works that give rise to the term "Cubism."

AFTER
1911 The first exhibition of Cubism at the Salon d'Automne includes works by Fernand Léger, Jean Metzinger, Henri Le Fauconnier, and Robert Delaunay, but none by either Picasso or Braque.

Cubism was one of the most radical movements in avant-garde art in Europe at the turn of the 20th century. Cubist artists portrayed the world as it was known, rather than as it was seen, challenging the idea, which had dominated Western art since the Renaissance, that art should imitate nature in a realistic way. The pioneers of this new approach to presenting the world were Pablo Picasso and Georges Braque, who worked together so closely in the early years of Cubism that, according to Braque, "it was like being roped mountaineers."

See also: *Bathers* 281 ▪ *States of Mind: Those Who Go* 298–99 ▪
Composition VI 300–07 ▪ *Cubi XIX* 340–41

Instead of showing a landscape, an object, or a person from a single viewpoint, the artists combined several features of the subject in the same composition so that they could be seen simultaneously. Solid objects were fragmented and rearranged so that they were often unrecognizable. Abandoning any traditional ideas of perspective and modeling, the Cubist painters were keen to draw attention to the two-dimensionality of the canvas.

Breaking the rules
The beginnings of Cubism are conventionally dated to 1907, when Picasso completed his groundbreaking *Les Demoiselles d'Avignon*, a crowded canvas that shows five prostitutes from Carrer d'Avinyó ("Avignon Street") in Barcelona, Spain. His previous works had concentrated on the human figure, but none of them had displayed the kind of distortions seen in this picture. The women do not conform to conventional ideas of beauty, and two of them have heads resembling tribal masks, reflecting Picasso's admiration for African art. Forms are faceted and space is ambiguous. These features may have been derived in part from the late work of Paul Cézanne (1839–1906), whose landscapes experimented with a different type of perspective in which subjects were seen from shifting positions.

Picasso's radical canvas was incomprehensible to many of his friends. But with its changes of viewpoint, anatomical distortions, and flattened perspective, it is seen as a transitional work that pointed the way toward a new type of art. One year later, Braque, who was painting at L'Estaque in the South of France, produced a series of landscapes characterized by geometric simplification and forms that appear to tilt backward and forward, confounding traditional readings of perspective. When the art critic Louis Vauxcelles saw these works, he referred to "*cubes*" and "*bizarreries cubiques*" (cubist eccentricities), thereby conferring a name on this new art.

Picasso painted a series of images in Spain—including *Bust of a Woman* and *Seated Nude*—in 1909 that also flouted conventional rules of perspective. In addition, these works broke the contours of the objects depicted, blurring the boundaries between what was space and what was solid.

Analytic Cubism
The early phase of Cubism, which is often referred to as Analytic Cubism, lasted until around 1912. It entailed detailed analysis and dissection of objects and the space they occupy, and their »

In *Les Demoiselles d'Avignon* literal representation and familiar forms and perspectives are abandoned in favor of splintered planes, disjointed volumes, and crudely painted figures.

Pablo Picasso

Pablo Picasso is widely held to be the most influential artist of the 20th century. He was born in Malaga, Spain, in 1881, where his precocious talent was recognized by his art-teacher father. In 1904, Picasso settled in Paris, and three years later embarked upon the great artistic experiment that would be known as Cubism. He later embraced a succession of artistic idioms, including elements of Surrealism.

Success came to Picasso early in his career: he received financial backing from high-profile, influential figures, and commissions for prestigious projects, including for ballet costumes and set designs. He was versatile, prolific (he is said to have created some 20,000 works), and a master of different media—including painting, sculpture, graphic arts, and ceramics. His work expresses the full gamut of human emotions, from comedy to tragedy. Picasso died in Mougins, France, in 1973.

Other key works

1904 *The Frugal Meal*
1925 *The Three Dancers*
1937 *Guernica*

reassembly in a new order on canvas. As the poet and critic Guillaume Apollinaire observed, "Picasso studies an object the way a surgeon dissects a corpse."

Picasso's *Accordionist* is one of the most extreme examples of the Analytic stage of Cubism. It was painted in 1911, when Picasso and Braque were sharing a studio in Céret, in the French Pyrenees. In the earliest Cubist works, objects are usually recognizable, but by the time this canvas was created, Cubist paintings had become almost entirely abstract, consisting mainly of intersecting planes and angles, and sometimes including fragments of a figure, object, or letters. The artists' favorite motifs during this period were still lifes and people rather than landscapes. They adopted a subdued, almost monochromatic color scheme, perhaps as a direct reaction to the more decorative hues of Impressionist and Fauvist works.

Braque's *Viaduct at L'Estaque* (1908) exhibits features of so-called Anaytic Cubism in its compression of space, exploration of geometric shapes, and dissolution of forms.

It is hard to make out the subject hinted at in the title of this canvas, but on close scrutiny a seated accordionist becomes apparent. His head is at the apex of the composition and the folds and keys of the accordion can be seen about two-thirds of the way down. The curving arms of his chair are visible toward the bottom. Forms are fragmented and there is no sense of recession or depth to help situate the sitter in space.

Synthetic Cubism

The year after *Accordionist* was painted, Picasso and Braque started to introduce a new element into their work—collage. Braque pasted some wallpaper printed with false wood-grain into a series of charcoal drawings, and Picasso glued a piece of oilcloth printed with a pattern of chair caning onto a still life of a café table. These

Every act of creation is first an act of destruction.
Pablo Picasso

works initiated the second phase of Cubism, known as "Synthetic Cubism," and a move away from the abstraction of Analytic Cubism. While the earlier experiments of Analytic Cubism focused on the visual analysis of objects and their breakdown into fragmentary images, Synthetic Cubism focused on shape, texture, pattern, and the flattening out of the image, losing any sense of three-dimensionality.

In this later, Synthetic, phase, the image was created using pre-existing elements—newspaper, print, and patterned paper, for example—rather than through a process of fragmentation. Color was reintroduced, and stenciled lettering was also sometimes added. Using materials other than paint added a level of paradox, even subversion: viewers may have wondered whether the papers and cloth represented something specific. Was Braque's wood-

Still Life with Chair Caning (1912), by Picasso, is an early example of collage in art, using rope and oilcloth as well as paint. The letters "JOU," from the French for "play," hint at the artist's playfulness.

The legacy of Cubism

Cubism was an adaptable art form that gave rise to or became an important aspect of a number of movements in 20th-century art.

Futurism
(1909–c.1916)
Led by Tommaso Marinetti and Umberto Boccioni, the Italian Futurists used the fragmented forms of Cubism to convey their vision of the fast-moving modern world.

Orphism
(1911–1914)
This offshoot of Cubism, whose prime exponents were Robert and Sonia Delaunay and František Kupka, was characterized by highly colored abstract canvases.

Vorticism
(1914–1915)
An avant-garde British movement, led by Wyndham Lewis, that drew on the faceted forms of Cubism. Vorticist paintings were often fragmented, angular, and mechanistic.

Suprematism
(1915–1920)
The Russian artist Kazimir Malevich was the founder of Suprematism. He created abstract works with lines and various geometric forms such as circles and squares.

Precisionism
(1920s–1930s)
Charles Sheeler was the leading exponent of Precisionism, a US variation of Cubism. The Precisionists made use of simple shapes and faceted and geometric forms.

grained paper, for example, meant to suggest a chest of drawers or was the material there simply to play with expectations? Whatever the intention, the effect was more decorative, less austere, than in the earlier Analytic works. Braque also began adding textures such as sand or gesso, calling further attention to the surface of the picture and emphasizing its status as a two-dimensional object.

The use of conventionally "non-artistic" materials—which would prove a revolutionary development in art—was not solely restricted to painting. Picasso, Braque, and other artists in their circle also produced sculptures in the Cubist style, employing the principles of collage by utilizing "readymade" objects.

A new visual language
Cubist ideas soon spread. By 1911, several other progressive artists had become Cubists, taking the movement in new directions. Two key exponents were Fernand Léger and the Spaniard Juan Gris. These artists, along with Picasso and Braque, received financial support from the art dealer Daniel-Henry Kahnweiler, which allowed them to make experimental work that was sold to a small group of connoisseurs.

Cubist work was being shown in public exhibitions such as the Salon d'Automne and the Salon des Indépendants in Paris. Artists who exhibited there included Albert Gleizes, Jean Metzinger, and Robert Delaunay. In 1912, Gleizes and Metzinger published *Du Cubisme*, setting forth the theoretical principles of the Cubist aesthetic, and including ideas on geometry, perspective, and space as well as the practice of achieving multiple viewpoints by moving around an

I paint objects as I think them, not as I see them.
Pablo Picasso

object to present it from different angles. They also elaborated on the new "conceptual" versus the old "visual" reality. "Let the picture imitate nothing," they wrote, "let it nakedly present its *raison d'être*."

Lasting influence
Cubism's heyday was in the years before World War I. Picasso and Braque were separated during the war and many artists were called to the front. After the Armistice, artists continued to produce and exhibit Cubist works, but by the mid-1920s many Cubists were also working in other styles. Picasso himself, although he carried on producing Cubist work, was experimenting with alternative idioms. But knowledge of Cubism had already spread far and wide, to other European countries and the US. Its influence was felt in painting, sculpture, the decorative arts, and architecture, and the new visual language it forged provided an important starting point for a number of other artistic movements, including Futurism, Orphism, Vorticism, Russian Suprematism, and American Precisionism. ∎

UNIVERSAL DYNAMISM MUST BE RENDERED IN PAINTING AS A DYNAMIC SENSATION
STATES OF MIND: THOSE WHO GO (1911), UMBERTO BOCCIONI

IN CONTEXT

FOCUS
Futurism

BEFORE
1882 Étienne-Jules Marey develops a way of recording several phases of movement in one photograph.

1896–1901 Italian painters Giovanni Segantini and Gaetano Previati produce works in a Divisionist style that combines broken color with spiritual and social themes.

AFTER
1913 In Russia, painter Mikhail Larionov launches the manifesto of Rayonism, a Russian version of Futurism.

1913 Joseph Stella paints *Battle of Lights, Coney Island, Mardi Gras*, one of the earliest American Futurist works.

1914 Painter and author Percy Wyndham Lewis publishes the Vorticist manifesto in London, aiming to purge British art and literature of the past.

The birth of Futurism was declared with an incendiary manifesto that appeared on the front page of the French newspaper *Le Figaro* in 1909. Its author, the Italian poet Tommaso Marinetti, had dropped a bombshell that shocked the world—exactly as he had hoped.

According to the manifesto, Italy was to be delivered from its smelly gangrene of professors, archaeologists, *ciceroni* (tourist guides), and antiquarians, and the Futurists would "sing the love of danger, the habit of energy and fearlessness." At the dawn of a truly modern age, the Futurists would look forward not back, producing defiant works of art that exulted in violence, dynamism, industry, cruelty, and youth. The Futurists had a radical agenda of political modernization and were prepared to incite violence and embrace conflict to promote their goal.

Behind the bombastic assertions in this and the many subsequent Futurist manifestos was a serious artistic attempt to embrace both modernity and the 20th-century realities created by technology, such as telephones, aircraft, automobiles, movies, newspapers—and war. Futurism's chief protagonists—Giacomo Balla, Umberto Boccioni, Carlo Carrà, Gino Severini, and Luigi Russolo— saw "a new beauty, the beauty of speed." A "racing motor car" was, they claimed, "more beautiful" than the classical Greek sculpture *Victory of Samothrace*.

The insistence of change
Boccioni's *States of Mind* triptych, Futurism's first great statement in paint, is set in a train station and explores the excitement of modern travel and the conflicting emotions it creates. It drew inspiration from

See also: *Street, Dresden* 290–93 ▪ *Accordionist* 294–97 ▪ *Bicycle Wheel* 308 ▪
Woman Descending the Staircase 341

> We will sing of great
> crowds excited by work,
> by pleasure, and by riot.
> **Tommaso Marinetti**

the ideas of French philosopher
Henri Bergson, who emphasized
the importance of universal flux,
dynamism, change, and intuition.
Boccioni painted two versions, the
first in the summer of 1911, and
the second in the fall of that year,
after he had encountered Cubism
on a trip to Paris. This second
version adopts the fragmented,
multiple viewpoints of Cubism
while also attempting to portray
"states of mind" and present a
"synthesis of what is remembered
and what is seen." With its rush
of line and color, it encapsulates
one of Futurism's most influential
artistic philosophies, which was
declared in the first manifesto by
Marinetti: that "Time and Space
died yesterday."

Triptych of movement

The Farewells—the central canvas
in the triptych—captures the chaos
of departure at a train station. The
left-hand canvas, *Those Who Go*,
expresses the "loneliness, anguish,
and dazed confusion" of departing
passengers. Powerful diagonals of
black, lavender blue, and green blur
the division between foreground
and background and suggest the
violence of speed taking travelers
away from their loved ones. Their
heads are seen in fragmented form
from a number of different angles
at once. Glimpses of houses and
landscape flash by at the top of
the canvas. The final part of the
triptych, *Those Who Stay*, conveys
the melancholy of those who have
been left behind, "their infinite
sadness dragging everything down
toward the earth."

The painting was shown as
part of a European tour of Futurist
art that took place between 1912
and 1913, which caused predictable
uproar in the art establishment.
Futurism's shock waves quickly
spread across
Europe, causing
ripples in France,
Britain, and Russia,
and its avant-garde
ideas were embraced
by the Vorticists and
the Rayonists. ▪

**States of Mind:
The Farewells**
shows clouds of steam,
embracing couples,
and movement as a
train pulls away.

Umberto Boccioni

Umberto Boccioni was born
in Reggio Calabria, Italy, in
1882, but his family moved
often because of his father's
work as a civil servant. After
graduation, Boccioni studied
at Rome's Academy of Fine
Art, and began work as a
commercial artist. In Rome,
he met Giacomo Balla and
Gino Severini, who introduced
him to the Divisionist style of
painting, in which forms are
broken down into small dots
of paint—a technique he used
in his early works. Following
stays in Paris and Russia,
Boccioni moved to Milan in
1907, where he became closely
involved with the nascent
Futurist movement, and
contributed greatly to its
theories. Like his fellow
Futurists, Boccioni welcomed
the outbreak of World War I
and volunteered for duty.
However, he was killed
during training in 1916 and
never saw combat.

Other key works

1910 *The City Rises*
1910 *Dynamism of a Cyclist*
1911 *The Street Enters the
House*
1912–13 *Unique Forms of
Continuity in Space*

COLOR EXERTS A DIRECT INFLUENCE UPON THE SOUL

COMPOSITION VI (1913), WASSILY KANDINSKY

Detail from *Composition VI*

IN CONTEXT

FOCUS
Abstract art

BEFORE
1846 J. M. W. Turner's *Angel Standing in the Sun* features recognizable motifs subsumed in a swirling vortex of color.

1908–12 Pablo Picasso and Georges Braque produce Cubist works that edge toward abstraction.

AFTER
1915 The Suprematist movement, an abstract geometrical style founded on "the supremacy of pure artistic feeling," emerges in Russia.

1917 Dutch artists Theo van Doesburg and Piet Mondrian found *De Stijl*, a publication that promotes abstract art.

1930s Paris becomes a center for abstract art, with two groups, *Abstraction-Création* and *Cercle et Carré*, promoting such work.

The aesthetic notion behind abstract art—that colors and forms have qualities that exist independently of subject matter—has existed since ancient times, and has been reiterated by artists and theorists over the centuries. However, genuinely abstract art that does not represent recognizable scenes or objects but consists of forms, shapes, and colors depicted for their own sake, is a modern phenomenon that developed at the beginning of the 20th century. An abstract work may take its point of departure or inspiration from something in the outside world, or it may use pure color or form that has no source at all in external visual reality. The term covers many different styles, from the gestural and expressive to the geometric and austere.

Abstract theory

The philosophical framework for abstraction was laid in the 19th century, in the theories elaborated by the French Symbolist literary and art movement, which rejected realistic representation in favor of suggestion and the expression of emotional experience. The belief

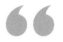

The more frightening the world becomes … the more art becomes abstract.
Wassily Kandinsky

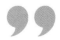

that art did not have to transcribe nature in a literal sense also found an echo in the early 20th-century work of the Cubists and Futurists, who manipulated and fragmented visual reality to the point where it was almost unrecognizable, and in the canvases of the Fauves, who liberated color from its naturalistic function. The first truly abstract works, devoid of all reference to the world of recognizable objects, were produced in the years immediately preceding World War I. Lack of an identifiable subject did not also mean lack of meaning; these early abstract works were underpinned by the artists' desire to arrive at

Wassily Kandinsky

Born in Moscow in 1866, Wassily Kandinsky abandoned an early career in law and went to Munich in 1896 to study at the Academy of Fine Arts. In 1908, he moved to the nearby village of Murnau, where he painted landscapes that were the starting point for his abstract works. A group of like-minded avant-garde artists (including Paul Klee, Franz Marc, and Alexei Jawlensky) coalesced in 1911 with the formation of the influential Blaue Reiter group. During seven years (1914–21) spent in Revolutionary Russia, Kandinsky helped to reorganize art education and museums in Moscow. In 1922, he accepted a teaching post at the Bauhaus in Dessau, where he remained until its closure by the Nazis in 1933. In 1934, he moved to the Parisian suburb of Neuilly-sur-Seine, where he spent the rest of his life. Kandinsky died in 1944.

Other key works

1903 *The Blue Rider*
1916 *Moscow I. Red Square*
1921 *Black Spot*
1925 *Swinging*
1926 *Several Circles*

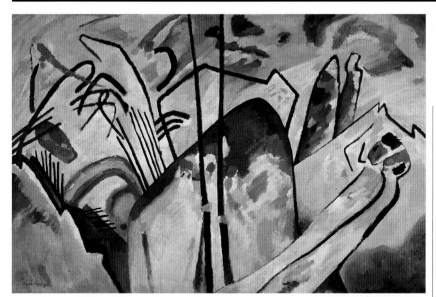

some fundamental spiritual truth that lay beyond the objective world of superficial appearances.

Spiritual foundations

Because abstraction appears to have developed simultaneously in several different countries, it is impossible to credit a single artist with its creation, but the Russian artist Wassily Kandinsky, who lived in Munich, Germany, from 1896 to 1914, was one of its most important pioneers. His first completely abstract piece, *First Abstract Watercolor,* is signed and dated 1910 (although some scholars believe the inscription was added retrospectively). By the time it was made, the artist had begun writing down his theories about the purpose of art, which provided an intellectual justification for abstraction. These theories were published in 1911 in *Über das Geistige in der Kunst* (*On the Spiritual in Art*), which proved to be one of the most influential texts on abstract art ever produced. In this essay, Kandinsky stated his

conviction that art should grow out of "inner necessity" rather than external impressions. He believed art had a spiritual role, and that it could act as a counterbalance to a culture that had become dominated by materialistic values. An artist needed to "touch the beholder's soul," and one way of doing this, he believed, was through color, since colors had a spiritual vibration that linked with corresponding vibrations in the soul. Kandinsky's ideas were strongly influenced by Theosophy, an esoteric philosophy based on the notion that the universe is spiritual in nature and that there is harmony beneath the apparent chaos.

While Kandinsky's path to abstraction certainly had a strong theoretical foundation, it was also prompted by some significant personal epiphanies. In 1896, while he was still in Moscow, he saw one of Monet's *Haystacks* paintings accidentally hung upside down in an exhibition, which made him realize that its beauty resided in

Kandinsky's *Compositions*, such as *Composition IV* (1911), were milestones in the artist's path to abstraction—the representational content decreased as the series progressed.

abstract qualities of color and form that were independent of the actual subject depicted. That experience was repeated many years later, when he returned to his studio after a walk and was struck by the beauty of one of his own paintings, *Composition IV,* which had been placed on its side.

Musical influences

Also in 1896, Kandinsky heard a performance of Richard Wagner's opera *Lohengrin*, and he realized that the way music could affect the emotions without any identifiable subject matter could also be extended to painting. Colors in a picture could relate to one another like sequences of chords in music. Several years later, in 1909, Kandinsky began work on a series of canvases that bore the titles *Impression*, *Improvisation*, or *Composition*, in a reference to musical terms. While *Impression* still drew on external sources of inspiration, the artist defined »

The artist must train not only
his eye but also his soul.
Wassily Kandinsky

Composition VI is monumental in scale (77 in by 118 in/195 cm by 300 cm), which contributes to the viewer's sense of being completely engulfed in the painting's space.

the *Improvisation* series as a "largely unconscious, spontaneous expression of inner character, non-material nature." These paintings were often preceded by preparatory watercolor sketches in which Kandinsky gradually moved away from recognizable motifs so that only some traces of representation remained. *Composition* was the most complex of the three types of painting. He described the works in the series as being expressions of "slowly formed inner feeling, tested and worked over repeatedly and almost pedantically."

Floods of energy

Kandinsky undertook six months of study in preparation for painting *Composition VI*. Its predecessor was a work entitled *The Deluge*, and he had a similarly apocalyptic theme in mind when he painted *Composition VI*, whose subject he specifically identified as the great biblical flood that ushered in a period of spiritual rebirth. For Kandinsky, the artistic process echoed the cataclysm; he described the act of painting as "like a thundering collision of different worlds that are destined in and through conflict to create that new world called the work."

After outlining *Composition VI* on wood panel, Kandinsky became blocked and could not continue. His fellow artist, and lover, Gabriele

Münter, told him that he was trapped in his intellect and suggested he simply repeat the word *überflut* (German for "deluge" or "flood"), focusing solely on its sound rather than what it meant. Repeating this word like a mantra, Kandinsky went back to work and completed the picture within three days. Knowing the subject, it is possible to read into the work the forms of crashing waves, boats, and slanting rain, but Kandinsky tried to veil any representational elements—he wanted to convey a mood, not a narrative or an event.

The deeply complex canvas radiates energy and color. A powerful sense of movement is created by contrasting light and dark areas of color and strong diagonals. There is no conventional

> Color is the keyboard. The eye is the hammer. The soul is the piano, with its many strings. The artist is the hand that purposefully sets the soul vibrating by means of this or that key.
> **Wassily Kandinsky**

perspective. Instead, layered forms and colors interact to create a swirling, three-dimensional effect. This contributes to what Kandinsky described as the "inner sound" of the picture. The viewer's eye moves restlessly over the vast composition, perhaps because, as Kandinsky pointed out, it has not one initial focal point but two: "On the left there is a gentle pink, slightly blurred center with faint, uncertain lines. On the right (slightly higher than the left center) is a rough, red-blue, somewhat dissonant center with sharp, slightly unkind, strong,

very precise lines." Between these two points is an area, to the left of the center, in which pink and white float in an indeterminate space, producing an effect of blurred distance; the artist likened this effect to that of being in a steam bath, where it is impossible to judge the exact location of one's fellow bathers.

Color equivalences

In his *On the Spiritual in Art*, Kandinsky had suggested that certain shapes and colors could be associated with particular emotions, and that the artist should not necessarily seek to produce harmony in his work, since opposition and contradiction would reflect the current social as well as spiritual conditions.

Accordingly, *Composition VI* is punctuated by solemn long lines and transverse lines, which almost appear to be in conflict but are held in balance by the pinks and blues. The artist also revealed that he believed that the browns in the picture, particularly at the top left, introduced an element of hopelessness, which is enlivened by the yellows and greens. He felt that the combination of rough and smooth areas in the canvas »

The sketch for *Composition II* (1910) is a vibrant mix of shapes and colors. On the left, figures appear to be engulfed by flood under a dark and stormy sky; on the right, a brighter, more idyllic scene is depicted.

Biblical themes

The painting conjures up the atmosphere of the Deluge, its forms containing echoes (but not direct representations) of ships, waves, and a rainstorm.

Mystical intention

Kandinsky intended his picture to communicate directly with the soul of the viewer through its purely abstract qualities of color and line.

Color associations

The color does not have a naturalistic or descriptive function, although for Kandinsky colors had strong associations with states of mind and emotions.

Construction

The swirling masses of line and color dispense with traditional perspective and baffle any attempt to read a sense of conventional space into the painting.

would enable the viewer to experience new emotions as he or she contemplated the painting.

War and beyond

Like much of Kandinsky's work in the years before the outbreak of the World War I, *Composition VI* evokes a world on the edge of destruction. At the time, Russia was in a state of turmoil: it had already undergone one revolution in 1905 and would experience another in 1917. The artist's adoptive country, Germany, was implementing an increasingly belligerent foreign policy. Perhaps it is not surprising that there is such an apocalyptic undercurrent in all seven of the *Composition* works Kandinsky painted before 1914.

The first three *Compositions* were destroyed during World War II and survive only as photographs or as sketches. The subject of the sketch for *Composition II* (1910) has given rise to debate, but the left-hand side seems to depict a cataclysm, while the right side suggests paradise and salvation (see previous page).

In *Compositions IV* and *V,* representational images can just about be made out. *Composition IV* (1911), suggests Cossacks with lances, as well as boats, reclining figures, and a castle on a hilltop. The Cossacks convey the idea of battle, while the tranquillity of the flowing forms and reclining figures suggests peace and redemption. In *Composition V* the palette is darker,

communicating a sense of menace. *Composition VII* was painted soon after *Composition VI*, and is closely related to it, embracing similar themes of Deluge, Resurrection, and Judgment.

The three *Composition* pieces that Kandinsky painted after the war are strikingly different in style. As a non-German, he was obliged to return to Russia at the outbreak of war and he stayed there until 1921. During that time he encountered the abstract works

Seeking a universal aesthetic language, Kandinsky turned to geometry in *Composition VIII* (1923), which is characterized by overlapping flat planes and delineated forms.

Kandinsky's later works feature free-floating quasi-molecular forms. *Composition IX* (1936) is a highly atmospheric, dreamlike image, bordering on the surreal.

of Kazimir Malevich and the Russian Constructivists, which stirred an interest in geometry that was further developed when he took up a teaching post at the Bauhaus in Dessau in 1922.

Composition VIII (1923) presents a total contrast to Kandinsky's prewar works. Here, triangles, circles, and linear elements create a surface of interacting forms, and it is form that dominates over color. In this painting, Kandinsky echoes the austere abstraction of Malevich. Like Kandinsky, Malevich believed that by abandoning the need to depict the natural world, he could break through to a deeper level of meaning. In 1913, Malevich developed Suprematism, an art of radical simplicity that aimed for complete purity of form. Its most extreme early statement was *Black Square* (c.1915)—showing just a black square with a white border.

European abstraction

Kandinsky's penultimate work in the *Composition* series, *Composition IX* (1936), reveals another change of direction. A more decorative canvas, it has diagonal stripes on which float the kind of biomorphic shapes seen in Surrealist works by artists such as Joan Miró. The final work in the series, *Composition X* (1939), shows flat colored shapes swirling and dancing against a black background, anticipating Henri Matisse's later "cutouts"— vibrantly colored, cutout paper shapes arranged in patterns.

Although Kandinsky is often credited with creating the first purely abstract work of art, several

other European artists were hugely influential in the development of the form in the years leading up to World War I. In Paris, the Czech artist František Kupka and French painters Robert and Sonia Delaunay were also experimenting with abstract works, and exploring theories about color and the links between music and painting.

The Dutch artist Piet Mondrian, who moved to Paris in 1911, was inspired by his encounter with Cubism to start looking at the underlying linear structure of the natural world, and to begin

From the very outset that one word 'composition' sounded to me like a prayer.
Wassily Kandinsky

removing identifiable motifs from his work. This would culminate in the grid paintings for which he is most famous, which use a restricted palette of the three primary colors and a grid of black horizontal and vertical lines on a white ground. Mondrian's severe canvases look entirely different from Kandinsky's more free-flowing, expressionist works, but the two artists were nevertheless both inspired by mystical aspirations, Theosophy, and a powerful sense of spiritual mission.

The new artistic ground that Kandinsky and his fellow painters broke before World War I was nothing short of revolutionary. Yet, paradoxically, abstract art was banned in Kandinsky's native Russia in the 1930s, as it also was in Nazi Germany, where it was seen as "degenerate." By the 1960s, abstraction had been absorbed into the mainstream of Western art, and in the US Abstract Expressionism had come to be widely perceived as the embodiment of freedom of thought: a triumph of the individual against totalitarianism. ∎

USE REMBRANDT AS AN IRONING BOARD!
BICYCLE WHEEL (1913), MARCEL DUCHAMP

IN CONTEXT

FOCUS
The readymade

BEFORE
1912 Pablo Picasso and Georges Braque incorporate fragments of items such as newspaper into their collages.

AFTER
From 1916 Members of the Dada movement begin to challenge conventional notions of art, prioritizing the absurd over logic and common sense.

1964 American Pop artist Andy Warhol produces his *Brillo Boxes*, turning products into works of art.

1993 Mexican artist Gabriel Orozco exhibits a shoebox in a room on its own, a banal and meaningless object intended to draw the visitor's attention to his or her surroundings.

I n 1913, the French artist Marcel Duchamp (1887–1968) threw aside the conventional materials and methods of making art to produce one of the most astonishing and groundbreaking works of the modern period. By mounting a bicycle fork and wheel on the seat of a wooden stool, he invented the first "readymade."

Duchamp was not the first to use everyday objects in art: the Cubists had done so in their collages, but they had chosen items for their representational or aesthetic value. By selecting two mass-produced objects with no intrinsic significance or beauty, Duchamp challenged the notion of how art is defined, declaring that craft and visual appeal were irrelevant. What mattered was that the artist had chosen something ordinary, completely stripped it of useful meaning, and—by giving it a title—created a new idea for it.

Strictly speaking, *Bicycle Wheel* was an "assisted readymade," as it involved selecting and assembling two objects, but more single-object readymades were to follow, including *Bottle Rack* (1914) and a porcelain urinal, *Fountain* (1917), which was rejected by the New York Society of Independent Artists as "by no definition a work of art."

Objects and thoughts
The current version of *Bicycle Wheel* is a replica Duchamp made four decades after he lost the first version, but he felt the "authenticity" of its anonymous components was unimportant. His readymades had profound repercussions later in the century, particularly on Pop and Conceptual art, which often featured mass-produced commercial items. ∎

See also: *Sunday on La Grande Jatte* 266–73 ▪ *Woman with a Hat* 288–89 ▪ *Accordionist* 294–97 ▪ *The Persistence of Memory* 310–315 ▪ *Whaam!* 326–27 ▪ *One and Three Chairs* 328 ▪ *Big Red* 340

IF THAT'S ART, HEREAFTER I'M A BRICKLAYER
BIRD IN SPACE (1923), CONSTANTIN BRANCUSI

IN CONTEXT

FOCUS
Minimalism

BEFORE
1910–12 Italian artist Amedeo Modigliani creates a series of abstracted, elongated sculpted heads.

1914 French artist Henri Gaudier-Brzeska begins to produce sculptures with radically simplified forms.

1915 Kazimir Malevich paints *Black Square*—a groundbreaking statement of Minimalism in painting.

AFTER
1964 American Donald Judd creates sculptures from stacks of boxlike objects with no trace of the artist's personality.

1966 American sculptor Carl Andre produces *Equivalent VII*, an arrangement of bricks.

C onstantin Brancusi (1876–1957) learned to carve wood while working as a shepherd in his native Romania. He studied art in Bucharest before leaving in 1904 for Paris, where he spent the rest of his life. Declining to take up an apprenticeship with the sculptor Rodin, he pursued his own sculptural vision, which was based on direct carving rather than the mechanical reproduction of plaster models in stone. He worked by paring away from a sculpture everything he considered superfluous, and smoothing the surfaces of his bronze and marble pieces to arrive at the essence of a form. Concentrating on a small number of themes, he produced representations of heads, couples embracing, and birds in flight, simplifying them almost to the point of abstraction.

All 16 versions of *Bird in Space*—produced between 1923 and 1940—portray the upward thrust of flight itself: there are no vestiges of wings, feathers, or any of the bird's physical attributes.

Legally art

Brancusi's minimalistic approach had an immense influence on the development of modern sculpture, but caused some confusion outside avant-garde art circles. In 1926, when *Bird in Space* was sent to the US for an art exhibition, the New York customs officials refused to accept it as a work of art—which would have been exempt from customs duties—and classified it as a taxable manufactured metal object. Two years later, after lengthy discussions in court about what constituted a work of art, the judge finally found in favor of the artist.

Brancusi's art distils forms seen in nature, but in later Minimalist work, forms are often purely abstract and geometric, with no reference to nature at all. ■

> Simplicity is not an objective in art, but one achieves simplicity despite oneself by entering into the real sense of things.
> **Constantin Brancusi**

HAND-PAINTED DREAM PHOTOGRAPHS

THE PERSISTENCE OF MEMORY (1931), SALVADOR DALÍ

Detail from *The Persistence of Memory*

IN CONTEXT

FOCUS
Surrealism

BEFORE
1900 *The Interpretation of Dreams*, by Sigmund Freud, is published and has an immense influence on the Surrealists.

1916–22 The Dadaists set out to scandalize and shock with their provocative art.

1924 André Breton launches his *Surrealist Manifesto*.

AFTER
1936 The International Surrealist Exhibition is held in London. Dalí delivers a lecture dressed in a diving suit.

1938 The Beaux-Arts Gallery in Paris shows around 300 paintings by 60 Surrealist artists from different countries.

1939–45 During World War II, many Surrealists flee to New York, where they have a great influence on the art scene.

During the 1920s and 1930s, many artists and writers became fascinated with the irrational and the incongruous. Their obsession with the bizarre was set in motion at the end of World War I, which had created widespread disillusionment with a society that had produced such terrible carnage.

The Dada movement, which was founded in Zurich in 1916, reacted to an incomprehensible world by promoting provocative art suffused with nihilism, irony, and buffoonery, that questioned every aspect of bourgeois society. By 1919, Dadaist revolt against rational thought and behavior had spread to Paris, where it took on a different flavor that paved the way for Surrealism. A number of artists who had been Dadaists transferred their allegiance to Surrealism when Dada was officially disbanded in 1922.

Something of the spirit of Dada lived on in the avant-garde writers and artists who converged on Paris from all over Europe in the early 1920s. Their pranksterish means of questioning assumptions about reality, and their experiments with new ways of living, were often

It is perhaps with Dalí that for the first time the windows of the mind are opened fully wide.
André Breton

absurdly inspired: one poet would ring randomly on a doorbell and ask the concierge who answered if he did not live there; others would insult priests in the street, get down on all fours and eat dog food, eat live spiders, or strike critics. Salvador Dalí himself would later lecture at the Sorbonne with one foot soaking in a pan of milk.

Manifesto for revolution
The chief founder and spokesman for the new Surrealist movement was the poet and critic André Breton, who penned the *Surrealist Manifesto* in 1924, and shortly afterward launched the journal *La Révolution surréaliste*. Breton, who had been an original member of the Dadaist group, was fascinated by the workings of the subconscious mind—an interest that had been fueled by Sigmund Freud's publications on dreams and the unconscious earlier in the century. But whereas Freud's investigations were aimed at curing patients of their mental illnesses, the Surrealists embraced departures from rational thought with great enthusiasm. Breton wanted to free the imagination from conscious control, and from aesthetic or moral preoccupations. He favored such techniques as free association

Salvador Dalí

Salvador Dalí's fantastic imagery and flamboyant personality made him one of the most famous artists of the 20th century. Born in the Spanish Catalan town of Figueres in 1904, he joined the Surrealists in Paris in 1929. Fascinated with psychoanalysis and Freud, he explored secret sexual desires, disgust, and neurosis in much of his work. In 1939, Dalí was expelled from the Surrealist group for supporting General Franco in the Spanish Civil War.

He spent the years of World War II in the US, and in later life devoted himself to painting for the purpose of making money. Dalí's prolific output as a painter, sculptor, illustrator, and designer can be seen in galleries all over the world and in the museum devoted to his art in the town of Figueres, where he died in 1989.

Other key works

1936 *Lobster Telephone*
1937 *The Metamorphosis of Narcissus*
1951 *Christ of St. John of the Cross*

See also: *The Garden of Earthly Delights* 134–39 ▪ *The Angelus* 279 ▪ *Street, Dresden* 290–93 ▪ *Accordionist* 294–97 ▪ *States of Mind: Those Who Go* 298–99 ▪ *Composition VI* 300–07 ▪ *Bicycle Wheel* 308 ▪ *Autumn Rhythm* 318–23

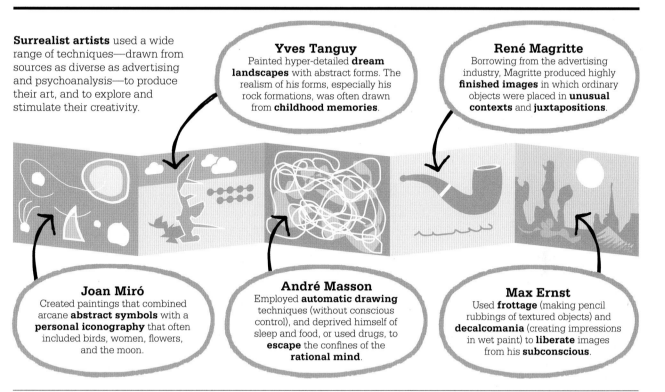

Surrealist artists used a wide range of techniques—drawn from sources as diverse as advertising and psychoanalysis—to produce their art, and to explore and stimulate their creativity.

Yves Tanguy
Painted hyper-detailed **dream landscapes** with abstract forms. The realism of his forms, especially his rock formations, was often drawn from **childhood memories**.

René Magritte
Borrowing from the advertising industry, Magritte produced highly **finished images** in which ordinary objects were placed in **unusual contexts** and **juxtapositions**.

Joan Miró
Created paintings that combined arcane **abstract symbols** with a **personal iconography** that often included birds, women, flowers, and the moon.

André Masson
Employed **automatic drawing** techniques (without conscious control), and deprived himself of sleep and food, or used drugs, to **escape** the confines of the **rational mind**.

Max Ernst
Used **frottage** (making pencil rubbings of textured objects) and **decalcomania** (creating impressions in wet paint) to **liberate** images from his **subconscious**.

and automatic writing to enable unexpected ideas and imagery to arise from the subconscious; his stated hope was to "resolve the previously contradictory conditions of dream and reality into an absolute reality, a super-reality."

Freedom from rationality

Surrealism's principles, although founded in literature, were soon adopted by a number of artists who shared Breton's preoccupations and his desire to produce a truly revolutionary art.

As might be expected of a movement that deliberately aimed to bypass reason in order to expose the "actual functioning of thought," there is no single style of Surrealist painting. However, two broad tendencies can be recognized. The first, as seen most clearly in some

of the work of Max Ernst and André Masson, relies on various types of automatism—such as allowing the hand to draw at random across the paper—to relinquish conscious control and arrive at spontaneous work direct from the imagination with no intervention. The second is exemplified by the work of Dalí and René Magritte, and evokes strange, hallucinatory states in which objects are depicted in unreal, dreamlike compositions with almost Academic realism.

Both types of art frequently involved the juxtaposition of completely unrelated objects, in accordance with the definition of beauty provided by a writer whom the Surrealists admired, the Comte de Lautréamont: "As beautiful as the chance encounter of a sewing machine and an umbrella on a »

André Masson's automatic drawings, such as this one from c.1924–25, were drawn with no conscious intention, but recognizable shapes and figures can be discerned in the jumble of lines.

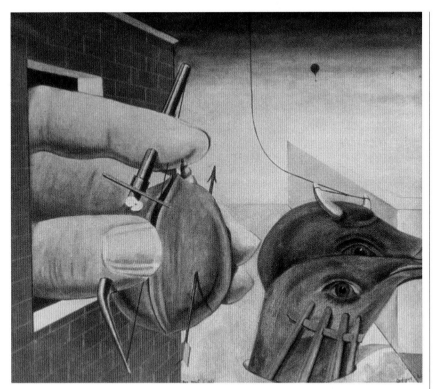

Oedipus Rex (1922) is an example of Max Ernst's early Surrealist work. The "meaning" of this painting, with its pierced fingers, squeezed walnut, and trapped, birdlike heads, is unclear.

dissecting table." And while the images in the Surrealists' works may have surfaced from the unconscious mind, the act of putting them to canvas required discipline, control, and mastery of technique.

Surrealist experiments

Salvador Dalí started to experiment with Surrealism in around 1928, when he worked with his friend Luis Buñuel on the film *Un Chien Andalou*. The movie replaced traditional plot and narrative with a series of dream sequences, some of them based on actual dreams experienced by the artist and the filmmaker. One of Dalí's dreams in the film featured a hand being eaten by ants—a motif that reappeared in several of his later works, including the painting *The Persistence of Memory*.

An apparently nonsensical image, *The Persistence of Memory* reveals considerable technical skill. Dalí mastered what he referred to as "the usual paralysing tricks of eye-fooling," and used fine sable brushes and a jeweler's magnifying glass placed in one eye for the minutely detailed work. The result is a highly finished, naturalistically painted, surreal scene, which effectively places the viewer in a hallucination. The atmosphere is eerie, still, and quiet. In the distance is a rocky coastal landscape—which Dalí described as lit by "a transparency and melancholy twilight"—based on the shoreline near his home at Port Lligat in Catalonia. Mount Pani, close to the Mediterranean village of Cadaqués, where his family had a summer house, casts a shadow over the foreground. Stranded on the beach is a bizarre, limp creature that is draped over a rock or ridge. Oversize lashes cover its closed eye and an object resembling a tongue emerges from its nose. Many have seen the animal as a schematic self-portrait of the artist, in part because the motif had already appeared in two earlier works of 1929, *The Great Masturbator* and *The Enigma of Desire*. The fact that the eye is closed suggests that the creature is asleep and may be dreaming, perhaps echoing Freud's description of dreams as "the royal road to the unconscious."

Clock symbolism

Three melting clock faces within the painting all show different times, while ants swarm over a metal pocket watch. A seemingly barren olive tree, with only one branch and no leaves, appears to be growing out of a wooden tabletop rather than from the bare earth.

The clock faces and the ants— the latter a symbol of decay—allude to the passing of time and death. Art historians have suggested that the melting watches may be an unconscious reference to Einstein's

Un Chien Andalou (1929) was a film made with an explicit rule: to exclude anything for which the viewer could propose a rational, psychological, or cultural explanation.

> I am the first to be surprised and often terrified by the images that I see appear on my canvas.
> **Salvador Dalí**

theory of the relativity of time, which proposed that time is not fixed, but relative, thereby undermining existing belief in the idea of a fixed cosmic order. However, Dalí denied that the objects had any connection with theoretical physics, claiming instead—perhaps playfully—that the watches had been inspired by an occasion on which he had been struck by the look of melted cheese: "We had topped off our meal with a strong Camembert, and after everybody had gone I remained a long time at the table meditating on the philosophic problems of the 'supersoft' that the cheese presented to my mind."

Systematic confusion

Other commentators speculated that the melting clocks reflected the observation that events within dreams do not follow an ordered sequence—that dream time is illogical. Still others approached the work from a psychoanalytical perspective, interpreting the melting watches as expressions of Dalí's well-documented fear of impotence. Ultimately, *The Persistence of Memory* is hard to interpret, which would have pleased the artist, who stated that

he painted the canvas in "the most imperialist fury of precision," in order "to systematize confusion and thus to help discredit completely the world of reality."

A cultural icon

Dalí's painting is small, measuring just 9½ x 13 in (24 x 33 cm), but it became one of his signature works and created a sensation when it was exhibited at the Julien Levy Gallery in New York in 1932. It was bought by a private patron who gave it to the Museum of Modern Art (MoMA) in New York, where it is now one of the highlights of the collection. The image has also been absorbed into popular culture, featuring in such television shows as *The Simpsons*, *Sesame Street*, and *Doctor Who*, as well as in films, cartoons, and video games.

Dalí returned to the piece in 1952, when he began work on *The Disintegration of the Persistence of Memory*, a reinterpretation of the original painting. Following the detonation of the nuclear bomb in 1945, he had become fascinated by

nuclear physics and the idea that matter consists of tiny particles— thereafter, he began to paint objects as though they were disintegrating into atoms. In the new painting, rectangular blocks and rhinoceros horns speeding through space suggest the underlying atomic structure of the original work. The floppy watches are no longer draped over objects but float in space.

Dalí's preoccupations had changed greatly over the 23 years that separated the two paintings. As he later explained: "In the surrealist period, I wanted to create the iconography of the interior worl—the world of the marvelous, of my father Freud. I succeeded in doing it. Today the exterior world— that of physics—has transcended the one of psychology. My father today is [the pioneer of quantum mechanics] Dr. Heisenberg." ∎

Dalí used a "paranoic critical" method to liberate imagery from his subconscious, deliberately cultivating self-induced hallucinations that merged dreams and fantasy with reality.

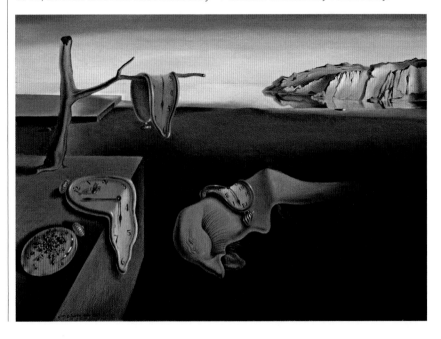

EACH MATERIAL HAS ITS OWN INDIVIDUAL QUALITIES

RECUMBENT FIGURE (1938), HENRY MOORE

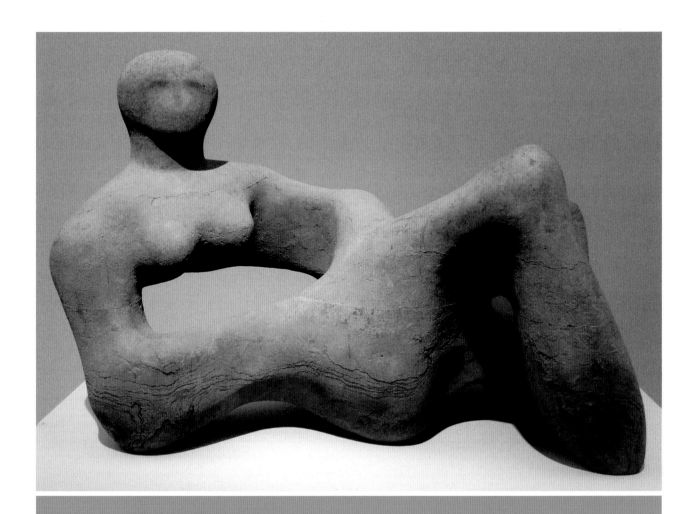

IN CONTEXT

FOCUS
Truth to materials

BEFORE
1872 The English critic John Ruskin denounces the system by which sculptures are created by assistants.

c.1907 In Paris, Constantin Brancusi begins to produce sculptures by carving directly into wood or stone.

1925 British artists Barbara Hepworth and John Skeaping begin to use direct carving in their works.

AFTER
1940–41 *Jacob and the Angel* by the British sculptor Jacob Epstein reflects the mass of the original block of alabaster.

1977 Moore establishes the Henry Moore Foundation to advance public awareness of sculpture.

See also: Riace Bronzes 36–41 ▪ *Laocoön and his Sons* 42–43 ▪ *Young Slave* 144–45 ▪ *The Gates of Hell* 280 ▪ Tomb of Oscar Wilde 338 ▪ *Single Form* 340

Henry Moore

Henry Moore was born into a Yorkshire mining family in 1898. He was injured in a gas attack in World War I. After the war he attended the Royal College of Art. His early work was inspired by sculptural styles of ancient non-Western cultures rather than by the ideals of classical beauty. Moore created some abstract pieces, but most of his sculptures were figurative, the themes of the female figure and mother and child being favorites. He was an official British war artist in World War II and won prestigious prizes and commissions in later peacetime. Moore died in 1986.

Other key works

1929 *Reclining Figure*
1934 *Mother and Child*
1940–41 Shelter Drawings
1953–54 *Warrior with Shield*
1957–58 *Draped Seated Woman*

In the 19th century, sculptors would usually create works for exhibition in plaster, and make bronze casts or marble carvings only once a commission had been received for the piece. A copy would be made of the plaster shape using a machine that measured precise points on its surface and transferred them to the material for the finished piece. This method meant that sculptors were able to produce multiple versions from a single model in workshops that employed studio assistants. It was not uncommon for sculptors such as Auguste Rodin to restrict their input on the finished work to just a few touches.

However, by the early 20th century, some sculptors had begun to feel that the unique qualities of the material used to make a sculpture should be evident in the finished work, which should be created by the hand of the artist, not that of an assistant. A number of artists, including Constantin Brancusi, Amedeo Modigliani, Jacob Epstein, Henri Gaudier-Brzeska, and Eric Gill started to make sculptures by cutting directly into the material rather than making wax, clay, or plaster models for casting.

Material and landscape

Henry Moore belonged to a slightly later generation of British artists, who took up direct carving with enthusiasm after the end of World War I. He wanted his pieces to reflect the shape and texture of the wood or stone from which they were made. Pursuing this idea of "truth to materials," and respecting the intrinsic properties of the chosen medium, he kept to simple forms uncluttered by detail in order to expose the material itself, which was often polished to enhance its color and markings. Moore's sculptures were almost always based on natural forms—human figures, pebbles, bones, and shells—and often echoed elements of the landscape. *Recumbent Figure* was designed to stand on the terrace of a modern home overlooking the undulating South Downs in England. In this context, it would have bridged the gap between the rolling hills in the distance and the angular lines of the house, especially because it is carved from local Hornton stone.

Like many of his contemporaries, Moore was fascinated with what was then considered "primitive" art. He felt that the sculptures of ancient Mexico and Sumeria had a vigor and truth to materials; *Recumbent Figure* seems to have been inspired by carvings of the Mexican rain god Chacmool.

Although Moore did have his work cast in bronze or lead later in his career, he continued to carve as well, working in stone and wood or carved plaster throughout his life. ▪

EVERY GOOD PAINTER PAINTS WHAT HE IS

AUTUMN RHYTHM (1950)
JACKSON POLLOCK

Detail from *Autumn Rhythm*

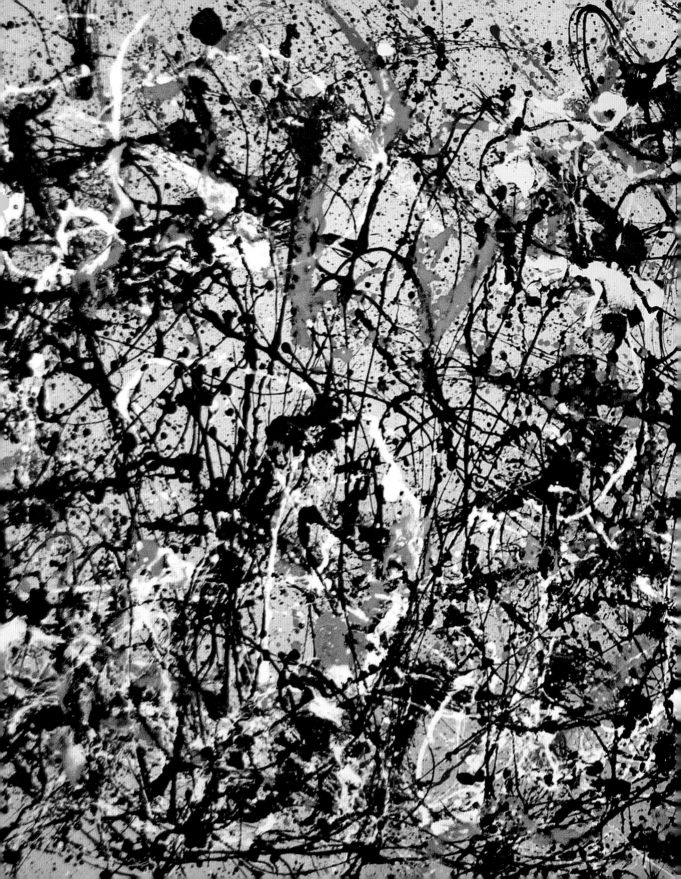

IN CONTEXT

FOCUS
Abstract Expressionism

BEFORE
Early 20th century Dutch artist Vincent van Gogh uses distortion, color, and line to express emotional messages: his works pave the way for Expressionism.

1920s Wassily Kandinsky's paintings are described as "Abstract Expressionist."

1935 The US Federal Art Project provides employment for artists, including future Abstract Expressionists Willem de Kooning, Jackson Pollock, and Mark Rothko.

1939–45 Artists, including Surrealists, leave Europe for New York during World War II.

AFTER
Late 1950s Allan Kaprow's "Happenings" in New York herald the start of performance art, another expressive art.

Abstract Expressionism is a term that describes some very different styles of painting that are linked by their extreme emotional or expressive content. Although the artists associated with the movement tended to share a sense of intense alienation from conservative American society after World War II, Abstract Expressionism has always been perceived as an "American" phenomenon. Produced during the Cold War, it was the polar opposite of the rigid conformity that came to characterize Soviet art.

Acts of creation

Abstract Expressionist artists can be roughly divided into two groups: "action" painters and "color field" painters, although some straddled the two tendencies. Action painters, who include Jackson Pollock, Willem de Kooning, and Franz Kline, produced dramatic works characterized by dynamic gesture, where the emphasis was on the act of creation itself. Color field painters, such as Mark Rothko and Barnett Newman, on the other hand, produced simpler, calmer compositions in which expanses

The modern artist ... is working and expressing an inner world—in other words expressing the energy, the motion, and other inner forces.
Jackson Pollock

of color were intended to induce a sense of transcendence and a meditative response in the viewer.

Many Abstract Expressionists were inspired by the Surrealist notion that art should come directly from the subconscious mind, and were drawn particularly to the idea of automatism, in which the artist does not seek to control his or her hands but allows the unconscious mind to take over. In the work produced by action painters, strong emotions were expressed through the exuberant application of paint, often to very large canvases. The

Jackson Pollock

Jackson Pollock was born in 1912 into an impoverished farming family in Cody, Wyoming. He trained at the Art Students League of New York under Thomas Hart Benton, and from 1935 to 1943 worked as a mural assistant and easel painter. His first solo exhibition was in 1943 at Peggy Guggenheim's Gallery, which led to the Museum of Modern Art in New York buying its first Pollock. He married fellow painter Lee Krasner in 1945 and they moved to a farmhouse in East Hampton, where Pollock produced his drip paintings.

Alcoholism dogged Pollock all his life. His volatile personality, hard-drinking, macho image, and revolutionary art attracted media attention and fed into the romanticized mythology associated with his name. Pollock stopped painting in 1954, two years before being killed in a car accident.

Other key works

1943 *Mural*
1946 *Eyes in the Heat*
1950 *Lavender Mist: Number 1*
1952 *Convergence*

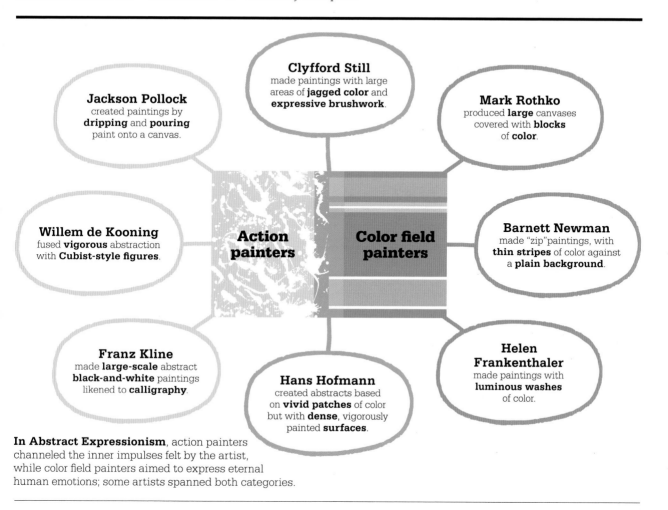

Jackson Pollock created paintings by **dripping** and **pouring** paint onto a canvas.

Clyfford Still made paintings with large areas of **jagged color** and **expressive brushwork**.

Mark Rothko produced **large** canvases covered with **blocks** of **color**.

Willem de Kooning fused **vigorous** abstraction with **Cubist-style figures**.

Action painters

Color field painters

Barnett Newman made "zip"paintings, with **thin stripes** of color against a **plain background**.

Franz Kline made **large-scale** abstract **black-and-white** paintings likened to **calligraphy**.

Hans Hofmann created abstracts based on **vivid patches** of color but with **dense**, vigorously painted **surfaces**.

Helen Frankenthaler made paintings with **luminous washes** of color.

In Abstract Expressionism, action painters channeled the inner impulses felt by the artist, while color field painters aimed to express eternal human emotions; some artists spanned both categories.

works for which Jackson Pollock is best known are the drip or poured paintings (1947–1952)—and it was for these that *Time* magazine dubbed him "Jack the Dripper."

Jack the Dripper

Autumn Rhythm is one of Pollock's most celebrated poured or dripped works. German-born photographer Hans Namuth photographed and filmed Pollock at work on the piece, creating an invaluable record of the artist's techniques and of the distinct phases in the painting's evolution. The photographs reveal

that although Pollock's method was spontaneous, involving no preconceived image or preliminary drawing, his work was far from haphazard, requiring immense skill and concentration. Nor did it involve complete loss of control; Pollock reported, "I can control the flow of paint, there is no accident."

Pollock worked methodically on the canvas, starting in the top right-hand corner and then moving from the right to the left. He held the paint can in his left hand; in his right hand he held a large stiffened brush, which he

swung over the canvas. First, he created a skeleton of thin black lines, accenting some of them with splatters. The paint was diluted so that it soaked into the unprimed canvas. Namuth's photographs reveal what seem to be three humanoid forms in the early phases of the composition, but these eventually disappeared beneath the dense layers of paint.

In the next phase of work, strokes of tan, white, and gray-turquoise paint were placed on top of the initial framework, breaking up the continuous lines, before a »

in the Experimental Workshop led by Mexican muralist David Alfaro Siqueiros, where he encountered unorthodox techniques, such as the artistic use of paint drips.

In 1938, Pollock was treated for alcoholism. In therapy, his Jungian analysts encouraged him to use drawing and exploration of unconscious symbolism, and it was at this point that archetypal forms began to appear in his art.

Pollock was familiar with the work of the European avant-garde, and particularly admired Pablo Picasso and Joan Miró. European Modernism was on his doorstep in the shape of a number of émigré European Surrealists, including André Masson, Max Ernst, and Roberto Matta Echaurren, who had all settled in New York to escape the horrors of Nazism.

A new way of painting

Pollock's early work was figurative, featuring compositions of American rural life infused with a certain energetic turbulence. By the 1940s, he was painting in an abstract style, with biomorphic forms and Native American mythic figures that may have been inspired by watching Navajo medicine men creating images from tinted sand spilled on the ground.

Around 1946, Pollock began to experiment with the entirely new type of painting that became his trademark. He would roll out rough, unstretched canvas and tack it to the floor of his studio. He would then stand or move over it, flicking, spattering, or dribbling paint onto the surface. The size of the studio

final layer of narrow black lines was added, contributing still further to the restlessness of the composition, which has no single focus or central point.

While the painting is abstract, and Pollock did all he could to eliminate figurative elements, it is not devoid of content. Given its agitated lines, its colors, and the clue to subject matter that is given in the title (added at the insistence of Pollock's dealer), it is hard not to read into it something of the energy of swaying trees or swirling leaves on a windy fall day.

The sheer size of *Autumn Rhythm*—110 in x 209 in (279 cm x 530 cm)—can give viewers the feeling that they are engulfed in a massive panorama in which elemental forces are at work. A number of commentators have found in the painting echoes of the rhythms of the Dixieland jazz that Pollock was so fond of, while its expansiveness and insistent

horizontality have also been seen as evocative of the wide open spaces of the American West.

Artistic evolution

Pollock's paintings, for all their apparent spontaneity, were the product of a lengthy and complex artistic evolution that was shaped by diverse influences. He studied under Thomas Hart Benton, who specialized in scenes of urban and rural life in the US, and later worked

I want to express my feelings rather than illustrate them.
Jackson Pollock

> He busted our idea of
> a picture all to hell.
> **Willem de Kooning**

allowed him to work all around the canvas, approaching it from every angle—in this way he could create an "all over" composition in which there is not one single focus, the outer edges of the canvas being as significant as the center. Eager to move as far away as possible away from the usual tools of the painter, Pollock set aside easel, palette, and traditional brushes in favor of sticks, trowels, and knives. He sometimes replaced oil paints with fluid aluminum

and enamel paint, adding in other elements such as sand or sometimes even broken glass.

Life in the public eye

Pollock's action paintings attracted both admiration and derision during his lifetime. They also earned him immense fame; an article in *Life* magazine in 1949 suggested that he was America's greatest living artist. But he stopped producing drip paintings after 1952, and recognizable images began to reappear in his art.

Pollock did not found a school of painting or spawn a host of imitators; his influence was felt in a more general sense. He initiated a liberation from traditional methods of making art, and the realization that the very act of creating could in itself have relevance. As the US art critic Harold Rosenberg noted, painters were now seeing the canvas "… as an arena in which to act. What was to go on canvas was not a picture but an event." Hans

> Each age finds its
> own technique.
> **Jackson Pollock**

Namuth's blurred and frenzied photographs of Pollock at work convey a sense of the energy of performance that was taken to a logical conclusion in the performance art of the 1960s and 1970s, when the boundaries between the artist and the work of art were gradually dissolved. ∎

Sinuous curves, hooks, and lines march across the canvas of Pollock's *Autumn Rhythm,* evoking the complex, shifting patterns of the natural world.

REAL ART IS LURKING WHERE YOU DON'T EXPECT IT
THE COW WITH THE SUBTILE NOSE (1954), JEAN DUBUFFET

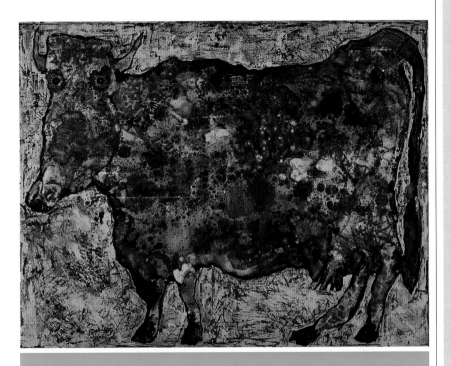

IN CONTEXT

FOCUS
Outsider art

BEFORE
1912 Paul Klee urges the public to take the art of the insane and children seriously.

1939 African-American self-taught artist Bill Traylor, born a slave, creates his first works at the age of 85—they are notable for their simplified, flat forms. He is later hailed as a pioneer of outsider art.

1949 Dubuffet organizes an exhibition of *art brut* ("raw art") in Paris, featuring more than 200 works by 63 artists.

AFTER
1972 English art critic Roger Cardinal coins the term "outsider art" to describe art that is created outside the official establishment.

1979 The Hayward Gallery in London hosts the first major exhibition of outsider art in Britain, co-curated by Cardinal.

Outsider art is an umbrella term that describes the art of individuals who exist beyond any official or widely recognized art establishment. It is sometimes applied to work made by people who do not fit easily into mainstream society, such as prisoners and the mentally ill, and also to work by naive individuals or those inspired by inner vision, rather than any artistic or historical precedent. There is no one style associated with this type of art. Its practitioners tend to be self-taught and pay little attention to prevailing artistic trends. Often their work is minutely detailed and involves an obsessive exploration of a single theme. It tends to be created purely for individual satisfaction rather than for sale or exhibition.

Uncooked art
During the 19th century, some psychiatrists began to collect the artworks produced by their patients; but outsider art was only recognized as a specific category of artistic production in the 20th century, when avant-garde artists, such as Franz Marc, Paul Klee, and Max Ernst, began to appreciate its expressive powers and originality.

The artist who did more than any other to promote outsider art was Jean Dubuffet, who embraced it as a theorist, a collector, and above all as a practitioner. His work, inspired by his fascination with the art of children and the insane, was direct expression, untainted by convention. Dubuffet called it *art brut*, or "raw art," because it was "uncooked" by culture.

The Cow with the Subtile Nose has many characteristics of outsider art, and is considered to be the perfect embodiment of Dubuffet's aesthetic, which extolled the unfashionable, non-naturalistic,

See also: Cave art at Altamira 22–25 ▪ *Bad-Tempered Man* 211 ▪
Street, Dresden 290–93 ▪ *Composition VI* 300–07 ▪ *Red Balloon* 338

> Here we are witnessing an artistic operation that is completely pure, raw, reinvented in all its phases by its author, based solely on his own impulses.
> **Jean Dubuffet**

and ugly. The line is jittery, the surface is highly textured, and the naively rendered, moon-eyed cow fits clumsily into the frame, with no relationship to its background. The image works on a visceral level, conjuring up frailty and vulnerability, while also appearing ridiculous.

Scorning what he saw as an elitist and snobbish art world, Dubuffet promoted the instincts of the ordinary man. He believed that Western society and French culture had conspired to brainwash the masses and induce conformity,

underpinned by an established reverence for masterpieces of the past. He believed that there should be no single standard of excellence, and hence no aesthetic hierarchy.

Painting and collecting

Ironically, as Dubuffet railed against the establishment, he became an immensely influential figure, whose rebellious stance, repudiation of taste, and use of junk materials inspired many other artists to follow in his footsteps. He made a large collection of *art brut*, which is now housed in a dedicated museum in Lausanne. Among the many famous outsider artists represented there are Adolf Wölfli (1864–1930), who was confined to a psychiatric hospital for most of his adult life; Madge Gill (1882–1961), an English mediumistic artist who made thousands of drawings under the influence of a spirit guide called "Myrninerest" (my inner rest); and Henry Darger (1892–1973), a reclusive Chicago janitor who produced hundreds of large-scale illustrations of female characters with male genitals, whom he called "the Vivian Girls." ▪

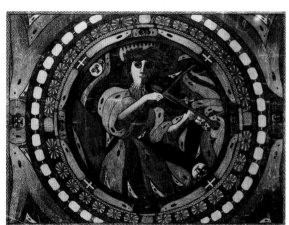

Holy Centtenaaia
(1927), drawn in colored pencil, is one of a vast number of drawings, texts, and musical compositions made by Swiss outsider artist Adolf Wölfli.

Jean Dubuffet

Born in Le Havre, France, in 1901, Jean Dubuffet initially trained as a painter in Paris but was put off by the cultural conditioning he encountered, and entered the wine business instead. It was only after turning 40 that he took up painting again, having become fascinated by graffiti he saw scrawled on the walls of Paris and the spontaneous art produced by the mentally ill. In 1948, he formed the Compagnie de l'Art Brut, an organization dedicated to collecting outsider art. He began to incorporate the qualities he found in this work into his own experimental art, often using materials such as sand and plaster, and making sculptures from junk. He was enormously prolific, working at speed without casting a critical gaze upon his works. Dubuffet died in 1985, having cataloged his entire artistic output in 37 volumes.

Other key works

1950 *Metaphysics* (part of the *Bodies of Women* series)
1952 *The Traveler without a Compass*
1955–56 *Man with a Hod*
1972 *Coucou Bazar*

I TAKE A CLICHÉ AND TRY TO ORGANIZE ITS FORMS TO MAKE IT MONUMENTAL

WHAAM! (1963), ROY LICHTENSTEIN

In the mid-1950s, artists on both sides of the Atlantic were beginning to rebel against traditional views of what art should be and turning to the commercial aspects of the world around them for subject matter. Abandoning the cultured language and aesthetics of "high" art, which was often seen as elitist, exclusive, or irrelevant, they appropriated the mass-produced images of popular culture.

Pictures from comic books, magazines, packaging, movies, and television all became the language of a new movement that was dubbed "Pop art," a term coined by the influential critic Lawrence Alloway. The British Pop art pioneer Richard Hamilton neatly encapsulated the essence of the movement in a letter in 1957 in which he listed the attributes of Pop art as: "Popular (designed for a mass audience) / Transient (short-term solution) / Expendable (easily forgotten) / Low cost / Mass produced / Young (aimed at youth) / Witty / Sexy / Gimmicky / Glamorous / Big Business."

Comic strip

In the 1950s, the US was newly affluent and enjoying a consumer boom. The growth of popular culture, and especially the proliferation of advertising that accompanied it, provided plenty of visual material for artists to draw on. Many American artists—including Roy Lichtenstein, Andy Warhol, James Rosenquist, Claes Oldenburg, and Tom Wesselmann—had backgrounds in commercial art, and understood the language and reach of mass media.

See also: *Bicycle Wheel* 308 ▪ *Autumn Rhythm* 318–23 ▪ *Mountains and Sea* 340 ▪ *A Bigger Splash* 341 ▪ *Woman Descending the Staircase* 341

IN CONTEXT

FOCUS
Pop art

BEFORE
1940s–50s American Abstract Expressionists embrace a style of art that is idiosyncratic, non-figurative, and personal. Pop art reacts against this to portray the external world using styles suggestive of mass production.

1956 The Independent Group in London stages the exhibition "This is Tomorrow," showing works that embrace popular and commercial culture.

1962 Andy Warhol produces his famous *Campbell's Soup Cans* series.

AFTER
1967 David Hockney paints *A Bigger Splash*—a view of a California swimming pool on a bright day—in a typically flat, realistic style.

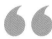

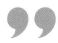

I want my work to look programmed or impersonal but I don't believe I'm being impersonal while I do it.
Roy Lichtenstein

Roy Lichtenstein

The painter, printmaker, and sculptor Roy Lichtenstein was born in New York in 1923. Early in his artistic career he experimented with Abstract Expressionism, but in 1961 he adopted a new style featuring the flat colors, banal imagery, and impersonal manner of commercial art, and especially of comic books and advertising materials. In the mid-1960s, Lichtenstein produced Pop versions of works by Cézanne and Mondrian, and started to turn more to sculpture and printmaking. In later life he received some important public commissions, including the enormous *Mural with Blue Brushstroke* (1986) for the atrium of New York's Equitable Tower (now the AXA Center). He died in New York in 1997.

Other key works

1963 *Drowning Girl*
1964 *Anxious Girl*
1967–68 *Modern Sculpture* series
1970–72 *Mirror* series
1980s *Reflections* series

Like many of Lichtenstein's works, his *Whaam!* diptych is based on an image from a comic book—an issue of *All-American Men of War*. On the left panel, an American fighter plane fires a rocket, which hits a plane in the right-hand panel. The painting retains the character of its source material, but Lichtenstein made a number of changes, maximizing the drama of his composition. He used different planes, enlarged the aircraft on the left and the flames on the right, and brought the two closer together. The source image is tiny, but Lichtenstein's painting blows it up to an enormous scale and reproduces the garish primary colors, insistent black outlines, and dots of the printing process to give it a mechanically produced feel. In the comic book, the frame is part of a fighter pilot's dream sequence, but Lichtenstein has isolated a single moment, depriving it of narrative context and leaving it up to the viewer to provide one.

Seriousness and satire

There was an element of parody in some American Pop art, and often an implicit criticism in its depiction of a consumer society that trivializes culture. British artists, such as Hamilton, Eduardo Paolozzi, David Hockney, Allen Jones, and Peter Blake, lived in a drabber reality. Viewing the superficial glamour of the American way of life from afar, they incorporated some of its alluring imagery into their own work, but their references to it were often more overtly ironic or humorous.

Because Pop art is fun and easy to look at, involving imagery that everyone recognizes, it has proved enduringly popular with the public. Although sometimes dismissed by critics as superficial, it is generally accepted as an apt artistic response to mass-produced culture. ▪

ACTUAL WORKS OF ART ARE LITTLE MORE THAN HISTORICAL CURIOSITIES

ONE AND THREE CHAIRS (1965), JOSEPH KOSUTH

IN CONTEXT

FOCUS
Conceptual art

BEFORE
1913–17 Marcel Duchamp develops the first "readymades," everyday objects chosen at random and presented as works of art.

1929–30 René Magritte's *The Treachery of Images*, a painting of a pipe with the inscription "*Ceci n'est pas une pipe*" ("this is not a pipe"), challenges conventional notions of how images and words relate to objects.

AFTER
1993 At the Venice Biennale, Hans Haacke systematically destroys the marble floor of the German pavilion once used by the Nazis, dematerializing both the art object and the institution exhibiting it.

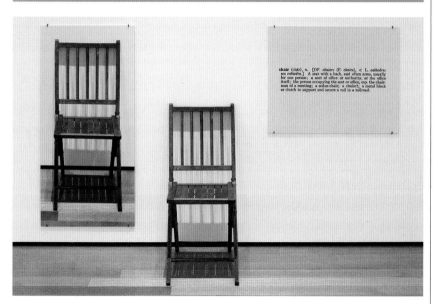

A merican artist Joseph Kosuth (1945–) has for many years been involved in an exploration of how art is defined: his opinion is that it is a continuation of philosophy, which has come to an end. In 1965, Kosuth began to produce works with a basis in language, sometimes simply reproducing texts, sometimes linking texts with objects and images.

His *One and Three Chairs* presents the viewer with three versions of a chair, lined up in a row. The object itself is flanked by a photograph of the chair as actually installed in the room, and a dictionary definition of the word "chair." The installation changes slightly every time it is made, since the choice of chair is left up to the installer, and so the photograph of the chair differs, too. The only constant element of the work is the hung dictionary definition.

The work is intended to prompt questions about the relationship between the real, physical, object (a "readymade"), and the visual and verbal representation of that object. This process of speculation is key to conceptual art, which arose in 1960s Europe and the US as a critique of Western art. In Kosuth's art, ideas and information are prioritized over emotion and aesthetics. In the 1970s and 1980s, other artists extended conceptual art to embrace criticism of the commercial and political systems that sustain the art world, and to democratize the process of making art itself by involving the spectator in its creation. ∎

See also: *Bicycle Wheel* 308 ▪ *The Persistence of Memory* 310–15 ▪ *The Dinner Party* 332–33 ▪ *The Clock* 336–37 ▪ *Away from the Flock* 341

ONE'S MIND AND THE EARTH ARE IN A CONSTANT STATE OF EROSION

SPIRAL JETTY (1970), ROBERT SMITHSON

IN CONTEXT

FOCUS
Land art

BEFORE
c.1000–700 BCE A stylized white horse is carved into the side of a hill at Uffington in Oxfordshire, England.

c.500 BCE–500 CE Geoglyphs representing creatures such as monkeys and birds are carved into the Nazca desert in Peru.

1967 Richard Long paces back and forth in a grassy field to create *A Line Made by Walking*. The work is ephemeral, but is recorded in a photograph.

AFTER
1977 American artist James Turrell begins the Roden Crater project, reshaping an extinct crater in Arizona as a gateway to the contemplation of light, time, and landscape.

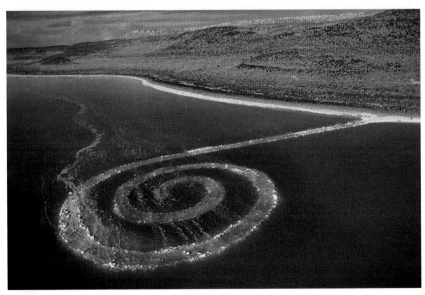

From the late 1960s, growing awareness of environmental issues such as deforestation, pollution, and species extinction caused widespread public debate and encouraged a group of mainly British and American artists—including Richard Long, Walter De Maria, Dennis Oppenheim, and Michael Heizer—to work directly with nature. The artists created monumental sculptures out of the land itself, or documented their various journeys through it in texts and photographs. Their work had

significant ancient precedents, including the megalithic Stone Age monuments found in Brittany, the British Isles, and elsewhere; the geometrical configurations at Nazca in Peru; and the figures carved into English chalk hills.

In 1970, US land artist Robert Smithson (1938–73) produced the large-scale earthwork *Spiral Jetty*, a spiral path 1,500 ft (457 m) long

and 15 ft (4.6 m) wide, composed of mud and basalt, which coils into Utah's Great Salt Lake. Smithson deliberately located the path in a part of the lake where the water has a distinctive blood-red hue. The jetty appears and disappears according to the water levels.

Smithson intended his work to prompt reflection on our essential unimportance in the face of time and entropy—the law of increasing disorder. The original black color of *Spiral Jetty*'s rocks has changed as they have become encrusted with salt, but the artist would have approved of the way that nature has reshaped his work. ∎

See also: Altamira cave paintings 22–25 ▪ Terra-cotta Army 56–57 ▪ Easter Island statues 78 ▪ *Running Fence* 341

ART IS THE SCIENCE OF FREEDOM
I LIKE AMERICA AND AMERICA LIKES ME (1974), JOSEPH BEUYS

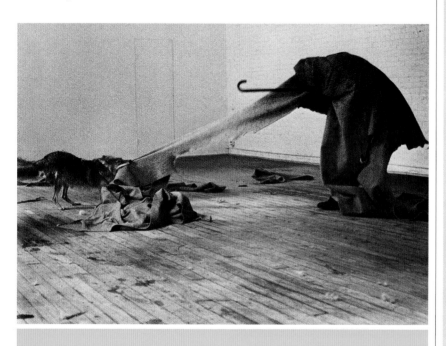

IN CONTEXT

FOCUS
Performance art

BEFORE
1916–1920s The Dada movement makes frequent use of performance and nonsense.

1959 American artist Allan Kaprow coins the term "happening" to describe an action by an artist, often with audience participation.

1960 French artist Yves Klein invites members of the audience in evening dress up on stage to observe naked models covered in paint being dragged across canvases.

AFTER
2010 Serbian performance artist Marina Abramovic performs *The Artist is Present* at the Museum of Modern Art (MoMA) in New York. In the 736-minute piece, she sits silently while spectators take turns sitting opposite her.

The second half of the 20th century saw the start of a major new phenomenon in avant-garde art, in which the focus shifted from the products made by an artist to the artist's personality, actions, and performance. The Futurists, Dadaists, and Surrealists earlier in the century had staged provocative events to promote their work, but "performance" only came to be recognized as a separate category of art in the early 1970s.

In performance art, the artist uses his or her own body as a medium, undertaking a series of actions that become the work of art itself. Because performances are ephemeral, they are usually recorded in photographs, films, and video, making them accessible to a wider public and posterity.

Performance art often sets out to be shocking or provocative in order to promote the artist's views or ideas; it can also include a strong element of social critique, forcing audiences to reevaluate their relationship with the world around them. The performance pieces of Joseph Beuys, who was a leading figure in the movement, were closely linked to his political activism. Beuys believed that what he called his "social sculpture" or "actions" could change society, yet they were also autobiographical, drawing on his personal experience.

Action in the gallery
Beuys's most famous action, *I Like America and America Likes Me*—staged in New York's René Block Gallery in 1974—united the artist's political concerns and his own story.

Beuys flew to New York from Germany, and was then wrapped in a large felt blanket and transported from the airport to the gallery in an ambulance. The felt was a crucial part of Beuys's personal mythology:

> The whole process of living is my creative act.
> **Joseph Beuys**

according to his own account, during World War II the plane he was flying was shot down. After several days buried in the snow he was rescued from near-death by nomadic Tartars, who wrapped him in fat and felt to keep him warm.

Beuys spent three days roaming the art gallery wearing his felt blanket, brandishing a cane, and performing a series of quasi-shamanistic gestures while staring at a coyote, which was incarcerated with him. The coyote periodically urinated on a large pile of copies of *The Wall Street Journal*. At the end of the three days the coyote, which had been aggressive at the start of the performance, had become almost companionable.

The coyote was a powerful god for the Native Americans, but seen as a pest by European settlers. For Beuys, the animal symbolized the damage done by the white man, and he saw his action as a kind of ritualistic healing process. The title of the action can also be read as a critique of US artistic hegemony and the military involvement in Vietnam, to which Beuys was bitterly opposed. But the title is also ironic, since Beuys hardly touched American soil—after the action ended the ambulance drove him straight back to the airport. ▪

Beuys was wrapped in felt during his three-day performance—this helped to "isolate" and "insulate" him. He wanted, he said, to "see nothing of America other than the coyote."

Joseph Beuys

Joseph Beuys was born in Krefeld, Germany, in 1921. As a young man he witnessed book-burnings by the Nazi party; he joined the Hitler Youth movement in 1936, the year that membership became compulsory. He enlisted in the Luftwaffe in 1941, and his plane was brought down over the Crimea in 1944. After the war, he studied sculpture in Düsseldorf, and turned to drawing in the 1950s.

Beuys was appointed to a teaching position in Düsseldorf in 1961 and joined the Fluxus group of artists, who promoted "anti-art" and "happenings." He created sculptures and installations that were made of junk or non-art materials, but is best known for his performance pieces. He toured the world delivering lectures on themes including politics and social sculpture, which can be seen as performances in their own right. By the time he died in Dusseldorf in 1986, Beuys was an international celebrity.

Other key works

1965 *How to Explain Pictures to a Dead Hare*
1969 *The Pack*
1972 and 1978 *Blackboards*

WE'RE ALL EDUCATED TO BE FRIGHTENED OF FEMALE POWER

THE DINNER PARTY (1974–1979), JUDY CHICAGO

IN CONTEXT

FOCUS
Feminist art

BEFORE
c.1907 Female artists lend their support to the women's suffrage movement, designing polemical feminist posters.

1965 In Yoko Ono's *Cut Piece* performance, Ono appears on stage while audience members cut her clothes to shreds, evoking sexual violence.

1974–76 US artist Nancy Spero produces *The Torture of Women,* her first feminist work.

AFTER
1980s In the US, Barbara Kruger creates montages with provocative feminist messages directed at a male audience.

1989 The Guerrilla Girls, a group of US feminists, launch a poster campaign to expose discrimination in the art world. The poster asks, "Do women have to be naked to get into the Met. Museum?"

For most of history, women artists have worked as amateurs and have been accorded a lesser status than men, because the serious pursuit of an art career was long thought to be incompatible with femininity. While a few notable women have been able to overcome such prejudices and make a living as artists (the Italian Baroque painter Artemisia Gentileschi and the 18th-century French artist Élisabeth Louise Vigée-Lebrun being two famous examples), the art world has traditionally been, and remains, dominated and defined by men.

The feminist movement in the US and Europe in the 1960s demanded a reappraisal of women's role in society and paved the way for real change. A parallel struggle also took place in the world of art, where a number of women artists opened up new opportunities and spaces that allowed them to address issues of concern, such as representation and identity, sexism, political and economic equality, and sexuality.

There is no one prevailing style of feminist art, although artists share a number of preoccupations: many practitioners prefer to work with newer media, such as video, performance, and installation, which are less tightly bound to male precedent and offer new perspectives; to organize group exhibitions; and to work more collaboratively.

A place at the table

Judy Chicago's *Dinner Party* is an icon of feminist art that celebrates the place of women in Western civilization. It features an immense triangular table—the triangle being a symbol of equality. There are 39 place settings, each with an individually modeled ceramic plate and embroidered

Judy Chicago

Judy Chicago named herself after the city where she was born in 1939, rejecting her given name in a celebration of independence from male dominance. She has spent most of her life living and working in California. In 1969, she set up the first feminist art education programme, at California State University, Fresno, and in 1971 co-founded the Feminist Art Program at California Institute of the Arts with Miriam Shapiro. In 1978, Chicago established Through the Flower, a nonprofit organization that supported her work and informed the public about the importance of art and how it can be used to emphasize women's achievements.

Other key works

1980–85 *The Birth Project*
1987–93 *The Holocaust Project: From Darkness to Light*

My abiding goal for *The Dinner Party* was to educate future generations about women's rich heritage and their important contributions to Western civilization.
Judy Chicago

runner. The 13 places on each side all represent an important female figure from mythology or history, and the table arrangement is a clear reference to Leonardo da Vinci's *Last Supper*, which shows Christ and his 12 (male) disciples. Chicago declared that she was amused by the idea of depicting a dinner party from the point of view of those who would traditionally have been expected to prepare the food and then disappear.

Revisiting history

The table rests on a porcelain floor, which is inscribed with the names of 999 women. The work follows a broadly chronological sequence: the first "wing" of the table has places set for the primordial goddesses, and figures from early Judaism and from Greece and Rome. The second wing moves from early Christianity to the Reformation; the third deals with the American Revolution, the women's suffrage movement, and the emergence of women's creative expression, and includes places for writers such as Emily Dickinson

and Virginia Woolf, as well as artist Georgia O'Keeffe, who was the only living "guest" when the piece was completed. O'Keeffe's flower paintings resonate with the overtly vaginal imagery of Chicago's plates, whose form and decoration become ever more elaborate as the place settings progress through history.

The piece embraces three central concerns of feminist art: a reexamination of history from

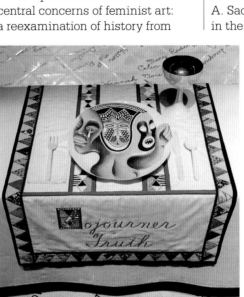

a feminist viewpoint; a reversal of the traditional view that craft (often the preserve of women) is in some way inferior to "high" art (often the preserve of men); and a collective method of working, since several hundred people—mainly women— were involved in the project.

This seminal work (now the central exhibit at the Elizabeth A. Sackler Center for Feminist Art in the Brooklyn Museum, New York) has been viewed by more than a million people in six countries during touring exhibitions. A core piece of feminist art, it has even had an impact on the way in which art history and history itself are taught and learned. ▪

More than 400 people were involved in *The Dinner Party*— in research, embroidering table linen, and decorating ceramics. This place setting honors 19th-century African-American abolitionist and women's rights activist Sojourner Truth.

I SHALL NEVER TIRE OF REPRESENTING HER

MAMAN (1999), LOUISE BOURGEOIS

See also: Woman of Willendorf 20–21 ▪ Studies for *The Virgin and Child with St. Anne* 124–27 ▪ Goddess Coatlicue 132–33 ▪ *The Child's Bath* 281

IN CONTEXT

FOCUS
Motherhood in art

BEFORE
3rd century CE *Virgin Mary with Christ on her Knee* in the Roman catacomb of Priscilla is perhaps the earliest version of a subject that will come to dominate Christian art.

1789 Élisabeth Vigée-Lebrun paints a self-portrait with her daughter Lucie, a tender evocation of mutual affection.

1973–79 American artist Mary Kelly produces *Post-Partum Document*, which charts all her infant son's developmental stages.

AFTER
2011 British artist Jenny Saville paints *Mother and Children*—showing herself, pregnant and holding two babies—based on a famous cartoon by Leonardo da Vinci.

Louise Bourgeois

Born in Paris in 1911, Louise Bourgeois first studied math at the Sorbonne before turning her attention to art, and working with Fernand Léger. Following her marriage to art historian Robert Goldwater in 1938, she moved to New York, where she focused on sculpture. Her early works were in wood, bronze, and marble, but she later used unconventional materials such as latex and fabric. Bourgeois died in New York in 2010 at the age of 99, having achieved artistic renown in her 70s.

Other key works

1947–49 *The Blind Leading the Blind*
1950 *Sleeping Figure*
1974 *The Destruction of the Father*
1993 *The Arch of Hysteria*

The theme of mother and child is a central motif in Western art; for centuries, the Virgin Mary has presented the ideal of the protective mother to which all women should aspire. In our own post-psychoanalytical age, however, the vision of motherhood has become more ambiguous and complex, especially in the work of female artists.

Louise Bourgeois drew on painful memories of childhood trauma to create her tribute to her own mother, who had died when the artist was just 21. When her father made fun of the grief she felt, she attempted to commit suicide by throwing herself into a river; but the tragic loss of her mother was the catalyst that prompted Bourgeois to take up art.

Maman is an immense steel spider, supported on eight legs, which enables the viewer to walk around and underneath the sculpture and look up at the vast body suspended above them. A mesh egg sac hanging down below the body holds 17 white and gray marble eggs. Bourgeois' mother had worked in the textile business, repairing tapestries, and the artist saw a parallel between her weaving and the spider spinning its web; while many people are repulsed by spiders, Bourgeois thought of them as helpful, friendly creatures that rid humanity of diseases.

Fear response

People who view the huge spider report complicated responses to the work, ranging from feelings of being sheltered to extreme anxiety. The scale of the work, which dwarfs anyone looking at it—it is more than 30 ft (9 m) high and 33 ft (10 m) across—can make the viewer feel like an infant looking up at an all-powerful mother, who is at the same time protective of her eggs and vulnerable as she balances on her spindly legs.

Bourgeois revealed that a prime motivation for her making art was to overcome her fear—in this case, possibly the fear of abandonment on her mother's death, and the fear she may have felt for her own children. Ultimately, *Maman* can be seen as referring to many maternal figures: the artist, her mother, and a mythological or archetypal mother.

When it was installed at the Tate Modern gallery in London in 2000, the sculpture overlooked three steel towers entitled: *I Do*, implying love and commitment; *I Undo*, indicating an unraveling; and *I Redo*, suggesting reparation and reconciliation. In all three towers, Bourgeois placed a bell jar containing small sculptures, each one a reflection on the mother–child relationship: in *I Do*, a mother and child embracing (the "good" mother); in *I Undo*, a mother distracted and a baby crying (the "bad" mother); in *I Redo*, a mother connected to her floating baby by an umbilical cord. ▪

CHANGE IS THE CREATIVE IMPULSE

THE CLOCK (2010), CHRISTIAN MARCLAY

IN CONTEXT

FOCUS
Video art

BEFORE
1960s Artists have access to affordable video technology for the first time.

1963 Andy Warhol produces *Sleep*, a film of his friend John Giorno sleeping for more than five hours.

1968 An early pioneer of video art, American artist Bruce Nauman begins to film himself performing in his studio.

1993 Douglas Gordon produces *24 Hour Psycho*, an adaptation of Alfred Hitchcock's *Psycho*; Gordon slows down the classic 1960 film to last 24 hours.

2003 *The Listening Post*, by Ben Rubin and Mark Hansen, pulls fragments of conversation from website chatrooms in real time.

See also: *The Persistence of Memory* 310–15 ∙ *One and Three Chairs* 328 ∙ *I Like America and America Likes Me* 330–31

Contemporary artists have adopted a range of technologies, including film, audio, video, and digital, to produce work that uses the moving image and features duration as a central theme. Time-based art takes a great diversity of forms, including installation and performance art. Some works mix a diverse range of media and may even incorporate the viewer's experience of the art.

The early development of such artworks was linked closely to the introduction of affordable video equipment in the 1960s. The nature of this technology made it ideally suited to recording the real world, and such art often reflects a close engagement with physical reality, using the language of the moving image that surrounds us every day. Video art may involve actors and the spoken word, but unlike cinema it does not necessarily involve narrative or plot. While early video art featured grainy black-and-white recordings, more recent examples are often colorful, large-scale installations shown over multiple screens. Works can vary in length from minutes to hours.

A moving collage

Time necessarily underpins all video art, but Christian Marclay's 24-hour piece *The Clock* engages with the notion of time itself. It is a montage of film and television clips that is also a working timepiece: every minute of the day is shown in "found" footage that includes a clock or a watch. The showing of the piece is always synchronized with local time, so that the viewer can tell the time from *The Clock*.

Marclay employed a team of researchers to seek out the very specific footage needed, and it took him three years to edit and assemble it into the finished work, which reflects a century of cinema history. The work touches on how plot and time are represented on film, and features everything from car chases, hospital wards, and shootouts, to mundane scenes of everyday life, including some wonderfully humorous moments.

Life's routines

Although it is a collage, *The Clock* has a sense of development that parallels daily rhythms: characters drink or are intimate at night; in the early hours of the morning they are sleeping or dreaming; they wake up and have breakfast at the expected times; and the action builds to a crescendo at noon with a clip from the film *High Noon*. The characters hurry for trains or miss them, eat dinner, and go to concerts at the appropriate hours of the evening; at midnight, a clip from the film *V for Vendetta* shows the famous London clock tower Big Ben exploding.

The Clock received critical acclaim when it was unveiled at London's White Cube Gallery in 2010. When it was awarded the Golden Lion Prize at the Venice Biennale in 2011, Christian Marclay thanked the jury for awarding the work its 15 minutes of fame. ∎

Christian Marclay

Christian Marclay was born in 1955 in California. He studied art in the US and Switzerland. His career has spanned many different media—installation art, performance, sculpture, and experimental music. In the 1970s, he made and performed vinyl record collages, and much of his work since then has fused sound with the visual aspects of music, recording, and performance. He now lives in London, England.

Other key works

1980–81 *Recycled Records*
2000 *Guitar Drag*
2002 *Video Quartet*
2007 *Crossfire*

PORTFOLIO

THE LAST SUPPER
(1909), EMIL NOLDE

Although he was briefly a member of Die Brücke, Nolde (1867–1956) trod an independent path. His output was varied, including Expressionist landscape and seascape paintings, prints, sculpture, and watercolors of flowers; but his most personal works are perhaps his religious

Jacob Epstein

Jacob Epstein was born in New York in 1880 but moved to England in 1905. Almost his entire career played out in his adopted country, where he became the leading avant-garde sculptor of his era. Epstein endured abuse from critics and the public—some of his work was denounced for its expressive distortions and alleged indecency. But his more traditional portrait busts always had many admirers; his sitters included some of his famous contemporaries. The busts were modeled in plaster and cast in bronze, but he was also a superb stone carver. Despite his controversial image, Epstein received several public commissions, including *Rima* (1925), reviled as "the Hyde Park atrocity." He died in 1959.

Other key works

1913–15 *The Rock Drill*
1940–41 *Jacob and the Angel*
1956–58 *St. Michael and the Devil*

paintings, which achieve intense emotion by means of grotesque distortion and vivid color. *The Last Supper* uses blood-red, blue, yellow, and white to depict Christ and the 12 disciples, who are grouped around an unidentified light source that illuminates their features and expressions. The painting was condemned by the Nazis in the 1930s and appeared, against the artist's wishes, in their "Degenerate Art" exhibition in 1937.

TOMB OF OSCAR WILDE
(1912), JACOB EPSTEIN

Few artists have caused as many public controversies as Epstein, and his tomb of Oscar Wilde was no exception. The powerful block-like figure of a hovering nude angel, in a hunched pose reminiscent of ancient Assyrian winged bull friezes, memorializes the celebrated playwright. The statue's conspicuous genitals were thought to be an affront to public decency and the tomb was covered for two years before it was unveiled in 1914.

THE JACK PINE
(1917), TOM THOMSON

The most famous of all Canadian paintings, *The Jack Pine* has become virtually a symbol of the country. Its bold patterning and strong contrasts of light and color create a suitable idiom for evoking the rugged wilderness landscape of Algonquin Park in Ontario, where Thomson (1877–1917) sketched and

for a time worked as a guide. He mysteriously drowned in a lake in the park only a few months after completing the painting, but he was an inspiration to the Group of Seven (which held exhibitions from 1920 to 1931), the first significant national movement in Canadian art.

RED BALLOON
(1922), PAUL KLEE

One of the great free spirits of art, Klee was unconventional in his methods and joyfully liberated in his imaginative approach. Although he began his artist's career as an etcher, he developed a subtle sense of color, and in many of his works created a delicate balance between abstraction and representation. At first sight, this work may seem entirely abstract—a group of playful geometric shapes—but in fact it whimsically evokes a balloon floating over a roofscape. Klee was an excellent violinist and thought color could enchant in a way similar to music. His work was too personal to inspire much imitation, but his ideas were influential.

THE DEFENSE OF PETROGRAD
(1927), ALEXANDER DEINEKA

In Stalin's Soviet Union, the arts were controlled: artists, writers, and even composers were expected to glorify the state. In the visual arts, this resulted in stereotyped images in a conventional academic style, although some artists were talented

Paul Klee

Paul Klee was born in 1879 in Switzerland and spent much of his time there, although he was a German citizen throughout his life. He worked in various places in Germany, including Munich, and from 1921 to 1931 he was a much-loved teacher at the Bauhaus (in both Weimar and Dessau), the most important art school of the 20th century. In 1933, the Nazis dismissed him from his position at the Düsseldorf Academy and he moved to Berne, Switzerland. During his final years, Klee suffered from a debilitating skin disease, but his work still showed his inimitable wit and fantasy until his death in 1940.

Other key works

1922 *The Twittering Machine*
1925 *Fish Magic*
1940 *Death and Fire*

enough to rise above restrictions. The greatest painter of the era was Alexander Deineka (1899–1969), whose work is vigorous and full of feeling. *The Defense of Petrograd* represents an episode in the Russian Civil War of 1918–21, capturing the rhythm and discipline, as well as the bleak heroism of battle.

COMPOSITION II IN RED, BLUE, AND YELLOW
(1930), PIET MONDRIAN

The Dutch painter Piet Mondrian (1872–1944) was a key figure in the development of abstract art. He gradually eliminated any representational elements to arrive at a style of geometrical purity, eventually restricting himself to straight lines, right angles, and the primary colors, plus black and white. *Composition II in Red, Blue, and Yellow* shows the taut, subtle balance he could achieve through such simple means. His art had a great influence on commercial design as well as on other artists. Although his works were austere, he said that they represented a greater, universal truth beyond everyday appearance.

AMERICAN GOTHIC
(1930), GRANT WOOD

Although it is now a much-loved image, this painting was at first highly controversial, some people considering it a cruel caricature of a simple farming couple. In fact, the models, shown in front of a farmhouse that features a pointed Gothic window, were the artist's sister and his dentist. Wood (1891–1942) was one of the leading figures of artistic Regionalism—a patriotic movement in American painting that flourished in the 1930s—in which artists rejected avant-garde ideas from Europe and depicted the small-town life of their own country, particularly the Midwest.

HURRAH, THE BUTTER IS FINISHED!
(1935), JOHN HEARTFIELD

A leading figure of the Berlin Dada movement, German artist Heartfield (1891–1968) changed his name from Helmut Herzfeld in protest at his country's nationalism in 1916. In this scene, a family is shown eating metal implements, expressing with absurd literalness the Nazi doctrine that "Iron makes a country strong; butter and lard only make people fat." Heartfield was harassed by the Nazis for such work, and for his satirical photomontages, of which he was a brilliant exponent. He moved to London in 1938 but returned to Germany after the war.

TOTES MEER (DEAD SEA)
(1940–1941), PAUL NASH

During World War I and II, the British Government sponsored artists to produce images for documentation and propaganda. Several highly distinguished painters served as official war artists in both wars, among them Paul Nash (1889–1946). In World War I, he memorably depicted the desolate wastes of battlefield landscapes in France. In World War II, his finest achievement was this eerie scene of an aircraft salvage dump in Oxfordshire, the wings of shot-down aircraft resembling undulating waves.

NIGHTHAWKS
(1942), EDWARD HOPPER

The Regionalism practiced by Grant Wood was part of a broader movement known as American Scene Painting, of which the greatest exponent was Edward Hopper (1882–1967). He created a distinctive, melancholic visual world through subjects taken from the banal, everyday life he saw around him, such as motels, filling stations, and cafeterias. Typically his paintings evoke what he called "the loneliness of a big city," as in his most famous work, *Nighthawks*. It shows a diner late at night on

a dark street corner, with four people (the nighthawks of the title) depicted through the large plate window in a hyperrealist style.

NED KELLY SERIES
(1946–1947), SIDNEY NOLAN

Australia's most famous painter, Nolan (1917–92) frequently worked in series, and returned several times to a favorite subject: the 19th-century outlaw and folk hero Ned Kelly. His first series on Kelly (1946–47) consists of 27 paintings. Although it follows the course of Kelly's story—which has also inspired films, songs, and novels—the series does not form a conventional narrative. It takes incidents from Kelly's life as the basis for meditations on themes such as love and injustice. In Nolan's words, the main ingredients are, "Kelly's own words, and [painter Henri] Rousseau, and sunlight"—a synthesis of Australian history and landscape with European ideas. Nolan had an international career and created a large and diverse output, but he is chiefly associated with works inspired by his country's landscapes and history.

MOUNTAINS AND SEA
(1952), HELEN FRANKENTHALER

A key work of mid-20th-century American art, *Mountains and Sea* was the first major painting in which Frankenthaler (1928–2011) used her innovative technique of pouring very thin paint over a canvas so the paint becomes integral with the surface. This technique allowed her to create delicate veils of color—a sharp contrast to the vigorously impasted surfaces that characterized much Abstract Expressionist painting. Among the major artists who were immediately influenced by it were Morris Louis and Kenneth Noland, who both saw *Mountains and Sea* in Frankenthaler's studio in 1953.

BIG RED
(1959), ALEXANDER CALDER

The American sculptor Calder (1898–1976) is renowned as the inventor of a type of free-moving abstract sculpture known as a mobile. His mobiles usually feature flat shapes of lightweight metal suspended from wire and are moved by air currents. Calder made the first small examples in the early 1930s but later worked with commercial fabricators on large-scale pieces, such as *Big Red*, which spans about 9 ft (3 m). It was in the 1950s that kinetic art began to be recognized as a distinct genre, and Calder is acknowledged as one of its chief pioneers and leading exponents.

SINGLE FORM
(1963), BARBARA HEPWORTH

Early in her career, Hepworth had been predominantly a carver in stone and wood, but in 1956 she began casting in bronze. The medium enabled her to work on a larger scale and to meet the growing demand for her art by producing multiple casts. *Single Form*—her largest work, at 21 ft (6.4 m) high—is a memorial to Swedish diplomat Dag Hammarskjöld, UN secretary-general, killed in a mysterious plane crash. It is a flat, irregular, upright form in bronze, pierced by a hole. Although completely abstract, the work has been said to embody a "vision of the cosmos."

CUBI XIX
(1964), DAVID SMITH

Arguably the most important and inventive American sculptor of the 20th century, Smith (1906–65) was a contemporary of the great Abstract Expressionist painters. He was a pioneer in using welded iron and scrap metal, and the leading figure in establishing polished steel as a sculptural material. In *Cubi XIX*, part of a series of 28 works, geometric forms—rectangles,

Barbara Hepworth

Born in Wakefield, England, in 1903, Barbara Hepworth studied art at Leeds and at the Royal College of Art in London. One of her fellow students was sculptor and artist Henry Moore (also from Yorkshire), who became a lifelong friend. In 1931 she met the painter Ben Nicholson, whom she married in 1938 (they separated in 1951). Together with Moore, they were at the heart of avant-garde art in Britain. With war imminent in 1939, Hepworth and Nicholson moved from their London home to live in Cornwall, where they formed the nucleus of a colony of abstract artists. Hepworth lived there for the rest of her life, which ended tragically in a fire in her studio in 1975.

Other key works

1927 *Doves*
1946 *Pelagos*
1955 *Curved Form (Delphi)*

Gerhard Richter

Gerhard Richter was born in 1932 in Dresden, which became part of East Germany after World War II, and studied at Dresden Art Academy. In 1961 (before the Berlin Wall was erected), he escaped to West Germany. Initially he lived in Düsseldorf, but in 1984 he settled in Cologne, where he still lives. His reputation grew throughout the 1960s and in 1972 he represented West Germany at the Venice Biennale. He has won many distinctions, and exhibitions of his work have been held in several of the world's leading museums of modern art. In addition to painting, he has worked in other media, notably designing a huge abstract window (unveiled in 2007) for Cologne Cathedral measuring 66 ft (20 m) high.

Other key works

1973 *1024 Colors*
1988 *St. John*
1998 *Seascape*

cubes, and disks—are arranged to create a dynamic balance that breaks away from the traditional idea that sculpture should be based on a stable core.

WOMAN DESCENDING THE STAIRCASE
(1965), GERHARD RICHTER

One of the most admired painters of his time, Richter has achieved equal success in abstract and figurative styles; he is particularly associated with his use of photorealism, which refers to the relationship between painting and photographic sources. *Woman Descending the Staircase* focuses on an elegant woman in an evening gown. The documentary-like piece imitates an out-of-focus snapshot by blurring all details—here, the technique immediately brings to the fore the issue of identity and the representation of women and beauty in photography, art, and the media.

A BIGGER SPLASH
(1967), DAVID HOCKNEY

The most acclaimed British painter of his generation, Hockney (1937–) has divided his career between Britain and Los Angeles, a city he first visited in 1963, attracted by its relaxed lifestyle. The swimming pool became one of his favorite themes, and this is his best-known painting of the subject, showing water spraying into the air after an unseen swimmer has dived in. Hockney had taken up acrylic paint in the US, and he found its bold, flat colors particularly suited to capturing the clean, sunlit forms of his idyllic California.

RUNNING FENCE
(1976), CHRISTO

Bulgarian by birth but a US citizen since 1973, Christo Javacheff (1935–) became famous for a type of art called *empaquetage* (packaging), in which he wrapped objects in canvas, plastic, or other materials. He began in about 1960 with small objects and progressed to large public buildings, including the Pont Neuf in Paris (1985) and the Reichstag in Berlin (1995). *Running Fence*—a collaboration with his wife, Jeanne-Claude Denat—was a white fabric screen, 18 ft (5.5 m) high, that ran through 25 miles (40 km) of northern California. The two-week installation made use of the sky, the ocean, and hills, and was designed to raise issues of freedom and constraint.

HUMANITY ASLEEP
(1982), JULIAN SCHNABEL

American Julian Schnabel (1951–) is probably the best-known exponent of Neo-Expressionism, one of the key art movements of the 1980s, especially in the US, Germany, and Italy. Neo-Expressionist paintings are typically large and assertive, with very rough handling of materials and bleak, obscure subject matter. Sometimes objects are embedded in the thick paint, as with the smashed crockery that encrusts *Humanity Asleep*. The painting shows an archangel with a raised sword hovering above a raft on which are two heads, one of them featureless. According to the artist, the work is "beyond logic" and not a literal illustration of its title.

AWAY FROM THE FLOCK
(1994), DAMIEN HIRST

The best known of the "Young British Artists" who emerged in the early 1990s, Damien Hirst (1965–) engages with fundamental aspects of human existence and has shown a particular preoccupation with the fragility of life and the finality of death. *Away from the Flock* consists of a glass-walled tank filled with transparent formaldehyde solution in which a dead lamb is arranged in a frolicking posture. Hirst has attracted a huge amount of publicity throughout his career, both positive and negative.

GLOSSARY

Abstract Expressionism A style of painting that emerged in New York in the mid-1940s. Artists usually worked on large canvases and combined varying degrees of abstraction with strong expressive content.

Academic art Art produced by artists trained at European academies, which aimed to educate in classical art, life drawing, and anatomy. Conservative and resistant to innovation.

Aestheticism A movement that flourished in the late 19th century, especially in Britain, fueled by a belief in "art for art's sake"—that arts should give pleasure rather than having an explicit social or moral purpose.

art brut A term roughly meaning "raw art" that was coined by 20th-century French artist Jean Dubuffet to describe art created outside the cultural tradition of fine art.

avant-garde A term applied to artists (or their works), especially of the early 20th century, considered to be innovative or ahead of their time.

Baroque A movement in European art and architecture that flourished in the 17th century. Baroque painting and sculpture are often characterized by dynamic movement, emotional intensity, and theatrical effects.

Blaue Reiter, Der A loose association of **Expressionist** artists, based in Munich, who were active from 1911 to 1914. The name means "The Blue Rider."

Brücke, Die A group of German **Expressionist** artists, formed in Dresden in 1905, whose work was characterized by compositions with strong colors and angular forms. The name is German for "The Bridge."

Byzantine art Art of the Eastern Roman Empire from the 5th century to 1493. Its austerity, hierarchical arrangements of figures, and flattened space remained influential in Italy until Giotto and the Renaissance.

chiaroscuro An Italian term meaning "bright-dark" that is used to describe the effects of light and dark in a painting.

Conceptual art Art movement of the late 20th century in which the idea is considered to be at least as important as the physical artwork.

Constructivism A movement that originated in Russia around 1914, characterized by the use of industrial materials, such as metal components, arranged in abstract forms.

contrapposto A term used to describe a sculptural pose in which a figure stands with shoulders twisted away from the hips, suggesting movement. The style, which originated in Classical Greek art, was adopted by Gothic and Renaissance artists.

Cubism A revolutionary style of art, created by Georges Braque and Pablo Picasso in 1907. It involved bringing together multiple views of an object in one painting, producing a fragmented, abstracted image.

Dada A deliberately meaningless name chosen by the founders of this early 20th-century European movement. It mocked convention and was characterized by an anarchic spirit of revolt against traditional values.

Expressionism A movement that flourished in Germany in the early 20th century. Artists sought to express a subjective world of emotion using distortion and exaggeration.

Fauvism An early 20th-century movement characterized by vivid expressionistic and non-naturalistic use of color that flourished briefly in Paris from 1905 to about 1907.

feminist art Art created in response to the feminist theories of the 1960s and 1970s that usually challenges cultural attitudes toward women.

fête galante A type of painting, usually small in scale, that shows figures in civilized recreation in a tranquil landscape. It was pioneered in the early 18th century by French painter Antoine Watteau.

Futurism An Italian **avant-garde** art movement of the early 20th century that celebrated the modern world, machines, and technology.

genre painting A painting that shows a scene from daily life, particularly popular in 17th-century Holland.

Gesamtkunstwerk A German term meaning "total work of art," first used in the early 19th century to describe operatic works but later applied to the synthesis of other art forms.

Gothic A term applied to the art and architecture prevalent in Europe in the late Middle Ages. The architecture is characterized by pointed arches and soaring, light interiors. Paintings and sculptures often feature figures that have a swaying gracefulness.

Grand Manner A term used mainly in England in reference to an idealized, classical approach to painting.

happening A type of **avant-garde** artistic expression that takes the form of an event or performance, often with elements of spontaneity and interaction.

history painting Painting in which classical, mythological, biblical, or historical events are the subject.

humanism A philosophy that broke from the medieval practice of placing religion at the center of art and embraced secular concerns inspired by classical thought. It informed the art, writing, and science of the Renaissance.

Impressionism A highly influential movement in painting that began in France in the 1860s. Artists were concerned with depicting the visual impression of the moment in terms of shifting effects of light and color.

installation art Artworks or assemblages often in mixed media and designed for a specific place and time.

International Gothic A style that flourished in Europe from c.1375 to c.1425. It was marked by its elegant beauty and delicate naturalistic detail.

kinetic art Art that incorporates an element of movement, or that gives the illusion of movement.

land art Art that is formed within or from the landscape itself.

Mannerism A style that flourished in 16th-century Italy after the High Renaissance. Practitioners valued style and technique over naturalism.

Minimalism A movement in abstract art that flourished in the 1960s and was characterized by simplicity of form and a deliberate lack of expressive content.

Modernism A movement in art and literature that arose in the late 19th century and rejected styles of the past and celebrated innovation.

naturalism The representation in art of people, objects, or landscapes with minimal subjective interpretation. Also (Naturalism) a 19th-century movement associated with this way of painting.

Neo-Expressionism A style that flourished particularly in the late 1970s and 1980s, most notably in the US, West Germany, and Italy. Neo-Expressionist paintings are typically large and aggressively raw in feeling.

Neoclassicism A movement in art and architecture that spread through Europe from the late 18th century. Inspired by the order and reason of classical works, it was partly a reaction to the frivolities of the **Rococo** style.

New Objectivity A style of art originating in 1920s Germany that tries to depict the world objectively; it arose as a reaction to **Expressionism**.

Orientalism In art history, a term that refers to the depiction of Eastern culture, especially that of the Middle East and North Africa, by **Academic** artists of the 19th century.

performance art An art form that combines various aspects of visual art, drama, dance, and music. It became popular in the 1960s.

Pop art A movement that emerged in the late 1950s and 1960s in the US and the UK. It was based on popular culture and mass media, using images from comic books, advertisements, products, television, and film.

primitivism Artistic style inspired by so-called "primitive" art—usually understood to mean the art of Africa and the Pacific Islands.

readymade The name given by 20th-century French artist Marcel Duchamp to a type of artwork he invented, made of an ordinary, everyday object removed from its usual functional context and placed in an art gallery.

realism Painting in a realistic, sometimes photographic style. Also (Realism) a movement in 19th-century art in which scenes of contemporary urban and rural life were presented in an unidealized, often earthy way.

Rococo A style of art and architecture characterized by lightness and playfulness. The style succeeded **Baroque** in the early 18th century.

Romanesque The dominant style of architecture and art in much of Europe during the 11th and 12th centuries. Painting of the style is often powerfully non-naturalistic, sometimes with expressionistically distorted figures.

Romanticism A movement of the late 18th and early 19th centuries that celebrated individual experience and expression and often looked to nature for inspiration.

Suprematism A Russian abstract art movement lasting from about 1915 until 1918, involving the use of simple geometrical forms such as squares, triangles, and circles.

Surrealism A movement officially founded by the poet André Breton in Paris in 1924 that became the most influential **avant-garde** movement of the 1920s and 1930s. Related to its predecessor **Dada**, Surrealism was less iconoclastic, seeking to release the creative potential of the unconscious.

Symbolism A movement that flourished in the late 19th and early 20th centuries. Adherents favored subjective, poetic representations of the world, often influenced by mystical ideas.

tenebrism The use of extremes of darkness and light in a painting to heighten its drama.

Vorticism A British **avant-garde** movement that flourished briefly from 1914. It was influenced by Italian **Futurism** and French **Cubism**, and expressed the dynamism of modern life, reacting against the perceived complacency of British society.

INDEX

QUOTATION SOURCES

PREHISTORIC AND ANCIENT ART

THE MEDIEVAL WORLD

RENAISSANCE AND MANNERISM

ACKNOWLEDGMENTS

Dorling Kindersley and Cobalt id would like to thank Helen Peters for the index.

PICTURE CREDITS

The publisher would like to thank the following for their kind permission to reproduce their photographs:

(Key: a-above; b-below; c-center; l-left; r-right; t-top)

2 Dreamstime.com: Tupungato (c). 6 Corbis: Christie's Images (bl). Dreamstime.com: G00b (tr). 7 Corbis: (br). 8 akg-images: World History Archive (tl). 9 Corbis: (bl). 12 Getty Images: DEA/G. NIMATALLAH (c). Alamy Images: INTERFOTO (tc). Bridgeman Images: Universal History Archive/UIG (tr). 13 Alamy Images: ffoto_travel (tl). Corbis: (tc). (cl). 14 Bridgeman Images: FineArt (tc). Alamy Images: Masterpics (tl). 15 Alamy Images: Heritage Image Partnership Ltd (tl). Corbis: Philadelphia Museum of Art/© Succession Marcel Duchamp/ADAGP, Paris and DACS, London 2016 (tc). Alamy Images: LatitudeStock (b). 20 Corbis: Leemage (c). 21 Alamy Images: age fotostock (b). 22 Alamy Images: MELBA PHOTO AGENCY (tl). 23 Alamy Images: Javier Etcheverry (tr). 25 Alamy Images: age fotostock (br). 27 akg-images: Maurice Babey (r). 28-29 Dreamstime.com: Dan Breckwoldt (b). 29 Dreamstime.com: Thirdrome (ca). 30 Corbis: robertharding (bc). 31 Alamy Images: The Art Archive (tc). 32 Corbis: Christie's Images (bl). 33 The British Museum: The Trustees of the British Museum (c). 34 Alamy Images: VPC Travel Photo (cl). 35 Corbis: Steven Vidler (br). 37 Getty Images: DEA/G. NIMATALLAH (c). 38 Alamy Images: The Art Archive (bl). 40 The Art Archive: DeA Picture Library/G. Nimatallah (bl). akg-images: Erich Lessing (t). 41 akg-images: Erich Lessing (tl). The Art Archive: Museo Nazionale Palazzo Altemps Rome/Gianni Dagli Orti (c). 42 Alamy Images: Stefano Politi Markovina (b). 43 Dreamstime.com: Tupungato (tr). 44 akg-images: Pictures From History (tr). 45 Alamy Images: Henry Westheim Photography (tr). Bridgeman Images: Private Collection/Paul Freeman (bc). 46 Bridgeman Images: (tl). Alamy Images: Peter Horree (c). 48 Corbis: Paul Seheult/Eye Ubiquitous (tl). 49 Alamy Images: National Geographic Creative (tr). Bridgeman Images: Alinari (bl). 50 Corbis: Gianni Dagli Orti (c). 51 Alamy Images: Lanmas (c). 52 Alamy Images: Realy Easy Star/Giuseppe Masci (b). The Art Archive (bl). 53 Corbis: GARCIA Julien/Hemis (br). 54 Getty Images: DEA/A. DE GREGORIO/Contributor (c). 55 Alamy Images: INTERFOTO (tr). Corbis: Pascal Deloche/Godong (br). 62 akg-images: Erich Lessing (tr). 63 Getty Images: Ayhan Altun (tr). Bridgeman Images: Treasury of the Abbey of Saint-Maurice (bc). 64 Bridgeman Images: The Board of Trinity College, Dublin (b). 65 Alamy Images: The Print Collector (tr). 66 Alamy Images: Danita Delimont (bl). 67 Alamy Images: The Art Archive (tl). 69 Dreamstime.com: G00b (tr). 70 Bridgeman Images: Metropolitan Museum of Art, New York (bl). 72 Dreamstime.com: Jozef Sedmak (tl). Corbis: Gérard Degeorge (br). 73 Alamy Images: Philippe Maillard (br). 74 Bridgeman Images: Universal History Archive/UIG (br). 74-75 Bridgeman Images: Musée de la Tapisserie, Bayeux (b). 76 Corbis: Angelo Hornak (b). 77 Bridgeman Images: Government Museum and National Art Gallery, Madras (tc). 78 Corbis: Kent Kobersteen/National Geographic Creative (cl). 79 Alamy Images: Malcolm Fairman (c). 80 Alamy Images: ffoto_travel (tl). 81 Bridgeman Images: Peter Willi (tl). The Art Archive: Manuel Cohen (br). 82 Alamy Images: funkyfood London, Paul Williams (t). 82-83 Bridgeman Images: (bc). 83 Corbis: Tuul & Bruno Morandi (tr). 84 Alamy Images: Universal Images Group North America LLC/DeAgostini (t). 85 Alamy Images: Universal Images Group North America LLC/DeAgostini (t). Dreamstime.com: Izanbar (bc). 86 Corbis: Alinari Archives (c). 87 Alamy Images: Alex Ramsay (tc). 88 Scala: (tr). Getty Images: DEA/A. DAGLI ORTI (br). 89 Getty Images: Mondadori Portfolio (r). 91 Bridgeman Images: Museo dell'Opera del Duomo, Siena (c). 92 akg-images: MPortfolio/Electa (t). Bridgeman Images: Museo dell'Opera del Duomo, Siena (b). 93 Bridgeman Images: Museo dell'Opera del Duomo, Siena (tc). 94-95 akg-images: Nimatallah (b). 95 Alamy Images: World History Archive (tl). 96 Scala: The Metropolitan Museum of Art/Art Resource (t). 97 Bridgeman Images: Pictures from History (tr). 98 Getty Images: Heritage Images (cl). Heritage Images (c). 99 Alamy Images: Heritage Image Partnership Ltd (bc). Heritage Image Partnership Ltd (br). 107 Alamy Images: PAINTING (tr). 108 akg-images: Rabatti - Domingie (t). 109 Corbis: Arte & Immagini srl (t). 110 Getty Images: Archive Photos/Stringer (tl). Alamy Images: FineArt (tr). 111 Corbis: Sandro Vannini (b). 113 Corbis: (c). 114 Alamy Images: PAINTING (bl). 115 Corbis: (br). 116 Corbis: (tr). 117 Corbis: Leemage (tr). 118 Alamy Images: Peter Barritt (b). 119 Alamy Images: Mary Evans Picture Library (tc). 120 Bridgeman Images: Ca' d'Oro, Venice (c). 121 Alamy Images: Chronicle (tr). 122 Corbis: (bl). 123 Alamy Images: Classic Image (tl). 124 The British Museum: The Trustees of the British Museum (b). 126 Corbis: AS400 DB (tl). Alamy Images: Dennis Hallinan (tr). 127 Corbis: Leemage (br). 128 Alamy Images: Photos 12 (bl). 129 Corbis: Historical Picture Archive (tl). Michael Nicholson (tl). 131 Corbis: adoc-photos (tr). 132 Corbis: Gianni Dagli Orti (bl). 133 Corbis: Alfredo Dagli Orti (tl). 135 Corbis: (c). 136 Corbis: Historical Picture Archive (bl). 137 Alamy Images: Masterpics (tl). 138 Alamy Images: The Art Archive (tl). Pbarchive (bl). 139 Alamy Images: Pbarchive (tr). Corbis: Leemage (bl). 140 Corbis: (c). 141 Corbis: (tr). 142 Corbis: Leemage (tl). Alamy Images: Heritage Image Partnership Ltd (br). 143 Corbis: Francis G. Mayer (br). 144 Alamy Images: Classic Image (tl). Bridgeman Images: Galleria dell'Accademia, Florence (tr). 145 Alamy Images: Mary Evans Picture Library (bl). 149 Corbis: (tr). 151 Corbis: (tr). 152 Corbis: Ali Meyer (c). 153 Alamy Images: Heritage Image Partnership Ltd (cl). 155 Getty Images: DEA/G. NIMATALLAH (c). 156 Getty Images: DEA/G. NIMATALLAH (c). 157 Corbis: Historical Picture Archive (tr). Bridgeman Images: Louvre, Paris (bl). 158 Alamy Images: Antiquarian Images (bl). 160 Corbis: The Gallery Collection (c). 161 Alamy Images: V&A Images (cl). 170 Corbis: (b). 171 Corbis: Ken Welsh/*/Design Pics (tr). 172 Bridgeman Images: (bl). 173 akg-images: Album/Oronoz (tl). Alamy Images: The Art Archive (br). 174 Bridgeman Images: Prado, Madrid/Index (tr). Alamy Images: Peter Horree (bl). 175 Alamy Images: classicpaintings (tr). 176 Alamy Images: Steve Vidler (b). 177 Corbis: AS400 DB (bc). 178 Alamy Images: FineArt (bl). 179 Alamy Images: Peter Horree (br). Corbis: AS400 DB (bc). 180 Corbis: Leemage (bl). 181 Alamy Images: World History Archive (b). 182 Getty Images: DEA/G. NIMATALLAH (bl). 183 Alamy Images: Heritage Image Partnership Ltd (tr). Corbis: Massimo Listri (bc). 184 Bridgeman Images: Cleveland Museum of Art, OH/Leonard C. Hanna, Jr. Fund (cl). 185 Scala: The Metropolitan Museum of Art/Art Resource (tr). Corbis: Leemage (bc). 187 akg-images: World History Archive (c). 188 Alamy Images: Peter Horree (br). 189 Dreamstime.com: Eugenesergeev (tr1). iStock: Stacey Walker (tr2). Sasha Radosavljevic (tr3). 190 Alamy Images: classicpaintings (br). Jeff Morgan 01 (bl). 191 Scala: Art Resource/© 2016. Banco de México Diego Rivera Frida Kahlo Museums Trust, Mexico, D.F./DACS (br). 192 The Art Archive: Ashmolean Museum (b). 193 Dreamstime.com: Steve Luck (tr). 195 Corbis: Michael Nicholson (tr). Heritage Images (bl). 196 Corbis: adoc-photos (tr). 197 Corbis: Leemage (bl). The Art Archive: Musée du Château de Versailles/Granger Collection (bc). 198 Alamy Images: Masterpics (cb). 199 Getty Images: DEA/G. FINI (tc). Alamy Images: Masterpics (cb). 200 Alamy Images: Lebrecht Music and Arts Photo Library (b). 201 Corbis: Burstein Collection (tr). 202 Alamy Images: PRISMA ARCHIVO (tl). 203 Alamy Images: Lebrecht Music and Arts Photo Library (br). 204 Corbis: GraphicaArtis (cl). 205 Corbis: (br). 206 akg-images: Erich Lessing (tl). 207 akg-images: Erich Lessing (tr). 208 Getty Images: Hulton Archive/Stringer (tl). 208-209 akg-images: Erich Lessing (t). 210 Alamy Images: The Artchives (cl). 211 Alamy Images: SuperStock (c). 212 Corbis: (bl). 213 Corbis: Leemage (tl). Alamy Images: Classic Image (tr). 214 Alamy Images: V&A Images (bl). 215 Alamy Images: Steven Vidler (tl). Bridgeman Images: Victoria & Albert Museum, London (cb). 217 akg-images: Erich Lessing (c). 218 Corbis: Leemage (br). 219 The Art Archive: Victoria and Albert Museum London/V&A Images (tr). 220 Corbis: Araldo de Luca (bl). 221 Corbis: (c). Dreamstime.com: Euriico (bl). 231 Corbis: Burstein Collection (c). 232 Corbis: Leemage (bl). 233 Alamy Images: classicpaintings (c). 234 Corbis: (bl). 235 Corbis: Burstein Collection (c). 236 Alamy Images: Masterpics (b). 237 Corbis: Alfredo Dagli Orti/The Art Archive (tr). 238 Alamy Images: classicpaintings (c). 239 Getty Images: Leemage (tr). Bridgeman Images: Hamburger Kunsthalle, Hamburg (bc). 241 Corbis: Leemage (c). 242 Alamy Images: Heritage Image Partnership Ltd (tr). 243 Dreamstime.com: Andrey Chaikin (bc). 244 Getty Images: DEA PICTURE LIBRARY/Contributor (tl). Corbis: Leemage (bc). 245 Corbis: Leemage (b). 246 Corbis: (b). 247 Alamy Images: Pictorial Press Ltd (tr). 248 Alamy Images: Dahesh Museum of Art, New York (cl). 249 Bridgeman Images: Corcoran Collection, National Gallery of Art, Washington D.C (c). 250 The Art Archive: DeA Picture Library (cl). 251 Bridgeman Images: Private Collection (tl). Private Collection/Photo © Christie's Images (br). 252 Corbis: (c). 253 Corbis: AS400 DB (tc). Leemage (bc). 254 TopFoto: Fine Art Images/Heritage Images (bl). 255 Corbis: Brooklyn Museum (tr). Getty Images: Print Collector (bc). 257 Getty Images: DEA/A. DAGLI ORTI (c). 258 Corbis: Bettmann (bl). 260 Alamy Images: The Art Archive (tl). Corbis: Leemage (br). 261 Corbis: Alfredo Dagli Orti/The Art Archive (tr). 262 Corbis: Christie's Images (tl). 263 Corbis: Francis G. Mayer (b). 264 Alamy Images: Niday Collection (tr). 265 Alamy Images: David Coleman (tl). Corbis: Hulton-Deutsch Collection (bc). 267 Corbis: (c). 268 Mary Evans Picture Library: INTERFOTO/Groth-Schmachtenberger (bl). 270 Corbis: (tl). 271 Getty Images: National Galleries of Scotland (tr). 272 Corbis: (b). 273 Corbis: Leemage (tr). 274 Alamy Images: Heritage Image Partnership Ltd (b). 275 Alamy Images: GL Archive (tc). 276 Corbis: Leemage (tl). Bridgeman Images: Bergen Art Museum / Photo © O. Vaering (tr). 286 Alamy Images: FineArt/Alamy Stock Photo (tr). 287 Corbis: adoc-photos (tr). Scala: Austrian Archives (bl). 288 Collection SFMOMA, Bequest of Elise S. Haas: © Succession H. Matisse/DACS 2016 (c). 289 Corbis: Christie's Images © ADAGP, Paris and DACS, London 2016 (tr). Alamy Images: Everett Collection Historical (bl). 290 Scala: Digital image, The Museum of Modern Art, New York (b). 292 Getty Images: DEA PICTURE LIBRARY/Contributor (bl). 293 Getty Images: Print Collector (tr). Mary Evans Picture Library: Sueddeutsche Zeitung Photo (b). 294 Alamy Images: Dennis Hallinan/© Succession Picasso/DACS, London 2016 (l). 295 Getty Images: Apic (tr). Corbis: The Gallery Collection/© Succession Picasso/DACS, London 2016 (bc). 296 Bridgeman Images: Musee National d'Art Moderne, Centre Pompidou, Paris/© ADAGP, Paris and DACS, London 2016 (bc). Corbis: The Gallery Collection/© Succession Picasso/DACS, London 2016 (bc). 298 Bridgeman Images: Museum of Modern Art, New York/Photo © Boltin Picture Library (cl). 299 Corbis: adoc-photos (tr). Alamy Images: LatitudeStock (c). 302 Alamy Images: INTERFOTO (bl). 303 akg-images: Maurice Babey (tr). 304 Alamy Images: LatitudeStock (c). 305 The Art Archive: The Solomon R. Guggenheim Foundation/Art Resource, NY (bl). 306 akg-images: (c). 307 akg-images: (tl). 308 Corbis: Philadelphia Museum of Art/© Succession Marcel Duchamp/ADAGP, Paris and DACS, London 2016 (b). 309 Corbis: Philadelphia Museum of Art/© ADAGP, Paris and DACS, London 2016 (bc). 311 Corbis: © Salvador Dali, Fundació Gala-Salvador Dalí, DACS, 2016 (c). 313 Bridgeman Images: Berlinische Galerie, Museum of Modern Art, Photography & Architecture, Berlin/© ADAGP, Paris and DACS, London 2016 (br). 314 Bridgeman Images: Collection of Claude Herraint, Paris/© ADAGP, Paris and DACS, London 2016 (br). Alamy Images: © Salvador Dali, Fundació Gala-Salvador Dalí, DACS, 2016 (br). 315 Corbis: © Salvador Dali, Fundació Gala-Salvador Dalí, DACS, 2016 (br). 316 akg-images: World History Archive/Reproduced by permission of The Henry Moore Foundation (c). 317 Corbis: Bettmann (tl). 319 Alamy Images: Peter Horree/© The Pollock-Krasner Foundation ARS, NY and DACS, London 2016 (c). 320 Getty Images: Tony Vaccaro (bl). 321 Dreamstime.com: Pdtnc (tc). 322 Corbis: Rudolph Burckhardt/Sygma/© The Pollock-Krasner Foundation ARS, NY and DACS, London 2016 (c). 323 Alamy Images: Peter Horree/© The Pollock-Krasner Foundation ARS, NY and DACS, London 2016 (b). 324 Corbis: Digital image, The Museum of Modern Art, New York/© ADAGP, Paris and DACS, London 2016 (cl). 325 Corbis: Pierre Vauthey/Sygma (tr). Christie's Images (br). 326 akg-images: Erich Lessing/© Estate of Roy Lichtenstein/DACS 2016 (c). 327 Corbis: Oscar White (tr). 328 Scala: Digital image, The Museum of Modern Art, New York/© ARS, NY and DACS, London 2016 (cl). 329 Corbis: George Steinmetz/© Estate of Robert Smithson/DACS, London/VAGA, New York 2016 (c). 330 Caroline Tisdall: (c). 331 Caroline Tisdall: (b). Alamy Images: INTERFOTO (tr). 332 Elizabeth A. Sackler Center for Feminist Art, Collection of the Brooklyn Museum: © Judy Chicago. ARS, NY and DACS, London 2016/Photo © Donald Woodman (cl). 333 Elizabeth A. Sackler Center for Feminist Art, Collection of the Brooklyn Museum: © Judy Chicago. ARS, NY and DACS, London 2016/Photo © Donald Woodman (c). 334 Alamy Images: Stefano Politi Markovina/© The Easton Foundation/VAGA, New York/DACS, London 2016 (c). 335 Corbis: Christopher Felver (tr). 336 Getty Images: Marco Secchi (b). 337 Getty Images: RAFA RIVAS/Stringer (bc).

All other images © Dorling Kindersley. For more information see: www.dkimages.com